A

*[signature: Philip E. Lilienthal]*

■         ■              ■

B O O K

The Philip E. Lilienthal imprint
honors special books
in commemoration of a man whose work
at University of California Press from 1954 to 1979
was marked by dedication to young authors
and to high standards in the field of Asian Studies.
Friends, family, authors, and foundations have together
endowed the Lilienthal Fund, which enables UC Press
to publish under this imprint selected books
in a way that reflects the taste and judgment
of a great and beloved editor.

D1596632

The publisher and the University of California Press Foundation gratefully acknowledge the generous support of the Philip E. Lilienthal Imprint in Asian Studies, established by a major gift from Sally Lilienthal.

# Mediums and Magical Things

# Mediums and Magical Things

*Statues, Paintings, and Masks in Asian Places*

Laurel Kendall

UNIVERSITY OF CALIFORNIA PRESS

Permission to reprint has been sought from rights holders for
images and text included in this volume, but in some cases it
was impossible to clear formal permission because of
coronavirus-related institution closures. The author and the
publisher will be glad to do so if and when contacted by
copyright holders of third-party material.

University of California Press
Oakland, California

© 2021 by Laurel Kendall

Library of Congress Cataloging-in-Publication Data

Names: Kendall, Laurel, author.
Title: Mediums and magical things : statues, paintings,
    and masks in Asian places / Laurel Kendall.
Description: Oakland, California : University of
    California Press, [2021] | Includes bibliographical
    references and index.
Identifiers: LCCN 2020051188 (print) | LCCN 2020051189
    (ebook) | ISBN 9780520298668 (hardcover) | ISBN
    9780520298675 (paperback) | ISBN 9780520970717
    (ebook)
Subjects: LCSH: Idols and images—Asia. | Religious
    art—Asia. | Religious articles—Asia. |
    Commodification.
Classification: LCC BL485 .K46 2021  (print) | LCC BL485
    (ebook) | DDC 202/.18095—dc23
LC record available at https://lccn.loc.gov/2020051188
LC ebook record available at https://lccn.loc
    .gov/2020051189

Manufactured in the United States of America

29  28  27  26  25  24  23  22  21
10  9  8  7  6  5  4  3  2  1

*To Hildred Geertz and Nguyễn Văn Huy who,*
*each in their own way, made it possible for me*
*to see and learn in places outside my normal beat*

# Contents

# Illustrations

COLOR PLATES

*Plates 1 through 15 appear between pages 58 and 59, and plates 16 through 30 between pages 106 and 107.*

# Preface and Acknowledgments

Paintings, statues, masks—like the bodies of shamans and spirit mediums—give material form and presence to otherwise invisible entities. Some images are passive, agentive only insofar as beauty or grotesquerie evokes an emotional response of adoration, fear, or iconoclastic rage. Those that are the subjects of this book, however, are understood to be enlivened, agentive on their own terms. They are active media for the devotee's engagement with buddhas, *nat, niskala, sin,* or other gods, spirits, or uncanny energies in many traditions of religious practice. They may be regarded as receptors for the transmission of prayers and blessings or as critical nodes for the flow of inspiration that propels a medium or shaman into mobile and efficacious manifestations of the divine. For some, this is "idol worship," a troubling notion contested in more than one religious tradition over centuries if not millennia. The idea that an object might be ensouled, animated, blessed, or otherwise numinous also challenges those who engage the material world through modernity's lens. Religious statues, paintings, and masks have been defaced as idols and burned as fetishes in acts of Christian conversion, Islamic purification, and anti-superstition campaigns over time and across a broad political and theological spectrum. A perpendicular but no less "modern" move than tearing down the statues installs them in museums, neutralizing their power claims while recuperating their value as art and national or world heritage.

Outside of museums and beyond the reach of iconoclastic enthusiasms, paintings, statues, and masks continue to be produced, and

increasingly mass-produced, for deployment as sacred or empowered things. Those that I will be describing in the following pages are contemporary or, at most, little more than a century old. The statues used by Vietnamese and Burmese spirit mediums, the paintings that hang in Korean shamans' shrines, and the masks deployed in Balinese temple festivals are commissioned, fabricated, bought and sold, ensouled and tended. Set to their intended work, they are subsequently refurbished or respectfully disposed of, and sometimes repurposed for new markets as antiquities and art. *Mediums and Magical Things* is about the processes whereby human actors, in different settings and through locally inflected interpretive frames, engage with these most particular statues, paintings, and masks. I am concerned with how the images are understood to be empowered—in other words, with how they "work" and why, sometimes, they do not. I am concerned with the production, ensoulment, and tending of the images, how they are eventually retired from active practice, and how, occasionally, normal protocols for their disposal are rewritten when they are sent in the direction of art markets and museums.

This is a comparative work, with the many cautions that must necessarily attend such an enterprise. It has been produced with an enormous debt to many people in many places: colleagues, co-researchers, and conversation partners. It builds upon four collaborative projects described in the next chapter and for which I had helpful professional partners; our work led to several jointly-authored publications, both noted below and used to make this text. I thank the shamans, spirit mediums, carvers, painters, purveyors of religious goods, and other devotees in South Korea, Vietnam, Bali, and Myanmar who took the time to answer our questions, challenge my prior assumptions, share experiences, and offer opinions. Through such encounters and through the generosity of spirit of those one meets, anthropology takes shape; it could not otherwise exist.

Nguyễn Văn Huy, founding Director of the Vietnam Museum of Ethnology, opened many doors as the co-principal investigator for our study of sacred objects in the collection of the Vietnam Museum of Ethnology (described in chapters 1 and 6), funded by the Wenner-Gren Foundation for Anthropological Research. For my own work on this project, I teamed with Vũ Thị Thanh Tâm and Nguyễn Thị Thu Hương, but also benefited from the knowledge and experience of other members of the VME staff, some of whom will appear by name and citation in what follows. A consulting project with the Women's Museum of Vietnam allowed me to continue research on the Mother Goddess Religion of Vietnam on a project funded by Ford Foundation Vietnam. I

have also done fieldwork with Nguyễn Thị Hiền, now of the Vietnam Institute for Culture and Art Studies, who has also taught me a great deal about the Mother Goddess Religion of Vietnam and its mediums.

In South Korea, I worked on a book about shaman paintings with Jongsung Yang, formerly of the National Folk Museum of Korea and now Director of the Shamanism Museum, and Yul Soo Yoon, Director of the Gahoe Museum. Sungja Kim Sayers was my field assistant for this and many other projects. Sun Yoo and Soo-jin Yoon transcribed field interviews into Korean script. Special thanks also to the Cheju National University Museum, the Face Museum, the Kyung Hee University Central Museum, the Mok-A Museum, the National Folk Museum of Korea, the Onyang Folk Museum, and the Seoul Museum of History, and to Young-kyu Park for all manner of help. My research on shaman paintings was partly funded by the Committee on Korean Studies of the Northeast Asia Council of the Association for Asian Studies.

Erin Hasinoff was willing to share her experience of Myanmar and her extensive contacts, collaborating with me on a research project that took us to festivals celebrated by spirit mediums and into art galleries. Thein Thein Win and Pyi Pyi Thant provided fieldwork assistance. The Myanmar sections of this project would not have been possible without recourse to Bénédicte Brac de la Perrière's extensive publications on *nats* and their mediums, cited extensively in what follows. John Okell advised us on Burmese romanization when Erin and I prepared our research for publication.

Hildred Geertz has been my fairy godmother with respect to all things Balinese, including an introduction to Ni Wayan Pasek Ariati, who has been an ideal research partner through several field trips. I am grateful to the many Bali scholars, both Balinese and not, who are abundantly cited in what follows. Special thanks for all manner of advice and help go to Ida Bagus Anom, Rucina Ballinger, Suasthi Widjaja Bandem and I Madé Bandem, Bruce Carpenter, Rachel Cooper, Cecily Cook, Ida Bagus Anom ("Gus") Ganga, David Irons, Thomas Hunter, Garrett Kam, I Ketut Kodi, Jeremy Taylor, Kari Telle, Tjokorda Raka Tisnu, and Adrian Vickers. My initial research in Bali was supported by the Asian Cultural Council.

Research support not otherwise acknowledged came from the Jane Belo-Tanenbaum Fund of the American Museum of Natural History. Jane Belo's own writing on Bali many years ago was one of my inspirations; I hope that what I have written would have pleased her. Katherine Skaggs, Kayla Younkin, and Barry Landua of the Division of Anthropology, American Museum of Natural History (AMNH), helped to prepare

this manuscript for publication. For the photographic images that appear in this book, I am grateful to the AMNH Division of Anthropology, the AMNH photography studio, the Vietnam Museum of Ethnology, the Gahoe Museum (Seoul), and the Shamanism Museum (Seoul), as well as Wayan Ariati, Erin Hasinoff, and Homer Williams for permission to use their photographs. Thanks to Reed Malcolm and Archna Patel for their faith in this manuscript and their willingness to see it through production and Catherine Osborne and Kate Hoffman for their expert editorial assistance. Piers Vitebski and Boudewijn Walraven read this manuscript for the press; their comments helped me to strengthen the final manuscript.

My husband, Homer Williams, was an aniconic Protestant sounding board for this research over many years. Many thanks to him and to our son Henry for tolerating the extended travel, time at the computer, and general state of distraction such a project requires. I alone am responsible for any remaining errors of representation and transcription, and other shortcomings of this work.

*Mediums and Magical Things* builds on thinking and writing done over more than fifteen years. I am grateful to the publishers who have allowed me to draw on earlier publications in making a new configuration and to those journals that, as stated policy, allow an author to reuse material published in their pages. The patches for this quilt come from the following publications:

2021.  With Ni Wayan Pasek Ariati. "Animism? Animated? Ensouled? The Active Lives of Balinese Masks." In *Handbook of Material Religion*, edited by S. Brent Plate. Abingdon, UK: Routledge, forthcoming.

2020.  With Ni Wayan Pasek Ariati. "Scary Mask/Balinese Local Protector: The Curious History of Jero Amerika." *Anthropology and Humanism* 45, no. 2 (Winter): 1–22.

2018.  2nd author, with Erin Hasinoff. "Making Spirits, Making Art: Nat Carving and Contemporary Painting in Pre-Transition Myanmar." *Material Religion: The Journal of Objects, Art and Belief* 14, no. 3: 285–313.

2018.  "The Shrine as a Motor: A Metaphoric Exploration of Shamans and Electrical Flows in the Republic of Korea." *Magic, Ritual, and Witchcraft* 13, no. 2: 267–85.

2017.  "Things Fall Apart: Material Religion and the Problem of Decay." *The Journal of Asian Studies* 76, no. 4: 861–86.

2017.  "Shamans, Mountains, and Shrines: Thinking with Electricity in the Republic of Korea." *Shaman* 25, no. 1/2: 15–25.

2015.  With Jongsung Yang. "What is an Animated Image? Korean Shaman Paintings as Objects of Ambiguity." *HAU: Journal of Ethnographic Theory* 5, no. 2: 153–75.

2015. With Jongsung Yang and Yul Soo Yoon. *God Pictures in Korean Contexts: The Ownership and Meaning of Shaman Paintings.* Honolulu: University of Hawai'i Press.

2014. With Jongsung Yang. "Goddess with a Picasso Face: Art Markets, Collectors and Sacred Things in the Circulation of Korean Shaman Paintings." *Journal of Material Culture,* 19, no. 4: 401–23.

2012. With Vũ Thị Thanh Tâm and Nguyễn Thị Thu Hương. "Icon, Iconoclasm, Art Commodity: Are Objects Still Agents in Vietnam?" In *The Spirit of Things: Materiality and Religious Diversity in Southeast Asia,* edited by Julius Bautista, 11–26. Ithaca, NY: Southeast Asia Program, Cornell University.

2011. "The Changsŭng Defanged? The Curious Recent History of a Korean Cultural Symbol." In *Consuming Korean Tradition in Early and Late Modernity: Commodification, Tourism, and Performance,* edited by Laurel Kendall, 129–48. Honolulu: University of Hawai'i Press.

2010. With Vũ Thị Thanh Tâm and Nguyễn Thị Thu Hương. "Beautiful and Efficacious Statues: Magic, Commodities, Agency, and the Production of Sacred Objects in Popular Religion in Vietnam." *Material Religion: The Journal of Objects, Art and Belief* 6, no. 1: 60–85. Reprinted in *Vietnam Social Sciences* 6 (2014): 35–51.

2008. "Editor's Introduction: Popular Religion and the Sacred Life of Material Goods in Contemporary Vietnam." In "Popular Religion and the Sacred Life of Material Goods in Contemporary Vietnam." Special issue, *Asian Ethnology* 67, no. 2: 177–99.

2008. With Vũ Thị Thanh Tâm and Nguyễn Thị Thu Hương. "Three Goddesses In and Out of Their Shrine." In "Popular Religion and the Sacred Life of Material Goods in Contemporary Vietnam." Special issue, *Asian Ethnology* 67, no. 2: 219–36.

# Conventions

Korean *mansin* are mostly, though not exclusively, female, and I use the female pronoun for generalization. Burmese *nat kadaw* are mostly, but not exclusively male, although there is evidence that most were women little more than a hundred years ago; I use the masculine pronoun for generalization. Spirit mediums in Vietnam include both *bà đồng* (female) and *ông đồng* (male) and cannot be generalized to a single gender. All of these communities include some members who in contemporary North America might self-identify as transsexual or nonbinary but whose numbers are difficult to estimate (see Ho 2009 on the pitfalls of making such distinctions with respect to Burmese *nat kadaw*). Balinese *pemundut* are male. Vietnamese ritual masters are male, although I have met an exception. Carvers in Vietnam, Bali, and Myanmar are male, and I know of only one possible exception to the generalization that all painters of Korean god pictures are men. I use the masculine pronoun for all of these.

Korean terms are in McCune-Reischauer romanization, with the exception of place names where common forms are used (for example, Seoul, Uijeongbu). Non-English terms such as *mansin* and *nat* are not pluralized with an 's.' However, both scholars and practitioners sometimes use the Anglicized plural form "*nats*," and I have retained that wherever it appeared in a source. With respect to personal names, I use authors' romanizations of choice where I know them. Like Korean names, Vietnamese names are surname first ("Nguyễn Văn Huy"), but

polite terms of address are by given name ("Professor Huy"), a convention I preserve for the colleagues with whom I worked closely over many years. Vietnamese American authors do not usually use diacritical marks ("Trian Nguyen"). I have provided Chinese character glosses in the text for a relevant ritual terminology that flows between China, Korea, and Vietnam, in part to make the point that such flows exist. I use the standard "Cokorda" for a member of the traditional Balinese ruling cast but honor an individual's preference for "Tjokorda," an older form gaining new popularity.

# MacGuffins and Magical Things

In fiction, a MacGuffin (sometimes McGuffin or maguffin) is a plot device in the form of some goal, desired object, or other motivator that the protagonist pursues, often with little or no narrative explanation. The specific nature of a MacGuffin is typically unimportant to the overall plot. The most common type of MacGuffin is an object, place, or person.

—Wikipedia

When the MacGuffin is an object, it is an agentive object, something that moves the action, causes things to happen. The Maltese falcon of the eponymous Humphrey Bogart film is the quintessential MacGuffin. The MacGuffin of *Mediums and Magical Things* sits in the storage vault of the Vietnam Museum of Ethnology (VME) in Hanoi—three goddesses with blissful smiles on their faces, carved of wood and covered with gilt and lacquer (plate 1). In anthropology, as well as in fiction, the MacGuffin takes us unawares, but the anthropologist is obliged to provide something in the way of a narrative explanation, which I will, by and by. The goddess statues in question are not "unimportant to the overall plot," although the plot will eventually overtake them. They are MacGuffin-ish, however, insofar as they administered the motivating nudge for this project. A research path opened imperceptibly, and a scholarly obsession took hold. It happened in 2002, on the morning when Madame Trần Thị Duyên (Bà Đồng Duyên) from the Tiên Hương Palace at Phủ Dầy, a primary seat of Mother Goddess worship in northern Vietnam, visited the VME. A few years would pass before I recognized that at mid-career, I had been MacGuffined, and was spinning in a new and unforeseen direction, a trajectory involving encounters with empowered images—statues, paintings, masks—that abide under the broad umbrellas of Buddhist and Hindu practice across the map of Asia (figure 1).

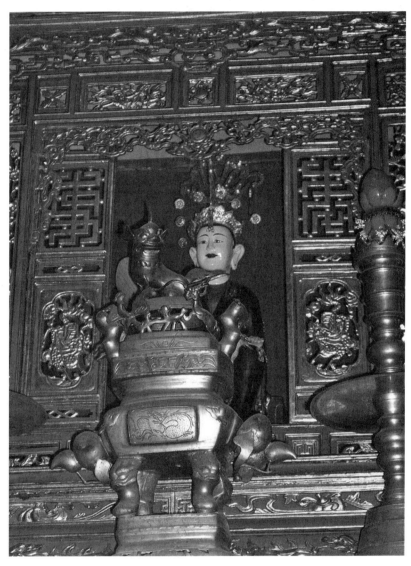

FIGURE 1. Newly refurbished image of a Mother Goddess in a spirit medium's temple, northern Vietnam, 2004. Photo: author.

## THE DAY THE SPIRIT MEDIUM VISITED THE MUSEUM

Early in the new millennium, I worked with Dr. Nguyễn Văn Huy, director of the VME, in co-curating an exhibition, *Vietnam: Journeys of Body, Mind and Spirit,* jointly produced by the American Museum of Natural History. It was a thrilling and exhausting endeavor involving three intense years of close collaboration between Vietnamese and American colleagues. For labels and exhibition book essays, we evolved a conscientious process of translation, editing, back-translation, and more editing, until the final joint signoff, all of which I experienced as an absorbing seminar in Vietnamese culture. This way of working would become a model for me as the projects that became this book took shape. At the same time, following one of the threads in our exhibition story and my own anthropological interests, I was swept into the exuberant revivification of popular religion that was taking place in Vietnam at the turn of the millennium. The spirit medium's visit occurred in the middle of our work.

Tiên Hương Palace, primary seat of Mother Goddess worship in northern Vietnam, had donated statues and other material to the new ethnology museum in Hanoi when it opened in 1997. For *Vietnam: Journeys,* members of the VME staff had explained our project to Madame Duyên's husband, Ông Đồng Đức, the keeper of the Tiên Hương Palace. We intended to exhibit statues of the three Mothers—the Goddesses of Heaven, of Mountains and Forests, and of Water. Hoping to gain respect for their religion overseas, the temple-keepers generously agreed to provide the statues, my MacGuffins, and politely turned down the VME's offer to pay for them. Ông Đồng Đức would later explain that he saw this donation as an act of devotion, of giving to the Mothers' children. He told us that accepting money from VME would be like "selling the Goddesses." Instead, he mobilized followers from all over the country to contribute to making the statues. The Palace organized a ceremony asking the Mother Goddesses to witness the offering of the carefully carved and gilded images. For their journey to the museum, the three Mothers were ceremoniously covered with red cloths as if they were on their way to be installed in a temple. Once at the VME, ritual protocol gave way to museum protocol as the staff catalogued the statues and housed them in the storeroom, removing their red cloths and silk turbans and storing these things with other textiles rather than keeping them in association with the images.

The statues arrived at the VME at an unfortunate moment in the history of our exhibition project. The financial crisis that hit New York City

in the wake of 9/11 forced us to drastically trim our objects list to a third of our original intention. Innocent of the Tiên Hương Palace's emotional investment in having the statues exhibited in New York, indeed innocent of the high quality of the statues that had arrived at the museum, I suggested that the pinched exhibition budget could not accommodate shipping large, fragile, and heavy objects and that the statues were obvious candidates for omission. In truth, I had been mistakenly shown other statues and had not been impressed with their quality; I would not see the actual statues from the Tiên Hương Palace until the day of the encounter. In December of 2002, during the final months of preparation for our exhibit, the curatorial team realized that we could not represent the world of spirit mediums and their rituals without some representation of the Mother Goddesses for a simulated altar. When I saw the actual gilded statues, I realized my mistake. They would have been a spectacular addition to the exhibit, but it was still impossible to cover the cost of shipping and it was by then impossible to accommodate objects of this size in the all-but-final exhibition design for the spirit mediums' altar.

Director Nguyễn Văn Huy turned to the Tiên Hương Palace for advice, wondering if some of the smaller statues in the VME collection could be sent instead. Ông Đồng Đức and his community were profoundly disappointed that the Tiên Hương statues would not be traveling to New York. Madame Duyên descended from the palace to assess the situation. Because the three Mother Goddess statues had grown dusty in storage, and in anticipation of Madame Duyên's arrival, the VME collections management team took the gold-covered images out of the storeroom, placed them on a low-planked platform, and began to clean them, everyone remarking on their fine quality. They were still at work when Madame Duyên arrived and reacted with horror. "On the floor! You put them on the floor! Would you put Ho Chi Minh's image on the floor?" Profuse apologies ensued.

Ông Đồng Đức and Bà Đồng Duyên had never intended for the statues to be kept in a storeroom, and said that the VME should return them if it did not intend to display them. The statues could be given to a Mother Goddess temple overseas, another means of making the religion known to a global community, the kind of work that the Tiên Hương Palace had hoped to accomplish through our exhibition. My Vietnamese colleagues, for their part, understood that these three statues had not been ritually enlivened with the souls of deities. They saw them as fundamentally different from the statues-become-gods that lead active lives on temple altars, practices with which they, unlike me, were already well acquainted.

So they were not enlivened—but at the same time, these were not ordinary artifacts, as Madame Duyên was causing us to see. What were they?

## MADE TO BE EMBODIED

The three Mothers are the sort of objects that are meant to embody a god/soul/energy, the sort of object that in early Western writing about non-Western religion was sometimes called a "fetish" or, in statue form, an "idol." These are material fabrications intended to foster "a sense of extraordinary, super-sensory presence which arises through a complex assemblage of acting and sensing humans," priests and other religious specialists, devotees, and the fabricators themselves (Meyer 2015a, 167). In studies of material religion, many productive conversations have taken the fetish and the act of "fetishizing" as an entry point (e.g., Meyer 2014; Latour 2010) such that it becomes necessary to distinguish the "fetish," strictly speaking, from the "idols" and other images that I will be considering here. Peter Pels (1998, 101) emphasizes the extraordinary materiality of the fetish: "we cannot only think animistically, of anthropomorphized objects, of a spirit in matter, but also fetishistically, of human beings objectified by the spirit of the matters they encounter."

The material form acts upon the human object, provoking a response. Yes, the empowered images described here can be said to objectify their human subjects, engendering awe, fear, comfort, grateful devotion, or trancing. The particular and remarkable form and substance of their materiality participates in this. The images that I will be discussing are also not innately animistic; they come to be inhabited by spirits or energies through ritual work and processes that could be described as "magic." Ensoulment is neither an inevitable nor an irrevocable condition. It is something that is enacted upon or inducted into a thing whose basic materiality pre- and postdates this special habitation. The possibility of there being a before, during, and after to the presence of spirit or soul stuff is of no small consequence for those who engage statues, masks, and god pictures. Pels's notion of "spirit in matter" becomes here a mutable quality that confounds and complicates the nature of solid matter and the ontology of the object. The discussion necessarily concerns materiality, but looks to a different causality. The images that concern us here are about spirit in matter but with respect to the acts and circumstances that cause spirit/god/soul/energy to be there, or not.

Where the fetish is commonly understood as a product of the practitioner's own fabrication, often homespun or a found thing, statues like the three Mother Goddesses are complex craft productions commissioned by individuals or communities. They are, for the most part, made by skilled artisans according to strict protocols, usually in workshops dedicated to this purpose, such as have existed in societies inflected by Hindu or Buddhist practices for a very long time. Those who do this work are skilled in the ways of working wood or stone or casting metal. Sometimes techniques are simplified, and production rationalized, but not without debate. As Teri Silvio (2008, 203) notes for Taiwanese popular religion, and as could be more broadly stated across time and space, these are places where "idol worship is not a historical heresy but everyday practice—where the divine was never conceived as absolutely separate from the human, never unique or indivisible, and never unrepresentable." The scriptural traditions of Hinduism and Buddhism include bodies of liturgical knowledge that accompany and enable the production and ensoulment of images. Gods, spirits, buddhas, and *nat* are ritually installed inside appropriately prepared sculptural forms as receptors for the transmission of prayer, blessing, and protection. Through appropriate procedures, the statue body becomes the body casing of a socially present god, spirit, buddha, or *nat*. Usually, an animation packet of ritually-indicated substances is installed in a cavity, analogous to the vital organs that are encased in the mortal flesh and bone of a living human body. A priest, monk, or ritual master awakens the image's senses and "opens" its eyes. Some images, thus enlivened, gain renown as fantastically efficacious sites of power and veneration, while others are grudgingly conceded to be duds. Most lead ordinary lives as recipients of petitions and bestowers of benevolent fortune.

Object failure, as well as remarkable assertions of object agency, are subjects of conversation in different domains of popular religious practice in many places, as will become evident in the following pages. The reasons given for both extraordinary agency and none at all may vary not only with the setting, but in the opinion of different tellers, for, as anthropologists have discovered, the actions abducted to otherwise invisible forces often provoke a multitude of local interpretations (Belo 1960, 72–73; Wolf 1992). Expressed skepticism regarding the veracity or appropriateness of a particular report of image agency is not everywhere to be conflated with a blanket denial of the possibility that an image can enable the presence of a god, spirit, or other non-quotidian

power charge. To explore the circumstances where such possibilities are alive and open to debate is to be concerned with how, as Webb Keane (2013, 4) writes, "material practices make the invisible world a presupposable ground for what practitioners perceive? How do people produce the immaterial using the material means available to them?"[1]

Religious images in Catholic communities in and beyond Europe also have long traditions of specialized craft production. When blessed to a sacred purpose, a Catholic statue inspires the worshipper to prayerful piety (*Catechism of the Catholic Church* 1997, 173–74; Schepers 1967, 791), a basic operation of object agency described in the work of David Freedberg (1989), David Morgan (2005), and especially Alfred Gell (1998). In the medieval European world, many images acquired reputations as miracle-working and became the foci of pilgrimages and other activities (Belting 1994). As has been noted in sensitive writing about contemporary vernacular Catholic practices, some statues acquire or maintain a sense of presence as the foci of community or personal devotion, and many devotees feel a strong sense of relationship when they address their prayers to an image. Statues of Christ, the Virgin Mary, and certain saints are, in some places, kissed, dressed, bejeweled, caressed, and addressed with heartfelt appeals for succor (e.g., Bautista 2010; Christian 1989; De La Paz 2012; Orsi 2005; Whitehead 2013). These are sometimes awkward matters for Catholic theologians. Caroline Walker Bynum has parsed how even in the late medieval period, when statues and other material forms were most exuberantly body-like, these intimations of blood and flesh were matters of significant ambivalence for many religious thinkers (Bynum 2015). Theologically and liturgically, a Catholic statue is not "animated" in the sense that statues and masks are ritually ensouled and enlivened in Buddhist or Hindu practice; they are not intended to house spirits, as objects and images in some shamanic traditions are known to do. Catholic images are not "worshipped," and Catholics are sensitive to this characterization.

Most Western museum visitors and temple tourists are not aware of the practices that enliven Buddhist, Hindu, and related images. The heavy hand of a Protestant-inflected modernity influenced the academic study of "Eastern Religions," making it for many years an enterprise of textual study.[2] The religious images that had unsettled early missionaries were rehabilitated as "art" in museums and heritage sites. Advocating respect for their chosen fields of scholarship, aficionados and scholars hewed to scripture and artistic formalism, avoiding the specter of

irrationality, superstition, and idolatry that accompanied what Tomoko Masuzawa (2005) has described as the Otherizing of practices outside the so-called "religions of the book." That battle is over; the Western academy regards "Buddhism" and "Hinduism" as "religions" and scholars of religion now generally accept that religious life—in any tradition—includes abundant popular practices, some of them material. A growing body of scholarship describes the making and ritual ensoul- ing of statues and reliquaries, and the networks of patronage and devo- tion that enable these projects within specific traditions of practice.[3] Art exhibits sometimes include material evidence of the ensoulment of a buddha made of metal, wood, or stone.[4] Accounts of popular religion, including my own and my colleagues' work, have described the social lives of sacred images in contemporary local contexts.[5]

*Mediums and Magical Things* attempts a broader conversation, an exploration of things material, social, and spiritual that enable and are enabled by ensouled images as they are understood in some different Asian places. This is a discussion in which "the 'things' themselves may dictate a plurality of ontologies" (Henare, Holbraad, and Wastell 2007). Statues used by Vietnamese and Burmese spirit mediums, the paintings that hang in Korean shaman shrines, and the masks worn on the heads of entranced dancers in Balinese festivals—the four central cases in my discussion—are all considered by devotees to be inhabited by gods/spir- its/energies that become present and agentive though appropriate use in appropriate settings. My examples all come from places where statue ensoulment is a part of local Buddhist or Hindu devotion and where such practices have also infused popular religion in more localized forms. While the social lives of god pictures used by shamans in Korea and temple masks worn by spirit mediums in Bali are not identical in every respect to the social lives of statues, there is sufficient resonance to sustain a conversation among them. Not all images in these places par- ticipate in shamanic or mediumistic practice, but my four core cases do. In these examples (and others) the relationship between images, the gods or spirits or energies that enliven them, and the bodies of shamans or spirit mediums, is dynamic rather than purely symbolic or represen- tational; immobile objects become material media that enable gods/ spirits/energies to operate through mobile human bodies, spirit medi- ums and shamans (see chapter 4). As a consequence of these expecta- tions, a great deal is at stake in how these images are made, tended, and used in popular religious practice. Some of the activities of making and the doing could be characterized as "magic," for want of a better term.

## WORKING WITH MAGIC

I use the word "magic" cautiously, aware of the essentialist pitfalls, the prejudices of Victorian anthropology, and the ways that this word has come to be associated with stage magic and slight-of-hand, but I use it, nonetheless. I share the concerns of Hildred Geertz (1975) and Elizabeth Graham (2018) that the word came into anthropological use attached to the shadow of its prior and distinctively Eurocentric incarnation—magic as the Satanic or mistaken practices of the Other. In classic works of anthropology, magic has been relegated to the bottom of a science/religion/magic hierarchy, either as a consequence of flawed primitive thinking (Frazer 1980 [1890]; Tylor 1958 [1871]) or limited technology (Malinowski 1954). S. J. Tambiah (1973, 221) made a rehabilitative argument for magic as an *illocutionary* act, "something very common in human activity: an attempt to get the world to conform to words (and gestures). . . . It assumes that through performance, under appropriate conditions, magic can achieve a state of change." For the purpose of the following discussion, magic-making gestures would include not only those of the ritual masters who awaken the statues' senses, but also the work of the artisans whose skilled craftsmanship is saturated with magical intention, to say nothing of the intended agency of shamans, spirit mediums, and the images themselves.

The notion of an illocutionary act, however, is very broad indeed. It elides an already imperfect distinction between routinized, formalized procedures (the pronunciation of man and wife in the wedding ritual) where the outcome is both predictable and generally positive, and the high-stakes and high-risk activities that are often a part of magic's claim.[6] High-stakes and high-risk actions are very present in Michael Taussig's (1993) magic of mimesis, an act of capturing the power of the object being portrayed. The Amazonian shaman's evocation of a jaguar or peccary acts "such that 'calling them up' is to conjure with their image, hence their soul, and hence give birth to the real. I am suggesting, in other words, that the chanter is singing a copy of the spirit-form, and by virtue of what I call the magic of mimesis, is bringing the spirit into the physical world" (105). We will encounter this sort of operation, this "calling up" and bringing out into the here and now of ritual space, in the following chapters, where attempts to bring the unseen god/soul/energy into the physical world are difficult, require effort, and carry the ever-present possibility that it might not work at all, or even worse, have a dangerous consequence. Similarly concerned with the process of

capturing power from out there, Alfred Gell's (2002 [1988]) essay "Technology and Magic" describes the latter as an artful means of trapping the spirits and seducing them to one's will. Gell specifically emphasizes the beauty or artistry of the magician/maker's skilled fabrication as the source of the object's enchantment, its ability to "enchant" a human or a spirit target. As we shall see, the beauty of skilled execution is not inconsequential for the success of an empowered image.

Magic remains a useful word. I share Graham's (2018) concerns that as deployed in contemporary English, "magic" is overfreighted with different and often trivializing connotations, easily evocative of theatrical conjuring, belief in Tinkerbell, or as an advertising superlative ("Experience the magic!"). I agree that native terminology is best when the local word can do the work intended, as in a case-specific ethnography (Graham 2018; Lederman 2017). But a native term will not always suffice, particularly where the task is dialogic and broadly comparative. When I make presentations about Korean *mansin,* religious practitioners who are at the center of much of my writing, and who will appear in the following chapters, I can assume that my audience will have been drawn by a common interest in those we have broadly, and not without debate, agreed to call "shamans," borrowing a Tungus word. Indeed, many anthropologists of religion and religious studies scholars regard the word "religion" itself with justifiable suspicion. Many of us spend ink and screen time explaining how our non-Western subjects cannot be stuffed into procrustean Western/Christian notions of what a religion is, a caution repeated with mantra-like regularity at scholarly fora devoted to the study of "religion." For the project at hand, I need a word that crosses boundaries, that gives at least the illusion of a possible translation. "Sacred" crops up with fair frequency; the term is broad, neutral, respectful, but far too passive a word for the actions abducted to these particular images and to the intentions of the people who make, use, and enliven them. "Technologies of sacred production" takes me most of the way without the baggage attached to "magic." It suggests ways of doing things that yield an efficacious consequence and that are not restricted to (but not necessarily exclusive of) procedures comprehensible to an Enlightenment understanding of the operations of cause and effect in the material world. When a skilled artisan applies proper tools to well-seasoned wood, he produces a beautiful statue, to Vietnamese eyes a statue more likely to be efficacious than one that is crudely made and ugly. But "technologies of sacred production" is a wordy turn of phrase and "magic" remains my most accessible shorthand. I will use it where shorthand is expedient, as in the title of this book.

## THE WORK OF A MACGUFFIN

Fast-forward: When *Vietnam: Journeys of Body, Mind and Spirit* opened successfully in New York in 2003, Richard Fox, then of the Wenner-Gren Foundation, encouraged Dr. Huy and I to apply for a collaborative research grant. The timing was right. Fox wanted to fund a research project in Vietnam, and Dr. Huy and I had proven that we worked well together. Memories of our encounter with Madame Duyên were fresh when we decided to focus on (what we were then calling) sacred objects in the VME collection. The VME was a new museum and these things had been collected within the last ten years, so that there were clear paths back to those who had made, used, and gifted or sold them. The research staff identified six VME objects that had either piqued their curiosity or had made them ill at ease (see chapter 6). We applied to and received funding from the Wenner-Gren Foundation for linked studies of how these things had been made, made sacred, used, and disposed of, and how it had happened that, in each case, the objects had come to reside in the Vietnam Museum of Ethnology. I worked with two young researchers, Vũ Thị Thanh Tâm and Nguyễn Thị Thu Hương, who wanted to learn fieldwork techniques. We would be the team that focused on the three Mother Goddess images that/who had set this process in motion. We went with due humility to the keepers of the Tiên Hương Palace and explained our project. Madame Duyên and Ông Đồng Đức received us warmly. With generosity of spirit, Ông Đồng Đức explained the careful crafting of the VME statues as on a par with that of statues made to sit in temples, and then sent us to the artisans who had done this work. Through this process, we began to learn what a temple statue was, and about the expectations placed upon it through procedures of careful fabrication, installation, ensoulment, and tending. During this process, our thinking developed in dialogue with the other VME researchers. Nguyễn Văn Huy and Phạm Lan Hương (2008) were researching a statue that had been de-animated and removed from a village temple under acrimonious circumstances. Vũ Hồng Thuật (2008), who was researching an amulet block, shared his deep knowledge of the Vietnamese occult.

This was my introduction to a new world of social practice, partially legible through my familiarity with Korean and Chinese manifestations of gods, ancestors, and ghosts. Basic principles of cosmology were also familiar to me when I encountered them in Vietnamese workshops and rituals. The deployment of lucky hours and days, substances, measures, and directions toward the making and enlivening of a statue drew on

the same basic system of person, time, and space that a Korean diviner, geomancer, or shaman and their Chinese counterparts might use. But the work in Vietnam was also filled with surprises. I had visited countless Buddhist and other temples throughout my adult life. I had made whatever obeisance seemed appropriate, had my inept kowtows corrected by more than one Korean mentor, and had even taken part in a statue's eye-opening in a meditation center in Seoul, a playful event attended primarily by expatriate meditators. But I had not yet fully grasped that these images were regarded as literal *presences*. Gods and buddhas had been inducted inside them through processes broadly analogous to the transubstantiation of bread and wine in the Catholic mass.

## APPROACHING AN IMAGE

My work with the sacred objects team coincided with my reading of Alfred Gell's *Art and Agency* (1998), which became part of the intellectual ballast of our sacred objects project. Gell offered the once-radical suggestion that people commonly abduct agency to things—my computer becomes moody and uncooperative; acts of iconoclasm cause bad things to happen. In using the philosophical notion of "abduction," the mental imputation of causation in the absence of immediate proof (I see smoke; I abduct fire as the cause), as a common mental process, Gell removed the idea of object agency from imputations of "primitive thought" and into the domain of sociological process. People enter into relationships with things and these relationships can be studied in the manner that anthropologists examine the rights and obligations that obtain in other human relationships (16–18). This premise was readily evident within the transactional frame of Vietnamese and other East Asian popular religious practices where deities in image form bestow blessings in answer to sincere devotion and send punishment when abused or neglected.

The notion of object-agency is a more radically object-centered position than Appadurai's (1986b) seminal observation that things have "social lives," that they move between different domains of social construction and different regimes of value, which are best apprehended through a focus in the peregrinations of the things themselves. In Gell's scheme, the object is not so much a moving dot as a provocateur, in effect a mover, inspiring devotion, fear, awe, or even vandalism. Gell cites art historian David Freedberg's *The Power of Images* (1989, xxii), which anticipates the notion of object agency in "the active, outwardly remarkable responses of beholders as well as the beliefs (insofar as they

are capable of being rerecorded) that motivate them to specific actions and behavior. But such a view of responses is predicated on the efficacy and effectiveness (imputed or otherwise) of images."[7] Fundamentally concerned with the human form in Western representational traditions, and with a nod to "primitive art" in museum displays, Freedberg ventures a speculative, productive, but ultimately essentialist appeal to universal human emotions. Gell's "abducted agency," more compatible with an anthropological perspective, generalizes process over specific content, enabling a broad and varied exploration of the relationship between people and things in diverse settings, a formulation that admits the possibility of different reactions to common events. Different reactions will surface periodically in my discussion.

Gell also took anthropology's bread and butter—the study of human relationships, expectations, and obligations—and expanded it to include the study of human relationships with things. The ritually awakened statue, the "idol" in Gell's writing, becomes in his words, "a locus for person-to-person encounters with divinities . . . and obeys the social rules laid down for idols as co-present others (gods) in idol form" (125, 128). This relationship, between the statue, mask, or painting on the one hand, and the shaman, spirit medium, or devotee community on the other, is the starting point for my discussion. In each of my four cases, "social rules" govern all aspects of the sacred image's social life: making, transporting, installing, maintaining, celebrating, and disposing (plate 2). Sometimes these expectations and protocols are stretched, transformed, exceeded, or violated.

Gell and Bruno Latour (1993 [1991]), who gives us the notion of the object as an actant around whom various activities are organized (as devotees and craftsmen were mobilized in the fabrication of the Mother Goddess statues for the VME), invite us to look with new eyes on the social relationships constructed between and around persons and things. This work made sense to my Vietnamese colleagues, reassuring them that contemporary anthropology had a space for respectful understandings of their own practice even if it could not prove the existence of gods and other spirits. When I used Gell's example of how he abducted agency to his family car, for Western readers an accessible bridging example, a distinguished professor of Vietnamese folklore opined that the agentive car was just silly, whereas statues were right and proper sites of object agency.

Such a project is also enabled by developments in material religion studies, an interdisciplinary endeavor that draws in religious studies, art history, material culture studies, the anthropology of religion, and

decorative arts (this is not an exhaustive list). As the editors of the field's eponymous journal describe it, "Materializing the study of religion means asking how religion happens materially, which is not to be confused with asking the much less helpful question of how religion is expressed in material form. . . . This entails not only paying attention to the actual use of 'material stuff' in religious practices, but also to religiously authorized ideas about the status, value, and the power of things, bodies, places, and other religious forms" (Meyer et al. 2010, 209–10). Material religion in these hands is a practice-oriented approach to the study of religion that takes into account the "constitutive role of objects" in the doing and feeling of religious experience, from sacred landscapes and religious architecture to illustrated bibles, rosaries, amulets, and religious deployments of films and new media (e.g., Engelke 2011, 210; Meyer 2014; 2015a, 165–66; 2015b, 140; Morgan 2010, 8, 11–12; Plate 2014). Of the material religion scholars, Birgit Meyer, in particular, has called for an appreciation of the processes of religious fabrication, the making of sacred things that are subsequently maintained and cared for as part of an interdependent relationship between the object and the practitioner (e.g., Meyer 2015a, 167).

On a separate front, Eduardo Viveiros de Castro (2004) and Philippe Descola (2014 [2004]) have rethought "animism" as a distinctive ontology rather than a mistaken primitive worldview. This project has provoked a lively discussion of shamanic engagements with the material world both within Amazonian Studies (Santos-Granero 2009a) and beyond (Pedersen 2007, 2011). Images produced in craft workshops to a high level of technical achievement, like the three Mother Goddesses, and also mass-produced for distribution in popular markets across much of the map of Asia, have largely been absent from the animism conversation, a conversation this volume hopes to broaden.[8]

In Vietnamese statue carvers' workshops, my colleagues and I soon learned that materials, skill, and magic were all entwined in the carvers' work of producing a potentially efficacious temple statue or a buddha. Carvers spoke of their careful choice of wood, its seasoning, and the desired proportions of the finished project, but the most expensive traditionalist carving also involved careful attention to horoscopes, workshop taboos, and other protocols that would contribute to the realization of an efficacious image. The practices I learned about in the carving workshops of northern Vietnam's Red River Delta would fuel many conversations in South Korea, Myanmar, and Bali, where the questions I asked were legible, but the answers sometimes veered off in surprising

directions. Tensions in Vietnam between those artisans and temple-keepers who hewed to strict and expensive traditional procedures and those who produced and consumed cheaper mass-produced goods would also have resonance in other places. The carvers' workshops would cause me to heed Tim Ingold's (2007a, 2007b, 2010, 2013; Hallam and Ingold 2008) attention to the material properties of things and the possibilities, limitations, and mutability of materials, tools, and the human hand. But where Ingold's deep materiality was intended as a riposte to Gell's notion of object agency, time spent with carvers in the Red River Delta of Vietnam, and then in Myanmar and Bali, caused me to see these two seemingly contradictory loci—abducted agency and deep materiality—as necessarily linked in the making of powerful images (see chapter 3).

The work of Arjun Appadurai (1986a, 1986b), Igor Kopytoff (1986), Fred Myers (2001a, 2001b), and others has revivified anthropological interest in the circulation of objects. In my discussion, the objects in circulation are potential or post-empowered images, the subjects of chapter 6. Global markets for ethnic art and souvenirs draw upon iconic images and handicraft traditions. In some instances, images regarded as sacred or empowered are adapted to market tastes and the needs of secular performance as discussed in chapter 5. Sometimes such objects are produced with a self-conscious omission or tweaking of fabrication magic. But the distinction between an empowered and sacred thing and a pure commodity can also sometimes blur, complicating questions about what makes an animated image "work." Balinese masks intended for secular use have been known to take on lives of their own. In Vietnam at the time of my fieldwork, temple statues were appearing in the antique market much as in Seoul, in the 1970s and 1980s, old god pictures flew out of runners' Gladstone bags, one of them to inhabit the wall of my own home. Chapter 6 explores some of the paths whereby once-empowered antiquities reach markets and museums, intersecting with existing protocols for the disposal of magical things.

## AFFORDANCES

This, then, is a comparative work. Anthropology is an innately comparative discipline but paradoxically, as Webb Keane (2003, 2013) observes, anthropologists are squeamish about making our own explicit comparisons lest we replicate the overblown generalizations of our Victorian ancestors or the retrospectively naïve controlled comparisons of some

mid-twentieth century work. This avoidance, he argues, "has come at a steep cost"(2013, 2–3); there are things to be learned by looking at the affordances—the enabling of an action on an object or environment—that result in somewhat similar practices. These outcomes should not be seen as inevitabilities so much as questions of possibility that might yield interesting conversations, new insights, or at the very least, better and more productive questions. *Mediums and Magical Things* is not a controlled comparison, a grand generalization, or an argument for a particularly "Asian" approach to religious images. These are statues, paintings, and masks in *some* Asian places within *particular* contexts of local practice. My project assumes that a careful mustering of ethnography, respectful of how people see things and the when and where of how they see things differently from each other, might yield better understanding than any sleekly constructed generalization (van der Veer 2016). The four primary examples are contemporary, but they rest, however uneasily, on multiple histories across an enormous swath of time and place, regional and local practices, iconoclastic moves, countermoves, modernist apologies, and general differences of opinion.

Following Keane's notion of an affordance, a handle enables the raising of a teacup to the lips, but cups come in different shapes and styles and in China, Japan, Vietnam, and Korea, where many teacups do not have handles at all, one learns to lift a cup gingerly, placing one's fingers close to the rim. This study examines what are, in effect, analogous teacups in different shapes and styles that reach the lips through similar operations recognizable, in the most general sense, across space as similar kinds of things intended for similar purposes. In the first instance, these are images that have bodies and faces (the mask face is conjoined to a medium's body), and they are recognizable as persons. Hans Belting's (1994, xxi) characterization of "holy images" in the medieval West is appropriate here: "The image, understood in this manner, not only represented a person but also was treated like a person, being worshiped, despised, or carried from place to place in ritual processions." The recognition of these images as persons and social actors is the first affordance, the cup as a small, hollow vessel that holds liquid for drinking. But Belting also describes a long history of Western ambiguity toward "idols," an uneasy comingling of image-venerating practices in the ancient Western world and aniconic Abrahamic traditions, symbolic representation versus possible agency (3, 40, 208).

By contrast, the images that I shall be describing have been ritually ensouled through established procedures. They are meant to be enlivened,

meant to be celebrated as the gods they represent, a distinction that is as marked a contrast with Western religious images as the presence or absence of a handle on a cup. This is not to deny acts of iconoclasm carried out with revolutionary fervor throughout the Asian world in both modern and premodern times. It is also not to ignore those intellectual rationalizations of popular practice that have accompanied different Asian modernities in attempts to explain away the actions of devotees as expressions of ignorance. Even so, for most devotees throughout the enormous universe of Hindu, Buddhist, and related popular practice, a venerated image is a ritually ensouled image, closer in concept to the transubstantiated communion host of the Catholic mass than to the plaster saint. This is the second affordance. As a final affordance, nested within the other two, statues in temples dedicated to the Mother Goddess in Vietnam, *nat* images used by Burmese spirit mediums, paper images of gods hung in Korean shaman shrines, and Balinese temple masks are the kinds of things that enable the work of shamans and spirit mediums. I am interested in exploring how this relationship is understood to work. My four image traditions spin off in their own directions, but these are directions that I might not have followed without looking at more than one of them in the first instance.

South Korea is a booming capitalist economy—the world's eleventh largest at the time of this writing—and an almost completely urbanized society. It was considerably less booming and fundamentally less urban when I first went there as a Peace Corps volunteer in the early 1970s. Vietnam is a capitalist/socialist party state with a rising economy where popular religion, covertly practiced under high socialism, returned in force with the reopening of the market in the late 1980s and has steadily gained in exuberance ever since. In 2011, when I visited Myanmar, the country was on the verge of democratic transition, poor but with evidence of foreign investment and improving consumer horizons even then, trends more apparent during a brief visit three years later. Bali is a majority-Hindu island province in the Muslim-majority Indonesian state. Even in colonial times, Bali was promoted for its traditional culture and arts and, on that basis, attracted international travelers. Since at least the 1980s, Bali has enjoyed a thriving tourist industry, and the local economy has grown in tandem with global tourism. Despite considerable differences in their histories and current economies, these are all places with recent memories of rural poverty and a palpable sense of rising fortunes, or at least their tangible possibility. But fortune is a volatile thing and popular religious practices blossom amid market

uncertainties. In all four places, practices of mediumship or shamanship are alive, robust, and by many reports growing.

It is sometimes assumed that rituals involving trance and magic erupt out of a primordial cultural substratum into a more sober history of premodern kingdoms and dominant religious worldviews. Counter to this, in the sites of my four examples, statecraft, cosmology, and aspects of ritual life that included shamans or spirit mediums were closely intertwined historically, and this enmeshment remains a part of their religious and cultural legacies today. Buddhism in South Korea and Vietnam is Mahayana, and both places share legacies of Chinese cosmological knowledge, resulting in the use of a common lunar calendar and related cosmological understandings as well as some basic principles of ritual practice. Although Confucian orthodoxy provided the language of traditional morality, statecraft, and life-cycle rituals in both places, the use of images in the popular religious practices of shamans (Korea) and mediums (Vietnam) derives from the use of images in Buddhist practice, as do some very general understandings of the afterlife. In Myanmar, Theravada Buddhism is a pervasive marker of Burmese identity and long ago "converted" local deities (*nat*) into essentially Buddhist moral understandings of cause and effect (figure 2). In South Korea, Vietnam, and Myanmar, the images we will be discussing are linked either historically or in contemporary practice to artisans who also produce images for Buddhist temples. In Bali, cosmology has a Hindu/Sanskritic cast, but Tantric influences are also evident in Balinese understandings of transformative interactions between demonic and divine forces, and in the iconography of religious practice. The masks that are an integral part of Balinese temple life are considered repositories of cosmic forces sometimes identified with Sanskritic gods. In all four cases, sophisticated cosmologies associated with dominant religious traditions undergird those practices that we might characterize as magic.

As a most basic set of linked affordances, then, Koreans, Vietnamese, Burmese, and Balinese bear the historical experience of complex politico-cosmologies and sophisticated material religious practices, including the artisanal production of images in human form for ensoulment. In the contemporary moment, some devotees in all four places have both the wherewithal and the motivation to maintain the production and use of these images. This much could also be said about China, Japan, India, Thailand, and likely other Southeast Asian and Himalayan sites as well. My four cases are not meant to be exclusive so much

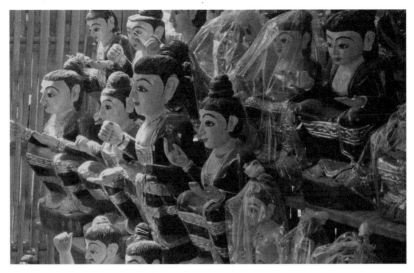

FIGURE 2. *Nat* for sale at a mat shed shop during the Taungbyon Festival, northern Myanmar, 2011. Photo: author.

as, by happenstance, the ones that I was able to focus on in some depth. I will reference some others in passing.

## COMPARISON

Comparative projects require courage, if not presumption. At midlife, Peter van der Veer took on the Chinese language and Michael Herzfeld studied Thai, projects that would lead them both to argue for the revitalizing value of comparative projects in anthropology (van der Veer 2014; Herzfeld 2017). Both found that the fieldwork and analysis that resulted from their bold departures from type had been enriched by the experiences of their earlier intensive encounters in other places. Both also felt that the sum of their journeying yielded otherwise unattainable insights for larger projects—"crypto-colonialism" and its consequences in Herzfeld's case; a non-teleological study of modernity through the relationship between religion and nationalism, in van der Veer's. At the same time, both recognized that their midlife projects could not deliver the same intensive, immersive knowledge they had acquired in the field as young men in India and Greece. By training, I am an anthropologist of Korea who began her career living in a South Korean village when there were still enough villages in South Korea to make them a logical and

anticipated site of anthropological practice. I painfully mastered the language, observed, listened to gossip, and wondered about such things as whether "grandfather" referred to the speaker's husband, her long-deceased father-in-law, her father-in-law's brother who had just wandered by, or a god in the shaman's shrine. I have returned to South Korea over the intervening decades and watched those I first knew as children grow to middle age, and Korean experiences inform most of my writing. But my career has also zigzagged in some unconventional directions that anticipate the big zag of the project contained in these pages.

The first zig was my job. I am Curator of Asian Ethnographic Collections at the American Museum of Natural History. Wearing a curatorial hat, I have dealt with such things as Chinese Treaty Port souvenirs, Siberian shaman costumes, and Indian printed textiles, but curatorial work, strictly speaking, is compartmentalized from the primary expectation of my position: my own research and writing. At the museum, the majority of my colleagues are biologists—very portable—and it was sometimes suggested that I might "broaden" myself by working beyond South Korea, a situation different from a university appointment, where I would likely have been "the person who does Korea." A second difference is that scientists typically work and publish as members or directors of research teams; this is also true of my colleagues in archaeology and biological anthropology. With many other veterans of village studies, I valued—and will always value—the qualitative insights that come from the deep and sometimes deeply lonely immersion of a solitary fieldworker struggling to swim in a language other than her own. Team research, as I had been exposed to it in a brief flirtation with medical anthropology, seemed a matter of tedious survey instruments leading to not very interesting results.

In 1991, I visited Vietnam for the first time, and like many other Americans whose political consciousness had been shaped in opposition to my country's role in the Indochina Wars, I found the opportunity to engage with Vietnamese colleagues compelling. In South Korea, I had spent many years with shamans, shamans who were in and out of costume and somewhat on the margins of society, always an interesting place to be. In Vietnam, I encountered spirit mediums, also costumed, also somewhat on the margins, and in the middle of a revival of popular religious practice that seemed to be popping up in front of my eyes (plate 2). I wanted to become an anthropologist of Vietnam as well as an anthropologist of Korea, as ethnographically ambidextrous as Herzfeld and van der Veer became at midcareer. But the Vietnamese

language defeated me, utterly and completely, with the possible exception of a passing familiarity with some useful cognate terms related to popular religion. I would not become a midlife anthropologist of Vietnam. Instead, other things happened. Even without the language, I found myself caught up in the exhibition project and then our collective fieldwork. I loved the work, but I also felt compromised and guilty for depending on interpreters, haunted by the specter of Radcliffe-Brown in his pith helmet. I was blessed here by ideal research partners. Nguyễn Thị Thu Hương spent more than two years in New York working on the *Vietnam: Journeys* exhibit and had interpreted for me in encounters with her other colleagues in Hanoi and New York before we collaborated in researching the Mother Goddess statues. Nguyễn Thị Hiền joined the exhibition team as a postdoctoral fellow for the final year of the project, and we have subsequently worked together on two different research projects. Both Thu Hương and Hiền figured out how my mind worked, and I developed a good idea of what their words and silences implied. I tried to compensate for my linguistic inadequacy through a replication of the rigorous process of translation, back-translation, and editing that we had developed during the exhibit when I edited the six sacred-objects project studies for English-language publication.

When I encountered carvers, spirit mediums, and ritual masters in Vietnam, my Korean experiences helped me to formulate logical questions and offer anecdotes from another Asian place. I would describe how, when a Korean shaman I knew well inappropriately placed new images/gods with the old ones on the wall of her shrine, they caused her bad luck and fell to the floor and stuck together because the gods/images had been fighting. This anecdote usually garnered a nod of recognition: yes, this sort of thing did happen. But the answers to my questions came to me in a distinctive and often surprising Vietnamese register; I learned things that I had not previously imagined. The Vietnam work made me want to flip things around, take what I had learned about the fabrication and ensoulment of images back to my comfort zone of Korean shaman shrines and the painted gods that hung above the altars, made me want to look again at fighting gods and falling paintings (figure 3). In Vietnam I had also learned the pleasures of teamwork, energized by ongoing exchanges with the other researchers. For the work on Korean shaman paintings, I joined forces with Yul Soo Yoon, an art historian, and Jongsung Yang, a folklorist and curator who has broad contacts in different Korean shaman traditions (e.g., plate 3). I respected their knowledge in domains I had not researched, and they were both broad-minded enough

FIGURE 3. *Mansin*'s altar near Seoul, Republic of Korea, 2009. Photo: Homer Williams.

to appreciate my own long experiences with shamans and my eccentric ideas, such as "let's talk to the shopkeepers who sell the paintings to shamans." Sometimes I worked on my own or with my longtime field assistant Sungja Kim Sayers, revisiting *mansin* I had known for many years, and sometimes with one or another of my research partners, interviewing collectors, dealers, and shamans they thought I should meet. It was a happy project, culminating in a book published under our joint authorship (Kendall, Yang, and Yoon 2015). I might have written something about Korean shaman paintings on my own, but collectively this was a better book and a far more enjoyable process.

Tacking between South Korea and Vietnam, I wanted to do something comparative. I wrote a few short pieces, but realized that beyond a very limited discussion, I was risking talking about apples and oranges to a not very useful end. I needed to broaden the conversation in order to suggest both resonances and points of departure, how a question framed in one place might open up an unexpected possibility elsewhere. Considering ensouled and empowered images and how they are made, used, and disposed of ushers in a multitude of ethnographic possibilities, including and beyond those contained in this volume. This project affirms nothing so much as the validity of asking. In van der Veer's (2016,

148) words, there is merit in elucidating "complex phenomena through comparison without 'generalism' or modeling of 'social systems' that allows one to steer clear of both universality and endless particularity."

Libraries could take me a great distance, but would not answer all of my now well-tried questions in places other than South Korea and Vietnam. I eventually explored two other sites where encounters with images were also a part of popular religious practice. I did this opportunistically and, of necessity, worked through an interpreter, as I had in Vietnam. Like Korea and Vietnam, Myanmar is a place where spirit mediums honor their gods in rituals that involve serial costuming and theatrics and where spirit mediums perform in counterpoint to static images of these same gods. It was a place that I had been curious about for a very long time. Erin Hasinoff, a postdoctoral fellow, then Research Associate, at the American Museum of Natural History, was willing to collaborate with me on a project that combined her interest in contemporary paintings of *nat* spirits with my interest in the carved images that the *nat* mediums placed on their personal altars (Hasinoff and Kendall 2018) (plate 4).

The Vietnam work had also raised the question of how sacred protocols are abandoned, or intentionally tweaked, when objects on a sacred prototype are produced for secular markets. I thought of Bali as a likely comparative case, a place where sacred temple masks coexist with those that have become tourist icons used in secular performances and also sold in volume on the souvenir market. Balinese masks had intrigued me since, as a graduate student, I had read Jane Belo's (1960) account of Balinese trance (plate 5), most memorably her description of a temple mask which, while being carried in procession, unexpectedly threw villagers into deep and spontaneous trance as it passed them by. Bali is a well-studied place where a few new questions could be deployed from the top of an already well-constructed scholarly scaffold. My best experiences in Vietnam had been on projects where my interpreters were also co-researchers, colleagues who knew me well and who had an equal investment in the project and an intellectual curiosity about the material that matched my own. Hildred Geertz, my mentor in things Balinese, liked the idea of my collaborating and publishing with a Balinese scholar and introduced me to Ni Wayan Pasek Ariati, a religious historian who also has broad experience in different kinds of fieldwork. This was another fortunate collaboration (figure 4).

I remain an anthropologist of Korea, not an anthropologist of Vietnam or Bali, and certainly not of Myanmar, where I have spent very little time. I have "worked" in all of these places in the sense of exerting

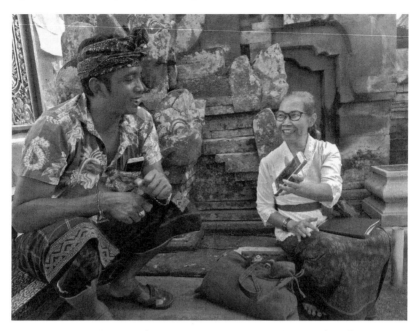

FIGURE 4. Wayan Ariati conducting an interview in 2018, Taman, Bali, Indonesia. Inside the temple precinct during a festival, both Ary and her conversation partner are wearing ceremonious dress, as is the photographer. Photo: author.

effort before, during, and after the field encounters, and I have been fortunate in having good research partners without whom these projects would have been impossible. This will be obvious in the following pages. *Mediums and Magical Things* is an attempt to bring all of this work together in the manner of a patchwork quilt that respects the different patterns on the different scraps of cloth but tries to make a useful and appealing whole. As in any synthesizing study, I will also draw on the work of many other scholars working in Asia whom I consider to be significant voices in this conversation.

Sometimes I have seen myself as the transnational medium of an imagined conversation, bringing what I heard in Vietnam or witnessed in Korea into an interview with a Balinese carver, listening while the Balinese carver talks back. I found sufficient common ground to fuel my conversations with artisans and practitioners in different settings, making possible a vicarious dialogue between them: "In a workshop in Vietnam I heard that. . . ." "A shaman in South Korea told me. . . ." "The gods fought with each other and the paintings fell to the floor." This study is, in the first instance, a realization of that wide-ranging dialogue. But there

were also obvious limitations to what I heard through the tissue of translation and saw through only limited observations. This was not, at the end of the day, "real" anthropological fieldwork, although I do believe that whatever one might call it, it was worth the effort. I entertain the fantasy of a pre-Babel situation into which I might bring some of the artisans—a Korean painter, a Vietnamese and a Burmese statue carver, a Balinese mask-maker—and treat them all to an evening of food and drink. I imagine the setting as a traditional wine house in the Insa-dong district of Seoul, a place where some of the interviews for this book actually did take place in the Korean language. In my fantasy encounter, these artisans from different places are magically vested with a common language and converse directly with each other, sharing cups of wine and enjoying flashes of recognition: "Are you supposed to be celibate when you carve?" "Yeah, we're supposed to be celibate, too." At an opportune moment I quietly slip out of the room to pay the bill, leaving the guys alone. The Korean painter leans across the table and fills the Vietnamese carver's wine cup, winking as he asks, "Are you *really* celibate?"

These are things I will not know.

# Ensoulments

We held, furthermore, in our conclusions, that sacred things,
involved in sacrifice, did not constitute a system of propa-
gated illusions, but were social, consequently real. We found,
finally, that sacred things were considered to provide an
inexhaustible source of power, capable of producing effects
which were infinitely special and infinitely varied.

—Marcel Mauss, *A General Theory of Magic*

This chapter deals with "effects that were infinitely special" and
approaches some of the infinite variety of their realization. I encountered
statue agency on an autumn day in 2000 in a village in greater Hanoi:
Mr. Nguyễn Tôn Kiểm, a researcher at VME, brings members of the
exhibition team to his home village to interview some votive paper mak-
ers. On our way through the village lanes, we see preparations for a
seasonal performance of *lên đồng*, a spirit medium ritual in a small local
temple where a large yellow paper elephant, a white paper horse, and an
abundance of paper servants have been set beside the doorway amid
preparatory bustle. Later in the afternoon, on our way back to the van,
the *lên đồng* is in full swing with cacophonous *chầu văn* songs to cele-
brate the different gods, while the *bà đồng* (in a succession of bright,
primary-colored silk costumes and elaborate turbans) dances as she
incarnates the different gods, accepting offerings and distributing small
gifts. A cluster of women clap the rhythm, keeping pace with the dancing
medium. Mr. Kiểm is their neighbor, and he is eager to join the celebra-
tory throng. He has known the spirit medium for forty years and his
own sister-in-law is among the laughing women who invite us to join
them, pour us tea, and offer betel chews, amused to have two foreign
women and a contingent of scholars from Hanoi attend their celebra-
tion. This is the Mother Goddess Religion (Đạo Mẫu) of Vietnam,
honoring the Goddesses of the Palaces of Heaven, Water, Mountains
and Forests, and their entourages: Mandarins, Dames, Princes, Damsels,

and Boy Attendants, beings who, after a brief time on earth, ascended to the sky but descend periodically into temple settings via their chosen mediums (H. Nguyễn 2016, 42–58).

It is the tenth day of the tenth lunar month, a time to honor the Tenth Prince, a wine-drinking poet and playboy. All of the action takes place outside the small concrete temple building, but an abundance of fruit, flowers, and other offerings, including a bottle labeled "champagne," are visible in artful arrangements on the interior altars, a burst of color against the temple's otherwise dim interior. Green boxes of cake and red and blue packages of instant noodles are stacked for distribution, soon to be passed from the hand of the god to the eager hands of devotees who receive these gifts as vehicles of auspiciousness (lộc, 祿). When the medium/god flings bunches of small cash notes, people scramble after them in laughing pursuit of the good fortune they carry. But in contrast with other spirit medium temples that I have seen before, there are no statues on the decorated altars, but only some paintings, barely visible, on the walls. The temple-keeper hostess points this out, gesturing with a flash of passion. Their temple used to have many fine statues. She describes how the district government forced her household to throw them in the river.[1] Other women affirm this. Statues had been taken down and destroyed and bad things happened. Some people had even died because of this, and some have terrible arthritis. She points to her own joints and grimaces. It was not the agents of the government who had cast the statues down. No, they did this themselves, "We were afraid of the government. We were the ones who put the images on a cart and took them to the river and tossed them in."[2] The women speak and gesture with passion. The interpreter does his best. The encounter stays with me.

Iconoclasm, "image-breaking" in classical Greek—the word appeared in eighth- and ninth-century Christian debates over whether the representation of Christ in human form constitutes idolatry, the mistaken and sinful worship of "graven images," or divinely-inspired devotion. A legacy of the sixteenth-century Protestant Reformation, iconoclasm versus iconicity remains a material marker of the abiding divide between Protestant and Catholic religious worlds (Freedberg 1989, 29, 386–88; Howes 2007, 8–10; Turner and Turner 1978, 140–43). Disdain for "idols" gained a modernist gloss as it passed through Enlightenment understandings of scientific reason and a nineteenth-century disenchanted naturalist material world (Tambiah 1990, 20–21). Webb Keane (2007) has famously demonstrated how Calvinist converts on the Indonesian island of Sumba regard themselves as necessarily

more "modern" than their Catholic or unconverted neighbors through their own rejection of material practices associated with devotion and custom. In many Asian places, the identification of iconoclasm with "anti-superstition" transcended Christian missionary efforts to become the project of religious reformers and nationalists of different theological and political stripes.[3] The most zealous iconoclasts aimed at exposing statues and other sacred things as no more than "useless bits of mud or wood" whose desecration provoked no consequence (Goossaert 2006, 326).

Accepted as a teleology, acts of iconoclasm did not always work out that way. Again, and again, counternarratives rise from the smoking embers of revolutionary fervor, tales of desecrated objects that bit back (Balzer 2011; Chau 2005; Mueggler 2001; Buyandelgeriyn 2007). We are in the domain of Bruno Latour's (2010, 68) iconoclash, a condition when "one does not know, one hesitates, one is troubled by an action from which there is no way to know, without further inquiry, whether is it destructive or constructive." Vietnam today is fertile ground for iconoclash, as are the other Asian sites I shall be discussing. In contemporary Vietnam, South Korea, Myanmar, and Bali, modern naturalism is a daily presence in schools, hospitals, and laboratories (and in South Korea, in a thriving biotech industry). On such ground in such places we can expect, as Latour witnesses for a Western "us," an irreconcilable quandary: there are those who argue for the purification of "a disgusting world composed of impure but fascinating human-made mediators" and those who tenaciously respond, "Alas (or fortunately), we cannot do without images, intermediaries, mediators of all shapes and forms, because this is the only way to access God, Nature, Truth and Science" (68).

In a terrain of iconoclash, counternarratives from Vietnam, like the temple-keeper's arthritis, reveal how devotees experience image agency in the first instance and how statue bodies, by human acts, attain this capacity. What we learn from Vietnam is also legible in Myanmar, Korea, and Bali through the affordance of similar ritual practices with deep and sometimes intertwined historical roots. But, recalling the analogy of the teacups that come in different shapes, while certain statues, masks, and paintings are regarded as more than representations, there are distinctions in how their empowerment is accomplished, what it means, its relative potency, and how it operates. In the broadest sense, I will be looking at "animation" or "ensoulment" as a rubric that approaches but does not quite tidily accommodate the affordance of empowered statues, masks, and paintings.

## TALES OF ICONOCLASM

Four years after that memorable autumn afternoon, Vũ Thị Thanh Tâm, Nguyễn Thị Thu Hương, and I return to the village where the statues had been cast down, and meet up with Mr. Kiểm, who has recently retired. He takes us back to the temple. Like much else in and around Hanoi, there has been significant renovation in the intervening years. The temple's walls are freshly plastered and painted and there are now several large glass cases holding the statue images of gods, with the three Mothers in the position of honor, elevated at the back of the room. The couple who keep the temple are proud of the results; they want me to take photographs, but only after the husband dons his special brown robe, such as ritual masters wear. Incense is lit, and we pay our respects. The statues have only been installed within the year, a project encouraged and financially supported by the community of temple devotees. Before bringing in the statues, the couple asked the goddesses' permission to take down the old paintings and replace them with the new statue images. They presented fruit offerings and cast coins for divination. The coin toss yielded a favorable response. Ritual masters were summoned to set the wooden statues in place and, in a separate ritual, to call the gods into the statues' bodies. A renowned ritual master had done this important ensouling work. The old paintings had been burned, a ritually clean means of riddance, and the ashes cast in the clear flowing water of the river. Mr. Kiểm regrets not having been able to secure the paintings for the VME collection (plate 6).

We ask again about the original statues, and about the anti-superstition campaign that destroyed them. In this conversation, and others in this same community, the most wrenching recollections are from devotees who were forced to cast down their own statues. The male temple-keeper tells us that when the district officer came to round up their statues, his father wept at the futility of resisting. Another temple-keeper mimed the gestures of supplication with which, in great agitation, she had requested the Mother Goddesses' permission to take them down from the altar, crying in desperation, "This is the nation's work, it is the nation that requests this!," seeking absolution for the sacrilege. We hear different versions of the basic story in different interviews, the most detailed from a woman who works in the district office and tells us that she knows all about it. The roundup was a major campaign, preceded by a training session for the local authorities and a mustering of vehicles to transport the statues. On the designated day, the confiscated statues

were carried to the back courtyard of the People's Committee Headquarters. There, the larger statues were burned, and the smaller statues cast into the scum-covered village pond. One minor official took a small statue and gave it to his son as a toy. The son beat the statue, experienced a sharp pain in the belly, and his father threw the statue into the bushes. A woman passing by found the statue—a small Prince (Ông Hoàng) from the pantheon of the Mother Goddess Religion—on the side of the road. She told the Prince, "Please help me and I will venerate you," and took the image/Prince to one of the local temples, where he could be properly tended. Inspired by this happenstance, she went to the Committee Headquarters under cover of darkness, as some others did, and rescued another Prince; both Princes are still in that temple. In the fullness of time, the policeman's child became a drug addict, but the woman who rescued the two Princes leads a happy life. Her children live abroad and send her money. So we were told.

In another widely circulated story about the anti-superstition campaign, the wife of the man who drowned the statues in the village pond went mad. Some identify this man as the vice head of the local police, although some do not remember the offender as having an official position. His family asked at local temples for a ritual to heal his wife's madness, but no one in this village would help him. He was forced to seek a specialist in another village, whose efforts had the desired effect: the woman's sanity returned. Some say that one of the policemen who carried the statues out of a small family temple that protected the riverbank saw his own son carried away in a flood and died himself within a few months, or in another version, the policeman drowned and his father died a month later. The keeper of that temple described how the chastened policeman's wife came to the empty temple to beg the Mother Goddesses' forgiveness. Another temple-keeper opined that apart from the civil servants who led the campaign, no one in this village suffered truly dire consequences because the destruction of the statues was not their fault; they had been overtaken by larger forces. The memory of iconoclasm in the past becomes an affirmation of the agency of gods who interact with devotees through wooden images in the present. These were operations of abducted agency in a most obvious sense, the destruction of the statues seen as "initiating causal sequences of a particular type, that is, events caused by acts of mind or will or intention rather than the mere concatenation of physical events" (Gell 1998, 16, 13–18).

But abduction here is doubled. In the first instance, gods operating through images are abducted to cause things to happen—bestow good

fortune or mete out punishment; the treatment of the image, respectful or iconoclastic, is a consequential engagement with the god. For the iconoclasts, the images in the village temples were also agentive insofar as their presence *encouraged* superstitious thinking which the campaigns for their removal attempted to allay. In effect, the images were agentive, but in ways counter to the dominant narrative of social progress. As Alfred Gell (1998, 63–64) and David Freedberg (1989, 386–421) both note, acts of iconoclasm involve abductions of agency, destruction *provoked* by images that represent false gods and tarnished heroes or—in the name of modernity or revolution—because they *foster* superstitious practice. In Freedberg's words, "When the iconoclast reacts with violence to the image and vehemently and dramatically attempts to break its hold on him or her, then we begin to have some sense of its potential" (425). In Vietnam, the widespread destruction of sacred sites, including temples and shrines and the sacred objects housed inside them, occurred during successive waves of revolutionary fervor, notably the August Revolution in 1945, the defeat of the French in 1954, the establishment of the Socialist Republic of Vietnam, and the First Five Year Plan for socialist industrialization (1960–65). According to Shaun Malarney (2002, 81–82), describing a village on Hanoi's periphery, a village very like the one we visited, "Party officials regarded superstitions as one of the greatest obstacles to the development of the new society." As a consequence, "Several prized statues were either destroyed or thrown down wells" (45–46). In effect, zealous revolutionaries abducted counter-revolutionary agency to the objects of their attacks.

Stories of statue retribution are widespread in the north of Vietnam (Endres 2011, 102–3). Malarney (2002, 93–94) describes punishments inflicted by tutelary deities on those who "have treated the communal houses in an inappropriate or offensive manner" or on a man who "threw a statue of the Buddha down the well." The infelicitous consequences abducted to statue improprieties were not restricted to anti-superstition campaigns. In another Red River Delta village, in times that have become more favorable to popular religious practice, Nguyễn and Phạm (2008) describe how the statue of a tutelary god was improperly inducted into the communal house. In normal practice, the tutelary would be represented by a wooden tablet, not a more potent statue presence.[4] While the sponsoring family described the project as a pious act, others saw it as a means of transforming the communal house (*đình*) into a temple (*đền*) where worshippers' donations would line local pockets. Under community pressure, the statue was ritually de-animated and

removed from the communal house. In this public setting, the original donor's daughter-in-law called out a curse on the opposing faction, claiming that the wrath of the tutelary god would fall upon them for taking down the statue. A decade later, villagers speculated that to the contrary, the tutelary had exacted punishment on the donor's immediate family through the death of his senior daughter-in-law and the debilitating illness of his son (Nguyễn and Phạm 2008).

Iconoclasm is not always a complete project. We glimpse Latour's iconoclash in the tales of chastened iconoclasts and in quiet acknowledgments that statues had been hidden, possibly buried, until it was safe to restore them. Iconoclash was evident in 2000 when a friend described how "people say" that, as a consequence of having torn down the temples in a period of revolutionary fervor, the Vietnamese people suffered bitter poverty before the opening of the market in the late 1980s and, more than a decade into the market economy, were still lagging far behind their more successful neighbors in China, Malaysia, and Thailand. This theme appears in Võ Văn Trực's autobiographical novel, *Pond Scum* (*Cọng Rêu Dưới Đáy Ao*) where youthful activism destroys sacred sites and results in subsequent bitter lives (Võ 2007).[5] In the new millennium, ethnographers were discovering that party members, civil servants, and former revolutionary fighters were sometimes also spirit mediums and ritual masters (Nguyễn and Phạm 2008; Vũ 2008; Pham 2007).

The doubled consciousness of civil servants is suggested in a recollection from the late Ông Đồng Đức, the keeper of the Tiên Hương Palace. During the years when the authorities converted temples and communal houses to secular uses, statues dedicated to the Mother Goddesses and their retinues were sometimes stored in a temple's forbidden room, the backmost chamber closed to all but the temple-keeper. We heard repeatedly that statues survived intact in many places because potential thieves were afraid to touch them.[6] Ông Đồng Đức described how in 1983 or 1984, when this important temple complex stood empty, a man from another place crept inside and stole two small god images, thinking that he would take them home and venerate them. The thief put the statues into his bag, but for some mysterious reason he could not move beyond the temple gate. He stood frozen at the threshold until some villagers saw and apprehended him (a story that would provoke smiles of recognition in Bali, where tales are told of potential thieves roaming dazed around the temple periphery, unable to move beyond it). At the People's Committee Office, the chief of police made a report and then locked the statues inside his cabinet, neglecting to return them to the temple. Two

nights later, the guards observed that whenever they turned out the light, mysterious noises emanated from the cabinet, but ceased once they turned the light back on. When they reported this, the chief called on his mother, who promptly appeared at the People's Committee Office bearing bananas and other fruit to make offerings and apologize to the deities who had been so rudely locked inside the cabinet.

Nor was religious activity ever suspended completely; veneration of images in temples and rituals involving spirit mediums had been performed simply and secretly in many places throughout high socialism (Endres 2011, 162–67; H. Nguyễn 2007, 544–45; Norton 2002, 74). The paintings that I had seen in the village temple in 2000 had been purchased from the back of a shop on Hanoi's Hàng Quạt Street. The temple-keeper told us, "They had them. They didn't show them out in front but if you asked, they would show them to you. There were one or two shops that sold ritual paraphernalia but now every shop on Hàng Quạt Street sells these things."[7] The ethnographic present of Vietnam in 2004 was a good moment in which to be asking about temple statues. Popular religion was now out in the open, indeed robustly so, and with steady improvements in the economy, temples were being refurbished and new temples built to accommodate an enthusiastic upsurge in ritual life (DiGregorio and Salemink 2007; Fjelstad and Nguyễn 2006; Kendall 2008; Malarney 2002, 3; Philip Taylor 2004, 2007). Even a humble temple, like the one described above, could undertake a renovation project, replace its desecrated statues, and summon ritual masters to enliven them.[8] Contradictory ontologies cohabit, sometimes flaring into open conflict, sometimes tacitly accepted, sometimes with noisy affirmation, as when a mother is summoned to the People's Committee Office with offerings for a god whose statue body has been locked inside a cabinet and is consequently raising a ruckus.

## ANIMATION?

I have used these encounters to foreground a discussion of image agency, but here, and in the other examples to follow, the image itself is not, strictly speaking, the agent. The god, soul, or energizing force has been inducted into the image and operates through it, using the image as a material prosthesis in the here and now.[9] The ritual work that effects this enlivening is commonly described as "animation." My interest in the Vietnamese temple statues developed in the disciplinary terrain of anthropology at a time when discussions of "animism" have emerged

from a post-Victorian slumber, a disciplinary turn which I find both intriguing and somewhat off the mark with regard to my own ethnographic beat. In recent works, animism appears as an ontological practice that recognizes spirits, humans, animals, and plants as endowed with more or less equivalent souls, a condition that enables interspecies communication, including hunting magic (Costa and Fausto 2010). In an animistic ontology, shamans merge with the souls of nonhuman beings such that, in Eduardo Viveiros de Castro's (2004) memorable description, the shaman as jaguar craves blood with an appetite that matches the shaman as man's craving for manioc beer. Philippe Descola (2014 [2004]) uses an animist ontology to destabilize the seeming universalism of the nature/culture divide insofar as in an animist worldview, soul stuff is held in common and migrates freely between people, animals, and features of the landscape.[10]

The spirit mediums and shamans encountered in the following pages inhabit very different life worlds from Amazonian hunters. Their practices are the legacy of tax-paying rice farmers rather than forest hunters, and they are not, as a general practice, in communication with animal souls, save in very rare instances of abnormal and usually undesirable animal possession.[11] They are not in communication with rocks and trees per se, but with rocks and trees when these become the habitations of a god or spirit much as statue bodies do. The shamans and spirit mediums I describe from Korea, Vietnam, and Myanmar interact with gods or spirits who, for the most part, once had human lives and are subject to human emotions, appetites, and desires. The dynamic is social but hierarchical, premised upon the gods wielding different degrees of consequential power. In contrast with the mutable shamanscape that Morten Pedersen (2011) describes for postsocialist northern Mongolia, these manifestations are the more-or-less predictable business of stock types: coquettes, imperious officials, dashing young men, grand dames, warriors, and such, the costume play of historical dramas as they vary in each of these three settings. What is most mutable is the repertoire of needs and desires that stoke devotion, the changing content of the things for which people pray. In the Korean tradition I know best, gods and ancestors, acting to type, offer a running and usually humorously dyspeptic commentary on the shifting social milieu of contemporary South Korea (Kendall 1996b; 2009, 129–76). In places where an imagery of antique kingdoms lingers in statue forms and ritual performances, one engages the divine with gifts and entertainments, with music, dance, and feasting in the ways that one might win the favor of a powerful human agent.

These are common idioms of enticement for statured humans and gods, a logic that holds into the present in the *kut* of Korean shamans and the *lên đồng* of Vietnamese spirit mediums. One also finds the evocation of a courtly past in Balinese *topeng* masked drama, sometimes performed to a sacred purpose, sometimes but not invariably with consecrated masks. In *topeng,* performance scholar John Emigh (1996, 105–6, 125) notes, "The pattern is that of a rite of visitation, but the playing out of this pattern has been theatricalized;" the performer is not expected to fall into trance and make the character fully present. The demon-like Balinese temple masks which will concern us in this volume are another matter, infused with cosmic forces whose energies morph from demonic to divine through a ritual dynamic that also uses performance and display, but to deadly serious and sometimes wildly unpredictable ends.[12]

The common thread in my four core examples is that while these statues, masks, and paintings are empowered by gods/souls/energies, these forces are not inevitably present inside them in ways that we might consider "animistic." They can be removed, reinstalled, or installed in new statue bodies, masks, and paintings—making animation (if we use this term at all) into an action verb whose realization, through human practice, is by no means inevitable. We are not so far from Mauss's (1972 [1950], 108) observation that "*Mana* is not simply a force, a being, it is also an action, a quality, a state. In other terms the word is a noun, an adjective and a verb," but in these contexts with more emphasis on the adjective and the verb than on the less generalizable noun.

And yet the animism conversation is useful here, insofar as it focuses attention on how communication happens between shamans, spirit mediums, and non-naturalist beings in material form, and because it encourages ethnographic projects that witness ontologies outside the frame of naturalism, as did Gell's more qualified discussion of objects onto which agency is abducted. "Animation" is no more easily generalized than "religion" or "shaman," and may not even be the best word for what I have been describing. In arguing that animation is good to think with, Teri Silvio (2019, 19) offers this helpful definition: "the construction of social others through the projection of qualities perceived as human—life, soul, power, agency, intentionality, personality, and so on—outside the self and into the sensory environment, through acts of creation, perception, and interaction." But the "animation" of static images functions differently from "animation" as the life-simulation of puppets, masks, and, in modern media, animated cartoons, game avatars, and social media personas (Manning and Gershon 2013; Silvio

2010, 2019). Yes, the objects that concern me are similarly constructed as social others, but they are not always made to move. With the exception of the Balinese temple mask, which conjoins with the body of a dancer/medium to produce the mobile presence of a god, the animated images that I describe remain stationary in the literal sense, separate from the moving bodies of the mediums and shamans that give them "animate" presence in the world. In Gell's (1998, 122) words, "Idols may be animate without . . . being endowed with animal life or activity. . . . It follows that 'ritual' animacy and the possession of 'life' in a biological sense are far from being the same thing." In verb form, "animation" can be used to describe the processes that render these things sensate, but is more confusing when used to characterize a fundamental condition of their being. The animated images of this project are animate because soul, energy, divinity, spirit has been installed as an active presence inside them, animated in the sense that an operation, "animation," has been performed to render them enlivened and present, and not because they, themselves, move.

For this reason, Fernando Santos-Granero's (2009b, 9) characterization of an "ensouled" object "amenable to some kind of subjectivation" may be the most apt expression for the project at hand. Ensoulment makes the divine image a more potent and consequential locus of worship than other sacred objects found on a Vietnamese altar. Incense burners, pictures, ancestor photographs, deity tablets, amulets, and spirit chairs function as tools or transmitters in sacred practice. Although these things have, in some sense, been activated by a ritual master, they are not presences in the sense that an ensouled statue is a presence. Once activated, amulets and other paraphernalia do or enable apotropaic work. Ancestor photographs and incense burners are sites and conduits of veneration and, as such, media for transmitting petitions to gods and ancestors. Devotees venerate prototypes for future statues, leaving offerings of fruit and flowers as a gesture of respect for the deity they represent. By contrast, the animated statue *is* the deity made present in the wooden or bronze container. Vietnamese spirit mediums described the profoundly efficacious potential of a temple with a full complement of properly animated statues. In such a place, the supplicant makes a direct petition to the gods who, facilitated by their statue bodies, come to the supplicant's aid. On ritual occasions, some of these embodied images also animate (in the sense of a puppet master) the bodies of mediums (see chapter 4).

## ANIMATION AS AN ACTION VERB

Here is a broad and general account of how temple statues are ensouled in Vietnam: The empty statue travels from the carver's workshop to the altar covered with a red cloth as apotropaic protection. A ritual master has the statue "sit in place" (*yên vị*) on the altar through procedures similar to the installation of incense pots on a family ancestral altar, which also requires the ministrations of a ritual master. In Gell's terms, correct placement is a part of the code of proper social relationship that obtains between people and statues, in this instance a code derived from old cosmological understandings of the necessity of placing people and things in proper spatial relationships. One of the spirit mediums we spoke with cited bad business and bad health as the sorts of ill effects that result from misplaced statues and incense pots. Another medium reported that she had been stricken with a mysterious illness when she inadvertently dislodged a statue on her personal altar, moving it ever so slightly from its proper place while cleaning it.

In anticipation of the animation ritual, the carver has prepared a small covered cavity in the back of a temple image where, in an auspicious hour, a ritual master installs an amulet bearing the god's name, a protective Buddhist amulet, colored threads to expel malevolent spirits, and a fragment of gold dust (plates 7 and 8). Depending on the ritual master's own tradition and his client's economic circumstances, he includes other precious elements such as scraps of gold leaf, silver, cinnabar, coral, amber, agate, gem crystal, mother-of-pearl, and pearl, as well as coins or folded bills of small denomination and a tiny human figure made of twisted threads.[13]

With its cavity filled and sealed, the statue sits on the altar covered with a red cloth pinned with a protective amulet, sometimes for several months (figure 5). On the proper day and hour, the ritual master performs the rite of *hô thần nhập tượng* (呼神入像), "calling the god into the statue," to induct the deity into the statue body and awakens its senses, ideally in the magically potent hour of the rat, or deep midnight.[14] At the climactic moment, the lights go off and, in the pitch-black room, the ritual master calls the god into the statue with appropriate textual recitation and gesture. The ritual master and his[15] assistants toss one hundred coins or small bills folded into boats or butterflies, one hundred needles (usually stuck into the folded cash), and five kinds of seeds—rice, corn, beans, peanuts, and sesame—to exorcise malevolent spirits and

FIGURE 5. A statue under a red cloth and covered with amulets awaits ensoulment, northern Vietnam, 2004. Vietnam Museum of Ethnology; photo: Vũ Thị Thanh Tâm.

bring good fortune. Participants scramble in the dark to grab these things as lucky talismans that have been power-charged by their association with the statue deity and the ritual master's work.[16] They rip the red cloth that so recently covered the statue and use the scraps as personal talismans. The amulets that were attached to the cloth reappear in domestic settings, auspicious and charged by association with the newly-empowered statue. Some followers of the Mother Goddess Religion say that once the ritual master pulls off the red cloth, the revealed statue is more beautiful than the original carving, just as Vietnamese spirit mediums claim that they become more beautiful when they incarnate a deity and are keen to exhibit photographs that validate their incarnations. One renowned statue carver who is also a spirit medium claims that sometimes he cannot recognize his own work in the animated statue that emerges from under the cloth; like the face of an entranced spirit medium, the statue image becomes more beautiful when the god is present.

After sending off attending buddhas and expelling imprisoned wandering ghosts, the ritual master takes up a small mirror, a tree branch, and three incense sticks to complete the animation of the statue body. With the incense he traces the words for "bright, clear vision," first on the mirror, and then in the air in front of the statue, awakening the statue's eyes with

the words, "The left eye is shiny as the sun. The right eye is shiny as the moon. The left and the right eyes must become five eyes to see all things." He also reads an incantation to set the image/deity's mind at ease.

Empowering a statue carries risk. To perform the animation ritual, the ritual master should be in a state of absolute purity, having abstained from sexual relations and observed a day-long vegetarian fast. A ritual master who performs an animation ritual should not have experienced a death in his family for the last forty-nine days, no births in the family within three days, and had no dog or buffalo butchered in his home before his departure for the ritual. These prohibitions are within a logic of purity and pollution that I first encountered when I went to pray on a sacred mountain with Korean shamans and would encounter again in image-makers' workshops from Seoul to Bali. In Vietnam, the youthful but experienced Ritual Master Thuy described headaches or a possible traffic accident as the likely consequences of ignoring these prohibitions. A ritual master also tries to avoid inauspicious encounters with pregnant women or cats on his way to an animation ritual. Ritual Master Thuy explained that if the ritual master is inept or does not keep himself pure, his clients will suffer misfortune and bad business, a magical "infelicity," in Tambiah's (1973) terms. In the words of an older ritual master: "if the ritual is not done carefully and the statue is still 'dirty,' the gods will not animate it." He spoke of a temple that had animated its statues in the early morning, and in the afternoon the family's motorbike was stolen. Shortly thereafter, someone in the family became ill. Eventually, the unlucky family called upon our conversation partner to correct the situation and properly animate the statues.

The unanimated statue body is itself a source of potential danger, its hollow cavity inviting habitation by ghosts or inauspicious spirits. For this reason, the statue travels to the temple altar under a red cloth and remains covered until the animation ritual, sitting with a demon-repelling amulet attached to the cloth for good measure. Indeed, careful people paste amulets on the head, mouth, eyes, nose, ears, belly, chest, and back of the statute above the cavity. According to Ritual Master Thuy, the danger of infiltration by evil spirits persists until the moment of animation, and during the animation ritual, "security is very tight." The ritual master takes precautions to fortify the ritual space against incursions by invisible and unwelcome forces and ritually "imprisons" any lurking malevolent entities, sending his captives away before opening the statue's eyes.

The cavity that is the focus of so much caution before and during the animation ritual can also be a site where ill-intentioned persons introduce

inappropriate material, usually before they present a statue to a temple. Although most spirit mediums and ritual masters we spoke with were familiar with stories of sorcery worked by introducing maleficent objects into consecrated incense pots and some described finding such material in their own or other pots, most felt that attempting sorcery on a Mother Goddess statue was a perilous act whose consequences would rebound on the sorcerer's own family. Even so, suspicions do arise. An elderly spirit medium in Hanoi's old quarter described how she had divined that another spirit medium's illness came from a statue of General Trần Hưng Đạo, gifted to her temple by a client. To avoid similar mishaps, she herself refuses her devotees' offers of statues, suggesting that they contribute cash instead. She and other cautious mediums have their statues refurbished, or new ones made, in their own temples, where they can supervise the artisans. With respect to the inappropriate statue that was precipitously removed from the communal house, the quarrel over the propriety of its installation had provoked rumors that the donor, a relative newcomer to the village, had smuggled his own ancestor's ashes into a position of veneration via the statue's animation cavity (Nguyễn and Phạm 2008). Such rumors persisted for more than ten years after the statue had been removed from the altar, de-animated, and the ritually appropriate contents publicly examined, recorded, and photographed. Ông Đồng Đức allowed that a statue could lose its power if a maleficent amulet were secretly placed on it or if a nail were driven into the statue, but in these cases, the temple-keeper would have neglected his or her sacred duty of protecting the statue body and would suffer the consequences.

Some temple-keepers described an annual ritual to bathe the statues in their care, practices analogous to lustrating buddha images in many Southeast Asian temples. Temple-keepers would purify their own bodies for several days and bathe themselves before beginning the task of purifying the statues in the steam of boiled water infused with fragrant spices, swabbing the statues with an immaculately clean piece of cloth. In addition, careful temple-keepers clean their statues regularly, usually before the first of each lunar month, and give them fresh offerings. In a traditional Mother Goddess temple configuration, the most sacred space is the backmost "forbidden room," off limits to ordinary worshippers, who regard the Mother Goddess images through a wooden lattice. At the Tiên Hương Palace, the temple-keepers frequently clean and vacuum the forbidden room to keep it spotless, keep the door closed, require anyone who enters to remove their shoes, and purify visitors at the threshold with a spritz of perfume.[17] Ông Đồng Đức

explained that even inside the forbidden room, a temple-keeper should not stare at the Mother Goddess images in his or her keeping. Although he had tended them for many years, he claimed, "I don't dare to really get a good look at the images. They are frightening!" When he saw the photographs of statues he himself had commissioned as replicas of the three Mother Goddesses in the forbidden room of the Tiên Hương Palace, he did not recognize certain details of their dress.

Temple-keepers are also expected to observe propriety in their own conduct. Ông Đồng Đức and Bà Đồng Duyên at the Tiên Hương Palace maintain that they are careful in their speech, dress, behavior, and family life. According to Bà Đồng Duyên, if someone sets up a private temple, they must make a clear distinction between ritual space and family space. Another temple-keeper told us that when his predecessor had been careless about eating dog meat and had conducted an adulterous relationship in temple space, his family fell apart and he went insane. Another temple-keeper spoke of how she had gone to a fair at another temple and eaten street food in a "dirty place." She came back home compulsively slapping her mouth and cheeks. Bedridden, she heard the Mother's voice: "I brought you to this temple to work for us. What do you mean by going out and eating in such dirty places? You are being punished now, but if you follow my commands you will follow me when you die." The temple-keeper subsequently avoided street food.

Propriety also governs the circumstances of a temple-keeper's removing the statue from an altar, a matter never undertaken lightly. A statue may be removed and destroyed when it has lost its power through sorcery or when it has been eaten by bugs or damaged by the elements, and some statues are removed to be replaced by larger ones. In all of these instances, a ritual master releases the deity from the statue and returns it to its pre-animated state in a ritual that is similar to, but less elaborate than, the animation ritual. After invoking the buddhas and gods and reading appropriate texts to release the deities from the statues, the ritual master removes the amulets and precious materials from the statue's cavity, recycling them in a new statue if they are in good condition, or carefully burning them and casting the remains into clear water. We found a range of opinions about how to deal with a de-animated statue body, the consistent theme being a respectful and "pure" disposal: burning, casting the statue into clear running water, burning and casting the ashes in clear running water, or ceremonious burial.

In the Red River Delta, where many temples are being refurbished and their statues repaired, refinished, and sometimes gilded, we encountered

a range of opinion about whether a temple-keeper must sponsor a de-animation ritual when he or she temporarily removes statues from the temple altar. In general, temple-keepers reported their intentions to the gods and tossed coins to divine the deities' permission before taking them down. The spirit mediums we spoke with all agreed that statues carried outside the temple should first be de-animated by a ritual master and then covered with red cloths "to protect their energy (*khí*, Chinese *qi* 氣, Korean *ki*기)." Ông Đồng Đức described how, when he refurbished the statues in the Tiên Hương Palace in 1991, no rain fell for the period when the statues were de-animated. He held the animation ritual on a clear night and at the precise moment when the ritual master turned out the lights to re-animate the statues, the rain poured down—a lucky sign attributed to the agency of the restored Mother Goddesses.

In sum, spirit mediums, temple-keepers, and ritual masters in Vietnam describe a liturgical process of statue ensoulment and a relationship with the statue body that assumes both careful etiquette and intimate devotion, acts that mark the devotee's understanding of the ensouled image as the site of an agentive and powerful entity. This relationship is a source of blessing and empowerment but also of potential danger if violated, even inadvertently. In this sense, the tales of iconoclasm related above are more than folkloric curiosities. They circulate as moral tales, injunctions to proper conduct and affirmations of the agency of gods acting through statue bodies. In a folk saying recounted by spirit mediums, "the Buddha is merciful, but the Mother Goddess resents every little thing."

Animation practices like those described above are known throughout Southeast, East, and South Asia, but with respect to the intimate workings of human relationships with images, how broadly can such practices, and the understandings that infuse them, be generalized? Now we are ready to travel.

## MYANMAR: THIRTY-SEVEN *NAT*, MORE OR LESS

August 2011: The small wooden images have traveled with their mediums to the Taungbyon Festival outside of Mandalay. Doll-like, gilded *nat* faces peer over the rims of their wicker carry baskets (plate 9). They arrive not piled inside for protection, or in an economy of space, but propped up so that they can see what is going on around them. They watch as the mediums and their helpers decorate the mat shed *nat kana* that they will all—mediums, followers, and *nat*—inhabit for the

duration of the five-day festival. The *nat*, in statue form, will preside over the *kana*, sitting amid splendid displays of flowers, offering food, and cash gifts. Some of the images have been freshly gilded. Their hair is shampooed with a special product sold around the festival periphery for the toilettes of both statues and spirit mediums and their small wooden bodies are dressed for the festival in new costumes, turbans, and gauzy shawls. Likewise, the *nat kadaw* competitively costume themselves and do extensive primping for their annual moment of glory, a grand procession with their followers to the Taungbyon Brothers' palace for a star turn in *nat* persona, dancing to the swelling encouragement of their entourage in front of the Taungbyon Brothers' primary statue manifestation (*pon daw*) and most potent presence (Brac de la Perrière 2016, 6–7; 1992, 208; 2002, 99).

Scholars describe the *nat* as the local tutelaries of pre-Buddhist Burma who were systematized into a state-sanctioned cult honoring thirty-seven historicized figures worshiped in officially recognized "palaces" (*nat nan*) in locations associated with their stories and in personal shrines maintained by individual mediums who serve the *nat*.[18] The creation of this cult under royal patronage has been interpreted as the transformation of potentially counter-hegemonic practices into something tractable to royal and Buddhist authority (Brac de la Perrière 1992, 204; 2016, 12, 26; Spiro 1967, 131–35).[19] Many *nat* stories include an act of "conversion" where the king who caused the subject's death transforms the resulting unquiet spirit entity into a *nat* and grants the *nat* a physical territory over which the *nat* reigns as a tutelary (Brac de la Perrière 2007, 215; 2005, 67). Most *nat* died violently, through treachery, or otherwise badly (Ridgeway 1964 [1915], 238–56, citing Temple 1906; Rodrigue 1992, 25–45). As a consequence of dying suddenly, usually filled with anger and resentment, *nat* were unable to assume a prayerful orientation toward their next life and were denied reincarnation. Thus *nat* remain trapped amid the emotions and appetites they bore while alive (Bekker 1993, 296; Brac de la Perrière 2007, 215; 2009, 285; Schober 2004, 804; Spiro 1967, 41, 51). In an explicitly Buddhist society, the *nat* exhibit explicitly un-Buddhist behaviors, giving vent to a range of emotions and desires that Buddhist practice discourages (Schober 2004, 803; Spiro 1967; Vossion 1891, 113). Where good Buddhists work toward salvation by periodically following precepts enjoining moral behavior, fasting, temperance, and other austerity, the *nat* exemplify the appetites and failings of the flesh in the stories told about them, the corporeal activities they enact via their mediums, and the rowdy and transgressive

behaviors of roistering devotees on the periphery of *nat* festivals (Schober 2004; Spiro 1967).[20] As victims of injustice who bear human passions and superhuman force that requires periodic calming, the *nat* are a potential source of danger and misfortune, and many Burmese express uneasiness about them. But because *nat* have essentially human feelings, they also bestow aid and good fortune on devotees who please them. *Nat* respond to supplications and tribute and concern themselves with a range of human problems, from illness to business, with an accessibility and immediacy that would not be presumed of the Lord Buddha, who is not of this world (see Rodrigue 1992, 19; Bekker 1993, 293; Schober 2004).[21] Melford Spiro's (1967) characterization of the *nat* as "evil spirits" seems at odds with other descriptions of the compassion that ordinary Burmese sometimes feel for the *nat* and their miserable fates (Bekker 1993, 296; Skidmore 2007). Some Burmese express a genuine affection for the *nat* they know from stories or as enacted in the mediums' performances. They are amused by the petulant demands of the little girl *nat* Ma Ne Lay (figure 6) who helps artisans and shopkeepers and the drunken antics of U Min Kyaw, or they feel sympathy for the tragic mothers, buffalo-headed Bago (Pegu) Medaw and ogre-headed Popa Medaw. The *nat* are an unambiguously subordinate presence in the Burmese moral order, but a presence within that order nonetheless (Brac de la Perrière 1992; Schober 2008). As Aung T., a serious practitioner of Buddhism and also a *nat kadaw*, put it, "The *nats* are outside of religion [Buddhist practice] but in their way, they support religion."

The presence of statues in association with spirit mediums (*nat kadaw*), and the care that the mediums take in transporting their *nat* images to *nat pwe* and festivals, has been noted from early accounts into the present (Brac de la Perrière 1992, 205, 208, 210, 213; 2005, 67; Brown 1915, 359; J. Nash 1966, 126; Rodrigue 1992, 6, 53–54, 67; Temple 1906; Shway Yoe 1963 [1884], 234), but outside of the prolific Bénédicte Brac de la Perrière's (2002; 2009; 2016, 5) work, *nat* statues have not attracted sustained analytic attention.[22] Like the temple statues in Vietnam, these are ensouled images; the *nat's* butterfly soul or butterfly spirit (*leikpya*) has been ceremoniously introduced into them (*leikpya thwin*), just as the *nat kadaw* received a butterfly soul during his or her initiation (Brac de la Perrière 2002, 99). As described above for Vietnam, several conversation partners told Erin Hasinoff and me that good treatment of an image brings the *nat's* favor while improper treatment results in bad luck for the *nat kadaw;* that the theft of an image would have broadly inauspicious consequences; and that even

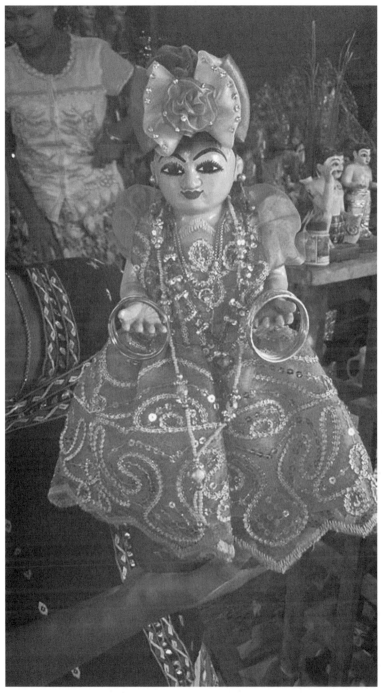

FIGURE 6. The little girl *nat* Ma Ne Lay presides over a mat shed shop during the Taungbyon Festival, Myanmar, 2011. Photo: author.

minor infractions of statue etiquette can incur the *nat's* displeasure. Those who insult the image of a god are said to be consigned to the worst possible hell (Rodrigue 1992, 6).

Women selling statues from a stall on the periphery of the Taungbyon Festival offered a telling example. Although not mediums themselves, like many other shopkeepers, they honor the little girl *nat* Ma Ne Lay and make offerings to her in their stall, where an image of Ma Ne Lay stands in her cradle holding two hard-boiled eggs at breast level. The previous year, their father had instructed them to change Ma Ne Lay's dress twice a day during the festival to fulfill a vow that would bring their shop good profit. Business was booming until the daughters carelessly sold the extra dress to a client, forgot to change Ma Ne Lay's costume, and were not able to sell a single thing for the rest of the day. When the sisters asked a *nat kadaw* why their customers browsed but did not buy, he asked them what they had done to offend Ma Ne Lay. Remembering the dress, they quickly bought a replacement from one of the many nearby stalls that sell stocks of little dresses, hung out like dolls' clothes, for the *nat*. Their business picked up.

One prominent spirit medium bested the readymade wares on sale in the festival market. He proudly gestured to his own statues, all dressed in costumes made from bejeweled gold brocade remnants provided by a prominent Myanmar fashion designer (figure 7). The bathing, the coiffing, the dressing are intimate engagements with a *nat* in statue form. Some statues are made with a wooden knob at the top of the head to attach a lock of the medium's own hair. Daw N., a spirit medium whom we met at the festival, told us how, when she satisfies the drunkard *nat* U Min Kyaw's craving for whiskey, she places his image in a basin and pours domestic whiskey over him, begging the *nat's* indulgence because she cannot afford to give him the Johnnie Walker Black that he craves. When she is done, she gives the poured-off whiskey to her husband, who swears that it tastes like water because the greedy *nat* has consumed all of its alcoholic essence. The antics of a petulant little goddess desiring a new dress and a bibulous *nat* are experienced and retold not only as assertions of *nat* power but as affirmations of the teller's own connection to it.

The statues on a *nat kadaw's* personal altar entwine prototypical forms with deeply personal experiences. Some of the mediums we met around the Taungbyon Festival proudly claimed that the statues enshrined in their *nat kana* came from their own teachers, a sign that this particular medium was the favored apprentice. In her discussion of

FIGURE 7. *Nat* coiffed and dressed in bejeweled, brocade gowns for the Taungbyon Festival, Myanmar, 2011. Photo: author.

how bonds between master, medium, and disciple are materialized through the teacher's images, Brac de la Perrière (2016, 22–23) observes that tension and jealousy may develop among a teacher's followers over the disposition of the images, something that we shall also see with regard to the disposition of a shaman's god pictures in South Korea. Two mediums shared their personal and fantastic experiences of acquiring their own statues. Daw N. received instruction in a dream vision early in her practice. A voice told her that she should acquire statues from the shrine of a *nat kadaw* who had died six months previously minus one week, the exact circumstance of a former classmate who had been a *nat kadaw*. She also feels that she heard her former classmate's voice at the moment of his death, asking her to tend his *nat*.

Aung T., a male medium, described his search for an appropriate image in the manner of a romantic quest. In 1988, he went to the Taungbyon Festival and saw the statue of a beautiful female *nat*, Ma Ngwe Taung, on sale in a roadside mat shed. He felt drawn to the statue and went back to the stall, hoping to buy it, but the festival had ended, and everything was packed away. He went around to the shops near the Mahamuni Pagoda in Mandalay, seeking the enticing image, thinking

that if he and this beautiful *nat* woman had really been connected in another life, he would ultimately find and acquire her statue. He continued his quest at the next year's festival and, with the help of a friend, located the elusive statue that had so enticed him. The friend was a skilled bargainer and brought the dealer's price down from 600 to 450 *kyat,* which, a delighted Aung T. immediately recognized, added up to the lucky number nine. It was meant to be. The statue came to his home with, in his words, "pomp and ceremony," first enshrined in a *nat kana* outside his residence, where she was ensouled with the music and dance that awakens Ma Ngwe Taung, and then placed on an altar inside his home (figure 8).

Another beautiful female *nat,* the serpent woman Shwe Nabe, captivated and willed Aung T. to dance to her music, but when he tried to commission a statue, the carvers' work disappointed him, and he left the statue in the shop. "You have to respect a statue and keep it for your whole life, and how can you keep for life a statue that displeases you?" A few years passed, and a carver in one of the shops near the Mahamuni Pagoda asked Aung T. if he might be interested in a statue that another client had rejected because the pose did not match that other *nat kadaw*'s dream vision of the *nat;* she was standing, but the client had dreamed her in a seated posture. Aung T. prayed for his own dream vision, received an appropriate sign, and brought the beautiful *nat* into his home.

Vietnamese and Burmese mediums share a common understanding that these images are ritually ensouled, and that the medium's relationship with the statue body is an extension of the medium's relationship with the deity inhabiting the statue body—the deity who, on occasion, inhabits the medium's own body. But there are also differences in the ways that Vietnamese and Burmese mediums interact with divine images. While some Vietnamese mediums maintain personal images on altars in their homes, they engage the gods primarily via temple images. Statue bodies are immobile once the ritual master has set them in place. In Myanmar, *nat* statues on the altars of individual spirit mediums are both more personal and more portable, accompanying their *nat kadaw* to festivals and other rituals (*nat pwe*) where *nat* are incarnated in their costumed spirit mediums. Brac de la Perrière (2002) observes that these personal images are secondary to the images enshrined in the *nat*'s main palace, the "original" images linked with the origin stories of particular *nat.* The latter are so closely identified with the *nat,* the *nat* so thoroughly present in the original image, that it is not considered necessary to further ritually animate them. When mediums carry their personal

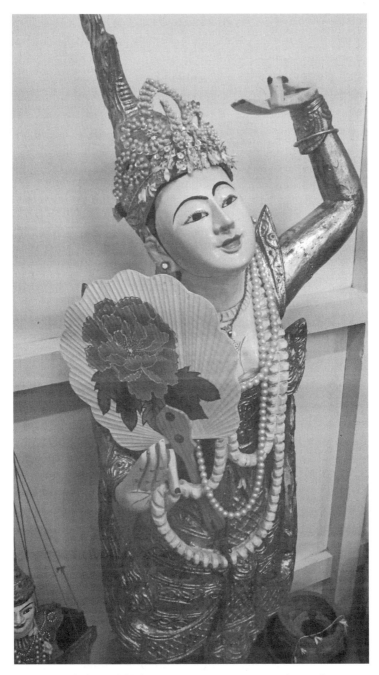

FIGURE 8. The beautiful lady *nat* Ma Ngwe Taung on a medium's altar, Mandalay, Myanmar, 2011. Her Korean paper fan is a gift from the anthropologist, appropriate because Ma Ngue Taung's presence causes her medium to experience intense heat. Photo: author.

statues to a festival in a *nat's* home temple and install them in their *nat kana,* the statue bodies are, in Brac de la Perrière's felicitous term, "irradiated" by their temporary proximity to the statues in the *nat's* primary temple (99–101).[23] These distinctions aside, the operable premises of ensoulment in Vietnam and Myanmar are mutually legible and broadly analogous to rites performed in both places and many others to ensoul buddha images in Buddhist temples. This is not the animistic terrain of Viveiros de Castro's (2004) "ontological perspectivism," of multiple perspectives waxing and waning such that the bearer, in turns, experiences the world as a human shaman, animal, or other life form (see also Pedersen 2011, 62, 177). Rather, the god is fixed inside the statue body, most literally contained and sealed against the intrusion of ghosts or objects of sorcery (as Warnier 2006, 193, describes for containers). With respect to Korean shaman paintings and Balinese temple masks, neither of them containers strictly speaking, the mutable qualities ascribed to a shamanic ontology may have more to offer us. The notion of an ensouled statue made me curious about the god pictures that hang above a Korean shaman's altar.[24] My prompt was the teasing incident of the gods/paintings that had fought and fallen to the floor, my curiosity now heightened by what I had learned about ensouled images.

### KOREAN GOD PICTURES: ENSOULED? SOMETIMES?

The paper images had fallen to the floor of the shrine and there they lay, the Great Spirit Grandmother and the Jade Immortal stuck together. I had heard the story many years before, the first time only a few months after it had happened early in the 1980s, and then again, equally vividly, when I asked about the paintings a quarter century later. "They had been fighting," the *mansin* Yongsu's Mother said. God pictures fighting god pictures? Gods fighting gods through the medium of paper images? Korean syntax permitted ambiguity, but the context implied the agency of gods. Yongsu's Mother spoke as a *mansin* (만신, 萬神), a Korean shaman.[25] In her world, paper images are inert matter unless inhabited by the gods (*sin* 신, 神, *sillyŏng* 신령, 神靈) they portray, much as the wooden images we have been discussing are inert matter unless ceremoniously ensouled. Yongsu's Mother's gods are active, demanding, and sometimes quarrelsome entities whom, before her retirement, she honored in her shrine, encountered in dreams, and manifested in her own body. Even so, the act of their falling and sticking together was an unusual and graphic indication of a battle of divine

wills. It became a tale, told and retold as further evidence of the uncannily active powers of the gods in her shrine, and sometimes as an indication of the contrasting wills of Yongsu's Mother and her own elder sister. One of the quarrelsome painted gods, the Great Spirit Grandmother (Taesin Halmŏni), belonged to Yongsu's Mother as her primary guardian god, one among the dozen she had installed in her shrine when she was initiated as a shaman. The other, the Jade Immortal, had been the primary deity of her sister, Chatterbox Mansin. The Jade Immortal had come to Yongsu's Mother in a bundle of paper images with Chatterbox's other god pictures/gods when Chatterbox Mansin, with the permission of her gods, retired from shamanship. In other words, the god pictures were the material manifestations of the gods that Chatterbox had served, and the transfer of the pictures marked the gods' transfer to Yongsu's Mother. Chatterbox's gods had indicated their willingness to enter Yongsu's Mother's shrine and work with her, stating their intention in the dreams of both *mansin* and once again when Chatterbox had manifested them, one last time, in the ritual that preceded their installation in Yongsu's Mother's shrine. But Yongsu's Mother's own gods were not willing to receive the newcomers. Once Yongsu's Mother had installed her sister's god pictures, placing the paper images underneath her own gods in the narrow room, things had gone wrong. Business was bad, her health was bad, her dreams were troubled, and most significant, she no longer received a clear flow of inspiration when she prayed in front of the images in her shrine. What she heard was mumbling and grumbling, the divine equivalent of television static. The fallen paintings were the final confirmation. She would take her sister's paintings/ gods down from the wall, roll them up, and retire them under her altar.[26]

Until I heard about the fallen paintings, I had considered the god pictures as a backdrop to the *mansins'* practice. I did understand that the pictures in the shrine were in some sense numinous, that these were things that should be treated with respect, that they were not meant to be touched by ordinary people, that they were something like the objects on the far side of the altar rail in a pre-Vatican II Catholic church. Most of the *mansin*'s gods were, like the *nat* and many members of the Mother Goddess pantheon, persons who had once been alive, some of them historical figures. The gods appear in the *mansin*'s god pictures as stylized images.[27] They resemble, in cruder form, the subjects of traditional commemorative portraits painted in dynastic times of kings, queens, statesman, generals, and other national heroes, portraits that were regarded as sacred media for veneration and, like ancestor tablets, were considered

the seats of souls (Cho 2010; Yoon 1994a).[28] A god above the altar usually appears in the forward-facing presentation of a seated or standing figure, the face sometimes turned very slightly to the side. Typically, the faces are disproportionately large, such that the eyes meet the viewer's gaze with a bold and penetrating stare which some viewers find unnerving (figure 9). A mansin in costume, manifesting an imperious god, might similarly lock eyeballs with a client, an unsettling engagement in a place where socially appropriate eye contact is usually oblique (plate 10). The paintings also claim attention through bright color, colors associated with the five elements of Sino-centric cosmology (ohaeng 오행, Chinese: wuxing 五行) and present also in the costumes the mansin wear. These are not the colors of everyday, but of king and court, Buddhist temple architecture, and celebrations carried out in liminal time.

They are also the colors of *kut,* the *mansin's* primary ritual. In *kut,* a team of *mansin* in an appropriate sequence of costumes manifests a series of gods who exorcise inauspicious forces, secure blessings and harmony, and offer divine prognostications. When she performs *kut* in the god's clothing, the *mansin's* body mirrors the painted image much as costumed medium bodies mirror statue images in Myanmar and Vietnam. The paintings indicate the stock categories of gods who appear in *kut*—General, Spirit Warrior, Mountain God, Birth Grandmother, and the like—but many of the *mansin's* gods were also known ancestors, personages who inhabit these god roles much as a known individual might become for a time "the President," or "the company director." The Great Spirit Grandmother who fell to the floor was a uniform category of god recognizable in a standardized image, but in this instance, inhabited by an ancestral grandmother of Yongsu's Mother who had been apotheosized by virtue of her own career as a shaman (figure 10). The *mansin's* own mother had also been a destined shaman but had never been successfully initiated. Once at a *kut* I saw Yongsu's Grandmother put on the Great Spirit Grandmother's yellow robe and fall into an intense trance, speaking angry words in the god's name that furthered her own position in a family argument.[29] After her own death and some years after the paintings fell to the floor, she took over the role of Great Spirit Grandmother. When this deity appeared during one of Yongsu's Mother's *kut* and the now apotheosized Yongsu's Grandmother saw me present, she would greet me as an old acquaintance whom she had not seen for a long time. The Spirit Warrior's role in Yongsu's Mother's shrine was assumed by her own dead husband (figure 11). The god shared the husband's insatiable appetite for drink, and when he appeared in ritual settings,

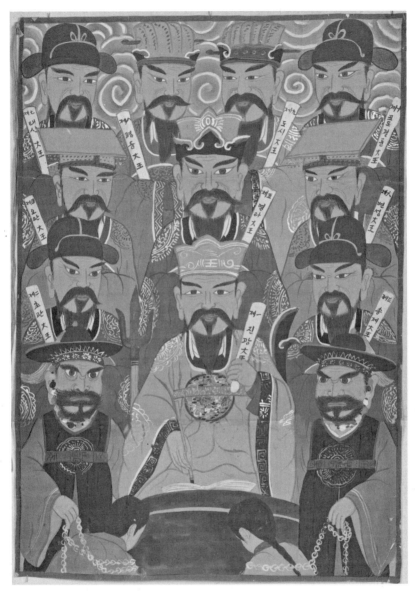

FIGURE 9. Korean god picture of the Kings of Hell, who cast their inquisitors' gaze on the viewer as well as on the malefactors who are brought before them in chains. Photo: American Museum of Natural History, Anthropology 70.3/7200.

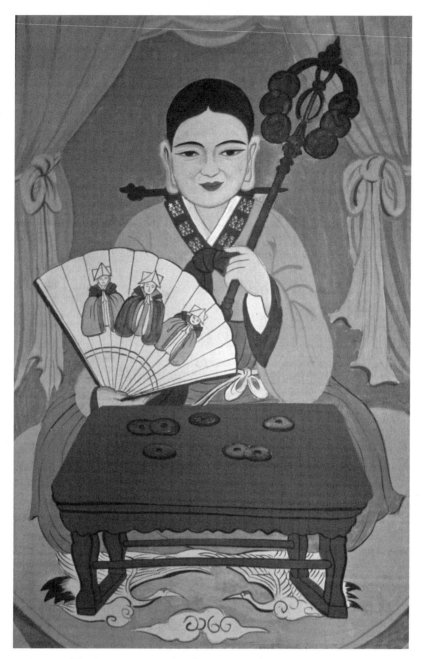

FIGURE 10. The Great Spirit Grandmother (Taesin Halmŏni, Taesin Manura) seated at a divination table, late twentieth century. This god is usually a deceased *mansin* who sends her successor inspiration for divinations. Photo: author.

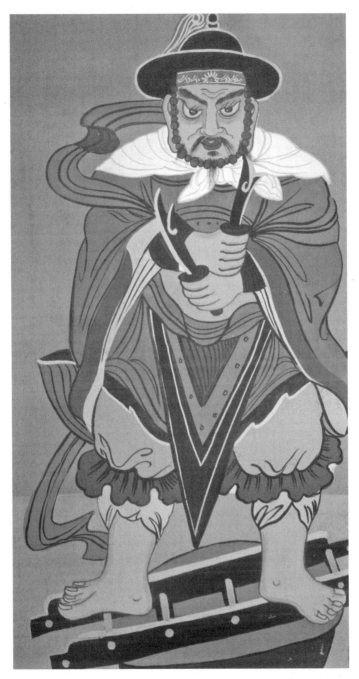

FIGURE 11. The Knife-riding Spirit Warrior in an image similar to the one in Yongsu's Mother's shrine, late twentieth century. Although the image is standard, Yongsu's Mother's god was understood to operate in the persona of her dead husband. Photo: author.

comically manifested by one of her colleagues, these reunions from beyond the grave were occasions for the continuation of domestic quarrels.

But despite these inflections of known persons in the appearances of gods during *kut,* the gods in Yongsu's Mother's pictures were standardized representations; when I first knew her they were mechanically reproduced cheap colored prints, subsequently upgraded to workshop paintings. The most personalized element on Yongsu's Mother's altar was the accumulation of *soju* bottles in front of the Spirit Warrior's image—this being the Korean vodka that had shortened his mortal life. In the Hwanghae tradition of northwest Korea, by contrast, when the god is a known person, such as a shaman teacher now deceased, the painter approximates verisimilitude, sometimes copying from a photograph (Walraven 2009).

Until her retirement from shamanship, Yongsu's Mother paid her respects to her gods via their images every morning with offerings of clear water, candles, incense, and cups of alcohol for the more robust members of her pantheon. She kept her shrine scrupulously clean, and every gift that she received went first upon the altar. She also greeted her gods before leaving her shrine to perform rituals in other places. With an echo of the Vietnamese ritual master's studied placement of statues on altars, the placing of god pictures inside the shrine and the location of the shrine itself are matters of some consequence. I knew that at least twice, Yongsu's Mother's gods had demanded a more favorable location inside her house, something accomplished on a lucky day by the lunar calendar. The Clear Spring Mansin's Spirit Warrior had made trouble for Clear Spring until he/his painting was moved into closer proximity with the buddha image so that he might benefit by the Buddha's teachings. Minju's Mother, Yongsu's Mother's apprentice, would ultimately burn an expensive collective painting that had been inappropriately commissioned from and inappropriately installed by a monk. And of course, there were the gods/paintings that could not live in close proximity to each other and fell to the floor in a quarrel. I would come to understand that god pictures, when deployed in a Korean *mansin*'s practice, were something powerfully charged and absolutely essential to her work, but I got there via statue encounters in Vietnam and the growing literature on the making and ensoulment of statues in Buddhist and Hindu practice referenced in the previous chapter. Much is familiar: the mirroring between the god in the image and the costumed appearance of the god in ritual, the careful tending of the image as a means of

engaging with the gods, the image as the material focus of a relation-
ship. But where images of the Mother Goddess pantheon in Vietnam
and *nat* images in Myanmar are akin to the material representation of
buddhas, containers for ensoulment carved in similar workshops and
activated through mutually legible processes, the *mansin*'s god pictures
are a different kind of thing.

## WHEN DO THE GODS GO INTO THE PAINTING?

When I returned to fieldwork in Korea, and to the question of how god
pictures might be so enlivened that they would fight with each other, I
anticipated that god pictures in shrines had received some ritual marking
that might approximate Vietnamese, Burmese, and other like practices,
some explicit indication that gods had been installed and their images
enlivened through liturgical means. Buddhist sculpture has a long history
in Korea, and *mansin* also place buddhas on the altars in their shrines.
When she installs a buddha image, a *mansin* does this with seriousness
of purpose, either calling on a Buddhist monk or doing it herself using a
text purchased from a purveyor of religious goods.[30] In a reprise of senti-
ments expressed in Vietnam and Myanmar regarding buddhas as benev-
olent but detached and consequently unavailable for ordinary human
needs, *mansin* likewise consider buddhas as gentle, helpful beings. In
contrast, their own gods' power is "frightening" (*musŏpta*) but more
directly efficacious in the human fray of family quarrels and business
anxieties that are the common stuff of a *mansin*'s caseload.

Thinking of the elaborate eye-opening that Yongsu's Mother had per-
formed when she installed new and larger buddhas in her shrine in 1986,
I asked what I thought was a basic question: "When do the gods go into
the pictures?" She brushed the query aside as nearly irrelevant, stating
that during the initiation ritual (*naerim kut*), the initiate sees the presence
of her gods, that their souls (*yŏnghon*,영혼, 靈魂) appear during the ini-
tiation ritual. Still not satisfied, I asked again in another interview a few
months later, "When do the gods come into the pictures?" "When the
initiate sees the faces of the gods in her initiation ritual then they are
present in her shrine." I asked if there was a special ceremony (*haengsa*)
for this. "Nothing special because the gods are already present. The gods
are responding to the *mansin*'s petition. They have already helped the
shaman make money so that she can install the paintings when she cele-
brates her gods (*kkonmaji kut*)." Paper slips bearing the gods' names
might stand in the shrine for several years before a *mansin* installs her god

pictures, although this was more common in the past when South Korea was a poorer place. In those days, and like the Burmese *nat kadaw* who only gradually acquired his images, the *mansin*'s acquisition of god pictures marked a higher level of practice; the gods had shown their presence through the *mansin*'s efficacious work such that she could now afford to buy the paintings. One Hwanghae *mansin*, lamenting the now common practice of purchasing paintings for an initiation *kut*, described how, in the past, the paintings would come in when the old shamans agreed that the initiate was ready to be fully empowered by her gods, when her gods had fully accepted her. Today, if the initiation fails, the paintings are a failed investment that go back to the shop. In the *mansin*'s logic, this authorization was a reading of the gods' own agency, an indication of the gods' desire to work effectively with a particular *mansin* and the *mansin*'s capacity to perform and serve them well. The gods are agentive but so, also, is the *mansin* who has made a successful practice.

"When the initiate sees the faces of the gods in her initiation ritual then they are present in her shrine." I mulled it over, and remembered a vivid moment from an initiation ritual that Diana Lee and I had captured on film in 1989 (Lee and Kendall 1991; Kendall 2009, 66–101). The young initiate, with great reticence and palpable fear, ascends a makeshift structure and balances carefully on large iron blades used to cut fodder, the climax of the ritual. The initiate bursts into tears, pounds the wall, turns to the *mansin* and the camera, and shouts in tearful triumph, "They're coming through, they're all here!" The older *mansin* tells her that it would really have been a disaster if she had gone all the way up on the blades and the gods had not shown up. This was it, the simultaneous activation of shaman and shrine as linked entities through the agency of willing gods, or so it seemed. The statue ensoulments which we have been considering in Vietnam and Myanmar are liturgically predictable; so long as the correct procedures are carefully followed, the appropriate gestures made, and the appropriate words chanted in the appropriate way, a properly crafted image will be enlivened as a buddha or a god. The activation of a painting, like the activation of a shaman, is in no way guaranteed. Indeed, in the filmed instance recounted above, the inspiration was eventually judged to be insufficient, the initiate did not become a *mansin*, and in retrospect the ritual was considered a failure.

Most *mansin* initiations fail. There is no guarantee that the initiate will find the inspiration to call in the gods, no guarantee that she will "see"—in what vision or waking dream—the gods' arrival, no guarantee that inspiration will pour out of her such that she will speak in the authoritative

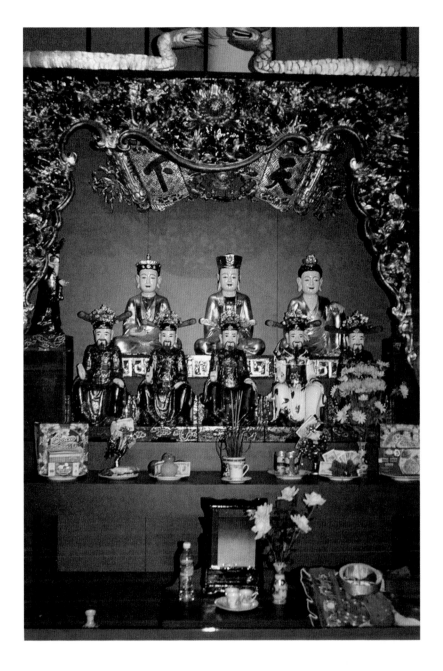

PLATE 1. MacGuffin: The Three Mothers gifted to the Vietnam Museum of Ethnology by the Tiên Hương Palace, 2004. Vietnam Museum of Ethnology; photo: Vũ Thị Thanh Tâm.

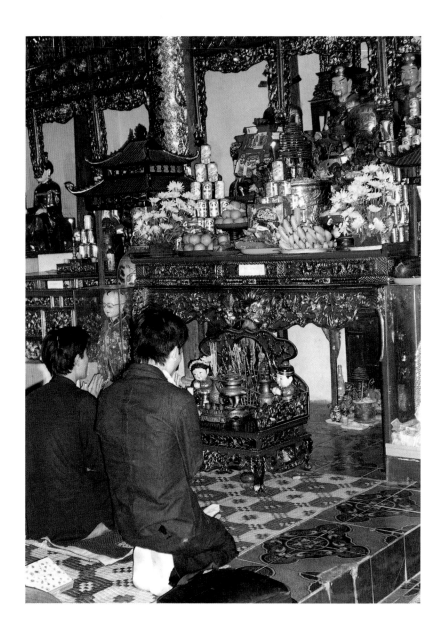

PLATE 2. A relationship with divinities of the Mother Goddess Religion in the newly refurbished temple of a spirit medium and ritual master, northern Vietnam, 2004. Photo: author.

PLATE 3. The altar of a male *mansin* in the Hwanghae tradition is crowded with the presence of many overlapping gods acquired over the course of his career, Incheon, South Korea, 2009. Photo: Homer Williams.

PLATE 4. During the Taungbyon Festival, *nat* dressed in colors appropriate to the day of the week sit on a medium's altar in his private mat shed (*nat kana*), northern Myanmar, 2011. Photo: author.

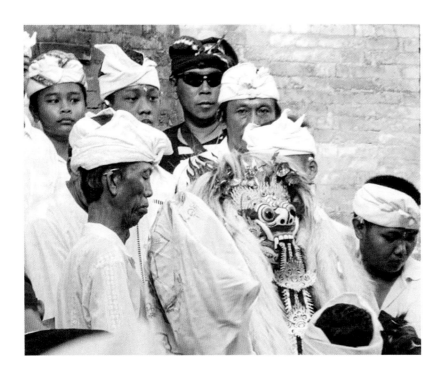

PLATE 5. Rangda appears through the gateway of the inner temple during the Festival at Pura Pengerebongan, Denpasar Utara, Bali, Indonesia, 2017. Her presence will throw several spectators into trance. Photo: author.

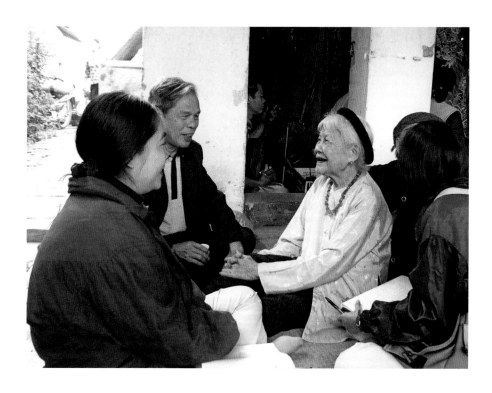

PLATE 6. Nguyễn Tôn Kiểm interviews a neighbor. Nguyễn Thị Thu Hương is at the left while Vũ Thị Thanh Tâm, notebook in hand, chats with another participant. Greater Hanoi, 2004. Photo: author.

PLATE 7. Carver preparing a cavity to hold the animation packet, Sơn Đồng Village, northern Vietnam, 2004. Photo: author.

PLATE 8. A ritual master prepares to seal a statue's cavity before bringing it to life, northern Vietnam, 2004. Vietnam Museum of Ethnology; photo: Vũ Thị Thanh Tâm.

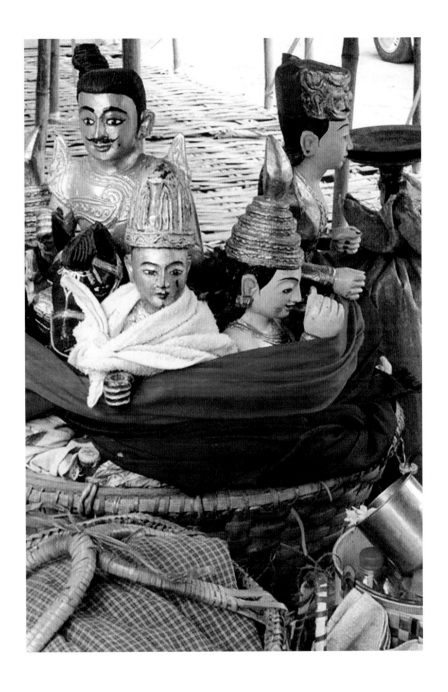

PLATE 9. *Nat* images arriving at a festival, northern Myanmar, 2011. Photo: author.

PLATE 10. A domineering Spirit Warrior eyeballs the author during a *kut,* Yangju City, South Korea, 2009. Photo: Homer Williams.

PLATE 11. Covered statue being carried from the carver's workshop to a Mother Goddess Palace where it will be ensouled, northern Vietnam, 2004. Vietnam Museum of Ethnology; photo: Vũ Thị Thanh Tâm.

PLATE 12. Old statue in a private collection. In a temple, the crumbling lacquer and dented wood would probably have been refurbished. The collector still shows his respect by burning incense, northern Vietnam, 2004. Photo: author.

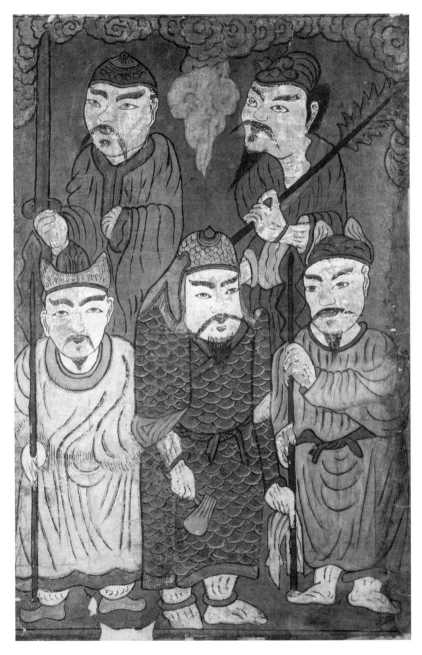

PLATE 13. Early twentieth-century rendering of the Spirit Warriors of the Five
Directions (Obang Sinjang); compare the freeform style with figure 14, a workshop
production. Museum of Shamanism; photo: Jongsung Yang.

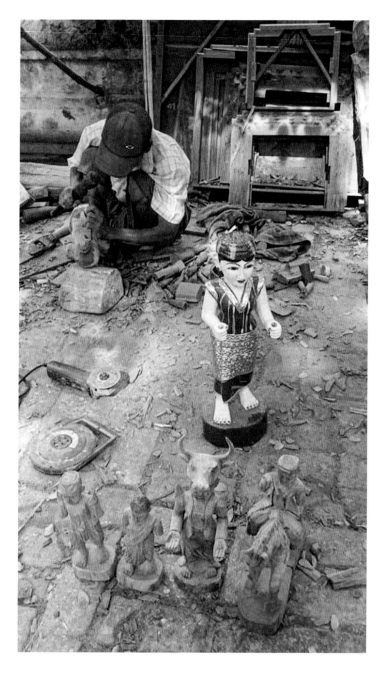

PLATE 14. Carving workshop near the Mahamuni Pagoda, Mandalay, Myanmar, 2011. Photo: author.

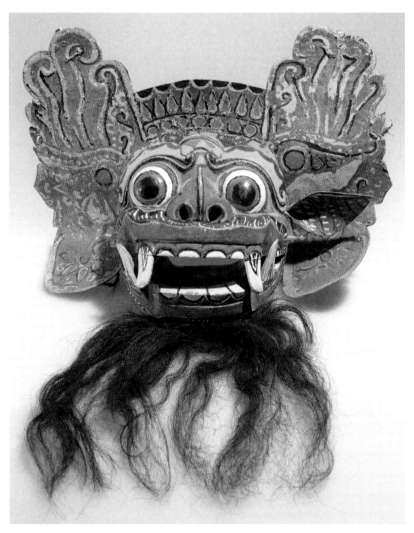

PLATE 15. Barong mask made by N. Tekek and collected by Gregory Bateson, Lod Sema, Bali, Indonesia, 1930s. Photo: American Museum of Natural History, Anthropology, 70.0/9830.

voice of a god. Failed initiates return to a cycle of prayers and austerities on distant mountains, and a new burden of anxiety over raising the money for another expensive ritual. Some try to give it all up, against the *mansin* world's understanding that they will be dogged with misfortune until they successfully receive their gods (Kendall 2009, 102–28). Initiation rituals fail for multiple possible reasons: the initiate is not ready, her calling is not sufficiently strong, her gods are not sufficiently powerful, her initiating *mansin* spirit mother is incompetent, the paintings are inappropriate and unwelcoming to the gods who want to work with the initiate. By broad analogy, liturgical practices for enlivening a statue resemble a cookbook: follow the procedures scrupulously, use good ingredients, and the result will be a soufflé, not easy but largely predictable. Missteps cause misfortune and some ritual masters, like some cooks, are simply more skilled than others at producing the best results. A *mansin*'s ability to receive her gods, by contrast, is like making a soufflé in the absence of a clear recipe and with the omnipresent possibility of high humidity troubling the egg whites or the fatal slam of an oven door collapsing the rising batter.

Recalling Atkinson's (1989, 14) distinction between liturgy and performance-centered shamanic practice, the *mansin*'s success turns on her ability to evidence an uncanny connection with powerful gods by making efficacious rituals and speaking astute divinations (*parŭn kongsu*). Although a Korean *mansin*'s world is a more orderly place than the slippery, uncertain shaman/not-quite-shamanscape that Morten Pedersen (2011, 36–37) sketches for post-Soviet northern Mongolia, his invocation of fluidity and mutability as endemic to shamanic practice could also apply to the non-fixity of a *mansin*'s engagement with things unseen. The *mansin*'s gods are not contained in statue bodies but transmit irregularly through the pictures in the shrine. In a world of Korean *mansin* practice, the gods are the most essential and sometimes arbitrary players, claiming an ordinary mortal as a *mansin* or not, powerfully inhabiting a shrine or not, staying with the painted images or departing. Even once successfully initiated, the *mansin* still operates in a domain of high ambiguity; her gods may be strong or not, they may be powerfully present in her shrine or not, they may currently favor her or not. Some *mansin* claim that other *mansin* operate a bogus practice, legible only to other *mansin* who recognize that the paintings in the shrine are inert. Gods may become angry with the *mansin* and, as in Yongsu's Mother's story, trouble her practice by denying her a clear flow of inspiration until the issue is resolved. At worst, angry gods may flee the shrine altogether, leaving silence in their wake.

A *mansin* might acquire additional gods, as Yongsu's Mother tried to do when Chatterbox retired. At a *mansin*'s final *kut* before retiring her practice, or at a *kut* held to send off her soul after her death, some gods affirm that they are willing to follow a successor *mansin* and are bundled off to new shrines. But as in Yongsu's Mother's story, old gods do not always live happily with new gods, and sometimes are taken down from the wall. Gods have also been known to operate through paintings to choose a new shaman when an old shaman persists in her practice into creaky old age. The gods might propel a destined shaman into the old shaman's shrine and set her to frantic bowing in front of the paintings, a sign that the gods are themselves signaling a transition. Or a prospective shaman might be tested during her initiation ritual, with the paintings hidden behind white paper. If her inspiration is strong, she is drawn to the spot and stands in front of the hidden paintings, urgently shaking her brass bells. Or a prospective shaman, tormented into frenzied wandering, might run to a hillside grave and dig up the cache of paintings and other paraphernalia that has been secretly buried there. In *mansin* logic, the energy of gods operating through paintings and other objects pulls the prospective shaman to the site.

A statue body containing a soul is similar to, but not the same thing as, a shaman painting which is a site of variable transmission. A spirit medium who has been taken over and animated by a god is not the same thing as a shaman who is herself an agentive presence in the encounter, engaging the gods to be vividly present. Temple masks in Bali are yet another matter, propelling the spirit medium's trance through a graphic conjoining of body and image. Here too, as in Korea, uncertainty attends the empowerment of an image.

### BALI, INDONESIA: MASK PRESENCE

In Bali, powerfully charged temple masks are inhabited by invisible entities called *niskala,* sometimes described as energies.[31] When the *niskala* conjoin with a mask, the assemblage becomes a local tutelary or *sesuhunan* whose agency tacks between demonic and divine. The lion-like Barong and fanged, demon-faced Rangda are broadly associated with Lord Siwa and his consort Uma but at the same time, specific masks in particular temples are also and most immediately identified as local tutelary gods and are given (usually Brahmin) names.[32] The genders of these *sesuhunan* are not necessarily consistent with the common expectation that the Barong is male and Rangda female. Unlike the statue body, which

is separate from the practitioner and ritually immobile, the Balinese temple mask is an intentionally kinetic object, enveloping and supplanting the medium's face as it energizes the medium's body.[33] Deity (*sesuhunan*), mask (*tapel*), and entranced body (*pemundut*) work in combination to bring forth and successfully transform dangerous forces. Hildred Geertz (2004, 73) describes the basic work of all Balinese rituals as "propitiations of potentially destructive spiritual beings; these propitiations are followed by rituals of gratitude to the beings and forces that have accepted propitiation and are willing to desist from hurting their people and to actively protect them." This is a cyclical process, marked by temple festivals where the *sesuhunan*/mask draws forth demonic forces like pus from a boil, usually through the ritual contestation between Rangda, mistress of black magic, and the lion-like healing Barong, or by performing the Calon Arang play where an aggrieved practitioner of black magic becomes a vengeful but eventually pacified and transformed Rangda experienced as a presence.[34] Performance scholar John Emigh (1996, 35, 105–25) draws a parallel between these masks and those deployed in similarly sacred, similarly Hindu performances in Orissa, India, where masks with a resonantly fanged and tongue-lolling demon iconography are also used to "contain and control—the felt presence of chthonic and, sometimes, demonic forces." David Napier (1986, 122–23), who draws an even broader comparison in the facial presence of demon-like and lion-like masks across a vast swath of Eurasia, is similarly attentive to the ever-present possibility of demonic/divine transformation. However, the impressive breadth of Napier's ambitions may, with respect to Bali, be over-driven by western notions of "good" and "evil," the one necessarily vanquishing the other. Rather, these forces or energies are considered omnipresent in shifting ascendancies.

To do their intended work, efficacious temple masks in Bali are enlivened (*idup*; Ind. *hidup*), charismatic or exalted (*berwibawa/wibawa*), and especially charged with a magical and potentially dangerous power (*tenget*).[35] In some places, the masks are considered so *tenget* that "no one who is not spiritually purified may handle them, and no one may photograph them except when they are being danced" (H. Geertz 2004, 56). Masks in some sense "contain" the potentially dangerous forces associated with and around them (Emigh 1996, 66; 1984, 31 and citing deZoete and Spies 1973 [1938], 94, 294; Ruddick 1986, 123–24). As charged and consequently dangerous things, they are themselves "contained," kept in baskets in the temple and covered with amuletic cloths in the hope that they will rest quietly there until taken up by persons with a sufficient store

of personal power (*sakti*) to engage with them. These are very different entities from the statue body openly displayed on an altar and approached by devotees as a positive and protective presence. While Rangda and the Barong are a ubiquitous presence in tourist events, on postcards, and as souvenirs all over Bali, the sacred gaze of a truly *tenget* temple mask occurs only in carefully controlled ritual settings.

Temple masks are ritually purified (*melaspas, mlaspasin/masupatin*) and then ensouled (*pasupati*).[36] Following Hindu practice, a Brahmin priest places five sacred elements (*panca dathu*) inside the mask, which act as conductors for the forces or energies that will empower it, making it a *tenget* thing.[37] The priest makes appropriate offerings and recites the appropriate mantra (*doa-doa*) to activate the process. One of our conversation partners, a priest who performs these rituals himself, described the *pasupati* as equivalent to the gas needed to make a motorbike run through an accurately connected cable: the gasoline is the offering (*upakara*), the priest is the cable that makes the connection between the mask and the divine, and the priest's performance of the correct mantra is the charge that brings the engine to life. This much should already sound familiar and this much would suffice for other Balinese masks and images that are similarly enlivened. But there is more to follow.

The process of activating a Balinese temple mask culminates in a night-keeping ritual performed in a cemetery where, at the midnight hour, the *sesuhunan* is expected to give dramatic indications of its presence and power. Angela Hobart (2003) describes the cemetery as a force-field of potentially dangerous energy where practitioners of black magic challenge and are challenged by the *tenget* forces empowering the mask and where any spectator might experience spontaneous and violent trance. "Tension builds up as the night advances. The unseen rituals in the cemetery produce an atmosphere of hushed excitement among the hundreds of onlookers settled in the darkness. The powers of the unseen realm become reality as the ritual *ngerehin* [or *ngerehan*] is carried out around midnight. This requires a person of great potency [. . .] In order to protect himself from the enormity of the prevailing power he recites *mantra pangerehin*" (147; see also Slattum and Schraub 2003, 26–27; Stephen 2001, 146–47). Fred B. Eiseman (1990b, 208) writes that "Tales are told of high priests, *pedandas,* actually falling dead while bringing an especially important and sacred mask to life" (see also Belo 1960, 98).

But as with the initiation of a Korean *mansin*, there is also anxiety as to whether the new mask will perform at all. Will it, as anticipated, explode in a ball of flame, emit a strange sound, or move of its own

accord, or will nothing happen in the end?[38] Will the *pemundut,* chosen by the *sesuhunan,* fall into deep trance, take on the mask, and run as the mask compels him, leaving no doubt as to the *sesuhunan's* presence? One veteran *pemundut* described his most memorable encounter. He was meditating in the cemetery, his eyes closed, when he "saw," in a visionary way, the Rangda mask illuminated with a great burst of light and felt it jump onto his face, and then, as willed by the mask/*sesuhunan,* he ran back to the temple. Scholar-performer I Wayan Dibia described how, as a young and newly initiated Barong dancer, he was asked to carry a new mask to the cemetery for this culminating ritual. As he approached, he felt a strange lightening of what had theretofore been an extremely heavy mask and costume body. He had a sense of his own body floating on the verge of trance. He felt that he was unready and handed the mask to another dancer, who immediately fell into trance. Dibia recalls this uncanny lightening as "the sign that an object was transformed into a sacred object. Before that, when I was on my way to the cemetery, the Barong was just a puppet, just a costume, but the spirit was not there yet. It was already blessed, but the spirit was not there yet. The body was there but the soul was not there yet."[39]

But not all midnight empowerments are equally graphic, and some explosions of light are more spectacular than others. Belo (1960), writing of events in the 1930s, records a woman in Tegaltamu enthusiastically describing the relative illuminations of newly-made masks commissioned by rival communities: flames small as a finger and shooting up to the sky, fire large as a fist, and most impressively, fire the size of a cock basket, confirming the *tenget* qualities of Tegaltamu's own Rangda mask. One mask showed no fire at all: "it was not *tenget.*" Another of Belo's conversation partners described a mask that failed to give any indication of power and had to be destroyed (75–76). The grandson of a priest who had performed many high order consecrations recalls his grandfather describing the explosion of light that he had witnessed in Sayan many years ago as truly memorable. In Balian A.'s experience, a reddish light infuses Rangda and Barong masks. Balian A. considers a small, gentle and refined (Ind. *alus*) light that flickers like fireflies as an indication of genuine power whereas in his view, mask pyrotechnics are just the *niskala* forces "showing off." A carver/priest sees different-colored lights identified with different directions and their associated deities.[40] A participant in a night-keeping ceremony for the Balinese community on Lombok describes a cascade of light rushing down a mountain, followed by the frightened disbursement of Muslims who

had been peeking at the ritual while hiding in a ditch. In a tourist area in north Bali, a night-keeping ritual failed and had to be held again because there were too many spectators in the cemetery. These are seriously spectacular events, underscoring the necessary power of the masks when deployed in a never-ending struggle against dark forces.

The expectation of fireworks injects frisson into what would, in the ensoulment of other Balinese things, be a liturgically predictable process akin to those reported for temple statues in Vietnam and Myanmar. In Bali, liturgical actions of ensoulment are (usually) necessary but not sufficient to evidence a *tenget* temple mask/*sesuhunan*. Such a mask is so dangerously powerful that in ordinary times, it is packed carefully away, a sensed but not visual presence. The night-keeping ritual suggests a higher calibration of potential danger than even the "tight security" that attends the ensouling of Vietnamese temple images. It suggests, with the Korean example above, the anxious uncertainty that can attend the "calling up" of invisible forces in some realms of ontological practice.

## CONCLUSION

In Santos-Granero's (2009b) language, the temple statues, temple masks, and god pictures that we have been considering are objects that become subjects as their material forms come to be inhabited by otherwise invisible entities, and subjects that become objects as otherwise invisible entities assume material form through the human actions and intentions that cause the fabrication of statues, paintings, and masks. As such, these things become sites of engagement governed by specific protocols which, if violated, have unfortunate consequences. Violations run the gamut from major acts of iconoclasm to minor infractions such as knocking a statue out of alignment while cleaning it or placing the images of two incompatible gods in close proximity. Stories of image agency become affirmations of the power of images as media for their inhabiting gods/spirits/entities. Ensoulment practices are broadly resonant across the region. Knowledgeable persons in Vietnam, Myanmar, and Bali (and Buddhist monks in Korea) would probably find it unusual, possibly even weird, that the animation packets for some temple statues in Southeast China include medicinal herbs and poisonous insects (Robson 2007) or even entombed birds.[41] Even so, they might understand these practices within a broad common logic; ritual experts in Vietnam and Korea might even be able to parse the links between medical ingredients and aspirations for the statue according to Sino-centric five-element medical the-

ory. They might also give a nod of recognition to how, when the tenth century "living body Śākyamuni" at Seiryōji temple in Kyoto was opened in 1953, a set of padded silk internal organs was found among some two hundred other items in the cavity. Although the installation of silken body organs was not a common practice in twentieth-century Japan, the temple monks recognized the link between the organs and the life of this statue; copies are now on exhibit at the temple but the originals were reinstalled before the statue was re-animated (Horton 2007, 26).

Korean *mansin*, who know and sometimes even approximate the eye-opening of a Buddhist image, see the habitation of the god pictures not as the consequence of a liturgical practice so much as an extension of their own mutable relationship with the gods they serve. Presence here is an ambiguous and unstable condition that hangs on the will of sometimes-petulant gods and on the precarious nature of the gods' relationship with the shaman. I might not have understood this without combining my years of acquaintance with the *mansin* world with new questions framed by a consideration of statue bodies in other places. The answers were not what I expected, but they led me to a better understanding of the *mansin*'s shrine, her work, and the ontology that informs her experience of inspiration. To return to the analogy of the cup as the vessel into which something is poured and for a while contained, then the contents of the *mansin*'s cup are vaporous stuff that sometimes condenses and sometimes evaporates completely. In Bali, the contents of the cup are a potent, roiling brew, such that its contents can be dangerous in the wrong hands; filled cups must be carefully covered up and stored away when not in immediate use. If such things are part of an animism conversation, then it must necessarily be a conversation receptive to fine-grained differences in ontology and practice.

This chapter has been concerned with the otherwise invisible content of ensouled or empowered images. In the next, we turn to the question of how such containers are made.

# Materiality, Making, and Magic

Magic is the art of preparing and mixing concoctions,
fermentations, dishes. Ingredients are chopped up, pounded,
kneaded, diluted with liquids, made into scents, drinks,
infusions, pastes, cakes, pressed into special shapes, formed
into images: they are drunk, eaten, kept as amulets, used in
fumigations. This cuisine, pharmacy, chemistry, what you
like to call it, not only causes magical materials to be
utilizable, but serves to provide them with a ritual character
which contributes in no small way to the efficacy of magic.

—Marcel Mauss, *A General Theory of Magic*

In the last chapter we saw how particular kinds of sacred images in
Vietnam, Korea, Myanmar, and Bali are understood to be made agen-
tive through roughly comparable but also interestingly discrepant proc-
esses of ensoulment. This chapter considers how the images themselves,
as containers or seats for gods/spirits/energies, are fabricated in ways
intended to prepare them for their subsequent careers through opera-
tions of magic and craft in ways consistent with Mauss's culinary meta-
phor. These are complex projects involving one or more multi-skilled
workshop artisans in places where levels of material consumption ena-
ble standards and hierarchies of value with respect to both materials
and craft. In most cases these crafts draw on, or have to some degree
internalized, the protocols for making sacred images that are contained
in religious texts (e.g., Chiu 2017; Davis 1997; Brinker 2011; Swearer
2004). Bruno Latour's (2010, 22) reflection on the fabrication of a fet-
ish by a Candomblé priest caused him to remark, "We are the offspring
of our works." The statues, masks, and paintings that we have been
considering suggest not so much that we are the offspring of our works
as that we (singular or as a devotee community) are the offspring of my/

our piety, wealth, and discernment in commissioning such works. Shoddy construction and visible decay belie these same claims. Practices which, for heuristic and comparative purposes, we might call "magic" are also integrated into the process of production and are considered consequential for the image's subsequent career as an ensouled and agentive thing. In contrast with Latour's Candomblé initiate, who personally fabricates the habitations of the gods who will reside on his altar and guide his practice, those who commission, install, and subsequently venerate sacred images in Hindu, Buddhist, and many Asian popular religious traditions are dependent on the good intentions of a workshop process that has been entrusted to other hands. The ambiguities that attend the commissioning of efficacious things are related both to understandings of how effectively such things can be expected to "work" as transmitters of divine intention and to the relative speed or slowness with which this work is overtaken and compromised by material decay, something that also adversely affects their efficacy. As Birgit Meyer (2015a, 167) reminds us, gods in material form require maintenance and care. Angela Chiu (2017, 159) describes the making of a buddha image as "not terminated with the conclusion of the consecration ceremony. The statue continues to be understood by devotees as a material object, with all of the physical strengths and weaknesses of its form; it is seen as openly vulnerable to, or even deserving of, manipulation by human agency." Practical matters of material and the working of material, insofar as they contribute to the production of an efficacious image, cannot be detached from its magical intention.

The material properties of things, Tim Ingold (2007a, 1) argues, are "processual and relational;" things become active through the manner of their production, use, and eventual deterioration (see also Ingold 2010; 2013, 21; Hallam and Ingold 2008). Image-makers who carve wood or stone, or who laminate paper and then paint on it, are entangled in this larger process of becoming and deterioration both with respect to the nature of the materials they work—the texture and durability of different woods and stones, the relative tenacities of different papers and their capacity to receive ink from a brush—and the corporeal limitations of the producer's own body to work with the tools and substances at hand (Ingold 2007b; 2010; 2013). Archaeologists and museum conservators have long been concerned with the dynamic properties of material objects transformed over time by air, earth, water, and the object's physical and chemical interactions with surrounding objects and substances. In museum conservation laboratories, objects

are "stabilized" as far as current methodologies permit, but a truly stable object is an oxymoron, and everyone understands this. Ingold's work is part of a citation circle concerned with the dynamic properties of material substances and provoked by the philosophical work of Gilles Deleuze and Félix Guattari: "How can the cosmos and Life within it exist in such a way that they are the result of change yet also be always susceptible to further change?" (Holland 2013, 53; Bennett 2010, 42; Ingold 2010, 8–10, following Deleuze and Guattari 1987 [1980], 39–74). Or as Ingold (2010, 8) puts it, "Life is open ended, its impulse is not to reach a terminus but to keep on going." Fabrication and decay are linked processes, a "keeping on going," a sign of the "vibrancy of matter" (Bennett 2010) that necessarily attends all work of fabrication and maintenance. This, of course, includes the statues, masks, and paintings that we have been discussing. Thinking with and through the material properties of things is a productive move (e.g., Drazin and Küchler 2015; Harvey et al. 2014), but as I and others have noted, Ingold's radical materialism, intended to topple and supplant the idea of object agency, elides some of the choices made by the human actors who produce and venerate sacred images and for whom questions of object agency are matters of great importance (cf. Kendall, Vũ, and Nguyễn 2010 for Vietnam; Venkatesan 2014 for India).

And where the resulting objects are intended as consequential to gods, buddhas, spirits, or occult energies, the practical and knowing choices involved in making them—however entangled with the vibrant properties of matter—cannot be collapsed into pure chemistry, biology, and geology. Ingold's (2013, 21) goal is "to place the maker as an active participant in amongst a world of active materials [. . . such that] in the process of making he 'joins forces' with them, bringing them together or splitting them apart, synthesizing and distilling, in anticipation of what might emerge." Such concerns necessarily inform a discussion of enchanted technologies. Bearing all of this in mind, we return to the MacGuffin of the piece, the three golden Mother Goddess statues gifted to the Vietnam Museum of Ethnology.

CREATING THE THREE MOTHER GODDESSES

In chapter 1, I described how, after a misunderstanding over the disposition of the spirit mediums' gift, Nguyễn Thị Thu Hương, Vũ Thị Thanh Tâm, and I went to the Tiên Hương Palace as part of a team intent on exploring the prior lives of sacred objects that were now part of the

Vietnam Museum of Ethnology's collection. Some of the people we talked with in the Tiên Hương Palace were still disturbed that the statues had been "placed on the floor" at the VME, but Ông Đồng Đức and Bà Đồng Duyên seemed pleased that we wanted to learn more about their religion. They were also eager to impress upon us the exquisite care with which the VME statues had been fabricated. Ông Đồng Đức sent us to his most trusted carver and gilder, artisans whom he had commissioned to make the VME statues. We talked with the ritual master at the Tiên Hương Palace, who explained in general terms how a statue cavity is filled with an animation packet and the image ritually enlivened. Through other contacts, as a snowballing research project, we would have conversations with more mediums, temple-keepers, and carvers, and with the dealer of a small shop who sold statues to spirit mediums on a crowded Hanoi street fairly bursting with religious paraphernalia. This project was the beginning of my education in matters related to images.

When he described the commissioning of the statues, Ông Đồng Đức emphasized that he had carefully selected the carver in the belief that only a craftsman with *tâm* (心), a craftsman with a sincere heart-mind, could produce a beautiful statue. By this, I understood him to mean that only an artisan with a deep commitment to fine craftsmanship and a sense of moral purpose in the work, a craftsman who would not cut corners in order to turn a profit, could produce a container worthy of a god. Ông Đồng Đức told us that he had been disappointed in the past when statue makers showed themselves to have lacked *tâm*. These sentiments were echoed by the couple described in the last chapter who had finally been able to replace the statues that perished in an anti-superstition campaign. Commissioning the new statues for their temple had been a serious task, for if the carver approached the work without a sincere feeling for it and the statues were badly made, misfortune would follow. Yes, they knew of instances where this had happened. Ông Đồng Thủy in Bắc Giang province told us that when he chose a carver, he looked for someone who had a harmonious family life and at least one son—in other words, a carver favored by gods and fortune.[1]

For the VME images, Ông Đồng Đức entrusted the carving to Mr. Nguyễn Bá Hạ from Sơn Đồng village, a third-generation carver who also practices as a spirit medium. I would learn through subsequent research on the Mother Goddess Religion that it was by no means unusual for a carver of statues, a seamstress who produces the mediums' costumes, or a fabricator of votive paper sculptures for *lên đồng* rituals, to be a devotee of the Mothers, or even a spirit medium who offers

periodic *lên đồng* rituals in gratitude for the continuing prosperity of their own enterprises. While many of these producers, like most *ông đồng* and *bà đồng*, perform *lên đồng* only as an act of personal devotion, Mr. Hạ is considered a master medium (*đồng thầy*) with the ability to initiate other mediums and either maintain a personal shrine or be appointed to the supervision of a major temple (Endres 2011, 132). When the artisan is also an *ông đồng* or *bà đồng*, someone who is directly accountable to the Mother Goddesses, this reassures *ông đồng* and *bà đồng* patrons that their commissions will be fulfilled with *tăm*. In this vein, Mr. Hạ describes himself as earning the trust of his customers through the honest production of high-quality products and through his careful observance of the rituals and taboos associated with his craft. He sees his work as a quasi-religious act, "doing the gods' things;" carvers must not only love their work but also have a strong moral sense of it. In his view, if carvers are not honest about the quality and price of their products, they will soon become jobless, either owing to dissatisfied customers or through divine retribution, but the Mothers and buddhas will reward a carver who performs well.[2]

Before going to meet with Ông Đồng Đức to discuss the commission for the three statues, Mr. Hạ followed his customary practice of burning incense in his private temple and asking the Buddha and the Goddesses for a good carving.[3] He petitioned the deities: "On behalf of my clients who have shown their kind hearts in intending to donate this statue and on my own behalf, I call on you to help me when I travel and so that my own family temple and the people of this village may have a happy life. I call on you to allow (client's name) to donate money to make this statue. When I return home, I will burn incense to thank you." After the mutually agreeable conclusion of Mr. Hạ's meeting with Ông Đồng Đức, the narrative thread of the story of the three gilt statues went back with Mr. Hạ to Sơn Đồng village.

In 2004, at the time of our interviews, Sơn Đồng village in Hoài Đức district, Hà Tây province near Hanoi, was basking in the revival of popular religion (figure 12). Before independence in 1954, Sơn Đồng had been a traditional craft village supplying statues and other carvings. Until the official opening of the market and liberalization of other social policies in 1986, the socialist state had regarded religious statues and temple decorations as objects of superstition and the practice of making and repairing them had nearly disappeared. Sơn Đồng households, organized into a craft cooperative, turned to producing lacquered rattan furniture for the Eastern European market. According to one carver who is now the head

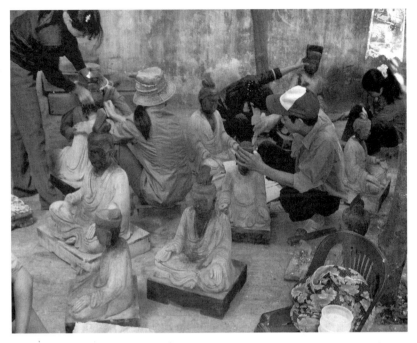

FIGURE 12. A workshop in Sơn Đồng village, northern Vietnam, 2004. Photo: author.

of a successful carving business, in the years leading up to 1986, the number of carvers in Sơn Đồng could be counted on the fingers of both hands. Even so, when the market for rattan furniture slumped in the 1980s and strictures against popular religion began to ease, the village authorities initiated a training course in statue carving including instruction in modern principles of anatomy. Mr. Nguyễn Viết Thạnh, chairman of the Sơn Đồng Wood Carvers Association and a graduate of this program, described the hand-to-mouth existence of carvers in a moment of cautious revival. He recalled the risk of harassment when he started to refurbish temple statues and woodwork in other places and sometimes had to outrun a posse. He observed that in those days, no one could have imagined present-day Sơn Đồng where, at the time of this interview in 2004, four thousand resident and one thousand non-resident workers were employed in the workshops and more than sixty percent of the income generated in this village came from carving. Since the turn toward a market economy in the late 1980s, followed by better conditions in the 1990s, village carvers have been meeting the accelerating demands of a religious revival, initially by repairing damaged statues or replacing

statues lost in the chaos of war or destroyed in anti-superstition campaigns. Overseas Vietnamese were contributing to this revival by commissioning statues for temples in their native villages. Today, amid extensive temple renovation throughout the Red River Delta, carvers also furnish the growing number of new private temples maintained by spirit mediums and Mother Goddess temples being built on the grounds of Buddhist temples to accommodate prayers for business success.

It was Ông Đồng Đức's intention that the VME statues should replicate in wood the three gilded bronze statues representing the three Mother Goddesses that/who reside in the forbidden room of the Tiên Hương Palace, the sequestered space at the far back of the main temple. He gave Mr. Hạ a photograph, as many clients do. Others give the carver only the name of the buddha or deity, usually by telephone, and the carver takes it from there, having internalized the forms of standard gods and buddhas. Absent the photograph of a prototype statue, the posture, shape, and decoration of statues varies with the carver's interpretation of recognizable forms. Some carvers of religious statues (and bronze casters modeling a prototype for the mold core) speak of a meditative discipline that enables the deity's image to take shape in their mind's eye before they begin their work, a practice I would encounter elsewhere.

Mr. Hạ assumes that his clients are motivated by some particular wish or aspiration when they commission a statue destined for an altar. In the manner of traditional carvers and carpenters, he determines the statue's height by finding an auspicious measure that will match the client's aspirations while falling within the client's spatial requirements. To illustrate, he pulled out his plastic-encased and otherwise ordinary-looking spring tape measure and showed us how it was marked in traditional Chinese units of measure (chi 尺), with particularly auspicious proportions signaled in Chinese ideographs. For example, the VME's Mother of Heaven and Mother of the Mountains and Forests are seventy-six centimeters high (including the base), a measure equated with "the palace of talent." The Mother of Water is seventy-eight centimeters high, a measure equated with the "palace of talent and good fortune." I had seen a similar tape measure a few years earlier when a VME colleague and I were trying to purchase an ancestral altar for our exhibit and a carpenter showed us how proportions of width and length were governed by auspicious measures. Identical tape measures, all mass-produced in China, were readily available from a corner shop on a street of carpenters. The plastic-encased spring metal tape measure was a contemporary incarnation of Luban's ruler (Lubanchi, 魯班尺), attributed to the Chinese

patron god of carpentry, who is said to have lived in the fifth century BCE. Luban is the author of record for a classic carpentry manual (compiled in the fifteenth century) for well-crafted and auspiciously endowed houses, furniture, and coffins, with attention to the various acts of sorcery that might also be deployed in making them (Ruitenbeek 1993). A Taiwanese image carver who had spent most of his long career carving images for temples later showed me the *Lubanchi* that had accompanied him in this work through the second half of the twentieth century and into the new millennium, a similarly marked straight wooden ruler. I would find early twentieth-century equivalents from China in the collection of the American Museum of Natural History.

A carver's integrity and experience come into play when he selects wood for the statues.[4] Wood, in the Sino-centric five-element scheme, is regarded as more energized, sacred, or efficacious (*linh*, 靈) than clay images, governed by the element "earth," which are now rarely seen.[5] Bronze statues, metal in the five-element scheme, are more *linh* than wood, and the material and casting process are significantly more expensive. Vietnamese carvers of religious statues favor jackfruit wood (*mít*), said to repel insects with its bitter taste. The material must be core wood that is not infested with woodworm and does not have knots, and the base of the tree must form the base of the statue, never the head. Before carving, a conscientious carver like Mr. Hạ also soaks the wood in white limewater as a further precaution against woodworms. Ông Đồng Đức recalled beautiful statues that were riddled with woodworms within a few years of their manufacture, one reason for not accepting statues from patrons but rather taking their cash donations and supervising the work himself. Materials vary with local circumstance, but the quality of the wood and the carver's integrity are issues among Luban's disciples in the woodworking craft well beyond Vietnam. A Taiwanese carver trained to produce temple statues described the blocks of precious sandalwood that clients would bring to the carver, stamped on the base with their own personal seal so that there could be no substitutions with inferior wood.

Mr. Hạ initiates the process of making a statue with a ritual for cutting wood (*lễ phạt mộc*, 禮伐木), choosing an auspicious day and consulting books written in Chinese ideographs which his family protected during the anti-superstition campaigns by hiding them in a deep wardrobe cabinet. Possession of these old books (which include a worn photocopy of a Sino-Vietnamese text), passed from generation to generation, is a mark of family distinction for Mr. Hạ. He told us that only his family can do these rituals with precision, while others can only

improvise, burning incense on the family altar and praying with a pure heart. Even so, any carver can determine a day favorable for cutting wood by consulting a vernacular Vietnamese translation of a lunar almanac like the one we saw in Mr. Hạ's workshop. These are hawked around temples at the Lunar New Year, and although illegal in Vietnam at the time of this research, they were as widely available in Hanoi as their equivalents in Taipei or Seoul.

Mr. Hạ describes a scrupulous practice on the day of the first cut as indicated by a lunar almanac.[6] He only allows those who have good horoscopes to participate in the ritual; anyone whose age ends with a 1, 2, 6, or 8, inauspicious horoscope years, cannot take part. Lễ phạt mộc expels ghosts or forest spirits who may have taken up residence in the old tree and whose presence would repel the god or buddha who will be invited to enter the completed statue. Ancestral altars, tablets, and couplet boards do not require this same ritual attention, only a lucky day for cutting the wood. In his invocation, Mr. Hạ asks the buddhas and Mother Goddesses to support the carvers in their work so that they will make a beautiful statue and so that there will be no accidents in the workshop.[7] When the invocation is properly made and the ritual is properly effected, he is able to focus his heart-mind such that he envisions the intended image—buddha or deity—in a mind model that enables a beautiful result. In addition to auspicious beginnings and ritually pure wood, the ritual also fosters workshop harmony. When I asked about the consequences of not doing lễ phạt mộc, Mr. Hạ mentioned workshop accidents, but he also spoke of clients who were unable to pay on delivery and police who made trouble when a statue was being transported. He recalled how a vehicle transporting a statue had gotten into an accident and rolled over, a horrifying possibility.

Because the completed statue will become an object of veneration for believers, Mr. Hạ exerts effort to make the process "as clean as possible." During the carving, he says, he keeps his workshop tidy and insists that his carvers be similarly meticulous about their personal appearance, keeping their chests covered. Out of respect for the images, he does not allow clothing to be hung above statues or over the woodpile. In the workshop, his carvers cannot curse or even mention inauspicious things such as deaths and accidents. He encourages people to tell joyful stories to raise everyone's spirits. Although women should not touch the images when they are menstruating, women sand and polish statues in the workshop and there is some uncertainty about how strictly the taboo is observed. Another Sơn Đồng carver also told me that in the

summer heat, no carver keeps his shirt on while working, not even in Mr. Hạ's workshop. The intention, at least, is there, even as a marketing point.

When the statue is complete, clients come to the workshop to inspect the work, bringing offerings and lighting incense. They petition buddhas, the Mother Goddesses, their own ancestors, and the Earth God, asking permission to bring the statues home on an appropriate day according to the lunar calendar. When the VME statues had been completed to Ông Đồng Đức's satisfaction, Mr. Hạ brought the unpainted statues to the Tiên Hương Palace, allowing Ông Đồng Đức, as the client, to choose an auspicious day and hour to accept them. As is proper for statues in motion outside of temples, the three Mother Goddesses traveled under red cloths (plate 11).

While Ông Đồng Đức believed that the carvers from Sơn Đồng make the most beautiful and youthful-looking statues, he felt that the carvers from Nam Định province did the best lacquer work. He selected Mr. Đỗ Đăng Toán to come to the Palace and paint the three Mother Goddesses. Mr. Toán had filled many commissions for Ông Đồng Đức and, like Mr. Hạ, he is the child of a family of statue-makers in a community known for this craft. During the ban on statue production, artisan households in his village produced lacquer boxes and trays for export and eventually, for the tourist market. As in Sơn Đồng, they began to receive sporadic orders for statue restoration in the early 1980s, a few years before the official proclamation of economic reforms (đổi mới) and general loosening of social strictures in 1986. They were now accommodating a large demand. When he introduced us to Mr. Toán, Ông Đồng Đức spoke of the importance of trust in his relationship with an artisan, particularly when, as in the case of the three Mother Goddess statues, the artisan's work includes the application of pure gold. Although he did not describe the same range of rituals that Mr. Hạ performs, Mr. Toán and his entire family observe a prohibition on dog meat, and when he is applying the final layer of lacquer to a statue, he abstains from garlic and strong-smelling herbs. He describes himself as having an affinity (duyên) for this work and believes that without this quality, an artisan cannot produce successful statues. With the gold and colored paint skillfully applied, the story of the three VME Mother Goddess statues now diverges from the standard biography of a temple statue. The VME statues were not ritually set in place on the altar, they did not have precious materials, colored string, and amulets installed inside them, they were not enlivened with the Mothers' presence, and

they did not have their senses awakened. But if ensoulment had been Ông Đồng Đức's intention, the statues of the three Mothers would have been ready.

## CRAFT AND THE CRAFT OF MAGIC

As with Mauss's alchemists—preparing and mixing concoctions, fermenting, chopping, kneading, and diluting with liquids—master carvers like Mr. Hạ operate with a skilled and knowing hand and use multiple ingredients. Carver and patron are concerned with the quality of the wood grain, the proper seasoning of the wood, and the carver's own good work. But as Mr. Hạ has described his practice, his workshop also harkens back to a long Sino-centric tradition of woodworking craft that deploys technologies of person, time, and space—magic, if you will—to determine auspicious proportions, set lucky days, and foster harmonious interactions as part of the production of a significant work. His workshop operation recalls Malinowski's (1954) Trobriand canoe builders, who likewise combined skill and magic to counter the uncertainty and danger of long ocean voyages but also for the magical work of enchanting a Kula partner (Gell 2010 [1992], 468). Where Malinowski assumed that modern navigational technology would displace magic in the construction of ocean-going canoes, carvers like Mr. Hạ have outlived modernity's teleology, growing up in a world conversant with science, cosmopolitan medicine, and Marxist materialism. Even so, life uncertainties persist in ways that continue to stoke the practice of popular religion. In Mr. Hạ's own practice, accidents happen, clients turn up short of cash, and local authorities make trouble. All of this is also implicated in the larger project of producing a temple image that is efficacious, a *linh* image inhabited by a god whose devotees petition against all manner of unpredictable turns of fortune. Magical knowledge—of lucky days, horoscopes, workshop protocols, taboos and small acts of devotion—comes braided with a deep understanding of materials and skilled craftsmanship. This amalgam yields a *linh* statue vested with something very much like Benjamin's (1969) aura, attending the object uniquely produced in a ritualized setting even when, as in this instance, it is produced to type.

But in the swelling market for ritual goods in contemporary Vietnam, many carving workshops, in Sơn Đồng and elsewhere, are knocking out statues under regimes of rationalized production, offering readymade products of dubious quality for sale off the shelves of their own

workshops or in the shops on Hanoi's Hàng Quạt Street. Dealers, carvers, and some spirit mediums recognize a clear distinction between statues mass produced for the market (*hàng chợ*) with little attention to quality or tradition, statues made to order (*hàng đặt)* which can be commissioned through the shops but are better quality than the mass produced statues on the shelves, and statues made according to old and authentic processes (*hàng thật*). Inexpensive readymade statues are produced with little attention to lucky days, workshop taboos, or—a persistent complaint—the quality of the materials the carvers use. A shopkeeper whose shelves were filled with cheaper goods told us that statues made by traditional processes are the most *linh* of all, and far and away the most expensive. In other words, the more auratic the statue's production, in Benjamin's sense, the more valuable the commodity; at the high end of the price hierarchy, commodity value is itself elided with a language of offerings and religious service as we shall also encounter in other places.

Do these auratic qualities continue to matter in an expanding market of less expensive goods? My Vietnamese colleagues and I asked several carvers, mediums, and temple-keepers in conversations that were haunted by the specter of Walter Benjamin. Old mediums described the ready-made images as appealing to young mediums who are less knowledgeable about choosing lucky days or less cognizant of the difference between core wood and less durable branch wood. Some mediums are inclined to see the ritual master's work of ensoulment as the solitary act that turns the statue into a god regardless of the quality of the statue's fabrication or the carver's attention to lucky days and small offerings. As we have already seen, established mediums and temple-keepers consider this a sloppy and dangerous practice. Readymade statues will quickly decay and, in the words of the late Ông Đồng Thịnh of Linh Tiêu Bảo Điện temple, such statues "often bring bad luck." Several of the mediums we spoke with described the care they had taken to choose a good master carver, in one temple-keeper's words "the man whose hand touches the wood in the *lễ phạt mộc* ritual," and described their own careful supervision of the carving process, all of this regarded as an aspect of their service to the Mothers. The orchestration of production and the setting of lucky days also mattered to a bronze caster we spoke to who, like traditionalist carvers, engages in a meditative process, in his case to model the prototype that will be the core of his casting model. When he casts monumental statues of Ho Chi Minh and other national heroes, he uses a standard plaster image as his prototype for the core,

but in his view, the resulting statue is relatively less *linh* than the one cast from a prototype first seen in his mind's eye. Even so, he described how statues made for civic display have amulets installed inside them, receive a quiet ritual ensoulment, and subsequently preside over civic sites where incense is burned and small offerings are set down.

Mass-produced porcelain images of gods appear in shops selling ritual paraphernalia, and some spirit mediums include them on their altars. Ritual Master Thuy considers such images as vacated of any *linh* potential through the process of high firing. The image is, in effect, "already burned," as an old statue might be cremated at the end of its career. Ritual Master Thuy considers porcelain-casting "a modern technology, not a traditional one," in effect a work of mechanical reproduction and not appropriate for sacred practices. In his term, it is not *linh*. He was pleased to learn that an early twentieth-century German Jewish Marxist philosopher might have agreed with him.

I wanted to know whether, in the broadest sense, the beauty of a well-crafted statue contributed to its *linh* qualities. Ông Đồng Đức had chosen Mr. Hạ and Mr. Toán because their combined work would yield a beautiful statue: the former was a skilled carver who used quality woods and knew from life experience in a family workshop just how to work them and the latter, similarly family-trained, was skilled in applying multiple layers of lacquer and gold leaf for a glowing and durable result. Beauty had been Ông Đồng Đức's stated objective when he described giving these men his commission, but when we asked if the Mothers were particularly attracted to beautiful statues, Mr. Hạ gave a more ambiguous reply. He told us that if the Mothers favored more beautiful images, this would mean that the Mothers favored the rich, who could commission more expensive statues, and the Mothers were not like that. But in almost his next breath, he criticized the careless carvers who make ugly statues that do not have the same sense of presence and consequently are less *linh*. The bronze-caster felt that a god would be more inclined to inhabit a beautiful statue and that when devotees gazed upon a beautiful statue, they sensed the presence of the god inside. A spirit medium felt that the beauty of the statue was irrelevant to the gods, a matter of appearance, not substance, "but beautiful images make the temple more beautiful, and as a result, devotees are drawn to it." In other words, aesthetic agency, as presented in the work of Freedberg (1989), Gell (1998) and Morgan (2010), is not out of place here even alongside the more literal agency of gods inhabiting statues. Jean-Pierre Warnier's (2009) definition of technology as "efficacious actions" per-

formed on something offers a bridge across the divide between considerations of agentive objects embedded in social relationships, including relationships with gods and buddhas, and things that come into being through material properties and processes. Actions performed in workshops are intended to make an efficacious product both through the deployment of minor magic—lucky days, prohibitions, offerings—and the deployment of skill in crafting a statue that will please a god. In this process, some aspects of "skill" and "magical intention" congeal in a single activity.

The statue body, like its human counterpart, deteriorates with time (plate 12). Good craftsmanship averts a precipitous and consequently inauspicious decline, an infestation of bugs or a premature rot, but even well-made statues eventually require repair and a fresh application of lacquer, the more so when, in Vietnam, statues that had been stored in the back rooms of abandoned or repurposed temples could once again preside from active altars and when religious communities had the wherewithal to make them whole and shiny. If the statue is to be repaired and re-lacquered, the temple-keeper divines with a toss of coins that the deity is willing to temporarily leave the altar. The statue would be de-animated in broad daylight as an inversion of its original midnight ensoulment. The midnight ritual ensoulment would be repeated after the repair. The de-activated statue is temporarily not a god, but it is something more than a block of carved wood, and statues sent out for repair travel to and from the workshop under red cloths for protection. Some temple-keepers, guarding against both shoddy work and possible sorcery, have the carver do the repairs in their own temples.[8] Statues that have deteriorated beyond repair are de-animated and carefully disposed of in a final acknowledgment of the statue body as extraordinary matter.

KOREA: PAPER SKIN

Korean god pictures are not durable statue containers but rather brightly-colored portraits that hang above the altar, seats that the gods are invited to enter, although they do so only when they are fully inclined, and stay only if it suits them. The paper mount is itself a fragile, mutable thing. God pictures become soiled with incense and candle smoke and are sometimes gnawed on by bugs and mice. In the Hwanghae tradition carried to Incheon and Seoul from Northwest Korea, *mansin* would fold up their paintings and carry them to *kut* much as Burmese *nat kadaw* carry their images to festivals and ritual performances; over

time, the paintings would tear along the creases. In these more affluent times, Hwanghae *mansin* keep one set of paintings in their personal shrine and an alternate set for *kut* so that they do not have to take down, fold up, unfurl, hang up, and take down again for every *kut*.[9] Gods in the *mansin* world prefer pure, clean things and when a *mansin* can afford to replace dirty and tattered paintings, she politely petitions her gods to leave the old god pictures. She takes the images down from the wall, burns them as a purifying means of disposal, and replaces them with fresh new ones, welcoming back the gods with appropriate ceremony. If a *mansin* retires without a successor, she buries her paintings with the rest of her paraphernalia in a mountain grave, to rot away as human bodies do, because the paintings once had souls (*yŏng*, 靈). The *mansin* Yongsu's Mother told me, "We do this just as we do for people who die." Where well-crafted and expensive statues in the Mother Goddess Religion of Vietnam are tenderly repaired, Korean god pictures are, in effect, shed and replaced like an old skin. Even so, the most traditional painters will speak of using quality mulberry paper (*hanji*) for their work and lament the declining availability of pure Korean handmade paper.

Given this assumed impermanence, how important is the crafting of the painting? At first blush, not very. Since the 1970s, most god pictures have been produced in rationalized workshops by trained commercial artists who follow standard prototypes, which many of them have internalized so well that they can reproduce gods from memory. Some workshop painters work with patterns (*pon*) copied onto thin mulberry paper and laminated onto several thicker sheets. Some copy images of old paintings from scholarly texts, a practice that can easily slide into art market fakery (Chang 1994; Petersen 2008; Yoon 1994b). Yul Soo Yoon showed me a bundle of paintings from a 1970s workshop that he had acquired for the collection of the Gahoe Museum. The paintings were all meant to represent the Spirit Warriors of the Five Directions (*Obang Sinjang*) in different states of completion that suggested how several different hands had been employed for different stages of the work, an approximation of an assembly line production (figures 13 and 14; cf. plate 13).

When I did my first fieldwork in the Kyŏnggi countryside in the late 1970s, most of the shrines I saw contained cheap colored print reproductions of painted god pictures. I had already encountered the prints a few years earlier when, as a Peace Corps volunteer, I had become intrigued by the (to me) mysterious contents of shaman supply shops (*manmulsang*). At the time, the brightly colored images reminded me of the acid

rock posters I had so recently used to decorate my dorm room walls. They were cheap, less than a US dollar apiece, and I bought and used some decoratively until I realized that they made my Korean acquaintances uneasy. In the poorer Korea of that time, these mechanically reproduced prints enabled new *mansin* to install images in their shrines where in the recent past, they would have used strips of paper inscribed with the gods' names until they could afford real paintings, much as temporary paper strips substitute for wooden ancestor tablets. In the new millennium, the production and circulation of god pictures changed again when conservatory-trained painters from China's Korean autonomous region began to flood the market with their work, underselling the workshop painters who were disappearing for lack of commissions.[10]

While the production of god pictures was likely always a commissioned enterprise, commercial workshop production altered the terms through which such a transaction was enacted and understood. Cho Yong-ja, a *mansin* in Yangju, north of Seoul, elderly and respected at the time of her 1960s interview with folklorist Chang Chu-gŭn, described how, in 1932, she went to Pongwŏn temple in the West Ward of Seoul and commissioned her paintings from a certain "Mr. Cho," an elderly "goldfish monk" (*kŭmŏ sŭnim*), a monk painter who produced both Buddhist and shamanic images (Chang 1994). At the time, goldfish monks were the primary suppliers of paintings for *mansin* in the Seoul tradition (Yoon 1994b, 16, 20). In Mansin Cho's words, "That old monk did a very good job of painting god pictures. He would paint for a sack (*mal*) of white rice per painting. The rice was so that before he began the painting, he could make offerings (*kongyang*) to Buddha" (Chang 1994, H). The visit to a temple with a bag of rice as a ritual offering, the exchange performed in the idiom of a ritual act, seems far removed from late twentieth-century workshop production and the mechanical reproduction of colored prints. Martin Petersen's (2008) study of a contemporary workshop describes god pictures produced with no attention to purification, workshop taboos, horoscopes, and lucky days, although these concerns are as well-established in many domains of Korean ritual practice as they are in Vietnam. A proprietor told Petersen that the paintings were "just commodities" (*sangp'um*) until various procedures had been performed on them by the shamans themselves (225), attitudes not unknown in Vietnam, as we have already seen.

At face value, the shaman supply shop provides standard services, brokering between the client and the workshop or simply selling the client ready-made paintings from the shop's own stock. It is not difficult to find the proprietor of a shaman supply shop who describes his or her

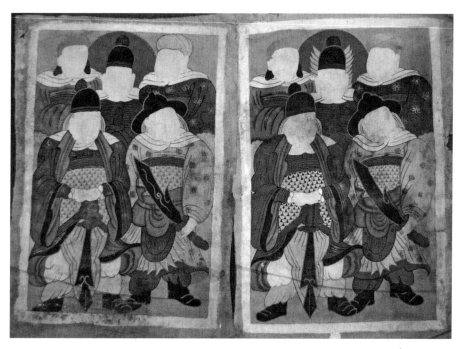

FIGURE 13. These incomplete late twentieth-century renderings of the Spirit Warriors of the Five Directions (Obang Sinjang) suggest that as in European Renaissance ateliers, the most skilled painters applied facial and other details at the end of the process. Compare with the completed painting in Figure 14. Gahoe Museum; photo: Yul Soo Yoon.

work as "just a business" or someone in the shaman world who describes the shops as "all alike," a standardized service such that it makes no difference where one buys one's paintings, because these are commodities whose auras are pending. However, on the recommendations of two old acquaintances in the *mansin* world, I met two shop owners who described their work in ways that recalled Mr. Ha's notion of "doing the gods' things" or the activities of those Vietnamese providers of sacred goods who have a personal toehold in popular religious practice. Both proprietors claimed that they had a special spiritual connection that enabled them to do this work, that sacred commerce was their own way of serving the gods.

The Righteous Town Manmul is Yongsu's Mother's regular supplier, and she and the middle-aged proprietor have a relationship of mutual respect. Not only does he have a solid knowledge of the gods and gods' personalities, he understands his regular clients as having particularly

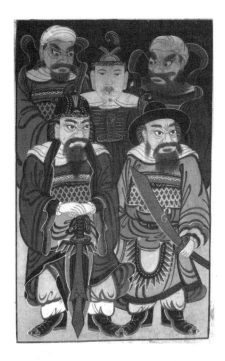

FIGURE 14. Workshop painting of the Spirit Warriors of the Five Directions (Obang Sinjang). Compare this standardized late twentieth-century work with the more freeform early twentieth-century painting in plate 13. Photo: American Museum of Natural History, Anthropology 70.3/ 6717.

strong associations with certain gods, just as he might know the composition of their immediate families. As the liaison between the shaman and the painters, he is particularly concerned that the commissioned painting should match not just his sample-book prototype of a Mountain God or a General, but the correct subcategory of god indicated by minor variations in the *mansin*'s sighting of the god. Was the tiger that the initiate saw with the Mountain God yellow or white? Was the General's arm raised or lowered? "If the god appeared in an ice blue robe, then it has to be ice blue in the painting, right? If the god appeared wearing a white vest, then it has to be painted that way, and, if it was a floral pattern, then it should be painted that way." He feels that contemporary Spirit Mothers, shamans who initiate and mentor apprentices, are careless when they instruct a spirit daughter. By contrast, he describes his own practice of sitting patiently with a client until he is satisfied that he understands what they saw in a dream or a vision and that the order he transfers to a painter is correct. As one might expect, the proprietor of the Righteous Town Manmul contrasts his own exacting approach to the commercialism of most others in this business: "In other places they're only trying to make a living, but people like me see

it another way. The painting is something that a new shaman is going to venerate, the one she will be looking at her whole life long, so I go to a great deal of effort to see that it is just right. . . . If the gods are angry . . . then it upsets me too, and that's why I am so exacting." Yes, he admits, his shop also carries the inexpensive works of the Korean-Chinese painters, goods necessary for the survival of his business because most new shamans cannot afford the more expensive commissioned works. But he tells us that the influx of these works and the desperate straits of more traditional painters "really makes my blood boil."

I received an introduction to the South Bank Manmul from the keeper of an old Seoul shrine I had known for many years, who said that this was the only *manmulsang* that she considered reliable. She described the proprietress as grounded in the shaman world, someone like herself and like the musicians who play at *kut,* people who have ties to the gods without being initiated as *mansin.*[11] The South Bank Manmul proprietress describes herself as a destined *mansin* who has successfully avoided this fate by serving the spirits through her business. Her husband is a musician who performs at *kut* and other events when he is not helping her with their very busy shop. The couple serve the gods faithfully with monthly offerings and sponsor *kut.* They recognize that their sense of accountability to the gods they serve is part of their appeal to their shaman clientele. The proprietress pointed to the curtained-off back of her shop, a private space, and said that many of her *mansin* customers regard her as their trusted confidante, the *mansin*'s *mansin.* Like the proprietor of the Righteous Town Manmul, the owners of the South Bank Manmul distinguish themselves from those who do this work "only to make money," who might even be Christian. Yes, the South Bank Manmul also carries paintings produced in bulk by the Korean-Chinese painters because "people ask for them," but the couple holds to the belief that a custom-ordered painting that accurately replicates the *mansin*'s vision of her god is more likely to be efficacious than a readymade production. And like the proprietor of the Righteous Town Manmul, they also express concern that spirit mothers often do not give initiates adequate guidance in these matters. This opinion matches a frequently articulated complaint in the Korean shaman world that the Spirit Mothers and Fathers who are initiating apprentices "these days" are not themselves sufficiently knowledgeable or inspired to be good mentors and are greedy to mount costly initiations before the initiate is ready to receive her gods (Kendall 2009, 102–28). In the view from South Bank Manmul, a spirit mother should have the wisdom to tell an

initiate to pray first and seek a clear vision of her gods before buying and installing god pictures.

Proprietors of the two *manmulsang* share the broad consensus that, just as workshop painters supplanted monks and visionaries, workshop painters are themselves being driven out of business by the Korean-Chinese painters who undersell them. Even so, the owners of the Righteous Town Manmul and the South Bank Manmul both claimed that some (or in the former case, "all") of the painters they work with have a particular spiritual connection to the gods (*yŏngi innŭn saram,* 靈氣 있는 사람) which makes their paintings particularly efficacious. I met Kim Hwabaek ("Kim the Painter") through the South Bank Manmul proprietress, who described him as exceptional among contemporary painters of god pictures, a painter energized by gods, who has their energy (*singi,* 신기, 神氣). She also mentioned that he might be difficult to meet because he does his work in seclusion, like a monk. I was lucky enough to catch him between commissions. In early middle age and with a bohemian flair, Kim Hwabaek does both Buddhist painting and paintings for *mansin* in the Seoul tradition, as did the old goldfish monks. Although painting god pictures was not, for him, a family tradition, he had sensed the force of temple iconography from his early childhood. Later, as an art student, he found part-time work with a painter of Buddhist and shaman paintings and took to it, something he sees as a karmic connection (*inyŏn,* 인연, 因緣). He makes no claims to being a visionary but he does have a sense of his own uncanny ability (*sint'ongryŏk,* 신통력, 神通力) to paint the gods' images.

Kim Hwabaek describes himself as "half a monk" (*pan sŭnim*), recalling a tradition of temple painters who first bathed, then chanted sutras and prayed before beginning their work. Before painting, he likewise bathes and then goes to pray in a temple where he puts his palms together and makes a slight bow, saying, "Now I am ready to begin." He claims to pray earnestly throughout the work and returns to the temple at the end to report, "And now I have finished." He describes traditional taboos that a painter should observe while working on a painting, including no marital relations and no meat. The painter should bathe and pray in order to work with a clean body and mind. Some painters go to temples to paint in an appropriately pure and quiet place, but he isolates himself in a small mountainside studio. To illustrate the seriousness with which a painter is enjoined to purity, he described an incident in the distant past when, through a misunderstanding, he accepted a friend's invitation to a dog meat restaurant. Horrified at what he had consumed,

a polluting substance that shamans also avoid, he felt himself teetering on the brink of madness. Only when he had returned home, torn off his clothing, bathed, laundered the clothes, and visited a barbershop as acts of purification did he feel that he could resume painting with a clean and settled mind. When he is working, he does not go outside, for fear of seeing something inauspicious or unsettling such as a traffic accident or a brawl. Kim Hwabaek feels a sense of protection from his completed paintings, which he delivers over great distances on his motorbike without a serious mishap. This is in contrast with those who regard the still uninstalled paintings as "just commodities."

I met the second painter, An Chŏng-mo, through folklorist Jongsung Yang when we worked together on researching Korean god pictures. Mr. An is probably the best-known living painter of god pictures in Korea. Shamans in the Hwanghae tradition consider the ownership of paintings from the An family as a mark of personal distinction. Mr. An grew up in a milieu of *mansin* practice; his father, An Sŭng-sam, was a skillful sculptor of flower decorations for *kut* and his mother was a shaman, but Mr. An credits an older Hwanghae painter, Pak Yong-gil, as his primary teacher. Traditional Hwanghae painters only paint for *mansin,* and indeed it would be difficult to imagine their bold, cartoon-like images hanging in a Buddhist temple. The abundant and continual induction of gods into the personal pantheons of *mansin* keeps Mr. An busy with orders for paintings, and I learned from interviews with some Hwanghae shamans that he is often overbooked. Superficially, Mr. An's work resembles other god pictures in Hwanghae style for sale in a *man-mulsang,* but he and his wife encouraged us to look closely at the individual images. They maintained that if one looks at Mr. An's paintings with a knowing eye, one sees an exact resemblance to a particular god (or a known ancestor transformed into a god), and that if one carefully examines a hundred of his paintings, none of them will be identical. Does Mr. An have a spiritual connection to do this painting? He modestly brushed the question off, but his wife rose to the occasion:

> You can't say this gentleman does not have some divine connection [*yŏng*]. If he's painting and inadvertently leaves a spot on the painting, right on the cheek, then, when the client comes to examine it, she says that her spirit mother had a mole on her face in that very same place! But he didn't know that. The mark was there because a drop of paint had fallen onto the painting. That's the kind of thing that happens. You can't say that spirits [*yŏng*] don't have something to do with it.

While Mr. An emphasizes his own skill and experience, he does not deny that there is something uncanny about his work. In this tradition, dead shaman teachers frequently enter the pantheons of their followers, and although Mr. An may never have met these people in life, he claims that *mansin* sometimes burst into tears at the uncanny resemblance when they come to collect the paintings.

> "Uncle, how were you able to make it come out like that?" I don't know. I just paint them, and that's how they come out. If you print them out on a machine, they're all very pretty, but they are all exactly alike. You can't call that painting.

Mr. An also describes a careful practice of sitting with a *mansin* client and asking her to describe the deceased teacher or the god seen in a vision. Like the owner of the Righteous Town Manmul, he is concerned with the accuracy of the representation, something he attributes to his deep understanding of a complex tradition:

> I wasn't even twenty years old when I started painting them, following my teacher. Which General rides this kind of mount and which General rides that kind of mount? Ordinary people, some shamans, they use a painting with a black horse for someone who is supposed to be riding a red horse. They don't know what they are doing. But for those of us who follow the traditional precedents, if it's General Im Kyŏngŏp, he rides a white horse with black spots. If it's the National Protector General, the horse is red. The Generals all ride different horses, and this distinguishes them. The painters today look at our things, but they just paint any old way. It isn't that they aren't good [skilled] painters, but, if you follow the tradition that has been passed down to us, a god who rides a black horse should ride a black horse in the painting. . . . Some so-called shamans might think that these less expensive paintings are fine, but they are useless [because] the *mansin* doesn't feel anything [*yŏnggami an onda,* 靈感이 안온다].

Like Kim Hwabaek, Mr. An approaches his painting in a state of purification, bathing before beginning a major commission, and avoids contact with polluting substances or events. When working on a painting, he refrains from eating "bloody food" (meat and fish), which used to leave him feeling shaken up and ill at ease. He avoids houses of mourning and does not paint if someone has died in the neighborhood or if there has been a birth. Here he admits that living in an apartment building, he is less aware of births and deaths in neighbor households than he would have been in a village or in the low-rise urban neighborhoods of decades past. He says that he rarely goes out because his temperance

and dietary restrictions limit his social life; he describes himself as living simply and quietly, focusing his heart-mind (*sim*, 심, 心) on his work.[12]

The painters and those *mansin* who expressed pride in commissioning careful work, then, describe a process of painter and *mansin* sitting together, the *mansin* recounting her own vision of the deity who will inhabit her shrine, the painter intently focusing on the description until he can see the god in his own mind's eye and reproduce it through intense, concentrated effort. This is particularly important in the Hwanghae tradition where shamans emphasize a multiplicity of gods, including gods who were once living teachers (*sŏngsu*), whose unique characteristics can only be manifest in a hand-drawn painting. According to a *mansin* who includes General Douglas MacArthur in her pantheon, a painter needs spiritual energy (*singi*) to make the face of each Guardian God in each *mansin*'s pantheon distinctive. *Her* General MacArthur, the image in the painting above her altar, has a different face from the face of MacArthur's commemorative statue in Incheon or in his photograph. *Her* General MacArthur, in US military uniform and with his iconic pipe, has the face that appeared to her in a dream, a face that would be different from the face of another *mansin*'s General MacArthur. A male *mansin* described how painters must have "divine energy from the gods" (*sinŭi sillyŏk*, 神의 神力). If they paint from a pattern, as is common today even for some painters of Hwanghae-style paintings, "it's someone else's divine energy that produced the original image [and it does not transfer]. The Guardian Gods' faces should all be different as they are in Mr. An's paintings." *Mansin* Sŏ described the careful process of conveying her vision of the god to the painter and through the painter to the painting itself:

> After I describe the god that I have seen, then we discuss it together and reach an agreement. I say that the god I saw had these clothes, this kind of hair, that sort of appearance. . . . We need absolute agreement. . . . We must share an understanding about just which god has appeared. What the painter says [identifying the god] has to be exactly what I intend: 'That's exactly it. It's exactly that god.' The painter has to be of like mind with the shaman. . . . If the shaman does her part properly and the painter does his, then the god will have a compatible relationship with the shaman. If not, the shaman will suffer a severe punishment.

Other conversation partners also emphasized the importance of the relationship between shamans, gods, and painters. A painter who did god pictures to supplement his usual work on Buddhist paintings praised the work of the An family painters: "If the shaman has a good relation-

ship with the painter, then the gods will come out when she has her initiation *kut*. With the An family's paintings, the gods come out sixty percent of the time." A failed painting, he said, has consequences not only for the shaman but for the painter as well. The keeper of a commercial shrine with a long history carefully selected the painter who would reproduce one of the valuable old paintings in her care so that she could keep the original in a safer place away from potential thieves. She selected a male shaman [*paksu mansin*] whose gods were "very high" and who was also a skilled painter, because "Those with high gods can converse with high gods." The Incheon General, who venerates General MacArthur, admitted to buying some of her paintings through the *manmulsang* because Mr. An was so often overbooked, but insisted that even with this compromise, the painter must have divine energy and observe workshop taboos. She said that she can tell when she examines a commissioned painting whether or not it will be efficacious. Mansin Sŏ is similarly exacting:

> It becomes beautiful only when the maker puts his entire soul [*hon*, 魂] into making it, makes all the right preparations, approaches it with the utmost sincerity, then it is beautiful. . . . If the painter has not poured his soul into it, then it isn't the least bit beautiful, and I won't buy it. But if it has been exquisitely made, then I will take it. To make it beautiful [the painter] has to pray zealously to the gods. . . . Mr. An produces paintings that souls [*yŏng*] enter, that gods [*sin*] enter. Art students and commercial painters may be less expensive, but you can't really say that the gods have gone into their paintings. They are nothing more than ordinary paintings. . . . I would never use them.

And yet, even as she described her own exacting standards for paintings, Mansin Sŏ maintained that "it is the shaman who calls the soul (*yŏng*) into the painting," much as Yongsu's Mother had described the process to my initial confusion. The gods are there when the initiate is able to see them in the paintings. Despite her own contempt for inferior images, Mansin Sŏ acknowledged that it is possible for an empowered *mansin* to use paintings produced by art students and commercial artists—indeed, "it is even possible to hold a conversation with a photograph—a person with a divine calling can do it, but first you have to welcome [*maji*] the gods." This is a useful reminder that agency can flow in at least two directions, as when Christopher Pinney (2017, 147) describes the sacralizing devotional acts that villagers in central India invest in cheap colored prints: "Villagers have no conception and no emotional investment in the 'materials artists manipulate,' since

without the devotee's creative input the images do not function properly. Like the *'Slashed' Rokeby Venus* . . . villagers produce infinitely more powerful images than the original artists ever managed" (Pinney 2017, 147, citing Gell 1998, 63–65). The power comes from accretions of devotion over time. Several scholars of material religion, including Pinney (2004), have already made claims for the auratic properties of prints, photographs, and reproductions (e.g., Freedberg 1989, 124; Morgan 1999; Morris 2000, 2009; Orsi 2005, 56). The debates witnessed in this chapter affirm that such a conversation is a matter of living practice well beyond the academy.

Mansin Sŏ places greatest emphasis on the intensity of the shaman's own prayers and the strength of her connection to the god; the shaman's reception of the painting is ultimately of far greater importance than the question of whether or not the painter has observed a pollution taboo. "Because there might be some misfortune, because the disciple could receive some fearsome punishment, lose her sight, become a cripple, die, you absolutely have to call the god into the painting [*hwan pullim*] and do it well."[13] Kim Hwabaek, when asked whether there were consequences if the painter did not paint in a ritually clean state, replied in a similar vein: "From long ago, the most important thing is what the client does with the painting and not what the painter does. The person who takes the paintings has to venerate them well, although the painter is still important. It's like raising a child; the teaching is more important than the birth itself." This makes sense in a tradition where a great deal of agentive power is vested in the *mansin* herself, but agentive power is also relative from *mansin* to *mansin* (see chapter 4).

Against the contrast between a statue container and a more mutably empowered painting, there are notable points of resonance in the production of sacred images, the purity of purpose and behavior enjoined on the carver or painter, the necessity of a dedicated heart-mind, and the careful visualization of the god. Similar practices may be the common legacy of Mahayana Buddhist traditions where image production and veneration were prominent components in the religion's expansion to and beyond China. In the foregoing accounts of image production in contemporary Vietnam and South Korea, we also see a tension between old methods, meant to be auratic in their consequences, and the near ubiquitousness of commoditized production. But images produced through these rationalized processes should not be mistaken for the products of a disenchanted world. If that were the case, temple statues and god pictures would not

exist at all, or would exist as decorative art only. Rather, those who use these works of rationalized production, even in the case of printed Korean god pictures, hew to the expedient belief that ensoulment happens independent of and subsequent to their making, that the work of the *mansin* in Korea or the ritual master in Vietnam is ultimately the most consequential factor. In Vietnam, statues are regarded as more efficacious/empowered (*linh*) than prints or paintings, and many mediums can now afford the mass-market statues for their personal shrines. The colored prints that I encountered in South Korea are the most extreme example of a mechanically reproduced sacred commodity among my four cases, but these seem to be less common today than they were in the poorer rural world I encountered in the 1970s. Cheap mass-produced paintings, however, dominate the market, and the future of traditional painters seems tenuous indeed, so much so that there is even talk of designating their skill as a new genre of national Intangible Heritage (*muhyŏng munhwa jae*, 무형문화재, 無形文化財) with a painter appointed by government committee as an official Heritage Bearer (*poyuja*, 보유자, 保有者).[14] And yet, in both Vietnam and South Korea, some practitioners continue to favor the older and costlier means of production, the mingling of magic and skill that they regard as yielding a more efficacious product. In a diversifying market, such a choice is also a mark of distinction for their own practice.

## MYANMAR: MATERIAL CONTRAST

When I visited Myanmar in the summer of 2011 with Erin Hasinoff, I expected image production to have many parallels with Vietnam, as in both places spirit mediums use ensouled statues, most of them carved from wood. Myanmar meant a step from the Mahayana into the Theravada world and into a different ritual calendar and horoscope scheme organized by a different cosmology, but much else seemed familiar. A "butterfly soul" (*leikpya*), ritually installed in the wooden image, enables the dancing medium to effectively manifest the *nat* much as enlivened temple images enable mediumistic performances in Vietnam. As with god images in Vietnam and South Korea, several conversation partners suggested that treating an image well would nurture the *nat*'s favor while improper treatment would result in bad luck for the medium (see also Brac de la Perrière 2009, 289–93; 2016, 23). Before felling a tree for carving, the carver propitiates the guardian *nat* of the forest (Fraser-Lu 2002 [1994], 86). Wood for carving is blocked in proportions based on an ancient Indic, rather than an

ancient Chinese, system, and horoscopes are governed, in the first instance, by the day of the week on which one was born. While the basic technologies of time and measure differ, the larger point holds that auspicious proportions and horoscopes are matters of consequence in commissioning religious images (Moilanen 1995, 81–83), reason to believe that here too, images are being produced with a mingling of magic and craft.

When Erin and I spoke with statue carvers near the Mahamuni Pagoda in Mandalay and the Shwedagon Pagoda in Yangon, the artisans were familiar with our questions (plate 14). Most claimed that the carver should abstain from alcohol and that he should work with a clean body and a respectful attitude, shoes removed (as at a pagoda or monastery), and that statues must be beautifully carved according to the proper prototype. A ritual offering might mark the start of a large and important commission, and depending on the client's willingness to pay, a carver will observe different levels of Buddhist precept. A devout lay Buddhist proudly described how, when she had sponsored the production of a buddha image for the local pagoda (*paya*), the workmen all wore traditional white Burmese dress and each carver observed not the usual five but a full eight Buddhist precepts throughout the duration of the carving. But we soon realized that our interest in *nat* images was confusing to the carvers, who considered carving *nat* a sideline business. Their primary focus was on producing larger, more expensive, and ultimately more spiritually consequential buddha images, a distinction that was not so evident in the workshops in Vietnam. When the Burmese carvers described prohibitions and purifications, they were referencing the work of carving a buddha for a major temple commission.

These, we would learn, are very different projects from producing *nat*. Craftsmen emphasized that making a buddha image demands strict adherence to precise norms and established protocols, while *nat* images are more crudely executed (Fraser-Lu 2002 [1994], 65, 95, 96).[15] The master carvers that Irene Moilanen (1995, 81) studied in the 1990s had so well internalized the correct proportions for a Buddhist statue that they did not need to mark the block of wood in order to produce an image of proper and exact proportion. By contrast, we found that a certain vagueness or inconsistency informed the production of *nat*. One carver pulled out a copy of Richard Carnac Temple's *The Thirty-Seven Nats: A Phase of Spirit Worship Prevailing in Burma* (1906) in Burmese translation; Temple's work is itself said to be an English translation of a Burmese carver's text (Ridgeway 1964 [1915], 237). Another carver made vague reference to ancient texts, and yet another described a tradi-

tion passed from teacher to apprentice. Where buddhas are carved according to strict protocols for form and proportion, *nat* images need only approximate the gestures and costumes deployed by mediums. As in Aung T.'s account of his purchase of the *nat* Shwe Nabe's image, *nat* postures might sometimes vary following the pose struck by a *nat* in a medium's dream. Not only form, but the process of making a *nat* is more casual than the work of making a buddha. A carver in Mandalay claimed that if a client paid a large commission, the carver would even observe precepts when carving a *nat*, but he also held that carving a buddha was "for religion" while carving a *nat* was "for tradition," an echo of Aung T.'s statement that the *nat* are "outside of religion," that is, outside of proper Buddhist practice. One carver told us that he felt happier when carving buddha images than when he carved *nat* because he could focus his mind on his work. The *nat*, he said, did not receive the same careful finishing as a buddha image, they could be rougher and cruder; this was appropriate for *nat* (see also Fraser-Lu 2002 [1994], 96). While buddha images are almost always covered with real or artificial gold leaf, *nat* are most often brightly painted (Moilanen 1995, 85).

And *nat* images seem to decay more quickly than buddha images. In a wall text accompanying a small section on *nat* in the Asia Society's 2015 exhibition, *Buddhist Art of Myanmar,* the curators Sylvia Fraser-Lu and Donald Stadtner observed that "few antique effigies of *nats* survived Myanmar's frequently humid wet climate. Once an icon shows signs of wear and tear it is quickly replaced by a new image." By contrast, antique wooden buddha images do remain and were well-represented in the same exhibition. The buddha image is either carved stone, cast metal, or fine carved hardwood—teak, ebony, ironwood, or other "rare expensive materials"—selected for compatibility with the client's horoscope (Moilanen 1995, 83) or, as seemed to be the case in the workshops we visited, carved from fragrant and durable sandalwood.[16] Wood is more likely to deteriorate when it has a wider grain and when it has been less carefully seasoned, and hardwoods are less appealing to insects than most softwoods, similar cautions and concerns to those at play when commissioning a Mother Goddess statue in Vietnam. But in Myanmar, where expectations of the highest quality are for buddha images, commissioned by communities, and *nat* images are a sideline enterprise produced for individual mediums, it is more likely that the *nat* are carved out of remnant branch wood, rather than durable core wood. This is speculation, but coupled with what the carvers did tell us, the use of poorer quality wood could explain why "few antique effigies

FIGURE 15. Plastic *nat* on sale in a stall outside the Mahamuni Pagoda, Mandalay, Myanmar, 2011. Photo: Erin Hasinoff.

of *nats* survived." Material quality is simply not so significant for a *nat* as for a buddha. *Nat* can even be made of plastic, while at the time of this writing, it would be difficult to find a plastic buddha image in Myanmar (figure 15).[17] The practice of carrying *nat* images to rituals and festivals, the companionability of the *nat,* would also take a toll on the durability of the image. In the early 1960s, June Nash (1966, 126) commented on the "battered images" that *nat kadaw* brought with them to festivals. In better economic circumstances, small personal statues might also be better made and better maintained, slowing the process of their deterioration. Those we encountered in 2011 seemed in good repair, some even freshly gilded. We did not have an opportunity to interview those who maintain primary images in the *nat's* home temples, the source images that, in Brac de la Perrière's apt telling, irradiate all of the secondary images that the *nat kadaw* bring with them to the *nat's* festival. These primary images are well-maintained but at root,

they are regarded as beyond human craft. As Brac de la Perrière discusses, their origin stories describe them as emerging fully-formed, a part of their power claim as material extensions of the once-living *nat*. Maintenance of these precious images is sustained by a network of spirit mediums and followers that extends throughout Burma. The primary images at the Taungbyon Brothers' home temple, and possibly in other primary temples, are re-gilded each year at the conclusion of their annual festival (Brac de la Perrière 2002, 99–101; 2005, 85).

This is not an argument that ordinary *nat* images are shabby or short-lived by intention, or that, like some sacred objects in some traditions, they are intended to decay as part of a cyclic process of renewal—Japan's Ise Grand Shrine rebuilt on a twenty-year cycle, the Chinese Kitchen God burned and replaced each year, the Korean village guardian pole that rots and topples to the ground beside its recent replacement. The durability of a *nat* image is desirable, and well-made statues are passed on to favored apprentices who subsequently regard this legacy as a mark of distinction. Fine images are gilded and re-gilded by successful *nat kadaw*, an indication of the medium's stature that Moilanen (1995, 85) describes as "a special favor to the spirit." Nor would I disregard the significance of Aung T.'s long quest for the beautiful statue that would fulfill his destiny to spend a lifetime with the *nat* woman Ma Ngwe Taung and his rejection of a commissioned statue that he did not consider adequate to the *nat* Shwe Nabe. Even so, any *nat kadaw*, most certainly Aung T., will acknowledge that *nat* are lowly beings in the Buddhist scheme of things, that they died badly, were denied reincarnation, and are filled with anger and resentment that potentially endangers the living.

Cheap, much-used images also testify to the intimate presence of *nat* in popular religion, as beings who intrude and disrupt ordinary lives but can be petitioned for less-than-spiritual needs. Most *nat* images are objects for the medium's personal use rather than community veneration. The accessibility and portability of small, relatively inexpensive statues and the looser protocols involved in fabricating them parallel the accessibility of the *nat* as present and agentive entities in popular religious practice. This seemed to be the nub of it; the relative roughness of the *nat* image and the relatively lesser concern for the conditions of its manufacture is acceptable to *nat*-ness, always relative to the refinement, purity, and overall quality of the buddha image. What makes the *nat* image less durable and precious also makes the *nat* image inexpensive and accessible, taken onto personal altars and into the lives of countless

*nat kadaw,* festooned with the *nat kadaw*'s own hair, groomed, bathed, dressed, and given small gifts as intimate partners in a sacred enterprise.

## BALI: CRAFTING *TENGET*

In Bali, ritual actions occur within the space of a Hindu cosmology inflected long ago with a heavy dose of Tantrism.[18] The mask-embodied presence of demonic-to-divine *niskala* forces has resonance with other masks elsewhere in the world of Hindu practice (Emigh 1996; Shulman and Thiagarajan 2006). And yet, with respect to the foregoing discussion, much will seem familiar in the mingling of technologies of ritual and craft, skillful magic and magically-intended skill, that makes a temple mask and makes it powerful, a Maussian culinary concatenation that has been well-recognized in writing about Bali. As Fred Eiseman (1990b, 207) describes it, "The status of the mask maker derives not so much from his ability as a craftsmen, but from his knowledge of the power of masks. . . . these activities involve powerful supernatural forces, and it takes a strong man to insure that these forces do not inadvertently get out of hand and create imbalance." In Angela Hobart's (2003, 133) words, "Rituals punctuate the creative process. . . . It is interesting that the rituals become ever more elaborate and compelling as the performative process unfolds. They continually confirm to the public that the masked figures produced embody great power that can regenerate, or conversely destroy, body and society." Describing the crafting of a temple, Hildred Geertz (2004, 242–43) unpacks a broad Balinese category of "work" (*karya*) that would also apply to making temple masks. It includes both material and spiritual aspects, "the physical labor, technical artistry, social collaboration of gathering materials and skills, organization put into a project," and also "service and homage paid to *niskala* beings who pervade the village." Through such effort, "the constant threat of destructive anger on the part of *niskala* beings—which could release not only all sorts of natural disasters but also the malevolence of local human sorcerers—may be dispelled." Margaret Wiener (1995, 55–56) writes of how the potency of such objects as *keris* blades and masks "depends in part on the spiritual power of their creators. . . . Throughout the process of manufacturing such things, offerings rest at the artisan's side, and at various stages he invokes invisible forces with mantras, sacred syllables, seeking to join their power with that of his creation." The Balinese carver's mode of work is a Maussean culinary effort, a by now familiar-seeming mingling of magic and skill.

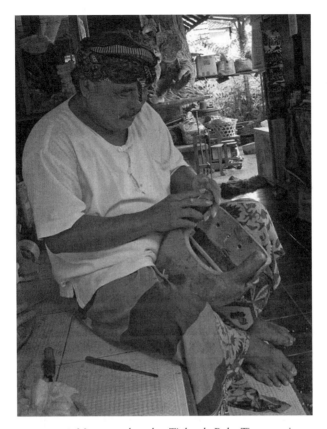

FIGURE 16. Master mask-maker Tjokorda Raka Tisnu repairs an old Barong mask, Singapadu, Bali, Indonesia, 2017. Photo: author.

Several authors have provided detailed descriptions of the process of making a *tenget* mask, a mask that is powerfully charged and, as a consequence, potentially dangerous if touched or used improperly (see figure 16). The following discussion is a composite summary of their work, enhanced with interview commentary from mask-makers.[19] The decision to make or refurbish a temple mask is prompted by a divine message (*pewisik*) received from trancers or heard in dreams or during meditation. This is followed by a period of deliberation on the part of a community; making a mask is no small undertaking both in terms of resources and possible danger. Temple masks are made from the wood of a *pulé* tree, a tree said to have sprouted from the divine seed of Siva, and in Bali, as we have seen elsewhere, the extraction of the wood is a serious matter.[20] By contrast, the wood for decorative masks, souvenir masks, and

masks intended for secular performance is usually purchased in commercial lots, generally from unknown sources. Temple masks, as sites of *sesuhunan*, are made from a *pulé* tree that grows either in or near the cemetery beside a Pura Dalem (Siwa-Durga Temple). The wood for a temple mask comes from a pregnant (*beling*) swelling on the tree, and not just any bump on any *pulé* tree, but one that the priest verifies has been struck by lightning, absorbed a ball of light seen in his own vision, or is identified by other divinatory means.[21] When the masks come from the same tree, they become siblings who reunite periodically when their mediums participate in festivals in the temple near the original tree. The ritual extraction (*ngepel*) of the appropriate bump takes place on an auspicious day (*dwasa ayu*) by the Balinese calendar, another operation within a schema of auspicious timing.[22] As in other horoscopic systems, the days "do not tell you what time it is; they tell you what kind of time it is" (C. Geertz 1973, 393). The priest wraps the trunk of the tree in a white cloth. He asks the Lord of the Forest (Banaspati Raja) for permission to extract the wood on the request of a particular community who desires a particular mask. After chanting appropriate mantras, he ritually removes the tree's spirit/soul substance to a temporary shrine for the duration of the operation and replaces it once the wood is extracted, spiritual maneuvers equivalent to what we have already heard about in Vietnam.[23] In doing this work, the priest engages powerful forces, and there are memories of priests dying as a consequence of doing this work.

The carver carries the wood to his family shrine and leaves it to properly season before he can begin to work the wood.[24] Inside the purified precinct of a temple on another auspicious day, a Brahmin priest (*pedanda*) initiates the carving with appropriate ritual (*ngendag*). For three days, while the wood rests in the temple, the priest and some members of the community meditate, collectively focusing on their intentions for the mask. Sometimes, and ideally, these efforts are blessed with a waking vision or other sign that the spirit (*bayu*) in the wood is compatible with the community and its intentions. Thereafter, the carver does his important work in a quiet, secluded place, either in the temple itself or in his own studio. He has prepared himself with a purification ritual (*mewinten*), and each day, when he begins this work, he does not touch the mask until after he has bathed and meditated. Similarly, his tools have been prepared for the task through a purification ritual for objects (*melaspas*). When he works the wood, the carver will preserve the tree's top-to base orientation as he works on the mask, just as a Vietnamese carver would do when working on a statue. Through

meditation, the carver attempts to bond with the wood, aiming to infuse the mask with something of his own soul/spirit/vital energy (*bayu*, Ind. *jiwa*), becoming one with it (Ind. *satu pikiran*).[25] A Balinese carver might recognize a resonance here with the heart-mind of a Vietnamese statue carver, a South Korean painter of god pictures, or a carver of buddha images in Myanmar. He might nod in understanding with the elderly carver of temple images in Taiwan who, while still producing exquisite decorative work, told me that he had given up the practice of carving temple statues because, as an octogenarian, he lacked the strength to put his whole heart-mind to the task. One Balinese carver showed Wayan Ariati and me how he works his chisel while holding a yoga-like posture, such that his hand assumes a *mudra*-like gesture as it bends toward the mask. He said that when he finds himself working this way, when he can hold this uncomfortable pose from morning until night while almost oblivious to it, he knows that he is producing a good mask. The calendar, with its indication of "what kind of time" it is, continues to inform the process; some carvers will not do this work on the inauspicious first day of the three-day Balinese workweek.

As in other workshops in other places, these practices combine with the artisan's skill in an enchanted technology/technology of enchantment, with the risk of neglect bringing bad consequences. Because the mask itself is a powerful and consequential thing, similar cautions and procedures also apply when it is brought into a workshop for periodic repair and repainting. In a village in central Bali, residents described how their masks had lost the charismatic energy (*taksu*) that enables a powerful connection between the performer and the observer because the carver who repaired them had not invested enough of his soul/spirit/vital energy in the task. When the mask appears in temple festivals, the villagers no longer experience *taksu*. Another carver noted that the sloppy restoration of a Barong mask might cause "something else," some ominous presence, to inhabit it, such that the mask might ask for "human sacrifice," the death of one or more community members after a performance (plate 15). Such reports recall Hildred Geertz's (2004, 242) observation, with respect to the construction of a temple, that "*Niskala* beings remain, of course, the main audience for most of the makers."

CONCLUSION

We return to Mauss (1972 [1950], 19–20), who observed that "the greater part of the human race has always had difficulty in distinguishing

techniques from rites," that the perceived powers of the artist and crafts-man are close to those of the magician, and that many human activities seamlessly combine magic with technology (Warnier 2009, 460). At the same time, Mauss distinguishes himself from "the greater part of the human race" by elaborating upon just such a distinction. "Everyone knows that the results are achieved directly through the co-ordination of action, tool and physical agent" while magic remains a domain of "words, incantations, ritual and astrological observances" whose causal efficacy cannot be proven. For Mauss, observed techniques with verifia-ble causes and effects encroach on the domain of unverifiable magic, as in the case of medicine. Gell (2010 [1992]) breached this divide in a radical way by claiming magic as something more than the words and incantation. Material technologies also participate in the work of enchantment as when they produce, along with a sea-worthy canoe, a deeply carved Trobriand canoe-prow intended to dazzle the senses of a Kula partner. In Gell's explication, the enchantment of the Kula partner happens through a braiding of magical acts and skilled technical execu-tion directed toward the common end of producing an extraordinarily powerful object, as we have seen in the carvers' workshops. The produc-tion of well-crafted temple statues, correctly executed god pictures, and powerfully *tenget* masks, as described in this chapter, can similarly be understood as technologies of enchantment that make use of enchanted technologies. These are present in the knowing operations of selecting and working wood or applying a brush dipped in the correct color to laminated paper to make a god picture. The circumstances in which these activities are carried out and the materials themselves are under-stood by some as contributing to the efficacy of the image; in this sense they are not only skilled but also magical acts, sometimes the more mag-ical because the more skilled. But it could also be argued, on the basis of material presented here and in a manner consistent with Mauss, that in rationalized workshops enchanted technologies of production have been reduced to pure technology for an expedient and cost-effective purpose. The transformation is nearly but not yet entirely complete in South Korea and is a point of argument in Vietnam. And yet in both of these instances, even where the enchantment of technology withers, the total project remains a technology of enchantment intended to produce a material object that will function as a magical thing, the habitation of a god. Benjamin could not have anticipated the marketplace for religious goods in twenty-first century Vietnam and South Korea, where aura enhances commodity value and mechanical reproduction is a matter of

type, degree, and price point. Likewise, Malinowski, who attributed magic to the uncertainties of life under primitive conditions of horticulture and seafaring, was far too much of an optimistic modern to have anticipated the volatility of advanced market economies and the pernicious consequences of many modern human projects. These contemporary examples of commodities that are more than commodities, and often elided as non-commodities, challenge us to think against old dichotomies and old teleologies.

While ensouled images and their modes and protocols of production are broadly recognizable across distinctive worlds of Hindu- and Buddhist-inflected practice, my four core examples also share a more specialized distinction. Not only are divine entities present in these images, the particular genres of statues, paintings, and masks that I have been describing also operate in conjunction with spirit mediums or shamans whose own bodies, on appropriate occasions, become temporary receptors of presence. We will explore these relationships more fully in chapter 4.

CHAPTER 4

# Agency and Assemblage

When particular statues bleed, or perspire, or move about, these are "miracles." But such happenings would not be miracles if the expectation was that all idols should behave in this way; in fact, they are generally expected not to. . . . The criticism of idolatry on the grounds that idols are not "alive" as human beings are (biologically) alive, or that idols are not realistic automata, but only statues, misses the point on both counts. The idol is worshipped because it is neither a person, nor a miraculous machine, but a god.

—Alfred Gell, *Art and Agency*

I asked the Mother Goddess why my body had been taken over (to serve as a spirit medium). The Mother said, a statue cannot walk or speak. If I did, then people would be afraid, so I chose you for this purpose.

—A Hanoi *bà đồng*, November 24, 2004

In the north of Vietnam, in a temple dedicated to the Four Palaces of the Mother Goddess, the *bà đồng* sits covered with a red cloth in front of an altar heaped with offerings while the musicians sing and play to invoke the spirits, the notes warbling and swelling through an electric amplifier (plate 16). A *bà đồng* described this moment: "Under the red cloth I feel far, far away, light, as though I'm floating, not really inside my body at all. Then I see things, I see the spirits." The liminality of the medium under the red cloth recalls the liminality of a soon-to-be animated statue body, covered with a red cloth and carried from the workshop, set upon the altar to await the climactic moment when the ritual master whisks off the cloth and fully awakens the statue's senses. From under the cloth,

the *bà đồng* gestures with the fingers of each hand to signal what goddess or god—what Mandarin, Dame, Prince, Damsel, or Child from the domain of Heaven, Mountains and Forests, Water, or Earth—has come to incarnate in her body. The attendants scurry to find the exact silk robe and accessories that belong to the present deity. They remove the red cloth from the medium's head, dress her, and construct an elaborate headdress of ornamental hairpins and flowers around the turban on her head. Once attired, the visiting god or goddess listens with appreciation to the music. The embodied presence of the visiting deity strides regally as a Mandarin, minces coyly as a Damsel balancing a flower basket on her shoulder, waves fire sticks and leaps in a frenzied caricature of ethnic minority dances from the Mountains and Forests, or engages in child's play with a toy unicorn mask. She/the visiting deity enjoys the music, smokes and drinks where character-appropriate, receives offerings, and showers blessings on the attendants, musicians, and spectators in the form of small gifts and fistfuls of money. Spectators scramble after the scraps of small-denomination currency that carry good fortune. Sometimes, very rarely, a *bà đồng* or *ông đồng* utters an oracle (Endres 2011; Ngô 2003; H. Nguyễn 2016; Norton 2000). While the statue body makes a stationary presence, the medium's body is mobile, enabling consequential action. For the brief period of time that unfolds within the carefully constructed ritual frame, the god moves and acts in ritual space in ways that a statue cannot because "a statue cannot walk or speak." In Vietnam, Myanmar, and Korea, the multiple costumes that are donned and removed throughout the ritual span welcome a parade of deities mirroring and animating gods in approximation of their appearance in the images (plates 17 and 18; figure 17). Morten Pedersen's (2007, 153) "knotted virtuality," with reference to the scraps of meaningful cloth associated with a Mongolian shaman's alter, becomes instead a layered virtuality as gods slip on and off in a sequencing of their costumes. Balinese masks work differently, as we would expect masks to do, the ensouled force becoming most fully present when the image is conjoined to the medium's mobile body. But even when wrapped with an amuletic cloth and stored away in a basket or hidden behind the closed doors of a shrine, the mask-image is never completely not present.

The god/spirit/energy in the image is, in all of my four cases, a presence, but a presence that needs both the image body and the medium's more mobile body to be vividly present. In the previous chapters, I have said relatively little about spirit mediums and shamans, in part because with respect to Vietnam, Myanmar, Bali, and Korea, there is already an

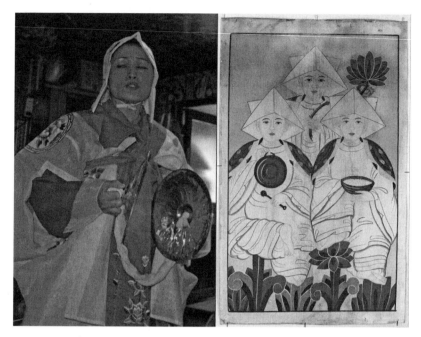

FIGURE 17. The *mansin* on the left (2009) manifests Buddhist-inflected gods who come from a high pure place, like the Three Buddhas (*sambul*) in the late twentieth-century god picture on the right. Left photo: Homer Williams. Right photo: American Museum of Natural History, Anthropology 70.3/6719.

abundant literature about them, one that I have contributed to with respect to Korea. Before the "material turn," anthropological interest in shamanship and trance phenomena bested interest in statues and other manifestations of material religion (cf. Houtman and Meyer 2012; Engelke 2011). It also made sense, given the intentions of this project, to first introduce the images in the ways that they are understood to be ensouled and agentive things, and then show how they operate in relation to their human counterparts. This relationship between the image body and the ritually engaged human body of the shaman or medium occurs in different settings of ritual practice but has been largely overlooked in a literature concerned with questions of possession and performance. How do these arrangements between bodies and images work in performance and practice? Is this collaborative working of bodies and things in any way generalizable from case to case? Does posing such a question yield deeper understandings of different possibilities? Such explorations are the substance of this chapter. Not only do my core cases contrast with each other, but the behavior of animating

forces in relation to specific images sometimes also collides with local expectations of image behavior.

## MEDIUM BODIES

Alfred Gell (1998, 7) describes a consecrated Hindu image, its senses ritually awakened and its eyes opened, as parallel to the entranced spirit medium who becomes a temporary habitation for the god: "from the point of view of the anthropology of art, an idol in a temple believed to be the body of the divinity, and a spirit medium, who likewise provides the divinity with a temporary body, are treated as theoretically on a par, despite the fact that the former is an artifact and the latter is a human being." The Nepalese "idol" and the young woman medium of Gell's description were both inhabited by the same god and subject to different but overlapping protocols and expectations (150–53).

For many Vietnamese devotees, an unanimated image of a divinity is necessarily more than "just a statue," and in the same sense, the medium, away from the *lên đồng* ritual, is an ordinary woman or man, but also a potential container for the deity and in that sense, far from ordinary. A medium lives (or is supposed to live) in anticipation of this expectation, leading a moral life, observing proper conduct, maintaining a personal shrine, and serving the Mothers. Korean *mansin* say similar things, while their gossip sometimes notes violations and consequences. As with the preparation and purification of a statue body, the Vietnamese medium prepares carefully for the *lên đồng*, purifying her or his body, bathing, dressing in clean clothes, and carefully applying makeup. My introduction to the world of Korean *mansin* many years ago included a growing awareness of the lists of pollution avoidances that *mansin* follow before performing *kut*. I also found myself witnessing long pre-*kut* primping sessions involving meticulous applications of cosmetics and a flourishing of the festive Korean blouses and long, ballooning skirts the different *mansin* would wear under the gods' robes. A major *kut* might be preceded by a long visit to the bathhouse for a professional scrub and massage and a visit to the beauty parlor. In Myanmar, vendors sell a special shampoo on the periphery of major festivals for the hair of both spirit mediums and their statues which, in many cases, sport lustrous locks of the mediums' own hair. A great deal of primping went on around the periphery of the Taungbyon Festival near Mandalay in 2011 (plate 18). Erin Hasinoff and I were invited to join a group of followers attending on a famous *nat kadaw* as he bent over his makeup box and transformed

his middle-aged male face into someone resembling a bewigged night-club diva, an impression heightened when he donned imposing founda-tion garments and a green sequined ballgown, the gift of a devotee. A professional manicurist whom we met after the event said that he volun-teers his skill to the mediums as his own way of serving the *nat*. In Bali, the medium is not facially present, but the body container is no less important. Mediums, priests, carvers, and others who engage with things powerful and sometimes dangerous undergo a periodic ritual purifica-tion (*mewinten*) in order to do their work.

These bodily practices underscore the parallelism of carefully prepared bodies and carefully crafted images as containers for things beyond them-selves, containers as "the point of departure for fully fledged technologies of power" (Warnier 2006, 188). However, the local idioms for what the medium or shaman is supposed to be accomplishing through these prepa-rations vary. Beauty (*đẹp*) is an operable intention in Vietnamese Mother Goddess Religion, a word used to describe statues, the ritual space, and the spectacular arrangements of offerings and flowers that devotees spend many hours constructing before a *lên đồng* ritual. The medium-becom-ing-god also receives extensive primping once she has indicated, with hand gestures as she sits under the red cloth, the identity of the god whom she will next incarnate. Attendants bustle to locate and bring the appro-priate costume, dress the medium, arrange and decorate an elaborate tur-ban on her head, and open boxes of jewelry to accessorize the god. Famil-iar with Korean *kut,* where layering-on the gods' robes is quick and matter-of-fact, I found myself impatient with this extensive and time-con-suming dressing-up until I came to recognize it as an integral part of the *lên đồng* itself, acts that would enhance the beauty of the medium body as a temporary container for the god.

Gods incarnated in a medium are expected to make the medium even more beautiful. Mediums would show me photographs of themselves performing *lên đồng*, their faces soft, smooth, gently smiling. "Aren't I beautiful?" one *ông đồng* insisted, proudly exhibiting photographs from a recent ritual. Noting that even on the otherwise ordinary day of this interview, he had painted his eyebrows and lips, I thought that he was just so vain. Then I realized that what I was being offered, through the photographs, was a tangible documentation of his transformation into a god—that the god's presence, captured by the camera, made him beautiful beyond his ordinary looks. Other mediums shared their own stashes of photographs, laminated for long-term preservation, and some played DVDs of recent *lên đồng* with a similar validating purpose.[1]

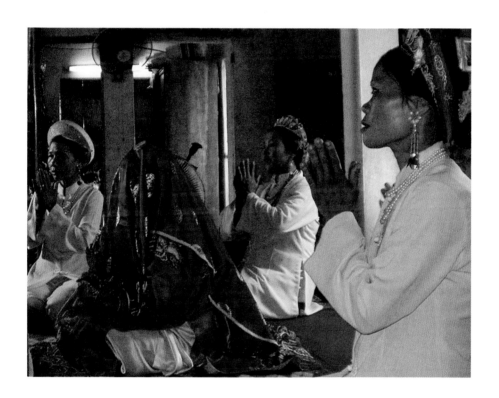

PLATE 16. A *bà đồng,* under the red cloth, gestures with her hands, revealing the identity of the deity whom she will next incarnate, northern Vietnam, 2004; compare with figure 6. Photo: author.

PLATE 17. A *bà đồng* incarnates a Damsel from the Palace of Mountains and Forests and does a lively dance with fire sticks in a costume pastiche of ethnic minority dress, northern Vietnam, 2003. Photo: author.

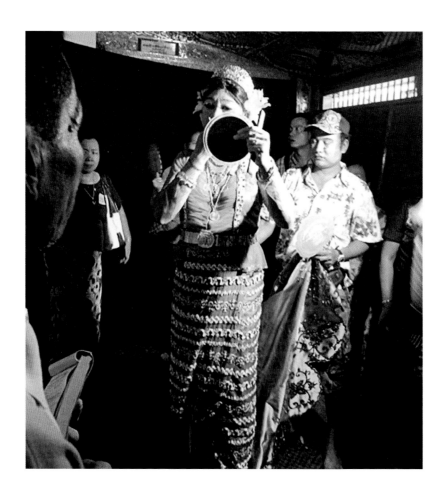

PLATE 18. A *nat kadaw* primps before entering the Palace of the Taungbyon Brothers at their festival, northern Myanmar, 2011. Photo: Erin Hasinoff.

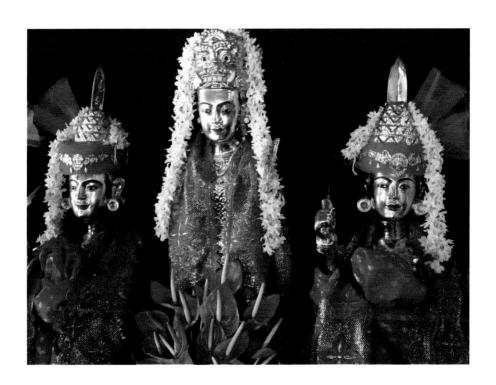

▲PLATE 19. The Taungbyon Brothers and their mother on a private altar, dressed for the festival in their honor, northern Myanmar, 2011. Photo: author.

▶PLATE 20. *Nat kadaw* dressed to pay his respects to the Taungbyon Brothers in their palace, northern Myanmar, 2011; he and the statues in plate 19 wear colors appropriate to the day of the week. Photo: author.

PLATE 21. *Mansin* summons the gods from a pure, high mountain to a *kut* in an ordinary home in Uijeongbu, South Korea, 1977. Photo: author.

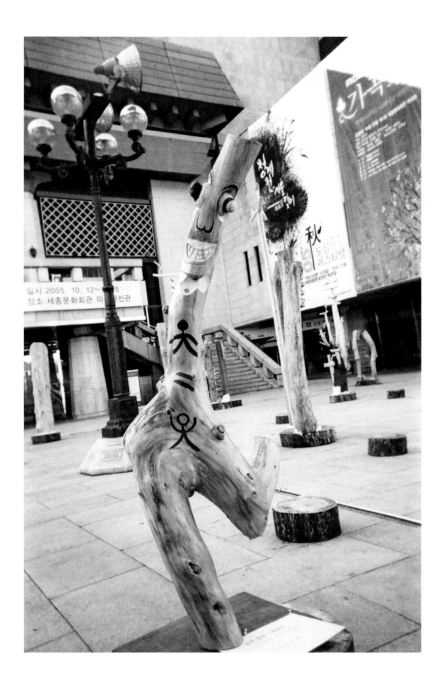

PLATE 22. "Running Changsŭng" by Yi Garag, on exhibit in the Sejong Cultural Center Plaza, Seoul, South Korea, 2005. Photo: author.

PLATE 23. Vendor stall in the Sukawati Market, Bali, Indonesia, 2017. Photo: author.

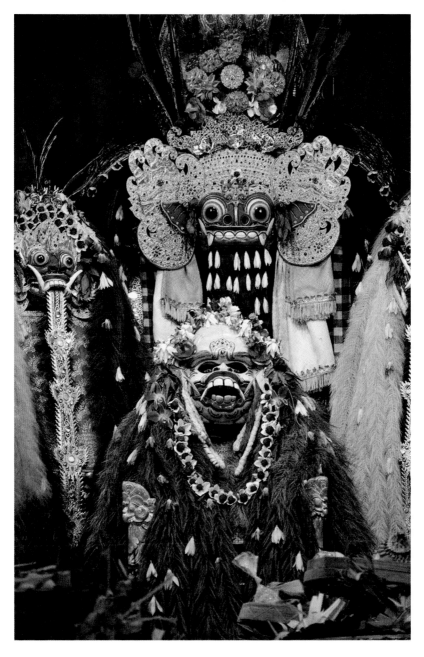

PLATE 24. Jero Amerika (lower mask), groomed and decorated for a festival, sits in state below a Barong and flanked by two Rangda masks, Taman, Bali, Indonesia, 2018. Photo: Ni Wayan Pasek Ariati.

PLATE 25. The large Rangda mask that threw a psychic from Java into trance and is now safely installed in a household shrine, Singapadu, Bali, Indonesia, 2017. Photo: author.

PLATE 26. Rangda installed in the Grand Gallery of the American Museum of Natural History, 2016. American Museum of Natural History Photography Studio; photo: Denis Finnin.

PLATE 27. Antique statue in a private collection, Hanoi, Vietnam, 2004. Photo: author.

PLATE 28. Mrs. Mỗ Thị Kịt (left) and her apprentices perform at the Vietnam Museum of Ethnology, Hanoi, 2004. Vietnam Museum of Ethnology; photo: La Công Ý.

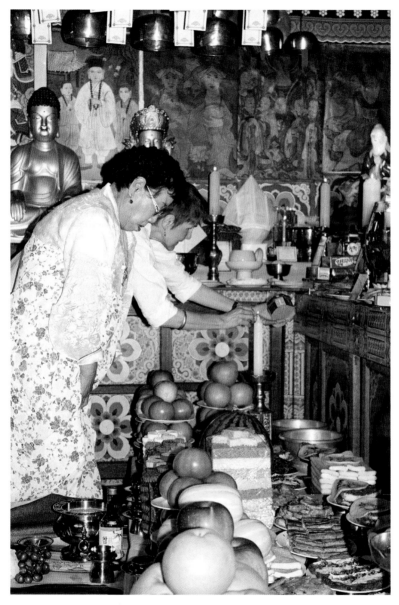

◄PLATE 29. Monk Great Spirit (Sŭng Taesin), a *mansin*'s ancestral guardian god who would have been a monk, nun, or serious lay Buddhist in life. The early or mid-twentieth century painting was purchased from a Seoul antique shop in 2008. Photo: American Museum of Natural History, Anthropology 70.3/6722.

▲PLATE 30. The author (right) paying respects in a *mansin*'s shrine in gratitude for assistance with her work, Yangju City, South Korea, 2009. Photo: Homer Williams.

Nguyễn Thị Hiền, a scholar of Vietnamese spirit mediums, introduced me to a former wedding videographer who had switched to the more specialized work of documenting *lên đồng,* work much in demand in the community of mediums. The medium who becomes more beautiful when incarnating a god is equivalent to the statue that becomes more beautiful after ensoulment, such that a carver could claim he was unable to recognize his own work; uncanny beauty verifies presence.

But when I tried to convey these ideas to the *mansin* Yongsu's Mother in South Korea, she paused from carefully applying her own makeup and responded with contempt, "Beauty? We do these things to make ourselves clean (*kkaekkuthada*)!" And yet the underlying principle is similar, the preparation of an efficacious human body that will act in engagement with an efficacious image and do the gods' work.

## ASSEMBLAGE

Engagement is the critical word. There is more at stake here than representational or even experiential parallels between material images and human bodies. Bodies, images, and gods operate as a machine assemblage, a fluid, unstable, not always predictable concatenation of forms, a claptrap engine of sorts (see Hodder 2012, 65; Holland 2013, 29; Holbraad and Pedersen 2017, 206; Pedersen 2011, 36). The notion of an assemblage of gods, mediums, and images that must be energized in order to operate flirts with the new animism mentioned warily in previous chapters and some distinctions are necessary. On the animist side, Morten Pedersen (2011, 37) argues that for Darhad Mongols, and with a nod to Amazonia, the critical components of a shamanic notion of force "are considered to *be* rather than to have force—namely, the occult capacity to compel the cosmos to orchestrate itself in a particular way" (emphasis original). The constituent components of the assemblage are what causes cosmic or near-cosmic operations. However, the bodies, statues, masks,  and paintings described in these pages as sometimes ensouled things hew to the *have* rather than the *be* side of the spectrum. Force/energy/soul/ divinity comes to them. As we have already seen, this is neither a certain nor a permanent condition, and for this reason, much effort is devoted to acts of preparation, fabrication, and maintenance of the seats and containers that will encourage or enable an efficacious presence.

Yes, some of the of the material components of images, certain woods for example, are considered to "be" innately energizing in Pedersen's sense. The Sino-centric cosmology that undergirds traditional craft

production in Korea and Vietnam assumes that a proper arrangement of energized materials enables an auspicious purpose, as in the practice of Chinese *feng shui* now popularized with how-to books in the West. Some materials are energized with more intensity than others, images made of clay are less energized than those carved from wood, which are less energized than those cast of metal. But in the production of images and other sacred things, these are enabling qualities intended to facilitate a more active presence, to contain, provide a habitation, and ultimately combine with, to almost but not inextricably "be" the presence itself. The selection of energized wood is particularly consequential in the crafting of a Balinese temple mask, but even the wood extracted from the pregnant bump of a *pulé* tree, a bump entered by uncanny light (chapter 3), is a necessary but not sufficient precondition to the spectacular ensoulment of a Balinese mask when this transpires in dark midnight in a cemetery.

An electrical connection may be the best analogy for the relationship between gods, shamans/mediums, and material images, a metaphorical descriptor for the powering of a machine assemblage that includes gods, human bodies, and material images. Daily and commonplace experiences with electricity help the anthropologist and her conversation partners to imagine the operation of things invisible, powerful, active, and sometimes dangerous. In some modern situations, "electricity" has provided a literal explanation for things otherwise unseen. As an emic explanation, it has figured in the "electro-biology" of Victorian spirit mediums (Owen 1990, 109), the enlightened imaginings of early twentieth-century Vietnamese spiritualists (Hoskins 2015), and the practices of some twenty-first century British amateur investigators who use electromagnetic energy as a pathway for establishing empirical evidence of ghosts (Hanks 2016). Far more often, almost unconsciously, the idea of electricity is deployed metaphorically, as I shall be using it here. Electrical analogies appear in writing about popular religion as both local metaphors and the scholar's own. Spirit mediums in northeast Thailand speak of their own spiritual energy within "rhetorics of batteries and electricity" (Morris 2000, 187). In some Thai Buddhist rituals, a cotton thread, the *sāi siñcana*, links a consecrated Buddha image to animate or inanimate objects. A lay devotee described the thread to Donald Swearer (2004, 80) as "an electric cord that conducts the power from a previously consecrated Buddha image in a lineage extending back to the original image commissioned by the Buddha himself, much as a cable conducts electricity from a generator." In another analogy that Swearer also records, the monks' chant produces the energy that gets transmitted along the cord to recharge the power of

an image (80). Sarah Horton's (2007, 11) conversation partner in a Buddhist temple in Japan thought in terms of television frequencies as well as electrical currents: "The Buddha beams signals to the statue, just as a broadcasting station sends signals to televisions. Televisions must be . . . plugged in and turned on. Conducting an eye-opening ceremony is akin to plugging in a television, explains Nishimura. Turning the switch on, however, is done by the believer, in the act of joining the palms (gashō) in prayer."

Electrical analogies have also enabled ethnographic writing about charged relationships between people, places, and objects in the material world that might otherwise be beyond the ken of a Western academic gaze, pushing away from a static, strictly material, or material-symbolic perspective in order to mesh material religion to the dynamism of ritual work. Gell (1998, 225), drawing on Küchler's work on the New Ireland *malangan,* describes these mortuary carvings as "a kind of body which accumulates, like a charged battery, the potential energy of the deceased dispersed in the life-world." In Yolmo shaman practice, "eyes brighten, *the body electrifies,* and the heartmind renews" (Desjarlais 1996, 149–50, emphasis mine). In her memorable description of the midnight consecration of Balinese temple masks, Angela Hobart (2005, 167) describes how the graveyard setting is said to be "electrically charged and dangerous, once the figure is complete." In these circumstances, a man of *sakti* serves "as a *conduit* for the ambivalent *energies* swirling around in the cemetery" (A. Hobart 2003, 147, emphasis mine).

To borrow from Claude Lévi-Strauss, electricity is good to think with, and I shall.

STATUE ENABLERS

The idea of a machine assemblage assumes a dynamic working connection between its còmponent parts. In Vietnam, a *bà đồng* or *ông đồng* needs the statue presence in order to incarnate the god, and more than a symbolic correspondence, their relationship is power-charged. Although mediums may acquire their own images and maintain small private altars for daily devotion, most *lên đồng* rituals take place in major temple sites (*đền, phủ*) where the statues enable a good incarnation. Some of these sites, like the Tiên Hương Palace, are regarded as particularly efficacious and have multiple temple spaces, all fitted with full complements of ensouled statues to accommodate several simultaneous rituals. In a renowned temple, the gods are powerfully present in

the statues on the altar. In the revivified market economy, spirit mediums grumble that some of the keepers of these essential sites charge too much for the use of this important space (Endres 2011, 174–75). For their part, temple-keepers claim that they make no profit, that whatever they earn is invested in maintaining and embellishing the temple; the more elaborate the site, the more such investments bespeak devotees' satisfaction with the efficacy of the rituals performed there, renown-generating socio-religious capital. As a part of this dynamic, temple-keepers described the particular attention they invest in supplementing and refurbishing the statues in their care and the unstinting oversight they give to this work.

In Myanmar, statue and medium are similarly joined. Based on her years of work in the word of *nat* and *nat kadaw*, Brac de la Perrière describes how the success of a medium is linked to the *nat* power resident in his images, images periodically irradiated by proximity to images in the *nat's* home temple. *Nat* claim their human *nat kadaw* through a variety of sensory signs and extraordinary experiences. A *nat kadaw* is subsequently initiated into the *nat's* service and ritually vested with his primary *nat's* butterfly soul (*leikpya*), received via the images in his teacher's shrine. Through this connection, the *nat* is summoned on ritual occasions and invited to enter the medium. The statues the *nat kadaw* eventually acquires for his own shrine will also have butterfly souls ceremoniously installed in them (Brac de la Perrière 2009, 289; 2016, 8; Rodrigue 1992, 53–54). The term *nat kadaw* encapsulates the nature of the relationship between living humans and *nat: kadaw* means "paying formal respect through appropriate salutations and offerings," an expression of tribute to the *nat* and also to the medium's teacher or master (Brac de la Perrière 2009, 287).[2] To "*kadaw*," the medium is enjoined to periodically dance and celebrate the *nat*, working with a master *nat kadaw* to learn the appropriate forms of service. Some *nat kadaw* become professionals who perform ritual services for others, including the theatrical *nat pwe* where the *nat kadaw*, in appropriate costume, dances the *nat* into corporeal presence. Others fulfill a personal obligation to the *nat* through private devotions including dancing and becoming possessed during *nat pwe* (Brac de la Perrière 2007; 2009, 284–86; 2011; 2016, 8; Spiro 1967; Rodrigue 1992, 52–54).

Brac de la Perrière (2005, 79–80; 1992, 214–15) suggests that the *nat kadaw's* dances, both in the festival and in other ritual settings, "are salient because they demonstrate the relation of possession between the medium and the *nat*. . . . Mediums are considered possessed: mediums

dance for the *nat,* but at the same time the *nat* dance through the mediums." Through inspired dancing, the *nat* ensouled in the image becomes, in the *nat kadaw*'s body, an animated, this-worldly presence, capable of eating, drinking, smoking and interacting with the spectators (Brac de la Perrière 2007, 216–17). These behaviors are not unlike what was described above for Vietnamese *bà đồng* and *ông đồng,* albeit with the religious and aesthetic expectations of another place. In Vietnamese *lên đồng,* the medium sits quietly under the red cloth, awaiting the gods' inspiration to move and dance, usually sedately. A bit more lively are the incarnations of those deities who appear costumed as ethnic minorities from the realm of Mountains and Forests (plate 17) and whose dancing is intended to suggest stereotypically impassioned primitivism and also the Boy (*Câu*) god who mimics the playful antics of a small child. But even these incarnations are relatively stylized and controlled. In Myanmar, the costume, the music, and the ritual engenders an experience which one medium described for us as being carried away into lively dancing by his sense of *nat* presence, "overcome with the joy of it." An observer described how this scholar/medium and devout lay Buddhist, circumspect in his daily life in contrast with stereotypically flamboyant *nat kadaw,* would, when possessed, dance, and dance, and dance.

The dancing presence of the *nat/nat kadaw* has intrigued scholarly observers of trance phenomenon for more than a hundred years and there is abundant writing on this subject (e.g., Bekker 1993; Ridgeway 1964 [1915], 228–62, 387–94; Rodrigue 1992; Spiro 1967; and Shway Yoe 1963 [1884], 421.) But until the work of Brac de la Perrière (1992; 2007; 2009), accounts have largely overlooked the role of the *nat* ensouled in the statue body. It is the butterfly soul, the resident *nat,* who activates the *nat*'s manifestation in the dancing medium, and it is because the images are activators that they accompany *nat kadaw* to *nat pwe* (Brac de la Perrière 1992, 213; 2009, 289)(plate 19, 20).[3] One *nat kadaw,* expanding on my Vietnam-derived analogy of a statue enabling inspiration and a cell phone connection to someone in another place, said that the experience was "more like the internet." As in Vietnam, as is true for much Asian popular religion, the conspicuous ritual consumption exhibited by artistically costumed *nat kadaw*—good quality statues re-gilded when needed, elaborately decorated altars, and the *nat pwe* as a meta-offering, a petition for favor or an expression of gratitude for favor granted—are all signs that the *nat kadaw* returns grateful tribute to the *nat* who grant him or her favor (Brac de la Perrière 2005, 79; Schober 2004, 804). The modest scholar/*nat kadaw*

mentioned above showed us how he had provided one of his *nat* "ladies" with a pearl tiara and a supply of cosmetics. Temperate himself, he generously supplies U Min Kyaw with the whiskey that this *nat* craves and acknowledges an affectionate *modus vivendi* with this being of such fundamentally different appetites.

## KOREA: SHAMANS AND ELECTRICAL CONNECTIONS

As with the Vietnamese and Burmese examples, Korean *mansin*, gods, and god pictures, participate in their own motor assemblage, but it is a different sort of contraption from what we have been considering. Chapter 2 described the shifting, mutable relationship between the *mansin* and her gods, where gods can be an unstable presence in the images and sometimes may not even be there at all. We have seen how, in the climate of discontent that preceded the fight between her old and new gods, Yongsu's Mother no longer received a clear flow of inspiration when she prayed in front of her god pictures, "only mumbling and grumbling," the inaudible, illusive, exasperating equivalent of television static. She regained their favor on this occasion and would surmount other rough patches at different junctures over a long career. I have already confessed to my initial confusion over the absence of ceremony in the ensoulment of the paintings, my realization that the *mansin*'s gods, like the Christian Holy Spirit, go where they want to be. Ideally, the gods stay with the paintings for the rest of the *mansin*'s career, remaining even after her death in order to draw in a new *mansin*. But my many years of acquaintance with *mansin*, and with the things they say about other *mansin*, have taught me that divine constancy is not necessarily the case. The gods' desire to inhabit a *mansin*'s god pictures, and to deliver a strong flow of inspiration, is largely a function of their relationship with the *mansin* whose devotion they claimed, or as Yongsu's Mother told me, "we cause the gods to be there." This is another operation of a "concrete machine assemblage" (per Holland 2013, 62). However, in this particular assemblage, *mansin* are more emphatically agentive than the spirit mediums in the Vietnam and Myanmar examples.

On the analogue of electrical circuitry, the *mansin*, the paintings, and also sacred sites in the Korean landscape could all be considered nodes for the energy flow that comes from the gods, the inspiration that *mansin* call "*myŏnggi*" (명기, 明氣), literally "radiant energy." Consider the shaman's own body as the first node. Shamanship is, fundamentally, an embodied practice. As a prospective initiate, her emaciated body gives primary indications of her calling, mysterious illnesses, and the manic behavior that

sometimes risks a diagnosis of insanity. These experiences are read—in Korea and many other places with shamanic or mediumistic traditions— as signs that the gods will torture the prospective shaman to death if she does not accept her calling and that they will also blight the lives of members of her family. The gods make their desires known through visions, voices, and vivid dreaming. Typically, a woman resists the calling, sometimes for several years, until she, her family, and her community are convinced that she has no recourse but to accept and serve the gods. To mark the initiate's transformation into an apprentice or "little" *mansin*, she holds an initiation ritual (*naerim kut*) where her shaman teachers dress her in the gods' robes and pray for the inspiration that will enable her to manifest her gods as they appear and speak through her, one after another, giving a compelling indication of presence. A successful initiate speaks, however haltingly, in the god's voice; ideally, she bursts out with convincingly accurate divinations for those who have come to witness her transformation. But as described in chapter 2, many, if not most, initiation rituals fail, and many initiates are forced to repeat this expensive ritual multiple times. The anthropologist also notes the canny and successful initiate's ability to transform her observations of the rituals she has seen and the instructions of her mentoring "spirit mother" (*sin ŏmŏni*) into inspired and compelling performance (Kendall 1985; 2009).

As a fully-realized *mansin*, she conveys the ritual presence of deities through her own facial affect, voice, and body, and in the name of the gods, performs physical feats and delivers divinations, most dramatically in *kut*. A *mansin* prepares for *kut* with devotions, prayers, and a three-day fast from meat, eggs, and fish as "bloody food"; must not be menstruating; and must have no recent birth or death in her household. She bathes and primps, and dresses in clean, festive Korean traditional clothing, the sum of these efforts transforming her body into an appropriate instrument for sacred work. When she performs *kut,* her body enters the work of active and engaged performance—bantering, scolding, singing songs of future good fortune, quaffing wine, smacking lips over offering meat, tugging on clients' clothing, spilling blessing into clients' laps in cascades of chestnuts and jujubes. Most spectacularly, some *mansin* are empowered to balance the soles of their bare feet on fodder-chopper blades and from that perch, deliver astute divinations (figure 18). A *mansin* might also hoist the cumbersome carcass of a large pig onto her own shoulders and haul it away with seemingly little effort, or maintain a vigorous dance with the weight of a cow's head or a heavy crockery steamer of rice cake on her head. To determine whether

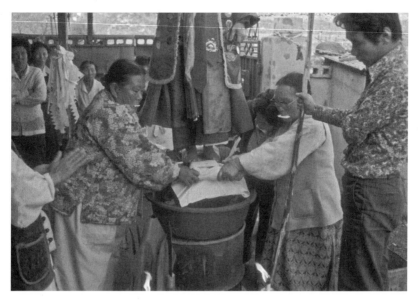

FIGURE 18. A *mansin* manifesting a General stands on blades for chopping fodder, Uijeongbu, South Korea, 1977. Devoted clients steady the blades with papers in their mouths to maintain purity. Photo: author.

or not the gods accept the offering of a *kut,* she balances a cudgel or a trident topped with a weighty burden of meat.

These are passing moments, and things not all *mansin* accomplish with the same panache. What every *mansin* must do is convincingly manifest a range of deities, one after the other, become the presence of an imperious general, a greedy lesser official, a flighty maiden, a tearful ancestor, a mischievous child. With face and voice and appropriately costumed body, she speaks and acts as a god would speak and act, and with the gods' authority, she creates an efficacious ritual theater where clients are chastised for past neglect and then promised the opening of an auspicious path. At the ritual's conclusion, the *mansin* casts away ghosts and ill humors that heretofore blocked the client's path, and when necessary, sends dead souls to the Lotus Paradise, a journey that benefits both the living and the dead. A skilled and inspired *mansin* causes participants to experience these things within the ritual theater of a *kut* (Kendall 1985; 2009).

For the *mansin*'s part, evoking gods in *kut* is not a one-on-one possession. It is not so simple, and in the *mansin*'s view, not so easy. A *mansin* must actively engage and manifest her gods, even so far as putting words

and gestures to their intentions. Within the ritual space of a *kut,* the *mansin* acts prosthetically on behalf of her gods, becoming the operable agent of their intentions, but not their puppet, a metaphor often applied to spirit mediums (plate 21). The *mansin* performs the gods into presence through divine inspiration—through a variety of aural and visual cues, including visions, vivid dreaming, and bodily sensations such as hunger, weakness, or rage—and sometimes inspiration is absent or insufficient. One aspiring shaman, Auntie Cho, told me with great frustration how full inspiration had long eluded her; she was a visionary, but she lacked the ability to put words to what she saw. "A friend of mine asked me to divine for her, and when I did, I could see everything, even to the graves of her ancestors. But a shaman has to have sense; she has to know how to put it all together, everything about all the client's kith and kin [to make a convincing divination]" (Kendall 2009, 25).

When the gods' intentions are unclear or ambiguous, the *mansin* must improvise. In footage captured by Diana Lee and myself for our film *An Initiation Kut for a Korean Shaman,* when the initiate falters, the experienced shamans tell her bluntly, "Hey, do you think some god is really going to move your tongue for you?" (Lee and Kendall 1991; Kendall 2009, 82). This was not an invitation to charlatanry. If the *mansin* got it wrong, if she did not faithfully transmit the will of the gods, she and her clients would be punished by dissatisfied gods. Even without a clear transmission, the *mansin* must get it right, perform it right. Some of this is formulaic. Gods resemble stock characters acting according to type; they say predictable things personalized to the situation at hand while *mansin* interpret domestic crises with a canny sense of family dramas built on experience. But even so, the stakes are very real for the *mansin.* This belief is widely held among Korean *mansin* and ritual infelicity is serious business with bad consequences; it also fuels the damaging gossip of rival *mansin.* A successful *mansin,* on the other hand—a *mansin* who correctly conveys the gods' intentions and consequently enjoys their favor both on her own and on her client's behalf—is said to enjoy a relationship of compatibility (*habŭi*) with her personal gods. Her gods send her the rush of inspiration, the radiant energy that informs her words and actions such that she maintains a successful practice, giving astute divinations and performing efficacious rituals; her reputation grows and she gains more clients.

*Mansin* engage the sacred in two primary spatial-temporal locations: in their personal shrines where their god pictures hang above the altar and on sacred mountains (*myŏngsan,* lit. "bright mountain," 명산, 明山). The

shrine is the site where the *mansin* daily seeks a condition of *habŭi* with her gods. In front of her god pictures, she makes her own daily offerings of pure water, lights candles, burns incense, and presents her petitions—a modest ceremonious technology involving both material and corporeal elements. An elaborately decorated shrine, a sign of the successful *mansin*'s return of gratitude to her divine grandmothers and grandfathers, bespeaks the presence of efficacious gods who have favored her with a successful practice. In effect, (although I doubt that any *mansin* would admit this) the shrine is an advertisement of the *mansin*'s success, a testimony to the efficacy of her work. Think of these operations as a sort of divine feedback loop. Neglect of the shrine violates the *mansin*'s relationship with her gods and brings repercussions. When Yongsu's Mother was flat on her back with a broken leg, her "grandfathers," her enshrined gods, gave her rough and violent (*sanapta*) dreams. With a sense of urgency, she ordered her son—who only grudgingly accepted his mother's profession—to pour water and liquor into appropriate bowls and cups each morning to satisfy the grandfathers and grandmothers in the shrine.

Different kinds of offerings are, in effect, plug-ins, sites of material connection between a particular client and the gods associated with her household, a particular *mansin,* and the *mansin*'s gods resident in the images in her shrine. Bowls of water, bottles of liquor, packages of candles and incense and boxes of replacements, a basin of rice grain, seasonal fruit, cellophane packs of candy for the Child Gods, come from the *mansin*'s own devotions and from clients. These require more or less constant replenishment. Whimsical touches such as artificial flowers, dolls in glass boxes, figurines of childish-looking monks, or even an aquarium with live fish to amuse the Child Gods are usually expressions of the *mansin*'s own intimate connection with different gods, as is the practice of placing personal gifts first on the altar before using or consuming them. Many of the incense pots, offering bowls, and decorative paraphernalia in the shrine bear the names of clients, and some of the costumes carefully stored under the altar are embroidered or inked with client names as indications of a more durable bond between the clients, the *mansin,* and the gods inhabiting the *mansin*'s shrine, a tap-in to the larger assemblage (Kendall 1985). Regular clients acknowledge these ties to a shrine by coming to the *mansin* for annual divinations and seasonal rituals, affirming that the gods in their regular (*tan'gol*) shaman's shrine respond to their petitions in effective ways. When the gods are not responsive, the clients go elsewhere, sometimes to a Christian church. A productive flow of inspiration—from gods to *mansin* and through

*mansin* to clients as divinations, divine manifestations in *kut,* and other ritual actions—can be disrupted by the improper use or placement of paintings in the shrine, as when Yongsu's Mother's gods quarreled and fell to the floor. More seriously, acts of impiety and pollution—touching a corpse, having sexual intercourse in an otherwise sacred place—might cause the gods to depart from their seats in the images.

While gods transmit inspiration to the *mansin* via the god pictures in her shrine, it is the *mansin* who draws the gods into the pictures and nurtures their favor through her acts of devotion and supplication, including pilgrimages to sacred mountains as the third node in our discussion. Mountains are particularly potent concentrations of divine energy in the *mansin*'s landscape, high pure places where gods gather and where *mansin* encounter concentrations of divine energy (figure 19). *Mansin,* and particularly recent initiates, describe a constant cycle of intense prayer and pilgrimage in order to build up their store of inspiration, to feel the gods' intentions more clearly, to make the gods more powerfully present in the *mansin*'s own sensing of their intentions. Some *mansin* have stories of the particularly vivid visions and uncanny voices they have encountered on these journeys. "When we go to the mountains it's as though we're recharging our batteries," an old male shaman told me with a grin. I grinned back because I had been using that very same metaphor when I told my students in New York about the *mansin*'s journeys to sacred mountains and what they hoped to accomplish there. Something metaphorically like an electrical connection binds the shrine with its god pictures to the distant mountain through the mobile body of the shaman who runs between them, much as per the Balinese priest's metaphor of the cable that transfers gas to the engine of a motorbike. Before departing on a mountain pilgrimage, the *mansin* announces her intention to the gods/images in her shrine and takes her leave. When she returns, infused with the energy of a sacred mountain site, she first enters the shrine and prostrates herself in front of the god pictures, announcing her successful return. She leaves on her journey with no words of farewell to any human, be they family member, neighbor, or passerby, and she returns with no words of greeting until she has bowed in front of the images. Social acknowledgments of arrivals and departures would sever the flow of energy between the mountain, the shaman, and the images in the shrine.

I was told many cautionary tales before setting off for the first time to Kambak Mountain with Yongsu's Mother and her colleagues in the spring of 1977. We had to be clean, not menstruating, not even making

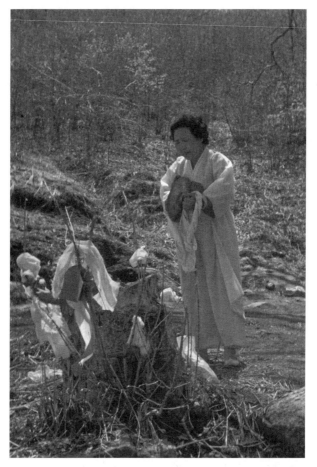

FIGURE 19. *Mansin* praying on Kambak Mountain, South
Korea, 1977. Photo: author.

verbal reference to menstruation, not from houses or neighborhoods
where there had been a recent birth or death, our bodies scrubbed clean,
our hair washed. We were to have "bathed" in cold water in the early
morning chill—a quick splash on the face sufficed. And if, en route, we
were to hear that someone had died, the project would be aborted, and
we would turn around and return home. The sighting of a dead frog or
a squashed bug would be reason enough to abandon our journey. We
left at dawn and hiked all day. Some of the *mansin* quarreled, we missed
a critical trail, and returned footsore and hungry. This was not auspi-
cious and in the following months there was speculation among the

*mansin* as to whether mistakes made on the mountain were the cause of some subsequent personal disappointments. As I have written elsewhere, these pilgrimages have become much easier in the decades since my first field trip: a short journey by private car on paved roads to a commercial shrine that provides on-site catering. All of this means that going to the mountain has become a more frequent activity. Potent mountain sites are sometimes crowded with worshippers, and *mansin* seek out pure and quiet places off the main path for particularly serious work, such as inducing the birth spirit into an infertile womb. But for any mountain visit, the pollutions and purifications and the sense of power on the mountain are all still taken very seriously. The mountain remains a power-charged and power-charging place.[4]

In sum, gods operating through god pictures "charge" the *mansin* with inspiration, empowering her to do her work, but the *mansin* also works to keep the images charged with the presence of gods. She does this in the first instance by drawing the gods to her through acts of devotion and purification, such that they desire to take up residence in her shrine. By these same activities, a fully-realized *mansin* with an active shrine sustains an amicable relationship with her gods and when necessary, repairs and reboots it (or not). Through her own effort, through the mobility of her carefully purified body, the *mansin* recharges the stationary images with divine energy from the mountain. This is a different sort of motor assemblage from the contained agency of statues set in place in temples in Vietnam or even the *nat* images in Myanmar who are carried to home temples for a periodic "irradiation" of *nat* power. A burden of agency rests constantly on the *mansin* to keep the gods present. And although I have been thinking about *mansin*, god pictures, and mountains for many years, I doubt that I would have fully appreciated their combined operation without comparing them with the operations of mediums and magical things in other places.

BALI: MASKS IN ASSEMBLAGE

Electricity is also an apt and pervasive metaphor in Bali. Angela Hobart (2003; 2005) and her Balinese conversation partners used it for the graveyard consecration ground; our priest conversation partner used the charging of a motorbike engine as analogous to the enlivening of a statue. Hildred Geertz notes that Balinese readily speak of electricity to indicate that if you touch a *tenget* thing, such as an empowered temple mask, it can hurt or kill you.[5] The empowered temple mask on a *pemundut's*

purified body becomes another work of machine assemblage powered by forces operating in and through an image. In Hobart's (2003, 131) words, "the mask, and to a lesser extent the costume and performer, is said to be impregnated by the gods." The work is dangerous; practitioners of black magic are expected to attack the *sesuhunan*. *Pemundut* who wear these masks are known as men of *sakti* with a store of mystical power sufficient to protect them.[6] Fanged Rangda is a particularly perilous role where entranced dancers thrust their *keris* at the masked figure's torso, the actions so memorably recorded in the Gregory Bateson and Margaret Mead film, *Trance and Dance in Bali* (1952). The stab thrusts, recreated for tourist viewing all over Bali and nearly every day, are easily simulated and secular performers wear protective belts just in case. But in the charged atmosphere of a temple festival (*odalan*), stabbing can be deadly serious business. Wayan Ariati and I heard from several conversation partners in different parts of the island about the young *pemundut* who died of his wounds a few years previously. Some said that he had precociously gone to perform in a community outside his own and that his personal store of *sakti* was not sufficient to the task. Others said that by wearing a protective belt in a sacred performance, he had not shown sufficient faith in the power of the *sesuhunan*. By contrast, the old priest who had described a mask's ensoulment as equivalent to putting gas in the tank of a motorbike, a veteran *pemundut* and a recognized man of *sakti*, described the thrusts of the *keris* blades as equivalent to the pleasure of sexual penetration.

Ubud people recalled an old *pemundut*, now retired, who walked unsteadily on arthritic limbs but who, when bearing the mask of the community's powerful *sesuhunan*, would sprint through the surrounding countryside for hours on end, his feet moving so quickly that they seemed to fly over the rice fields without touching the ground. But in contrast with what might be said of the feats of a Korean *mansin*, this Balinese tale was told not to glorify the *pemundut* so much as to witness the extraordinary power of the mask/*sesuhunan*. While the temple statues and god pictures we have been considering are similarly regarded as empowered, approached with caution, and not touched casually, they remain on the sidelines, they do not walk and talk. Balinese temple masks, by their nature, move directly into the center of the action. In Korea, the *mansin* herself is a miming presence with a reputation at stake, twisting her face into Grotowskian masks and assuming the characteristic postures of her gods.[7] In Vietnam or Myanmar, where less is expected of the medium than of the Korean *mansin*, presence still

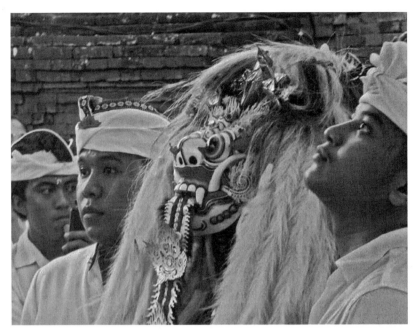

FIGURE 20. Masked Rangda and devotees during the Festival at Pura Pengerebongan, Denpasar Utara, Bali, Indonesia, 2017. Photo: author.

becomes palpable through the transformation of the medium's own facial and bodily affect. In Bali, the individual medium all but disappears. When I tried to track down a medium a few days after an unforgettable temple performance, I discovered that outside the circle of festival organizers, people seemed unconcerned about his identity. In performance, the human *pemundut* is subsumed by the head-covering mask, the body-enveloping cloak, and the overwhelming presence of the *sesuhunan* operating through the mask (figure 20). As performance scholar John Emigh (1996, 7) puts it, the mask is not an element of cosmetic disguise but rather "an instrument of revelation, giving form to the ineffable." Hildred Geertz (2004, 72–73) describes the ritually consecrated Balinese temple mask as an "engaged agent within ritual action (and therefore dangerous to treat casually)." The mask is at the center of the work, but who/what is it that inhabits the mask?

Demonic-looking Rangda with her fangs and lolling tongue, and the lion-like Barong who prances on four legs, are characters both divine and demonic who appear in the sacred dramas performed in temple festivals all over the island (figure 21). These are also iconic images

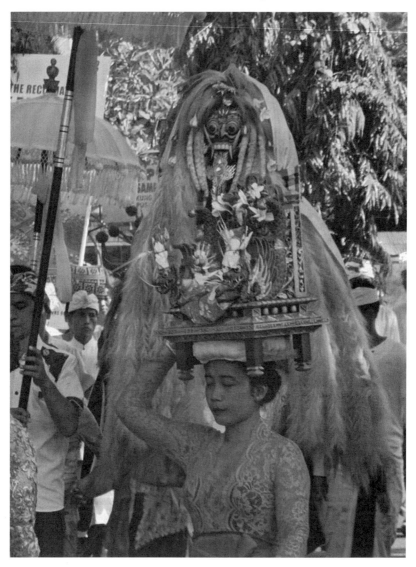

FIGURE 21. Rangda mask carried on the head of a devotee in a festival procession, Tegaltamu, Bali, Indonesia, 2017. The mask that Belo describes was probably displayed this way as the procession approached this same village. Photo: author.

reproduced in nearly every promotional representation of Bali, enacted daily for tourist consumption, and have been performed on theater stages all over the world. Their iconicity as Balinese things obscures the particular identities of their local manifestations as vehicles for the energizing forces that have gone to ground in particular masks resident in particular places. Local masks/*sesuhunan,* while recognizable as "Rangda" and "Barong," acquire their own honorific titles, their own distinctive histories, and some have been known to lead complex lives. I read the following passage from Jane Belo's *Trance in Bali* (1960) when I was in graduate school and it stayed with me for many years:

> As the procession neared Tegaltamoe [Tegaltamu], villagers who were subjects of the god but who had not gone on the excursion fell in trance spontaneously as the Rangda passed. 'There was a man working upon a culvert, and when he saw the Rangda arriving from Padangdawa he ran home, his body still covered with mud, and took up his Kris [*keris*], and did *ngoerek* [*ngurek,* chest-stabbing] before the Rangda. . . . There was also a woman cooking in her kitchen, and when she saw the Rangda arriving she ran and took a Kris and began to *ngoerek* before the Rangda' . . . [followed by other equally dramatic examples]. 'Many were the people who went in trance . . . All the women cried and were afraid to see the people doing *ngoerek*' (73).

A mask radiating a sufficient force field to throw villagers into spontaneous and violent trance as it passed in procession (figure 22) constitutes a ferocious abduction of agency to something sensed and emanating from the mask itself. Whether that something was, on that occasion, divine or demonic, would be debated in Tegaltamu. Some would stoutly argue that only a demonic presence would have possessed villagers covered with mud or engaging in mundane housework, persons not properly bathed and consequently not prepared to engage the divine. On another occasion, in another community where she had seen many trance performances, Belo recorded how "The spirit in the mask is not necessarily the same *as the spirit in the man in the mask.* A man may go into trance when he is dancing in the Barong, but there may be no connection between the spirit which takes possession of his body and that in the Barong; whereas the spirit in the Barong may at the same time be in possession of someone on the outside" (149, 3, emphasis original, and also observed by A. Hobart 2003, 131). This mobility abducted to god/spirit/*sesuhunan* is also implicit in the practice of moving an enlivening force/*sesuhunan* from one mask to another, as would happen when an old mask is replaced with a new one. Similarly, when an old mask is temporarily de-animated for repair and refurbishment, the

FIGURE 22. Balinese artist Lempad's interpretation of trancers deploying *keris* blades (*ngurek*), 1930s, painting collected by Margaret Mead. Photo: American Museum of Natural History, AMNH 70.3/4187.

*sesuhunan* lodged in a temporary shrine until the mask is ready for rehabitation (also in Stephen 2001, 146–47).[8]

Sometimes *sesuhunan* act on their own volition, as in the case of the *sesuhunan* Ratu Anom who, having been abused in one temple, transferred to another.[9] It happened in a village in Gianyar Regency, where a single village had separated into two, Village A., the original village, and Village B., the new village. Village B. had a booming handicraft industry and wished to distinguish itself from its former neighbors. One lingering symbol of their former unity was the Rangda mask/*sesuhunan* known as "Ratu Anom," which the two villages had honored collectively but which now remained in the Pura Dalem of Village B. To mark their new identity, Village B. commissioned a new mask, so distinct that even the wood would come from another community. Having consecrated the new mask "Ratu Ayu," the villagers prepared to cremate the now ritually deactivated Ratu Anom.[10] A trancer snatched the mask from the flames and, speaking as the *sesuhunan*, announced, "Since you ignore me, I'm not going to be here anymore." The mask was not

burned but neither was it given offerings; it remained in a basket in the temple. Ratu Anom next spoke through a trancer in Village A., describing his abuse in Village B. and declaring his desire to return to Village A. This was Village A.'s first public knowledge of the abandonment of Ratu Anom. The *sesuhunan*'s claim was a serious matter, requiring careful deliberation and more confirmation from trancers before the new mask was made for Ratu Anom in village A. The mask-maker in Village A. who had carved the new mask for Ratu Anom told us that the original mask in the basket in village B was "just wood," an empty shell.

Another mask-maker, living near Ubud, made a new set of masks for a temple in Peliatan. When, following protocol, the old masks were to be cremated (*pralina*), the carver found himself unusually attracted to the Celuluk mask, representing an old woman practitioner of black magic. He considered this mask to be beautifully carved and wanted to use it as a prototype. The villagers consented but he felt uncomfortable about taking a community's Celuluk and demurred until some of the villagers delivered it to his door. Because the mask's enlivening presence had been moved to a new mask, the old Celuluk should have been nothing more than a mask, and in practice the Celuluk, as a comic role, may never have been enlivened with a *pasupati* ritual in the first instance. But when the mask-maker hung the mask on the wall of his studio, it began to show signs of life, knocking against the wall as if summoning the mask-maker's apprentice ("Wake up De") and knocking on the door of the mask-maker's son and daughter-in-law, rousing them in the morning.

The mask-maker says that he was skeptical at first but consulted a *balian* (healer) friend who immediately asked, "Where did you get that mask in the corner?" The *balian* had never seen the mask hanging in the corner, but he could visualize it clearly and discerned that it was now inhabited by the spirit of the sacred *lontar* texts the mask-maker's uncle had studied in the family shrine slightly east of his studio. The mask was placed in a basket and venerated with daily offerings. We asked if this was equivalent to turning the television set to a different channel and the mask-maker suggested a more consequential act of unplugging an electrical cord and plugging it into a different circuit altogether.

Balian A. had joined us for this interview, eager to meet the mask-maker. Early in the interview, and long before the mask-maker had shared the story of the Celuluk mask, I saw Balian A. move to another part of the room, closer to the basket, and wrote this into my notes. He later told us that he had felt something very like a vibration emanating

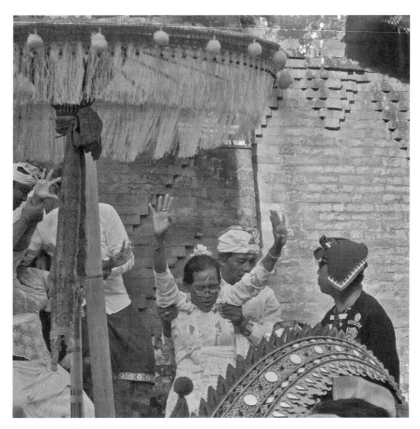

FIGURE 23. Women fall into trance during the Festival at Pura Pengerebongan, Denpasar Utara, Bali, Indonesia, 2017. The Barong's tail appears in front of the woman at center while followers hasten to catch another woman to her right. This festival is well-known for intense trancing. Photo: author.

from the basket, a sensing very like what he had described a few weeks previously at the start of a temple festival in Tegaltamu when a particularly powerful old mask had been carried past on the head of a devotee. Similarly, a member of a troupe that regularly performs for tourists told us that even in these performances, dancers sense the presence of invisible *niskala* energies around them on the stage. They experience this presence as something like a vibration, a growing sense of heaviness in the body, and then a loss of emotional control when trance unexpectedly takes them over (figure 23). Belo's description of the mask that drew people from their daily tasks and, out of proper context, threw them into trance no longer seems so eccentric.

*Tenget* masks, *lontar* texts and *keris* blades are imbued with energizing forces that can also depart from them (Wiener 1995) and, as noted above, mask types are not always consistent with the deities who appear when the masks are borne on the heads of human hosts. Ratu Anom from Village B. and the *lontar* spirit in the mask-maker's Celuluk would seem to have chosen their own habitations. Jero Amerika, renowned in and around the town of Ubud, is considered a male *sesuhunan* but likewise eccentrically inhabits a mask of old woman Celuluk. One expatriate connoisseur of Balinese art opines that Jero Amerika is not even a very good Celuluk mask, and some do not believe that the mask, whose origins are murky, was even made from sacred wood (Kendall and Ariati 2020). The *niskala* goes where the *niskala* wants to dwell. Where the *mansin*'s gods choose whether or not or how intensely to inhabit their proper images in a shrine, the *niskala* seem occasionally to make radical departures from type in choosing the image itself.

Masks made for secular performance (*bali-balihan*) are often commissioned from master craftsmen and are of good quality, but they are not made according to the same strict protocols and are not ensouled with *pasupati* rituals, much less night-keeping rituals. Some communities that regularly offer performances for tourists have developed a tradition of using substitute Barong (Barong *serep*), stored outside the temple for times when the community has been temporarily polluted and cannot bring out the temple Barong for a scheduled performance. *Serep* are also used on foreign tours and sometimes left behind in foreign museums. But because the performers make offerings and burn incense for the success of the performance and the well-being of the dancers, these repetitive expressions of sacredness may be cumulatively absorbed by the *serep*.[11] A respected mask-maker told Wayan Ariati and I that "When they get old, Barong *serep* become sacred. The sacred Barong in the temple [of his village] got old and needed to be retired. The Barong *serep* informed the people through trance. It was consecrated and no longer called Barong *serep*. It became 'Barong *waris*,' the Barong heir."[12]

Sometimes the process is less-anticipated. A French collector, "J.," visited Bali every year and stayed in the compound of a mask-maker while studying the craft. When he left Bali, J. acquired a Barong used in tourist performances that had been left in the workshop after the mask-maker had made a replacement. In France, the mask upset J.'s daughter and made her cry, so J. returned the mask to Bali. The mask-maker assumed that the once-neutral mask had been enlivened by the offerings

set out at the start of performances during its career as a *serep*, absorbing prayerful attentions and *niskala* presence over a period of years. He provided J. with a perfectly neutral new mask. Soon after the Barong's return, the carver received a commission for a temple mask and offered J.'s Barong, which had already proven itself as an efficacious mask. It then became a local *sesuhunan* of the commissioning temple.

Just down the street from this mask-maker's studio in Singapadu, another experienced well-known mask-maker had a tale to tell. He had carved a Rangda mask for the Institute of Art in Denpasar, a mask that would be used by the students and housed in a storeroom.[13] He was a well-known carver and the mask was likely of good quality. The mask would not rest quietly in the storeroom. It walked out and disturbed the sleeping security guard on the *kajeng kliwon* day by the Balinese calendar, a time for making offerings.[14] The mask had demonstrated a need for its own enshrinement. The students now make offerings to the mask on *kajeng kliwon* days and the mask no longer needs to wander about. This or another Institute mask troubles anyone who presumes to wear it and dance in a state of impurity.

Sometimes, it seems, a Barong wills himself or herself to be present in a mask. We heard the following tale, with great enthusiasm and detail, from several sources. What follows is a paraphrase of a version told to me in English by Drs. Suasthi Widjaja Bandem and I Madé Bandem: The female Barong, Ratu Mas, was carved in Singapadu several generations ago by the renowned mask-maker Cokorda Api. The Cokorda had just completed two major commissions for Barong masks and when he was done, he brought the remaining wood home and used it to carve another Barong. But the resulting mask displeased him, and he threw the mask into the rice field south of his residence. The local people set it in the rice field like a scarecrow, to frighten birds away.

One day a delegation was on its way to the mask-maker to commission a new Barong for their village. They walked from Sanur, on the coast, up to Singapadu, and were approaching the Cokorda's residence from the south. They halted and some of them went into trance. There was an uncanny atmosphere all around them. Before they could reach the *puri,* they heard the sound of crying. Someone was crying; the Barong was crying: "I've been thrown away, please save me, please save me." It had not been enlivened, it was just carved wood, but it was crying. They looked for it, they went into trance. The trancers said, "Somewhere around here there is a mask, or a scarecrow, or a figure. We have

to find that first before we go to meet Cok. Api," and they searched zealously because they were on a mission for their community and determined to meet with Cok. Api. They searched until they came upon the scarecrow. They carried this mask to the *puri*. There, Cok. Api said, "I don't like that mask, it's not good, I threw it away." The people from Sanur knew that mask has power, while Cok. Api never paid attention to it. So, the Brahmins from Sanur told the Cokorda, "Cok., don't make a new Barong. We found this one. Please fix it, give it a good form, and we will take it to Sanur and make it our own Barong." And that's what happened. The Cokorda repaired and painted it and then the people from Sanur took it home and had it ritually enlivened to make the process complete. It is still an active Barong to this day.

Masks that have drawn energizing forces to them without human intention and *sesuhunan* who are agentive in their own mobility are consistent with a broader Balinese understanding that well-crafted things have the potential to become "filled with the presence of *niskala* beings" (H. Geertz 2004, 164). In this vein, performer and scholar I Madé Bandem asserts that in Bali "there are really only phenomena that are very *wali* (sacred), *wali,* or less *wali*" (quoted in Herbst 1997, 131), all sacred but with different degrees of potentiality and realization. Beyond these unexpectedly enlivened masks, masks made by carvers who would, in other circumstances, produce masks for *sesuhunan,* there are also stories about masks that have circulated through the market, most as tourist commodities, some of them carried far beyond Bali, but then begin to act in uncanny ways. Some of these will be described in chapter 5.

CONCLUSION

This chapter began with a premise of connection, analogous with electricity, between ensouled images and the mediums and shamans who enable their animate presence in ritual settings. A deep dive into ethnography enabled both a demonstration of how these motor assemblages of image, human body, and divine energy are seen to operate and how these various contraptions are assembled in somewhat different ways. Gods operating through images "charge" the medium, such that she or he becomes their animate presence. The Korean *mansin* actively encourages the less contained and potentially volatile presence of gods in the images in her shrine, sustaining a sometimes-tumultuous relationship

throughout her career. The burden is on the *mansin* to show that she enjoys the gods' favor, that they empower her to do efficacious work. In the Bali examples, not only does the mask efface the medium, the *niskala* forces that animate it are abducted to a high degree of agency regarding their choice of mask-mount, a sign of their own uncanny power rather than the skill and effort of the medium or even of the mask itself.

# The Ambiguities of the Unsacred

When I first began talking with Western travelers, I wondered
if they were really serious about their beliefs in powers
objects have. One in particular, a man from Georgia on his
first trip to Indonesia, convinced me that this kind of thinking
was prevalent and sincere. He started off by telling me about
a mask he owned while living in Bali. He said it "just
attracted" him from the very first moment he saw it, so he
bought it and hung it on the wall. When he came home later
in the day, he found it on the floor cleanly broken in two
pieces, and a more knowledgeable friend who happened to be
with him clicked his tongue saying, "Oh, you got a wall-
jumper there, pal." He was told that the mask had a strong
energy, a powerful spirit.

—Andrew Causey, *Hard Bargaining in Sumatra*

The souvenir is, or ought to be, a pure commodity much as the making
of art, as "art," is commonly understood to be a modern secular activity,
a "fetish" only insofar as it has the seemingly miraculous and arbitrary
power to expand or contract in value, a "commodity fetish" as Marx
understood them (Belting 1994, 14–15, 458, 470–90; see Marx 1867).
Previous chapters have described the human labor—artisanal, ritual,
and in combination—invested in producing statues, masks, and paint-
ings that are intended to be more than neutral matter or inert representa-
tions, more than art as it is commonly understood. As elsewhere within
and beyond the Hindu and Buddhist world, the objects that I have been
describing act as conduits for prayers and blessings, and as in some other
places, these images combine with the efforts of shamans and spirit
mediums who make efficacious action through their own embodied
practice. And yet, as I shall argue in this chapter, boundaries between

magically empowered (or empower-able) things and pure commodities are not everywhere so strictly policed, either with respect to cognition of what they are or to the practices surrounding them. Indeed, this may be another false dichotomy derived from modernity's commonsense.

Statues used in spirit mediums' (and other) temples, god pictures, and temple masks are not, in the strictest sense, un-commodities, although the transactions that undergird their production and exchange are often elided where commissions are construed as a kind of religious offering and the artisan's work as a service to the gods. In Myanmar, the carving and gifting of buddhas for temples is a form of *dana,* giving to make merit in the Buddhist sense, something which "must not be perceived as nor resemble an exchange" (Kumada 2004, 4). Balinese master carvers will claim that they do not carve temple masks for money, or that there was less concern for payment in the past. The work, they say, is a service to a community that depends on the masks and the work that masks accomplish when they act in conjunction with *sesuhunan* for the community's protection and well-being. Recall also the sacks of offering rice that, in decades past, a Korean shaman brought to a temple when requesting a god picture from a monk painter and how the monk, having first bathed and purified himself, would place the rice upon the altar. And yet, even Mr. Hạ, the Vietnamese traditionalist sculptor who described himself as "doing the gods' things," acknowledged that the specially commissioned statues he produces are expensive. Production sites such as those for temple statues, god pictures, and temple masks pose an unavoidable area of ambiguity.

A vocabulary restricted to "commodities" and "transactions" risks missing the context-specific content of some of these operations. It is not unimportant that some conversation partners find it necessary to distinguish those commissions and purchases that have an intended sacred purpose from more mundane commerce (for example, Geary 1986 for medieval Europe). But as Ian Reader and George Tanabe note for a similar assertion of "donations" rather than "transactions" with respect to the enormous variety of religious goods and services produced and consumed in contemporary Japan, purchase and religious practice are in many situations inseparable (Reader and Tanabe 1998, 182–85). Witnessing this widespread discomfort over the market in sacred commodities becomes a starting point for the following discussion. The desire to elide any whiff of commercial transaction in many of these exchanges should be recognized as part of the complex social and economic circumstances in which they unfold. Vietnam, South Korea,

Myanmar, and Bali are far from the only places where magical things are the subjects of market transactions, and have been for a long time. From possibly as early as the fifth century, Chinese Buddhist practice fostered temple markets for offering food and other votive goods (Gernet 1995 [1956]) and by the sixth century, Chinese stone carvers were producing ready-made buddha images in standardized forms (Swergold et al. 2008). Walter Benjamin might find it ironic that in several twenty-first-century places, the more auratic the claims for the completed work, the greater its value, both tangible and intangible. At the same time, differently situated subjects debate the possibility that a product produced in a rationalized workshop and sold off the shelves of a shop might yet become efficacious in subsequent practice.

From another direction of theoretical practice, the inert thingishness of otherwise secular "art" images, their reduction to pure commodities in art market exchanges, is also muddled. David Freedberg (1989), David Morgan (1999; 2005), and especially Alfred Gell (1998) have caused us to see how agency is abducted to works of art, or even tourist kitsch as in Causey's traveler's tale, provoking strong emotions that range from deep and reverential engagement to emotional unease or even acts of vandalism. Indeed, the agentive ability of such objects to "attract" moves not only art markets but, for eyes accompanied by slimmer pocketbooks, the sale of souvenir masks and carvings.

Early in the new millennium, when I worked with the VME research team, the production of temple statues coexisted with a new enterprise of making brightly painted wooden genre sculptures, trimmed with touches of gold lacquer. These were mostly small human figures in traditional Vietnamese dress, no more than a foot high and intended for shops catering to foreign tourists. They were a category apart from temple statues, even from those crudely produced statues intended for shopkeepers' shelves in the market. Unlike the Mother Goddesses gifted to the VME, they could not claim even so much as the possibility of an alternative career as an enlivened temple statue. The figurines' purpose is decorative, and their intended customers are primarily non-Vietnamese. Many of these genre figures are produced by skilled carvers, and potential consumers have found them sufficiently attractive to have sustained a market for novelty carving for over two decades (figure 24). During our research, a Hanoi vendor of religious images grumbled to us that the successful market in novelty carving was corrupting the skill of the Sơn Đồng carvers, such that he sought his own stock in temple statues elsewhere. Genre figures are, for the most part, products of rationalized and

FIGURE 24. Novelty carvings, including a buddha, on sale in the CraftLink shop at the Vietnam Museum of Ethnology, Hanoi, 2019. Photo: author.

swift production, more explicitly pure commodities than even the cheapest temple images. Even though some workshops produce both temple statues and genre images, no Vietnamese would confuse them as to meaning or purpose. Newly carved temple statues have not become tourist commodities, although old statues (and just possibly recent fakes) do appear in the antiquities trade, as is also true for Burmese *nat* statues, Korean god pictures, and Balinese temple masks.

In the early 1990s, Irene Moilanen (1995, 17) reported on similar developments in Myanmar, "where religious art coexists with commercial or tourist art which needs only to please aesthetically and suggest 'tradition'. . . . The image is many times a mixture of Japanese, Chinese, Indian and Myanmar features." Unlike the scrupulous production of Buddha images finished in gold leaf or paint, novelty Buddhas were simply polished and stained in an appeal to tourist tastes. Some images were finished using industrially produced paints and lacquers that "can react unexpectedly to traditional surfaces," and some new forms, in particular a "pagan princess" inspired by mural paintings, were gaining traction for their popularity among tourists. On request and with the use of photographs, carvers were reproducing a range of new images, from Tibetan

statues to cigar-store Indians. A few carvers were also sculpting gallery art. The carvers themselves had all been trained in a tradition of religious carving, but a new market was pulling many of them into this new specialization, their work much in evidence on the shelves of souvenir shops in neighboring Thailand (17, 90–93). Twenty years later, with more tourism in Myanmar itself, decorative figurines were on display in handicraft shops in Mandalay and Yangon: genre figures, buddhas, and even *nat* in the archaic forms depicted in Richard Carnac Temple's (1906) early monograph. These were, again, souvenirs.

## SOUVENIR, COMMODITY, WORK OF CRAFT

Carvers of novelty images in workshops in Vietnam and Myanmar do not work in isolation from the world of belief and practice for which others of their number still carve. A Burmese, Thai, or Vietnamese would likely wince to see a novelty buddha placed on the floor or otherwise mistreated, much as a Catholic might wince at the abuse of a plaster saint, or as Madame Duyên reacted to the perceived disrespect of the Mother Goddess images. Even so, artisans regard decorative carvings for the market, even carvings of buddhas or barongs, as a fundamentally different kind of product from statues or masks that will be ritually enlivened as the subjects of consequential relationships with devotees. The venerable pedigree of workshop carving in Vietnam, Myanmar, and Bali, and the fact that carving and installing images in religious sites remains a contemporary practice, makes for a situation distinct from what has been described for the circulation of "ritual masks" and "idols" as souvenirs and high-end handicraft in some other places. The complex networks mustered in the production and distribution of African "woods," some of them piled on vendors' tables along the sidewalk outside New York's Museum of Modern Art, has been abundantly documented by Christopher Steiner (1994). Most of the traders are Muslim and as such, "completely detached from the spiritual aspect of the objects they sell" (88). Andrew Causey (2003, 87) similarly recounts a brisk business in woodcarving among the Toba Batak in Sumatra, people who have been Christian since the 1930s, but whose products are consumed by Western tourists who assume that these things are still part of a living animist practice. As one carver told him, "I was born a Protestant, right? So, when I make these carvings, it's just for the tourists, not for me. It's not like I think these things still have power. You know? I only make them to sell" (131). Elsewhere, distinctions and responses may be more

ambiguous, and vary among producers of a single genre. Among the Southwestern Santos carvers documented by Laurie Beth Kalb (1994), all at least nominally Catholic, the most cosmopolitan carvers regard their work primarily as art and engage a clientele of galleries and museums. Those who were less-educated and more devout Catholics considered their own craft productions as something other than sacred, while "The Santos they actually used in prayer were often mass-produced or historic" (38). And yet, when one of the art-identified carvers combined his wife's braid and his children's teeth in a reproduction of a death figure who rides in a processional cart during Holy Week, he would not disclose the names of his family members for the exhibition label: "He may not have made the Death Cart for religious purposes, but it still represented a sacred expression. In the Catholic religion, it is sacrilege to associate [ordinary] humans with religious images," (72) as saints' relics might be incorporated.

Igor Kopytoff (1986) has famously described how a single object biography might involve migration between different categories of meaning, as once-sacred things enter markets as antiquities and curios, becoming pure commodities with a whiff of their past lives enhancing market value. Some of these same objects recuperate sacredness in a different key as museum artifacts displayed in glass cases, carefully lit and respectfully gazed upon. While Kopytoff's notion of the object biography assumes a permeability of categories, the arc of his discussion traces a move away from domains of religious practice and into secular markets, galleries, and museums. In art museums, the prior religious purpose might barely be mentioned in the label text: "ritual object," "reliquary." A broader ethnography, however, suggests that images can wobble in several possible directions, rather than lurching irrevocably in the direction of disenchantment. Shifts between sacred and secular identities can sometimes be unpredictable and inconsistent.

## INCONSISTENT OBJECTS

Korean god pictures have not been reproduced in explicitly secular forms, although a few contemporary South Korean artists, notably Park Saeng Kwang, have drawn inspiration from them. In general, most South Koreans are reluctant to bring the trappings of a *mansin*'s shrine into their homes in the understanding that the paintings and other paraphernalia may have "ghosts" (*kwisin*) or "souls" (*yŏng*) still attached to them.[1] However, another Korean image, once regarded as powerful and

potentially punitive, has had a varied career in multiple secular forms, including souvenirs and contemporary sculpture, and is worth considering as part of this discussion. Village guardian poles or *changsŭng*, "devil posts" in popular English-language writing about Korea, once stood in pairs at the village gateway to frighten malefactors both human and spirit. In village settings, *changsŭng* received periodic veneration with wine and offering food in rites enacted by ritually "clean" officiants, usually at the lunar New Year. The *changsŭng*'s history over more than a century suggests a plasticity of meaning, in Susan Stewart's (1984, xii) terms, an object generated by means of multiple and changing narratives. *Changsŭng* are typically slender poles with the suggestion of deeply contorted faces at the top, bulging eyes, and Dracula mouths filled with pointed teeth, usually wearing the traditional winged caps of scholar-officials, and inscribed as a pair: "male general under heaven," "female general under the earth." In contrast with the statues, paintings, and masks of my four core examples, *changsŭng* in village settings were not artisanal productions. Rather, when they began to deteriorate after a few years of exposure, ritually purified elders would select an appropriate tree and ritually purified villagers would chop a log of appropriate size in an auspicious hour. Using their own simple tools in an atmosphere of communitas, villagers would collectively hack out the features and paint on the faces and inscriptions with black ink. A village elder would ceremoniously invoke the *changsŭng* into the newly erected poles, much as an ancestor is invited to descend into the tablet on an offering table. This homespun village process reflects the rudiments of carpentry magic that we have encountered in other places, the deployment of ritually "clean" participants, the selection of an auspicious day and hour, and the understanding that lapses could bring misfortune both for those who performed the ritual and for the village as a whole. These elements are typical of Korean village ritual more generally. Not crafted to endure, the biodegradable *changsŭng* were expected to rot, topple over, and be ceremoniously replaced in cyclical fashion every three years.[2]

In their writing about Korea, missionaries and travelers saw the *changsŭng* as an example of heathen idolatry, its crude, fanged visage demonically primitive and unsettling. The awful form fascinates. They documented it with photographs and used it to illustrate their accounts of life in Korea, committing their own acts of fetishization by causing the *changsŭng* to stand out as, in Peter Pels's (1993, 103) definition of the fetish, something "'curious' and 'rare' from the everyday world of commodities" (figure 25).[3] From the late nineteenth century, *changsŭng* also

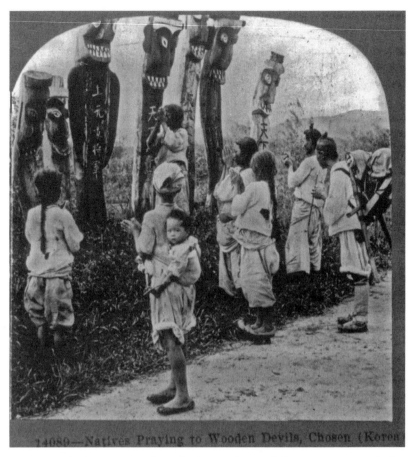

FIGURE 25. Paying respect to *changsŭng* in an early twentieth-century stereograph of Korean life. Photo: Library of Congress, LC-USZ62–72671.

entered the Japanese inventory of things Korean and the work of Japanese and Korean folklorists.[4] Through the dissemination of these different accounts by missionary, traveler, and colonial ethnographer, and especially through the reproducibility of photographs, the *changsŭng* became "quotable," in Thomas Hine's sense of a widely disseminated iconic image that "works" because it resonates with consumer expectations that "might or might not be at odds with the meaning of the original upon which the icon was based" (cited in Jonaitis 1999, 121). *Changsŭng* were exhibited in early world's fairs and miniaturized as souvenirs signifying "Korea." One finds them today in the souvenir stands of the Seoul/Incheon Airport and for sale in theme parks and tourist hotels, more often molded than

carved. For many decades, wooden *changsŭng* produced as decorative art have graced "traditional" Korean restaurants and wine shops, and some have found their way into museum collections.[5] But these "*changsŭng*" were produced, exhibited, and marketed in settings far removed from the places where, as guardian figures, *changsŭng* had work to do. Unlike the Vietnamese, Burmese, and Balinese workshops, where carvers who turned out decorative products were not far removed in their training and milieu from carvers of temple images, the workshops that began to produce *changsŭng* had no genealogical ties to the form's village origins, where *changsŭng* had been shaped in a ritual setting by the tools of village farmers. The rustic crudity of these renderings was a part of what caused them to "stand out." Gwon Hyeok Hui's (2007) research reveals how the miniatures were initially produced in Japan and shipped to the Korean colony for consumption by Japanese and other tourists. In other words, these commercial *changsŭng* have more in common with African "woods" and Toba Batak carvings, produced as unabashed commodities, than with those rare *changsŭng* still ceremoniously raised at the entrance to rural villages in celebratory recreations of a folkloric past for the benefit of television broadcast crews (see Kendall 2011).

From the 1980s, the identity of the *changsŭng* began to shift again. The then-dissident Popular Culture Movement (*Minjung Munhwa Undong*) of the 1970s and 1980s made a claim for a collective Korean national spirit experienced through direct contact with the music and arts of the common people. The *changsŭng* became a "widely regarded symbol of the masses (*minjung*)" when dissidents raised *changsŭng* at demonstrations bearing protest slogans such as "Great General Democracy" (*Minju Taejanggun*), or "Great General Who Liberates the Masses" (*Minjunghaebang Taejanggun*) (Yi Kwan-ho 2005, 4). Placed at the entrance to the Seoul Olympics Park in 1988, the *changsŭng* gained new prominence and a new identity as celebrated icons of a revalued past, not Other but "something uniquely ours . . . something that can only be seen in our country" (Kim Tu-ha 1990, 20–21). With an enthusiasm for things authentically Korean, both scholarly and amateur folklore surveys documented still-standing *changsŭng* (e.g., Kungnip minsok pangmulgwan 1988–97). By the 1990s, workshop carvers were producing large *changsŭng* to stand in front of museums, restaurants featuring traditional cuisine, public parks, pocket parks, amusement arcades, private homes, old peoples' homes, village halls, rural railway stations, and as posts for signboards advertising other folkloric activities such as pottery production.[6]

Art carvers who would vest their *changsŭng* with the "authenticity" of art and culture were now careful to distinguish their products from *changsŭng* produced as souvenirs, and novelty decorations, "devoid of beliefs associated with the original forms" (Kim Tu-ha 1990, 27; Yi Pilyŏng 1997, 272). One carver distinguished the signboard-bearing *changsŭng*, which can be made in a day and has no special meaning, from those that are actually intended to protect a house or business. Mr. Pak, Mr. Tak, and Mr. Sim (all pseudonyms), three sculptors producing innovative contemporary riffs on the *changsŭng* form, approach their work as something more than a secular enterprise (e.g., plate 22). Mr. Sim and Mr. Pak produce gallery art, while Mr. Tak carves quality *changsŭng* for restaurants and other businesses. All in their forties or early fifties when I interviewed them in 2006, they were young enough to have identified with the Popular Culture Movement, when *changsŭng* were raised on university campuses and other protest sites and inscribed with new identities. The sculptors were familiar with, or had themselves participated in, the half-playful, half-solemn ritual offerings, called *kosa,* made to the politically-inspired *changsŭng* as part of the ritual theater that preceded pro-democracy demonstrations. *Kosa* are offerings made to household and community tutelaries (such as village *changsŭng*) and are done today as a culturalist gesture on such occasions as the opening of a new factory or restaurant.

Each of the three sculptors incorporates a *kosa* to the *changsŭng* into his own carving process. Mr. Tak speaks of a carefully carved *changsŭng* as having a "soul" (*hon,* 혼, 魂) inside it. In Mr. Pak's words, "The *changsŭng* is not just about beauty, it is sacred (*sinsŏnghada,* 神聖하다)". When I asked Mr. Pak if he believed that the *changsŭng* had a spirit (*sin* 神) he answered with no hesitation: "I believe, I bow, I pray, and when I do my work, I bathe, I don't drink, and [with a grin] I'm someone who likes to drink." His words recall those of the carvers and painters I met in other places. Mr. Sim makes a *kosa* when he receives a large shipment of wood, or when he receives an exceptionally large commission. He does this, he says, because *changsŭng* "are not commodities (*sangp'um*)." Mr. Tak and Mr. Pak described artisans' taboos against sex and other pollutions that they claimed to observe when carving *changsŭng*. Mr. Tak described a slip of the knife as a common punishment for negligence, and Mr. Pak rolled up his trouser leg to reveal a gash on his shin. In other words, although *changsŭng* were not traditionally carved in workshops, much less sculptors' studios, these sculptors are producing them with an eye to the workshop magic found throughout the Sino-sphere, as well as

with a nod to village ritual forms. By such practices, they have caused the *changsŭng* to migrate back from the domain of pure commodity, where it had spent most of the twentieth century, to something more responsive to things unseen.

Mr. Tak produces *changsŭng* on commission for businesses that re-appropriate the *changsŭng*'s function as a guardian spirit, making it, in effect, a shop tutelary like the bearded Guan Gong figures so often present in Chinese restaurants. He asserted that one hundred per cent of the restaurant owners who order *changsŭng* from him do *kosa* when they set them up, usually turning to the carver for instructions on winding a white cord between the male and female pair, dangling a dried fish from it, and setting up a steamer of rice cake, a pig's head, and rice wine. "If they don't do it, they won't have good fortune (*chaesu*) in their business." According to Mr. Tak, *changsŭng* made precisely to a client's needs and specifications over a month or two of hard work bring good fortune to the client, while *changsŭng* sold off a shop floor would not. With an echo of Benjamin's notion of the "aura," in Mr. Tak's view, mass-produced *changsŭng* "lack souls," an argument by now familiar from other contexts of image production. While distinctions between aesthetic and spiritual appeal are blurred here, as when one speaks of an "animated sculpture" in English, Mr. Tak was clear about the potentially dangerous consequences of an inappropriately carved changsŭng. He also noted that Koreans might be reluctant to buy *changsŭng* figures out of fear of the spirit's strength (*yŏngŭihim,* 靈의힘) that resides in the wood. A sense of *changsŭng* power is echoed in the observations of shopkeepers and sculptors that idolatry-averse Korean Christians do not purchase even the small decorative *changsŭng* that are sold as souvenirs.

The *changsŭng* challenges a trajectory that would inevitably cast the once-empowered object into the reinscribing maw of "Western" or "modern" practices of commoditization. Something else happened with respect to some *changsŭng* which, by the late twentieth century, had been reimbued with a flavor of sacredness in such traditionally unprecedented sites as sculptors' studios, galleries, and traditional-style restaurants. Not all producers of *changsŭng* hold that the images have souls, but Mr. Pak, Mr. Tak, and Mr. Sim have a strong sense that they do, or ought to.

And while the *changsŭng* experience is intimately linked to shifts in recent South Korean history and the particular narrative of Korean national identity that has accompanied them, these somewhat individualized, sometimes playful sensings are far from unique to Korea. Teri Silvio (2008, 2019) describes the recent popularity in Taiwan of

miniature vinyl figurines of Daoist and Buddhist deities, all bearing the stylistic mark of Japanese *anime,* cute and accessible, and regarded by most of Silvio's informants as lucky talismans that help them to feel peaceful and optimistic. Some of these figures appear in business settings in ways that recall more traditional representations of the God of Wealth. While a few among Silvio's informants, high-status men, denied any link between deity toys and temple images, some others, mostly women, attributed agency to the deity figures, seeing them as effective means for communicating with the gods. These women saw the figures as being able to bestow comfort, good fortune, and other consequential action such as pregnancy. They held that their own belief and persistent practice could transform the toys into personally efficacious images, an adaptation of popular religious practice whereby in Taiwan, as in Bali, Vietnam, India, and doubtless many other places, applications of prayer and incense over time enhance the sacredness of an image (see also Lin 2015). With respect to the deity toys, Silvio (2019) finds these personal practices appropriate to the extra-village, extra-familial circumstances of many urban women.

*Ogoh-ogoh,* large demon puppets, are a recent addition to the New Year processions performed by Hindu communities across Indonesia. In Hindu-defined Bali, *ogoh-ogoh* are a celebratory form now traded on the international folk-art market. Kari Telle (2019) describes how among the Balinese minority on the island of Lombok, *ogoh-ogoh* processions intimate that Balinese have access to invisible powers. She found that the making, treatment, and disposal of *ogoh-ogoh* on Lombok reveals an emergent sense of presence and power vested in the figures. In West Bengal, Moumita Sen (2019) describes another initially secular expression that may be becoming something else. In a detailed and fascinating discussion, she describes how indigenous communities have refashioned the once-demonic figure of Mahishasur into a new narrative and a muscular heroic image consistent with their own leftist perceptions of Mahishasur as a working-class hero. Displays of this new Mahishasur, initially a secular political expression, have taken on some of the attributes of religious images.

In places with active traditions of image veneration and where national heroes almost inevitably become gods in popular religion, even civic statuary may not be immune to ambiguity and possible re-inscription. The quiet and thoroughly official installation of amulets into the public statues of national heroes in Vietnam has already been mentioned, and it is not unusual to find a standard plaster bust of Ho Chi

Minh, identical to those seen in government offices, on an altar in a Mother Goddess temple in Hanoi, sometimes draped with a spangled cloak. One thoughtful spirit medium explained to the VME team how she had once maintained a bust of Ho Chi Minh as a gesture of patriotic respect and would loan it out to the neighborhood committee for their meetings. In both her home and at the meetings, the bust was a patriotic symbol and not a god. Over time, she decided that Uncle Ho was ready for apotheosis in her own temple, appropriately set in place by a ritual master. She placed the modern revolutionary leader on an altar toward the front of the temple because Uncle Ho was a recent hero, in contrast with the thirteenth-century general Trần Hưng Đạo whose statue is situated toward the back of temple, closer to the main altar. Set in place on amulets and enlivened, Uncle Ho's image could not be moved, so she gifted her original bust to the neighborhood committee.

The appropriation of recent national heroes in statue form is not unique to Vietnam. In Korea, historic figures, particularly generals, have also been incorporated into the *mansin*'s pantheons. Shrines where national heroes were venerated in dynastic times have become modern national monuments. Heonik Kwon and Jun Hwan Park (2018) have noted that *mansin* sometimes avail themselves of these sites in ways not officially countenanced by the local authorities. In Incheon, South Korea, the site of the Incheon Landing that turned the course of the Korean War, some local shamans in the Hwanghae tradition include General Douglas MacArthur among the generals in their personal pantheons. However, with a significant and vocal Christian population, authorities in Incheon are far from pleased about local shamans' ritual activities venerating MacArthur at the site of his statue in a local park.

With this sense of the possible wobbling of an object identity, the non-inevitability that things intended to become pure commodities, art, or sites of secular public display will be only thus, we turn again to the fourth core study, Balinese masks like the one in Causey's story which sometimes uncannily resist the stabilizing categories of "decorative art" or "souvenir."

## THINGS THAT GO BUMP IN THE NIGHT

I had encountered workshops in Vietnam and Myanmar where distinctions were made between products intended for subsequent ensoulment and other products produced as novelties, and had met carvers who were highly cognizant of these different intentions. Bali intrigued me as

another possible example of pure commodity production cheek-by-jowl with something taken far more seriously. In Bali, replicas of temple masks have long been produced as souvenirs and decorative art. Like the Korean *changsŭng*, the masks of fanged Rangda and the lion-like Barong are widely deployed icons of place, most often the floppy Barong rather than the demonic-looking Rangda. They appear on travel posters, tourist brochures, guidebook covers, mugs, refrigerator magnets, and t-shirts (see figure 26). Masks of generally poor to mediocre quality are hawked in shops and from stalls. Unlike the *changsŭng*, which even from the early twentieth century signified to modern urbanites and cosmopolitan travelers the increasingly distant culture of rural villages, temple masks and the rituals surrounding them are woven into the contemporary fabric of Balinese life in towns as well as villages. Tourists and long-term ex-pats have been a part of the Balinese landscape since at least the 1930s and since that time, temple rituals involving sacred masks have been offered for their consumption and also taken on tour (Belo 1960, 97, 124–25; Covarrubias 1972 [1937]). These activities have injected an element of ambiguity into the sacred and secular divide that has productively agitated conversations within and about Bali ever since (Picard 1990). Today, ritual dramas derived from temple festivals are performed for tourists at multiple sites and by polished professionals as Indonesian regional performing art. In contrast with these performances, community temple festivals are not generally publicized to tourists, and some temple communities restrict admittance to Balinese only. The boundary between sacred performance and ritual entertainment would seem to be carefully policed. Even so, some enlivened masks are used in tourist performances (Picard 1996, 29, 159–62, 176) and sometimes those who give these performances find themselves falling spontaneously into trance. We spoke with a troupe whose members attributed the trancing to ritual activity in the adjoining temple, occasions characterized by a mustering of *niskala* forces.

Studies of Balinese mask-making record clear distinctions between the production and subsequent consecration of sacred masks and the less serious enterprise of mask-making for secular performances, museums, and especially the tourist market.[7] In contrast with the careful procedures described in chapter 3, masks for ordinary performances or decorative display are made of wood purchased in commercial lots, trees that have simply been chopped down instead of having their pregnant bumps ritually extracted on a lucky day and hour. Production also takes place without reference to the calendar, and the carver need not be

FIGURE 26. Boogie boards with iconic Barong on sale in the Sukawati Market, Bali, Indonesia 2017. Photo: author.

in a state of purity nor particularly meditative as he goes about his work. Even so, quality carvers produce quality work. In the last chapter, we encountered *serep* masks, substitutes for consecrated Rangda and Barong masks that are used in some tourist performances and on foreign tours. Because offerings are made for the success of even a tourist performance and for the well-being of the dancers, some *serep* may, in the manner of J.'s Barong, absorb this sacredness cumulatively over time and become *waris,* or "heir" masks used in temple rituals. Tourist masks, by contrast, are knocked out quickly in workshops dedicated to souvenir production and receive only a few coats of paint. The vendors who sell them in tourist markets in Ubud and Sukawati regard them as pure "commodities" (Ind. *dagangan*), in emphatic contrast with temple masks (figure 27; plate 23). Some vendors told us that they would be scared of the real thing. Hildred Geertz (2004, 72–73) describes the ritually enlivened temple mask as an "engaged agent within ritual action (and therefore dangerous to treat casually)." Unconsecrated masks, ordinary masks (*topeng biasa*), are, in her words, "merely a representation of demonic being (and sold safely to any tourist)."

FIGURE 27. Novelty Celuluk mask at Hardy's, Sanur, Bali, 2017. Few, if any Balinese would act so playfully with a real temple mask. Photo: author.

But in making this distinction, Geertz also notes an attentiveness to sacredness that pervades Balinese life. This includes the incense, offerings, and prayers that accompany even secular performances and enable some *serep* masks to become ritually potent *waris* masks over time. Material forms have the potential to become abodes of *niskala* beings, as some of the master mask-makers described. Fred Eiseman (1990b, 209) writes that "almost anything in Bali can become sacred, depending on one's feeling toward it and the way one treats it," and writes that "Even an ordinary mask can become *tenget* if it has been in the possession of the owner for a long time, and if the owner has made regular offerings to it out of respect." Ed Herbst (1997, 63) notes that "Spiritual energy in a mask is taken for granted even if not especially *tenget* (magically charged), ritual care and deference are always due a mask" (see also Eiseman 1990b, 208). Slattum and Schraub (2003, 13), who are elsewhere emphatic about the distinction between masks made by master carvers and tourist products, add the qualification that "even art shop masks, those made in an unconsecrated assembly line manner to be sold to tourists, have been known to become possessed." When we visited one of the many workshops in Sukawati where Barong were available off the shelf, the proprietor insisted that some of these would be purchased to become *sesuhunan.* The master mask-makers would probably dispute the efficacy of such *sesuhunan,* but we have seen such disparate positions with respect to magical images in other places. Performer and scholar Dr. Suasthi Widjaja Bandem told Wayan Ariati and me about a beautifully carved Rangda which she had placed in an art display thinking that it might be purchased by one of a group of visiting students from Hawai'i. Instead, a village delegation bought it to become their temple Rangda, circumstances she considered unusual but plausible because it was such an arresting mask.

The private family temple of the former rulers of Ubud houses a remarkable and much remarked upon mask, known in the popular media as "Jero Amerika" as mentioned in the previous chapter (plate 24).[8] Wayan Ariati and I have explored and analyzed the Jero Amerika phenomenon elsewhere (Kendall and Ariati 2020) and just a brief account will satisfy here. The story is perennially retold in human interest journalism and on social media, has been enacted in one spooky docudrama, and was related by several conversation partners. The mask in question was gifted to an expat as a wedding present, a seemingly ordinary decorative mask. But when the owner carried it to North America (some say New York, but the owner of the mask was a Canadian) it rattled in the dead of

night, made chewing noises when the family dined, and terrorized the children. Some say it flew. The owner returned the mask to Bali where it was received by the former ruling family of Ubud and, after yet more uncanny mask behavior, was recognized as being energized by a *sesuhunan*. On the head of a *pemundut*, Jero Amerika appears at local festivals, patrolling through and beyond Ubud to expose practitioners (*leyak*) of black-magic (*pangiwa/pengiwa*) (Ballinger 2004, 26; Kendall and Ariati, 2020).

## SACRED BY ACCIDENT

Jero Amerika, if spectacular, is far from unique. We heard many other tales of masks that, with no prior intention in their making, give some sensate indication of an animating presence charged with power and agency. In the words of scholar/performer I Wayan Dibia, such things become "sacred by accident."[9] As one small example, an unpainted mask carved by an American student hung on the wall of Wayan Ariati's home until her sister and cousin, disturbed by strange noises emanating from the mask, made her wrap it up and put it away until the student could claim it. Wayan Ariati notes that the whirring noise may have been made by bugs, but it just may have been the minor symptoms of an energized mask, as her sister and cousin suspected. Others offered more dramatic narratives about other masks.

In his student days, Balian A. went one day to pray at a temple and met an old man standing under a tree. The mysterious stranger gifted him with a Rangda mask, an ordinary decorative mask (or so the young Balian A. thought). But when he returned to his boardinghouse and his roommates decided to throw the mask around, as if it were a soccer ball, they all got diarrhea, which Balian A. "healed" with a similarly playful mimicry of a priestly gesture of giving them water that had passed through the Rangda's hair. The mask hung on the wall of his boardinghouse until he graduated and returned to his home village, where he gifted the mask to the priest of the Pura Dalem. Still considering the mask as decoration, the priest hung it in his home compound, but when he slept, the mask would come alive and hover over him. The priest returned the mask to Balian A., but when Balian A.'s father went to collect it from the priest's house, he could not budge it. Balian A., however, hefted the mask with no difficulty, uncanny object behavior that I had heard of in stories about miraculous buddha images elsewhere in Asia. The mask was housed in the temple in the family garden,

but the structure caught on fire. The mask's abundant hair burned but the mask survived intact, as sometimes happens with *tenget* masks.[10] This was all a strong indication that Balian A. should become a *balian* (healer), a destiny confirmed by a woman in trance. The mask now hangs in Balian A.'s personal shrine (*kamar suci*), a source of power and a biographical object in Hoskins's (1998) sense, an object that becomes a means through which a significant life turning might be narrated.

The director of a performing arts troupe told us how she had purchased two inexpensive masks from the Badung market, "ordinary things" which she carried in her backpack like any commonplace purchase. Even so, one of her students fell into deep trance when dancing with one of these masks. She danced and danced until members of the troupe managed to pull the mask from her face, leaving her weeping compulsively. Thereafter, the mask was marked "do not use," but another dancer put it on by mistake and the same thing happened. The mask now lives in a temple in the dancers' home village.

I Wayan Dibia describes a village in Bangli Regency where, in the early 1960s, a bull Barong had been made to enact the National Party's logo at rallies, a campaign stunt akin to the refashioning of demon Mahishasur as a working-class hero, a work of political theater and not initially a religious act. Retired from political work after the 1965 coup, the bull Barong was hung in a private house. Weirdly, the house began to shake. The owner moved the Barong to the community hall and the shaking began again. The members of the community (*banjar*) decided that the Barong was very strong, that something was empowering it, and they installed it in a temple as a source of protective power. The bull Barong is now performed to contest demonic forces, encourage good crops, and especially for the health of cattle and horses, who are sprinkled with holy water that has passed through the Barong's beard.[11]

Mask-makers were also keen to describe how masks they themselves had made leapt a category, like the mask that had been carved for the Institute of Art in Denpasar and took to nocturnal rambling. A carver in Singapadu made an oversized mask as a novelty for handicraft exhibitions and, in between times, hung it by his gate to advertise his skill. A psychic from Java who was passing by one night screamed and shouted that he wanted to worship the mask. After that, no one would exhibit the mask; it had ceased to be regarded as a neutral, secular thing, and the mask-maker moved it into his family shrine (plate 25).

As in the case of Jero Amerika, some masks that have been taken away from Bali rattle to signify a desire to return. A Javanese academic

visiting Bali bought a mask in a carving village. At home, the mask made his family uneasy and gave him nightmares, so he packed it up and sent it back to Bali in a carton addressed to Dr. I Madé Bandem. When Dr. Bandem stepped over the carton without opening it, his foot went numb. When two of his household staff opened the carton, they screamed. Then his wife, Dr. Suasthi Widjaja Bandem, took charge, offered the mask incense and water, and told it, "If you would like to stay here, stay, but don't do anything to disturb us," and so it was. A Rangda mask left at the Indonesian Embassy in Washington DC by a visiting performer remained stored in its original carrying basket and was left in a closet until another guest from Bali saw mysterious lights in the dead of night and heard laughter inside the seemingly empty space. The mask returned with him to Bali. Similarly, the director of a gamelan group in California received a Rangda mask from an anonymous woman who had acquired it in her travels but seemed anxious to transfer it to someone else. The recipient also felt uneasy about the mask which has since returned to Bali, where it passed through another pair of uncomfortable hands and resides now in a priest's family shrine when not performing in local temple festivals.

## ONTOLOGIES FOR THINGS UNEXPECTED

When we asked carvers and other knowledgeable Balinese how a mask could become "sacred by accident," beyond the intentions of a carver and a temple community, most began their explanations with the wood. In one mask-maker's words, "The wood must have been taken from a really special place. The carver bought the wood from someone [in a commercial lot], he didn't know," but the wood could have come from a charged and powerful *pulé* tree with an enlivening spirit/soul (*bayu*) already present. Or the carver might have used wood left-over from a sacred commission and therefore already the beneficiary of sacred protocols for making a *tenget* mask. The carver of the Art Institute mask that roamed around on offering days spoke of the strangely forked wood he had used for this commission, wood from a *pulé* tree that had been cut to widen a road and whose shape he still remembered vividly years after carving the mask. He wondered if potent material was the ultimate source of the mask's midnight wanderings. Even if a woodcutter had paid no attention to the calendar, since he was cutting a tree and not ritually extracting a bump, and even though there would have been

no ceremony, the tree could have been cut on a lucky day, just by chance. The carver might have begun his work in a good hour on a good day by happenstance. The carver and his tools might have been in a state of purity for another commission, and he might have worked in a properly meditative frame of mind owing to personal temperament and work practice, unintentionally producing a powerful mask. And finally, the *niskala* forces enlivening a mask might have exerted their/her/his own agency in choosing a vehicle: the crying Barong discarded by Cok. Api who willed herself to be found, repaired, and enlivened; the abused Ratu Anom who left Village B. and relocated to Village A.; the bull Barong, intended for political theater, who became enlivened and efficacious; the *niskala* that relocated from *lontar* texts to a Celuluk mask; Jero Amerika and the other eccentric examples described above and in the previous chapter.

Many Balinese do speculate that the buzzing noises emanating from a particular mask could be from insects, as Wayan Ariati did, and that "flying" masks are moved by the wind. And yet, most of our interlocutors comfortably abducted agency not only to ritually ensouled temple masks, but to some others that had given evidence of being ensouled and *tenget* outside the rules and procedures that normally obtain between Balinese and temple masks. While some of our interlocutors disputed the specific claims made for Jero Amerika, the *sesuhunan* identified with the town of Ubud, they did not discount the sometimes-uncanny power of masks. A Denpasar intellectual who wrote off the Jero Amerika story as "urban folklore" is the same person who related how seemingly ordinary masks that she had purchased from the market threw members of her dance troupe into deep trance. The carver who felt that Jero Amerika's antics in the town of Ubud were "all in the mind" regarded his own carvings of temple masks with supreme seriousness.

CONCLUSION

This chapter began in a space of polarity and opposition, between things enlivened and powerful and the iconic forms of such things when they appear as pure commodities and are put on secular display. The preceding chapters have already suggested that for the temple statues, god pictures, and masks of my core examples, an absolute distinction between magical things and commodities cannot be so clearly parsed.

The most traditional carvers of Vietnamese and Burmese statues or Balinese temple masks, and the few remaining traditionalist painters of Korean god pictures, mark the production of magical things with a careful selection of materials and adherence to workshop protocols, at least in the most traditional workshops. Korean god pictures are not reproduced as decorative art, absent the faking of old paintings for the antique market and a very few contemporary artists who play with the form. But even with respect to workshops that craft images for ritual use, we have already seen how fabrication protocols are not absolute and the prerequisites of efficacy are a matter of argument. As has been shown for the photograph (Edwards and Hart 2004; Morris 2000, 2009), the lithograph (Morgan 1999; Pinney 2004), and the print (Pinney 2017), including Korean god pictures rendered as prints, rationalized production is not always seen to evacuate the auratic quality of the image, although it does complicate the discussion.

When souvenirs, secular statues, and works intended for political performance are abducted to new intimations of agency, as described above, they further muddle the distinction between things fabricated to an intended magical purpose and things fabricated as pure commodities. Here, I took a detour by way of the Korean *changsŭng*, the village guardian poles that were once considered enlivened and powerful, but for much of the last century primarily known within and beyond Korea as a nostalgic decoration, if not a work of kitsch. I used the *changsŭng* to suggest how something rendered as pure commodity could, in particular circumstances and in largely idiosyncratic ways, be reinvested with a sense of power, even to the degree of bestowing auspiciousness on a new business. This was followed by other examples of images from other places, initially produced with secular and sometimes playful or political intentions, that seem to be taking on a flavor of empowerment through emergent practice. All of this was prelude to a discussion of the Balinese temple mask, produced for temple communities according to serious protocols and reproduced to varying degrees of craftsmanship for secular performances and as souvenirs. The processes that distinguish temple masks from souvenirs are well understood, but an ontology that allows for the sometimes-arbitrary operations of the *niskala* ultimately defies any clear boundary between things necessarily empowered or *tenget,* and things that are not. When the boundary is breached it becomes the stuff of remarkable tales.

This chapter has considered types and prototypes that morph across categories, following Kopytoff's discussion but complicating the trajec-

tory of his argument. The next and final ethnographic chapter considers the intersection between magical images and acts of human agency and intention where transactions in once-sacred objects take place in art markets or with museums. For this we return to our MacGuffin, the three gilded Mother Goddess images.

# Afterlives

"Museumification"—the entry of an object into a museum—
has a striking parallel with "sacralization"—the making of an
object sacred. Both are processes that remove the object from
the mundane world, and most notably remove the object's
exchange value. In theory at least (and the principle, though
often violated, is still normally held), neither museum objects
nor sacred objects, once they have been accessioned or
consecrated, can be exchanged.

—Crispin Paine, *Religious Objects in Museums*

This project began in a museum; it seems appropriate that we return
there to round out the discussion. In most institutional settings, the
process of an object's becoming a *museum* object is a significant passage
in its life trajectory, as Paine suggests: formal, solemn, and in the ideal,
irrevocable. What Paine's observation and its inspiration in Kopytoff's
(1986) formulation of the object biography do not yet account for are
the multiple and varied acts of human intention that move this process
before the object reaches a museum. The key players are often anony-
mous and their motivations unrecorded (O'Hanlon 2000). Different
and sometimes contested ontologies of object protocol and their possi-
ble violations or modifications enable a sacred or once-sacred object's
apotheosis as an art object or a museum thing. The paths that objects
travel on their way to becoming museum things can be more complex
and ultimately more interesting than grab-and-run (e.g., Küchler 1997;
Kendall et al. 2013). As with the three gilt Mother Goddess statues in
the VME storeroom, an object's prior history may continue to color its
identity even once this transformation has been effected and, as with the
three Goddesses, the residence of such an object in a museum may cause
unanticipated things to happen.

Museums are assumed to be agentive entities; they "collect," "accession," and thereby perform operations of "museumification." Objects, as we have more slowly come to recognize, are also agentive, but so too are the hands through which they pass in their journey. Because the prior lives of objects are most often only partially documented in museum records, we sometimes miss in these engagements the similarly agentive work of human actors such as Ông Đồng Đức and Bà Đồng Duyên who have been partners to these histories. In looking at agents and intentions, this chapter broadens, ever so slightly, the volume's focus on magical images to include other magical things that have come to museums from similar worlds of belief and practice and that were once, in some sense, enlivened or ensouled, or could have been. The discussion hews to the affordance of objects that can be both intentionally enlivened and intentionally disempowered, qualities of being that are too often absent in a now substantial literature about sacred material in museum collections.

Michael O'Hanlon (2000, 3) has suggested that "far more of the ethnographic material in the world's museums than was previously suspected may have been made specifically for sale to them." "Made for the museum" was most certainly true of our MacGuffin, although in this instance, emphatically not "for sale." The Vietnam Museum of Ethnology initially desired statues to use in an international exhibition, artifacts that would illustrate an exhibit story about the Mother Goddess Religion. But to characterize this acquisition as "commissioning," and leave it at that, misses the beating heart of the story. Recall that Ông Đồng Đức, the essential partner to this project, saw his contribution as a religious act, a service to the Mothers by sending their statues abroad as an educational medium intended to foster knowledge and respect for his religion. He solemnized his gift with an appropriate ritual. In front of the Mothers' altar, piled with offerings, he asked their permission to send the three images on a journey to New York via the VME and cast coins to verify the Mothers' assent. He described this presentation as calling on the Mother Goddesses to "witness" (chúng, chúng giám), actions similar in principle to what happens when a devotee makes an offering of a new statue in a temple. With their gift, Ông Đồng Đức and Bà Đồng Duyên were making a metaphoric equation between the Vietnam Museum of Ethnology and a small temple in their orbit to whom the Palace might have gifted a statue. Covered with their red cloths, the three new Mother Goddess images were carried in state to the museum through an improvisation on a protocol for relationships between

temple-keepers, devotees, divinities, and statues, a protocol that regarded gifting statues to temples—and now by extension to a museum—as a devotional act.

There was a precedent. When the Tiên Hương Palace made a similar gift of statues to the soon-to-be-opened VME in 1997, there was a similar witnessing. This was a proud moment and photographs of the procession that escorted the three covered statues on their progress to the new museum were prominently displayed in the reception room of the Palace, still there on my most recent visit in 2017. Once at the museum, the 1997 statues had gone on display in a glass case, as statues are sometimes presented in temples, engaging the visitors' gaze as temple statues are meant to do. It is understood by all involved that the museum is not a temple (there is no bowing, no lighting of incense) and that the statues have not been enlivened, but otherwise the analogy holds and the exhibitionary intentions of the gift are fulfilled by museum visitors on a daily basis. What Ông Đồng Đức had not anticipated when he made his second gift in 2001 was an area of ambiguity between his own understanding of what should happen to the statues and a professional code of museum practice that maintains surplus objects in a storeroom, keeps textiles like the statues' red veils separate from wooden objects, and sometimes makes difficult decisions about the scope of the objects it can accommodate in an exhibition. In other words, exhibiting statues in a museum was a new way of "doing the Mother's work," whereas leaving them uncovered and ungazed in a storeroom was a breach of the proper conduct that should obtain between people and divine images. The misunderstanding was compounded when Bà Đồng Duyên saw the statues placed close to the floor.

In our subsequent discussions, Ông Đồng Đức and Bà Đồng Duyên requested that the statues be stored high off of the ground, covered with their original cloths, and if possible, displayed facing the door in a spatial arrangement analogous to a temple floor plan (or palace throne room). In other words, the unanimated images were not, for Ông Đồng Đức and Bà Đồng Duyên, "just statues" or even just museum objects that were being treated according to the best understanding and resources of the VME staff. Through many conversations, the museum staff gained a deeper appreciation of how to care for temple images and the temple-keepers came to appreciate the museum's good intentions. The Tiên Hương Palace has since gifted statues to at least one other museum. A complete object biography would necessarily include an

appreciation of Ông Đồng Đức and Bà Đồng Duyên's intentions, how they adapted existing practices to an unprecedented situation, and how they remained in dialogue with the museum long after the statues had entered the VME's storeroom.

The dialogue over the treatment of the statues resembles the kinds of discussions that are taking place in museums all over the world as descendant communities make claims for the respectful treatment of their cultural patrimony (e.g., Drumheller and Kaminitz 1994; Mibach and Green 1989). The VME staff was reading some of this material in translation as part of our sacred objects project, described in chapter 1, and in one instance sharing with a young ritual master. In general, and in most of the existent literature on this subject, the parties to such negotiations have been descendant communities, on the one hand, and museums identified with the claimants' former colonizers or their equivalent, on the other. The Mother Goddess statues, by contrast, were understood by the VME as artifacts from Vietnam's majority Việt (or Kinh) ethnicity, an identity shared by most of the museum's staff. Staff also shared the temple-keepers' understanding that statues in temples have been enlivened with the presence of gods or buddhas and that these are not ordinary objects. Because the VME was a relatively new museum, researchers in our project had the enviable opportunity to have further conversations with the people who had commissioned, made, or used the things that had become the focus of our six research teams. In the course of this work, we were all learning to appreciate how objects in the VME (and other) collections carried persistent traces of their histories. As discussions continued regarding the proper treatment of statues, deities from the Four Palaces also made their feelings known in a remarkable incident shared by VME researcher Vũ Hồng Thuật:

> In 2004, I was responsible for bringing two guardian statues to the Museum that were a gift of the Tenth Prince Temple in Nghệ An province. I made appropriate offerings and asked the temple-keeper to cast coins for the spirit's permission to bring the statues to the Museum. The cast said it was possible [and I took the statues with me]. Several months later, I came back to the temple to participate in a *lên đồng* ritual performed by ritual master Trần Minh Thủy who was familiar with the goals of our project. When the Tenth Prince appeared, he addressed me, speaking through the medium but in the accent of Nghệ An province, "Why did you bring the god's statues to the Museum and let them lie down without a red cloth?" I answered, "Prince, we apologize for our ignorance. Please forgive us." The medium continued, "Although the statues were de-animated at the temple before you trans-

ported them to the museum, they are still sacred, so you have to stand them upright and cover them with a red cloth." As soon as I returned to the Museum, I went into the storeroom and saw that the two statues were lying on the shelves without a red cloth. I then asked my colleagues in the conservation department to follow the words of the medium.[1]

## BEFORE MUSEUMIFICATION

As the VME project continued, we realized that Ông Đồng Đức had not been the only improvisor. A member of the research team, Võ Thị Thường, had been troubled by the presence in the museum of a colorful "flower tree" (*xặng bók*), resplendent with paper flowers and other decorations. In Thái rituals practiced in Vietnam, shamans use *xặng bók* to lure celestial spirit *phi* down into the human world. The flower tree had been commissioned by the VME for the new museum and the identity of the woman who fabricated it was known. A joyful ceremony celebrating its completion had been documented on video and was on continuous replay in the exhibition hall, as if it were a traditional Thái shaman ritual. The researchers had assumed that this was a "women's tree," made by a female shaman. However, when Thường ordered another tree from this same source for another exhibition, Thái shamans made it clear to her that they regarded a flower tree as a potentially powerful and dangerous object. Local shamans avoided any contact with the tree fabricated for the VME. Thường wondered if Thái visitors to the museum might also be uncomfortable when they encountered this object. Her subsequent research revealed that the VME tree bore no resemblance to the trees used in women's rituals; it was not a "women's tree" for shamanic communication with *phi*. Instead, it replicated those used by male shamans. The woman who had fabricated the VME tree was not a shaman at all, but the leader of a Thái performing arts group whose performances included dances around a simulated flower tree, a cultural icon of the Thái ethnicity which the troupe used to set the scene. This same woman had fabricated the trees for these performances, although she considered the VME tree the most spectacular tree of all (figure 28).

Then the story took another surprising turn. Thường learned that in fabricating the tree, the woman had intentionally scrambled or omitted some key elements of the process in order to *discourage phi* spirits from ever using it as a *xặng bók*. She left out the long strings of bamboo that enable the *phi*'s descent, did not place the branches on the tree in tradi-

FIGURE 28. Making the Thai tree for the Vietnam Museum of Ethnology, late 1990s. Vietnam Museum of Ethnology. Photo: Phạm Lợi.

tional sacred numbers, and did not set jars of rice wine under the tree as an offering for the *phi*. She told Thường that, counter to the intentions of a real *xăng bók*, she was emphatically not inviting the descent of the *phi*, that she had nothing to do with shamans, and that while her work might resemble a *xăng bók*, the VME tree should not be regarded as a real *xăng bók*. The woman also admitted that some villagers were uncomfortable with the idea that she had fabricated a tree and blamed her for misfortunes in the community, but she emphasized that the tree she had made for the museum was not a tree of the *phi*, "so why blame it?" (T. Võ 2008).[2]

These improvisations, Ông Đồng Đức's gift of statues and the fabrication of a flower tree, were responses to an unprecedented situation: active collecting for the new Ethnology Museum and then for an international exhibition. In the one instance, traditional protocols were followed up to the point of enlivening, such that the statues *could* have been enlivened had Ông Đồng Đức gifted them to a temple, while the flower tree was made so that it would never enable the descent of *phi* down its branches, thoughtful negotiations in both instances. In Bali, as I would discover a few years later, a direct commission from a museum for a Rangda or Barong, a mask resembling a temple mask, is in no way remarkable. As with the VME's Mother Goddess images, there is no enlivening, something undertaken by the recipient community in any case. The carver need not concern himself with the careful selection of energized wood, the purifications of person and tools, the meditative attitude, and the attention to the calendar that accompany the carving of a Balinese temple mask.[3] This is a contrast with the VME statues, which could have gone to a temple and been enlivened had the VME relinquished the statues.

Making a museum mask in Bali is roughly analogous to carving a substitute (*serep*) mask for secular performances, as described in the last chapter; indeed some *serep* masks taken on tour have been acquired by overseas museums, saving the troupe the cost and trouble of shipping them home. While in some circumstances an extraordinary *serep* mask that has absorbed offerings and prayers over time might gain the stature of a temple mask, as described in the previous chapter, museum masks that are removed from incense, offerings, and the presence of *niskala* beings have less likelihood of ever becoming enlivened.

When I commissioned a Rangda mask for AMNH from the master-carver Tjokorda (Cokorda) Raka Tisnu (Tjok. Tisnu), I affirmed that no, I was not seeking a sacred (Ind. *sakral*) mask, but one of good quality that might, a century hence, show people the beautiful mask-making work that had been done in Bali. It would have a great bush of hair,

sometimes omitted in gallery masks of Rangda but important for conveying the full impact of an encounter with this demon-countenanced being. Tjok. Tisnu suggested using frangipani wood, harder, more durable, and more bug-resistant than the sacred *pulé* used for temple masks, and more of a challenge to carve. Like a proper temple mask, or a good-quality *serep,* the AMNH Rangda would receive multiple layers of paint over a month or more. This is in contrast with the more hastily painted tourist masks from mass-production workshops.

As is also desired for temple masks and for *serep,* the Cokorda told me that the AMNH mask must have *taksu,* that possibly untranslatable Balinese aesthetic quality mentioned in chapter 3. *Taksu* could be described as a kind of divine charisma, inspiration, or energy realized through the quality of a performer's or a carver's ability. Tjokorda Raka Tisnu described *taksu* as special (in his words, "very unique") and mysterious. A virtuoso carver necessarily has *taksu,* something in the manner of a divine gift, extraordinary skill and something beyond skill. The carver's *taksu* enables the creation of a mask that has *taksu.* Performers also have *taksu,* an ability to enthrall spectators with an extraordinary sense of presence, something the spectators also experience as *taksu.*[4] *Taksu* is not to be confused with another Balinese term we have also encountered: *tenget,* the potentially dangerous power of an enlivened object. *Tenget* objects and objects that are not considered *tenget* can both be vested with *taksu.* Secular but virtuoso performances of Rangda and the Barong should ideally exhibit *taksu.* Consider a broad general parallel in the study of material religion, where some images are known ethnographically to be enlivened, ensouled, or animated but many others, on aesthetic grounds alone, agentively arrest the gaze of those who encounter them (Freedberg 1989; Gell 1998; Morgan 2005). In Bali, the ontological assumption of presence combines with aesthetic enchantment such that in a temple festival, a sensing of *taksu* in the appearance of a masked performer makes a connection to the divine (Herbst 1981, 43). But even in secular performances and for secular masks, *taksu* engenders a profound visual response. This is the inverse of Pinney's (2017) discussion of Hindu devotional prints and also of the cheaply-printed Korean god pictures described in previous chapters. If aesthetic qualities can move us in agentive ways, even without magic, let us also remember that in some other contexts of devotion and practice, an aesthetically unremarkable product can still be charged with divine presence in its proper context.

But beyond pure aesthetics, according to Tjok. Tisnu, *taksu* is also necessary if the mask is to last for a long time; a mask without *taksu*

will only last for a few years before bugs attack it. Balinese have told me that they know *taksu* when they see it. I would not trust my non-Balinese judgment, but I will note that when Tjokorda Raka Tisnu's Rangda was placed on exhibit in the American Museum of Natural History, it drew museum visitors from across the expanse of the Museum's Grand Gallery for a closer look at the mask installed in a small exhibition case in a far corner of the hall (plate 26).

## APPROPRIATIONS, THEFTS, AND FRAGMENTARY HISTORIES

Histories of fabrication, where we do record them, teach us a great deal about the objects they are intended to represent and the intentions of those from whom they came. Old objects that were once in use often reach museums by circuitous paths and vague or unknown histories. Rarely are transactions with the original owners recorded in any detail. More often they are shrouded in tiers of trade secrets, both those of the runner and those of the dealer. At the turn of the last century, Waldemar Jochelson described his acquisition of a shaman's robe from the Yukaghir Yegor Shamanov (identified by Jochelson as AMNH, Anthropology 70/8440) (figure 29). Jochelson (1926, 171) records the encounter with these poignant lines: "He sold it to me after much persuasion on the part of the chief. When the deal was concluded, he passed the money over to the latter and in silence left the tent where the purchase was arranged. As I was informed later, he was crying because he had been deprived of the hereditary shamanistic dress, in which he saw the main source of his shamanistic power." As the curator of a collection that includes the likely Shamanov robe, I have long been troubled by this story and have asked visiting indigenous scholars familiar with the Yukaghir how a shaman, a figure regarded with awe and fear, could have been persuaded to relinquish this powerful object. They attribute Yegor Shamanov's capitulation to his perception of the even greater power of the Imperial Russian state. History does not tell us whether Yegor Shamanov intentionally disempowered the robe or performed other acts to disassociate himself from it before his melancholy relinquishing. When his grandson, the Yukaghir linguist and poet Gavril Kurilov, saw the robe on exhibit at AMNH in 1997, he told me that it was "dangerous" and that I should avoid any contact with it.[5]

With respect to Yegor Shamanov, we have a name, a few lines of circumstance, even an encounter with a descendant, and this is rare.

FIGURE 29. Identified by Jochelson as Yegor Shamanov's robe, collected c. 1900.
Photo: American Museum of Natural History, Anthropology 70/8440.

Sometimes, intentions leave a faint material trace for informed supposition. Laurie Margot Ross (2016), in a detailed study of masks used in the ritual dramas of Cirebon, Java, describes how these masks typically had empowering amulets placed where the wooden interior of the mask would have encountered the performer's forehead, practices similar to the ensoulment of masks in Bali. Masks from Cirebon sent to the World's Columbian Exposition in Chicago in 1893 and subsequently acquired for the Field Museum of Natural History reveal that their amulets were destroyed somewhere in transit, probably by persons "who knew or feared the masks would not return to Java. They were correct" (50). In other words, the Cirebon masks may have been quietly disempowered, an initial and expedient desecration in order to prepare them for a future that would necessarily be profane.

Records in the Liverpool Museum describe how, when a complex of Buddhist images were removed from their altars on Putuo Island during the first Opium War (1838–42) and subsequently shipped abroad, the brass plates at the statue bases were removed by the collector and the "manuscripts," probably amulets and other enlivening matter, were stored separately and subsequently lost. Louise Tythacott (2011, 34), who has made a detailed object biography of the "Putuo Five," observes that "As no ceremony has ever been undertaken to close them, the eyes of the Putuo Five are still, to this day, open." Or perhaps not. The collector, a British officer, claimed to have obtained the images "from the priests," although, as Tythacott dryly notes, "Whatever was intended by 'obtained,' it is clear that the deities were acquired during a period of military occupation and in circumstances of unequal power. The Buddhist monks, officials, museum curators and scholars whom [Tythacott] interviewed on Putuo and the Zhoushan archipelago in 2007 all believed that the sculptures were, in effect, stolen" (62–63). But might the monks, even without full and proper ceremony, have acted in extremis and with more of an invocatory arsenal than the women in the Vietnamese village who implored the Mother Goddess's forgiveness as they removed them from a temple altar at the height of an anti-superstition campaign? There is also a general sense in the Hindu and Buddhist world that ignored, decrepit, broken, or otherwise desecrated images lose their power as a matter of course.[6] The precise timing of a repair or a replacement would depend upon individual or communal resources. Recall the extensive temple renovations undertaken from the 1990s in Vietnam, projects which coincided with the appearance of many old statues on the market. Some of these were likely stolen, but others had equally likely been replaced by larger images as communities began to assert their stature with new wealth.

Yegor Shamanov's robe, the Cirebon masks, and the Putuo Five are not happy stories, and they are consistent with the contemporary recognition that insensitivity, ignorance, and sacrilege has too often accompanied the transformation of empowered objects into museum things in "the hall of stuff we stole from other cultures" as a *New Yorker* cartoon recently put it (e.g., Causey 2003, 153–54; Paul Taylor 1994; Volkman 1990). In the absence of specific histories, we are left with Stephen Greenblatt's (1990, 44) troubling assumption that most of what we see in museums and galleries was necessarily "pulled out of chapels, peeled off church walls, removed from decayed houses, seized as spoils of war, stolen, 'purchased' more or less fairly by the economically ascendant from the economically naïve." Outright theft from temples and shrines is most certainly known

in the places that I have been describing. In Vietnam, tales of temple images inspiring fear and so discouraging potential thieves in the past—the well-intentioned thief who could not advance beyond the temple threshold and the statues that remained intact in abandoned temples—often lead to unhappy comparisons. In the present moment, the market in antiquities encourages larceny. The tellers offer a wry awareness that before the radical revision of economic policies in 1986, there was little or no market for stolen antiquities. In the new economy, the traffic in temple statues implies both a lack of respect for the potential agency of divine images as the body containers of deities, and their revaluation as "art" such that a new desire for cash or possession is abducted to them (cf. Hoskins 2006, 77) (plate 27). And yet, a whisper of statue agency persists. Nguyễn Thị Thu Hương, Vũ Thị Thanh Tâm, and I did hear of a recent and notorious theft from a Buddhist temple where the thieves killed a monk but were subsequently apprehended at the border, circumstances construed as divine retribution. When an ambitious collector experienced a family tragedy, his friends thought of the many antique temple images that he had collected and displayed in his home. Such cautions are not sufficient to dissuade the traffic in antique images, some of them destined for foreign markets where buyers are innocent of these concerns. Ông Đồng Đức told us that he was now commissioning bronze statues for his temple because their weight would make them more difficult to steal.

Hanoi dealers are not unaware of these concerns. One told us that he only handles statues that come to him with the temple's documents authorizing the sale of a properly de-souled statue. Temples might do this when renovating and installing larger or better-quality statues.[7] We saw divine images, their cavities covered as though the statues were still ensouled, purchased by a collector from the same dealer who claimed that his merchandise always comes with a de-animation certificate from the temple. Some temple statues in the hands of private collectors had empty cavities testifying, unequivocally, that they did not hold the material accoutrements of ensoulment, while others were seemingly intact, their status an open question. Perhaps a restorer had simply covered the aperture to the emptied cavity on a properly de-souled statue. Perhaps animation materials remained in a sealed but otherwise properly deactivated statue, awaiting discovery by X-ray in a museum conservation program (cf. Reedy 1991, 1992). Perhaps some of the statues with empty holes had been stolen and emptied in a profane search for the precious materials believed to be inside them. In the home of another private collector, we examined a beautiful old statue, the aperture covered in

place, that he had recently purchased in an antique shop. The collector described himself as a practicing Buddhist and therefore a "good person" who did not fear punishment from the deity resident in the statue; he seemed untroubled by the possibility that the little statue could have been stolen from a temple. Another dealer who described herself as a serious Buddhist visits the temple twice a month and places the statues in her shop at a respectful height above the floor to show respect. She makes no distinction between statues with their amulets and other ensouling material still inside them and empty statues. Another dealer has a ritual master perform a de-souling when he acquires a suspicious statue, just in case. These are objects of ambiguity.

I know little about the prior history of the bronze warrior image from Central Vietnam which was collected for the American Museum of Natural History in 1968 by a researcher in the employ of the US Armed Forces (AMNH, Anthropology 70.2/5449). It came to the museum with the aperture open and the statue body empty, save for a few old Chinese coins. One can only speculate, as Tythacott does regarding the acquisition of the Putuo Five during the Opium War, as to how the bronze warrior image might have been acquired in the chaotic months after the Tet Offensive. This statue has stood for forty years in the Hall of Asian Peoples of the American Museum of Natural History, described fancifully in the original label as a "Vietnamese Money God. Small change was dropped in the back of the god for good luck and good fortune." The square hole in the back of the image and the presence of a few coins prompted its misreading as something like a piggy bank, an interpretation which one critic described as "grotesque."[8]

Looting and more ordinary theft have a long history in Bali, dating back to the early twentieth-century plunder of court treasures by the conquering Dutch troops and, as Margaret Wiener (1995, 350) notes, museums were often the beneficiaries. Belo (1960, 231) reports a spate of thefts from temples in the 1930s, thefts of "sacred objects honored in temples as receptacles of the gods' presence." She adds that, "If they could be traced, the authorities would do their best to return these objects to the temples whence they came. But very often the members of the temple refused to have the objects reinstated—they had lost their sacred power, and it could not be restored to them. It was assumed that as long as the objects retained power, it would be impossible to steal them: the gods would strike down anyone who dared to handle them irreverently." A mask or other image that could be stolen was no longer

*tenget.* And then there was the story of the would-be thief who was found wandering round and round the temple grounds in a daze, the intervention of the *tenget* forces of the place.

Hildred Geertz (2004, 178) describes the late 1940s in Bali as a time of postwar inflation and crop failures where temple thefts were common. Again, in the 1990s, a series of thefts from temples gained notoriety in the local press, often attributed to "outsiders" from other islands in the Indonesian archipelago, on the assumption that no Balinese would dare to commit such a sacrilege, that such acts polluted not only the temples but the entirety of Balinese culture (Howe 2005, 5; McGowan 2008, 238, 241; Santikarma 2001).[9] Others, in a manner also reminiscent of conversations in Vietnam, attribute more recent thefts to an erosion of traditional beliefs and the temptation of new markets. A well-known carver explained:

> They keep that sacred mask in the temple, you know, nobody in the night to take care of the temple, many old things [were] stolen in the temple. . . . This is one negative effect of tourism, supply and demon [demand] ha, ha. [I interjected that Jane Belo had described thefts in the 1930s.] Yes, certainly but not so often as these days. If they stole a sacred mask what for? [Where was the market?] And if the people stole a sacred mask then it was hard to handle. And the spirit can disturb the person, but now steal and sell and the people who stole that mask don't care, but in the past if you stole a mask what for? This is the effect of tourism.

He affirmed his own belief in karmic retribution—that if the offender were not punished, then his descendants would be. This carver had been commissioned to replace a temple's stolen masks, one of several linked crimes that ultimately resulted in the arrest and imprisonment of an Italian dealer. He described the ritual activities that followed in the wake of the theft in terms not unlike toxic abatement of the magical kind.

> The temple, the owner of the masks, sculpture, something [stolen] from the temple, they make a big ceremony. . . . It was not because the masks were stolen but [because] the people took from them the energy, bad energy. The community from the temple, they held a ceremony to neutralize that energy, to clean it. . . . Something unlucky happened in that temple. And then they make ceremony to neutralize. . . . The size of the ceremony depend[s] on the value of the mask or things lost from the temple.[10]

Some speculate that Jero Amerika, described in the last chapter as a hyper-active mask that had come back to Bali from abroad and been

enshrined in the Puri Ubud, was a stolen temple mask. Such a prior biography would account for Jero Amerika's extraordinary power and perennial media buzz. (Others consider the actual mask a work of ordinary craftsmanship and, given the mask's origin story as a wedding present to a foreigner, suggest that it had likely been hawked on the streets of Sanur.) Before the Puri Ubud undertook to enshrine the mask, the Cokorda invited representatives of the Bangli Regency, where there had been well-publicized temple thefts in the early 1990s (MacRae 1997, 124), to determine whether the mask had been stolen from one of their own temples. The Bangli delegation did not recognize the mask. According to several of our Ubud conversation partners, the *sesuhunan* was originally from Bangli, but wished to remain in Ubud and had rendered the mask unrecognizable, an interpretation that enhances the town of Ubud's special claims for Jero Amerika. The *sesuhunan*'s desires were confirmed by a psychic; the mask had come back "to protect the people of Ubud" (Ballinger 2004, 26; Kendall and Ariati 2020).

In Myanmar, Erin Hasinoff and I heard from several sources that selling a *nat* image for profit—not to mention stealing it—is a matter of profound ill consequence. Brac de la Perrière (2009, 289–93; 2016, 23) describes incidents where, following the death of a *nat kadaw,* the heirs sold the statues instead of tending them or passing them on to a disciple, and were punished by the *nat.* Several of our Burmese conversation partners agreed that selling a statue for profit would bring bad luck to both the seller and the buyer and that the theft of an image would have broadly inauspicious consequences. Dealers to whom we mentioned this stoutly denied that they had ever heard of any such concern, but this might be an expected response. Old *nat* images do circulate. We found them in antique shops in Yangon and Bangkok, and on sale in a New York flea market, brought over the border to Thailand and from there both to local shops and to a global marketplace. Rodrigue (1992, 24) reports a major theft of old *nat* images from the Shwe-zigon Pagoda in Pagan in recent times, such that their replacements are locked in a barred structure as a precaution.[11] Today they can be approached during daylight hours and gazed at through a protective pane of glass.

Taking images from the altar of a major pagoda is an unambiguous act of larceny and daring but other, more ambiguous circumstances can attend the disposal and subsequent acquisition of old *nat* images. In the absence of a successor *nat kadaw* to tend it/the *nat,* the image might be cast into running water or left in or near a shrine, sometimes hanging in a tree. Those who are destined to tend these *nat* in the future might thus make a

fated connection when encountering them by chance, much as Aung T. happened upon the image of his destined lady *nat* in a vendor's stall. An elderly scholar of our acquaintance found an image floating in the river and, although not a medium himself, felt somehow destined to take it home. His wife, initially wary of the image, began to tend it with incense and offerings and came to regard it as a benevolent sort of house tutelary. Collectors sometimes make away with *nat* images abandoned by temples and shrines, although, again, this risks bad luck. Foreigners, with a presumption of innocence regarding the intentions for abandoned objects, also pinch them for their own purposes. This has been a longstanding practice, as a British civil servant observed in the 1880s, seeing "little clay painted and gilt specimens that you can put in your pocket, and that idolatry-detesting Britishers often do so serve and afterwards exhibit as having actually 'been worshipped'" (Shway Yoe 1963 [1884], 193).

In Korea, some of the most valued god pictures hang or once hung in shrines that were sites of quasi-official veneration in dynastic times. In the colonial period, many of these sites became commercial shrines (*kuttang*) where space could be rented to *mansin* for performing loud and lively rituals.[12] One such shrine, whose paintings had gained attention through a scholarly publication, experienced a major theft in the dead of night, the shrine having been kept unlocked to invite the gods' presence (much as families leave their front gate open during rites of ancestor veneration) (Yang Jongsung 2008, 69). Some keepers of other shrines with old paintings took this as a lesson and stored their old paintings away, replacing them with reproductions.

## HISTORIES RECUPERATED, TO A DEGREE

We have already seen how protocols exist not only for the ensoulment of images but for the de-soulment of inhabiting gods/spirits/energies before an image can be repaired or replaced. Practices of removal and wastage (Küchler's 1997 term) seem to be widespread and may be part of the unknown histories of images from Asian places that are now in museums. Richard Davis (1997, 2015) makes the highly plausible argument that Hindu images, excavated in good condition from centuries in the ground, had their animating energies removed through proper scriptural procedures when a temple community found it prudent to bury and hide them during times of war and strife. The temple community likely assumed that once the danger had past, the images would be brought out of the ground and reanimated to resume their proper function as the

material presence of gods. Davis reconstructs how, by nefarious slights of hand, some products of contemporary excavation have instead entered the contemporary art market.

For the most part, the ensouled or de-souled status of an object in a museum collection is unrecorded and consequently unknown. It takes both good luck and effort to retrieve this information, and a recognition, in the first instance, that such information constitutes an important component of image identity. In the case of the One-Eyed God from Họa Village, a VME object removed from a village communal house (*đình*) as described in chapter 2, the thoroughness of the prior de-souling process was itself at issue, and this uncertainty affected how museum staff regarded and interacted with the statue. When, as a result of a village quarrel, the statue was removed from the communal house, VME entered the story as something of a *deus ex machina,* enabling the community to resolve a dilemma about the statue's material fate. By transferring the One-Eyed God to the Museum, the officiating authorities could avoid burning it or casting it into a stream, ritually appropriate measures but still likely to stoke the animosity of the donor who had made a significant investment in the image, the donor's extended family, and his faction within the community. But even ten years after these events, the image was an uneasy presence in the VME storeroom. Rumors persisted that it had not been properly de-souled, or worse, that it had been filled with inappropriate matter (ashes from the donor's ancestor), and one village faction held that the donor's family had suffered divine retribution for having inappropriately installed the statue. In light of this history, some of the VME collections staff were reluctant to approach the statue. Nguyễn Văn Huy and Phạm Lan Hương's research confirmed that the statue had been properly de-animated. They were able to retrieve the photographic documentation and official certification of the de-souling. They were also able to record a Rashomon-like tale of village politics that enriches this particular object biography (Nguyễn and Phạm 2008).

Procedures for removing the enlivening presence apply not only to images but to certain other paraphernalia deployed in sacred practices. Through our sacred objects project, it was possible to recuperate a few precious histories of encounter that included the actions and intentions of those who relinquished once-empowered objects to the VME. An ethnic Thái diviner, Mr. Tắm, agreed with some hesitation to sell his divination kit to VME researcher Vi Văn An. He did this because he regarded An as a child of the community who was also an educated man working at the

Museum in Hanoi, a servant of the nation, by implication a man of power. Mr. Tấm felt that were this not the case, An would never have presumed the otherwise unthinkable act of asking to buy the kit. Before transferring the kit, he emphasized to An that "this is a very sacred object." Then Mr. Tấm performed a ritual to de-sacralize the kit, setting out offerings which An provided and reporting his intentions to the founding ancestor of the diviners' profession. An writes, "I sensed a rush of emotion on the part of the diviner. . . . His eyes were full of sorrow as he respectfully addressed the ancestral diviner. He spoke of his regret and offered self-criticism about this 'unavoidable circumstance'" (Vi 2008, 261).

When An returned to the village a few years later, he learned that the diviner's wife had died, Mr. Tấm himself had been injured in a fall from the high veranda of his house, and members of his family thought that these misfortunes were a consequence of his having sold the divination kit. For his part, Mr. Tấm felt that when he had addressed the ancestral diviner and relinquished the kit, he had not been certain that he had the ancestral diviner's agreement to the transaction. Reading the diviner's thoughts, An explained that the kit was now catalogued to the Museum and had become the property of the state, "kept in the Museum's storeroom where it is well preserved" as part of a "rare and precious collection" (Vi 2008, 262). An gave Mr. Tấm money for further offerings to the ancestral diviner that would better complete the process of transition. An reports how thereafter, Mr. Tấm regained his health and was receptive to An's long-suspended research on Thái divination. One can read this story, as many of my students do, as the equivalent of Jochelson's acquisition of Yegor Shamanov's robe: an empowered representative of the state coercing a member of a marginalized minority to relinquish his sacred tools. An's privileged position is undeniable, but so too is his integrity in conveying Mr. Tấm's conflicted feelings. Overly-predictable readings ignore An's own position as a museum researcher who is also an ethnic Thái, a member of this same minority community, and who desires to bring honor and recognition to "our Thái people" by making the collection (Vi 2008, 262). Both An's and Mr. Tấm's agency are now a part of the record of this object.

*Then* shamans of Vietnam's Tày people use a special stringed instrument (*đàn tính*) in a manner similar to the way many other shamans use a drum. In ritual, the *đàn tính* becomes a musical mount that enables the *then*'s campaigns with the *then* spirit army and accompanies her singing as she simultaneously recounts the story of her journey. Mrs. Mõ Thị Kịt, a renowned *then*, agreed to sell one of her *đàn tính* to the VME, but "she first removed the spirits. She took the *đàn tính* in her

hands, pressed the strings, and whispered a spell, adding a prayer for the good fortune of the Museum staff. The *dàn tính* was now a secular instrument; spirits would no longer follow it" (La 2008, 277–78). Unlike Ycgor Shamanov, Mrs. Kịt continued a vigorous career using her other *dàn tính* and was proud of her association with the VME, where she and her colleagues had performed (plate 28).

Research can also reveal that the rites performed over an object were insufficient. Vũ Hồng Thuật has described how wood for a block carved to print powerful amulets is prepared with procedures and precautions similar to those attending the carving of a temple statue. The carved block is then activated by the ritual master, who invokes buddhas and gods to descend into the block as a prelude to his striking amulets from it. When Thuật acquired a complex amulet block for the VME, he traced the line of transmission from his own purchase back through the two previous owners. He learned that the original owners had simply burned incense and reported the sale to the ancestors. Critically, they had not invited a ritual master to de-animate the block. This was a matter of no small concern to Thuật: "In other words, the amulet woodblock that I was researching had not been properly de-sacralized; it was like a wood-block in the possession of a ritual master, awaiting future use, but the Museum was storing it with secular objects of a similar material type, such as . . . woodblocks for petition sheets and woodblock genre paintings. . . . The heritage value of these objects and the museum's commitment to preserve and document them necessitates an understanding of and respect for their power" (Vũ 2008, 253–54). This kind of information is as intrinsic to an object's ethnographic identity as its material components, but museums, as quintessential temples of materiality, have historically been ill-equipped to document things invisible. This is changing in some North American and European museums where spiritual claims are now part of a dialogue with descendant communities.[13]

The status of a Korean god picture with a murky provenance is likewise ambiguous when it becomes a museum thing. I recall the Korean *mansin* who told me that no god would inhabit a painting bound for a museum or a shop, that they simply fly away of their own volition rather than enter alien space. But I also know that many Koreans see these paintings as still inhabited by souls and, for this reason, are uncomfortable about bringing them into their own homes. Until the late twentieth century, there was no real market for old Korean god pictures. They were considered, on the one hand, to be potentially dangerous objects and, on the other, as a much-too-crude form of folk painting, objects of little art

market value. Korean folk paintings of tigers, flowers, and leaping carp were themselves only beginning to gain appreciation in the 1970s. At that time, a runner who also had connections to the *mansin* world found a market for old god pictures in the expatriate community. These potential buyers (including this author) were blissfully ignorant of cultural cautions and had no inhibition about hanging god pictures from a *mansin*'s shrine on their walls, enjoying them as a whimsical genre of folk art. If the paintings in the runner's pack had been discarded by *mansin* who were replacing them with fresh images, then the gods would most certainly have been sent off. What cannot be retrieved is what the *mansin* intended for the paintings when they gave them over to the enterprising runner. Preserving paintings and selling them to an emergent market for god pictures meant eliding prior understandings that two coterminous images of a particular *mansin*'s god should not co-exist, because two possible seats would only confuse the god, as one *mansin* explained to me.

When this particular runner died young, some attributed his death to his unwholesome association with the god pictures. Nevertheless, and even despite lingering inhibitions, a market of Korean collectors developed in the 1980s, encouraged in part by the Popular Culture Movement's enthusiasm for national folklore and a more general promotion of things seen as innately Korean, including, from the time of the Seoul 1988 Olympics, the shaman tradition. By then, other runners and scholar-collectors had gotten into the act, befriending aging shamans and combing the countryside for old god pictures. In a time of large-scale urban development projects, collectors and runners also benefited from the destruction of many theretofore isolated sites of shaman activity, retrieving old paintings from soon-to-be-demolished shrines.

Absent outright theft, Korean god pictures reach art markets and museums through more than one possible path, intersecting with older practices for taking paintings down from a shrine. Some of these paths do suggest that gods have been sent away from the pictures before they reach the market. In traditional practice and in most instances today, gods are politely asked to vacate used paintings, which are either burned or buried. Paintings removed from the shrines of dead *mansin* are one point of intersection. In old accounts, the shrine would stand until a new *mansin* was inspired to serve its resident gods (Landis 1895). This would have been an anxious time for the dead *mansin*'s family, since gods often claim a replacement from among a dead *mansin*'s kin. Retiring or dead *mansin* (the latter speaking through living *mansin*) sometimes transmit gods and paintings to successors (figure 30). But as described with

FIGURE 30. A shaman in the Hwanghae tradition performs her last *kut*, Seoul, South Korea, 1977. The paintings hanging on a line would be disbursed to her "spirit daughters" as indicated by the gods; the *mansin* passed away a few weeks later. Photo: author.

respect to the troubling paintings in Yongsu's Mother's shrine, this does not always work out, leaving the god pictures as unused seats for uncooperative gods. I have mentioned how shaman supply shops (*manmulsang*) now offer the service of sending off gods and taking down a dead *mansin*'s shrine, doing this work with different degrees of competence and integrity. Families might anticipate that the paintings and paraphernalia will be respectfully disposed of, but dealers and collectors assume that by this path, the accoutrements of many a dead *mansin*'s practice have found their way into the market, some to museums. Owners of shaman supply shops smiled when I asked about runners and collectors who would come around asking for old paintings.

While old paintings that had been discarded for new ones and paintings from the shrines of dead shamans were likely properly vacated of

gods before they entered the market, they had also been vacated of their specific histories. As art commodities, they are reduced to their primary form as a type-cast General or a Spirit Warrior, but with no trace of the particular General or Spirit Warrior who was served by a particular *mansin*, a god whose role might have been inhabited by one of the *mansin*'s own ancestors, like Yongsu's Mother's drunken spouse, or whose dreamed presence might have marked a significant turning in the *mansin*'s own biography. When I purchased a fine old painting from a Seoul antique shop in 2008, a woman in the gray robes of monastic practice, I could understand it as the probable representation of a *mansin*'s apotheosized ancestor, a woman who might have been a nun or, at very least, an active lay Buddhist (plate 29). My subsequent research would also sensitize me to the possible paths that would have brought the painting to the shop. But I will never know the identity of the *mansin* who venerated the pious woman ancestress in the painting, or what biographical circumstance caused the former to enshrine the latter on her wall.

Once inside the museum, gods in paintings become generic examples of shaman paintings (*musindo*), usually housed with other folk paintings and detached from the other paraphernalia that were part of the same assemblage of a single *mansin*'s shrine and its altar.[14] They reside as artifacts of a vanishing folk culture rather than as signs of a lived, and in other shrines still living and intimate practice. When museums purchase from dealers who have held onto their stock for a long time or from private collectors, there may be no memory of the specific source and in any case, a dealer's work typically involves one or more black boxes of trade secrets along a chain of transaction that might involve runners and private collectors as well.

Some god pictures reach Korean museums by more direct paths, either as gifts from *mansin* or from the families of deceased *mansin*, all named in the museum record. Curators, dealers, and collectors cultivate relationships with *mansin* and are sometimes rewarded with the eventual acquisition of their paintings. Some have subsidized the necessary ritual for a final send-off of the gods. Through these encounters, *mansin* communities have come to value their paintings, as they have come to value their own practice, through a new language of national culture and heritage. As part of a similar project, my colleagues in Vietnam impressed upon potential donors the importance of the work of the VME and the significance of their own objects for a national project of heritage appreciation, as in the examples given above.

As in Vietnam, collectors of Korean god pictures also found themselves drawn into a process of transaction that involved not only shamans but gods. One South Korean dealer described to me how when working on a major commission for a new museum in the 1980s, *mansin* asked him to sponsor a small ritual which included a divination where the gods indicated their willingness to be part of a transaction including the dealer's subsidizing fresh paintings. Two directors of small private museums who have long and respected relationships in the *mansin* world mentioned that they are sometimes tipped off as to the location of buried paintings and paraphernalia. One of these men is also called upon to disassemble the shrines of dead *mansin* where, with the aid of Buddhist chants, he quiets the restless souls of those who—because their afterlives were turbulent—became the *mansin*'s gods.

When old shrines have been torn down for various urban development projects, their paintings and other paraphernalia have sometimes been absorbed by museums or collectors, arrangements that would typically involve a final send-off for the gods subsidized by the collector. These transactions assume at least some agency on the part of members of the *mansin* community and, in some instances, the gods themselves. In a museum setting, the paintings are considered empty and yet, because the painting is always a potential site of divine activity, there have been intimations of presence even in museums. One *mansin* described how she had gifted the god picture of a General to the director of a private museum which (according to the dealer) he valued for its aesthetic appeal and placed on display. In the *mansin*'s view, the museum stood on troubled ground where many people had died in the past. Because this *mansin* had good feelings toward the director, she sent him a General for protection. When a university museum accepted fine old paintings from a shrine dating to dynastic times, the shrine-keeper and her daughter secured an invitation to visit the museum every year and make offerings in front of the now empty god pictures as a gesture of respect. The story did not stop there. The daughter-in-law of a collateral branch of the family living in Japan became gravely ill and saw the image of a divine woman in a dream. Her husband recognized her description of the dream image as resembling a painting in the shrine his family had maintained, an image he remembered from his own childhood. He also knew that the paintings had gone to the university museum back in Korea. The family in Japan received a copy of the image for private veneration, and through the museum, they were also able to reestablish contact with their Seoul kin.

CONCLUSION

As a key affordance of this study, we have been considering geographically broad examples of places where gods/spirits/energies are installed with proper protocols, temporarily removed, transferred to replacement images, or otherwise sent away. Conditions of ensoulment/de-soulment, empowerment/de-empowerment are invisible and rarely accounted for in museum records, unknowable even where statue interiors have been X-rayed for the presence or absence of animating material that might raise this possibility. It is not necessary to rehearse here the modern museum's origins in the bosom of a materialist/rationalist Enlightenment, save to insist, as I have been throughout this chapter, that museumification is a sometimes incomplete process (e.g., Kreps 1998; Tapsell 2015, 275). As the foregoing examples suggest, the ambiguous status of an image may become a matter of consequence for museum staff, visitors, and particularly, for those who sell, gift, or otherwise relinquish objects to a museum collection, and those who seek to reconnect with them as members of descendant communities. Acknowledging the ontological possibilities of different object worlds enables a more complete understanding of what each image is, how it has been understood and used, and the work it was once expected to accomplish. Such information also facilitates creative responses to the ambiguous status of things. I will end this chapter with a hopeful example, not one of my four case images but involving magical images and soul/spirits nonetheless. Taiwan anthropologist Hu-Tai Li's (2012) documentary *Returning Souls* describes how a carved pillar of the Amis people resident in Tafalong Village, Taiwan, toppled over in a typhoon many decades ago, was removed, and came to reside in what is now the Museum of the Taiwan Institute of Ethnology. Decades passed. In an era of cultural revitalization for Taiwan Aborigines, the Museum entered into discussions with young members of the Amis community who initially intended to repatriate the pillar that was the residence of their ancestors. Museum staff pointed out that if the pillar were again exposed to the elements in a traditional way, it would soon deteriorate, concerns that their Amis counterparts appreciated. As a resolution, the Institute of Ethnology subsidized the carving of a new pillar in Tafalong Village and a shaman, with due ceremony, retrieved the ancestral souls and carried them home.

# Conclusion

> We want to propose a methodology where the "things"
> themselves may dictate a plurality of ontologies.
>
> —Amiria Henare, Martin Holbraad, Sari Wastell,
> "Introduction: Thinking Through Things"

This project has been an exercise in thinking through things, engagements with objects of more-than-ordinary materiality, presences at the center of locally inflected and sometimes even idiosyncratic practices and meanings. The drunken spouse sits in an otherwise standard portrait of a Spirit Warrior in a Korean *mansin*'s shrine, a beautiful woman *nat* image becomes the object of a quest by a Burmese medium seeking a life-long relationship, a bull Barong made for political theater takes on a life of its own. Perhaps Leonard Cohen (1991, 125) said it best in a poem that witnesses religious medals hanging from silver chains, pinned to underwear, or abandoned with cufflinks in a drawer. The thing itself—the religious medal, statue, image, picture, mask—can be recognized in ways sufficient to translate across borders and languages, but then things begin to get interesting when experiences and stories take shape around then. Following van der Veer (2016, 148), I began writing with the intention of making a comparison between four different kinds of empowered/ensouled images without resorting to "universalism on the one hand or endless particularity on the other." You, dear reader, may judge whether or not I was successful.

I situated my study within three affordances—features that act as prompts for what can be done with an object—and nested them in my discussion like a set of Russian Matryoshka dolls. Europe and Asia have life-like religious images in common, images whose faces, and particularly eyes, can provoke in the viewer a range of emotional responses on

a spectrum from comfort to intense fear. This has been well noted (e.g., Freedberg 1989, Gell 1998, Morgan 2005). Also noted, but less remarked upon, is the fact that across Eurasia there are long traditions of skilled specialist artisans producing religious images on commission from devotees or devotee communities, images well-crafted to have a desired effect in their subsequent use as objects of religious practice. These traditions of religious image-making through quality workshop production are the first and most expansive affordance, the largest doll in the nested set. The devotee is distinct from the fabricator who performs to a high level of specialized skill; the devotee's choice of fabricator confers distinction (or not).

But differently from Catholic understandings of religious images within and now well beyond Europe, in Hindu, Buddhist, and related popular practices, bodies and masks are ensouled with a god or a buddha through liturgical rites. Here, ensoulment is the expectation of what a religious image is supposed to be, although some modern religious reformers talk back to an aniconic western modernity by arguing that the core premise of these rituals is not so literal, and for some practitioners it is not. The expectation of ensoulment is the second, more restricted affordance, the somewhat smaller doll within the larger doll. The production of an image intended to become an ensouled thing gives added salience to questions of how statues, god pictures, and masks should be fabricated, installed, tended, and disposed of, and how questions of magic are at play with questions of skill. Within this understanding and as the smallest and most specific of the nested dolls in the Matryoshka set, some ensouled images enable the work of spirit mediums and shamans in some Asian places. This final affordance enables the expression of more distinctively localized traditions, but flows from broader understandings of what images are as ensouled things, how they are enclosed within ideas about ensoulment and image-making. In these settings, ensoulment and the related activities of shamans and spirit mediums do not emerge from a primitive substratum of cultural history. Rather, they incorporate complex technologies associated with (what are sometimes called) Sinocentric and Sanskritic cultural practices, rooted and intertwined with local practice and sometimes with each other, not at odds with Hindism and Buddhism but emerging from the very stuff of it. A broad comparative frame makes it possible to see this more clearly.

Thinking through things, I have examined four primary cases: statue images and spirit mediums (ông đồng and bà đồng) in Vietnam and Myanmar (nat kadaw), temple masks and mediums (pemundut) who

perform in Balinese temple festivals, and shamans (*mansin*) and the god pictures in their shines in Korea. I chose these examples because of their accessibility and my own curiosity. Much more could be said about other examples elsewhere; images in Chinese temples and the paintings that Yao ritual masters unfurl when they do serious work come immediately to mind (Lin 2015, T. Nguyen 2015, Silvio 2019). I have approached my work as a wide-ranging conversation where things learned in one place pose fresh questions in another and sometimes garner surprising answers. Although in all of my four examples, practitioners understand statues, paintings, and masks as being ensouled and understand this condition as a state of both power and potential danger, my four examples are not identical kinds of things. What they are is, in part, led by their forms, functions, and materiality. I have described how the workshops in Vietnam impressed me with the expectation that a buddha or Mother Goddess should be elegantly crafted. In Myanmar, I learned that the materiality of a *nat* was not that of a buddha, but cheaper stuff that yields a less expensive and consequently more broadly accessible thing intended to live in an intimate relationship with the human *nat kadaw,* sometimes while bearing a lock of the medium's own hair. The god pictures that hang above shaman shrines in Korea do not work in exactly the same way that ensouled statue bodies do, although the *mansin* are themselves familiar with Buddhist practices regarding sculpted images. This difference caused me to reflect again—within a more than forty-year encounter—on why *mansin* are appropriately characterized as "shamans." I understand them to be precariously agentive in the necessity of keeping the gods' favor, which comes to them as a clear flow of inspiration most often transmitted through their paintings. Inspiration enables them to convey the gods' will, exorcise, heal, and usher in auspiciousness. The flip side is the ever-present possibility that the gods enshrined above the altar might withdraw their favor, leaving the *mansin* to flounder and improvise on limited inspiration or abandon the *mansin* profession altogether, possibly with disastrous consequences for herself and her family.

Even so, I recognize that a heuristic contrast between "shaman" as a doer and "medium" as a puppet can be overdrawn; "master mediums" in Vietnam and Myanmar seem very much like shamans when their work brings healing and good fortune to clients who seek their services. In Vietnam, Myanmar, and Bali, gods/spirits/energies also sometimes abandon their image containers in extreme circumstances of decrepitude, iconoclasm, or other violations of the protocols that define the relationship

between humans and images. Vietnamese *bà đồng* and *ông đồng* nodded knowingly when I described how the gods in improperly placed paintings in Yongsu's Mother's shrine in South Korea fought with each other, causing the paintings to fall to the floor. For their part, *mansin* would probably regard the work of most *bà đồng* and *ông đồng*, who perform rituals only for the benefit of their own families rather than for clients, as recognizable but relatively easy activities involving gentler gods. Gods in these two traditions choose their human mounts; the *sesuhunan* who inhabit Balinese masks have, in some remarkable circumstances, gone to ground in unexpected or even eccentric masks, events read as evidence of powers more uncanny than the usual Balinese uncanny. Similarity enables the underscoring of subtle but revealing difference.

In my Vietnamese, Korean, Burmese, and Balinese examples, the images operate in ways analogous to power nodes that "charge" the bodies of the practitioners such that they become the mobile presences of gods or spirits, enacting what the god/soul/energy operating through the ensouled statue, painting, or mask cannot otherwise accomplish. The physical presence of the medium or shaman, the transformation evidenced through an extraordinarily energized body and a distinctive facial affect, is marked in Korea, Vietnam, and Myanmar, where particular mediums or shamans are noted for compelling performances of presence. In Bali, the face and body of the *pemundut* disappear under the head-covering mask and bulky cloak and the *sesuhunan*/mask takes over. Masks are intended to become mobile when conjoined with a human body; statues and paintings remain in place. While the extraordinary endurance of some *pemundut* is renowned, it is attributed, in the first instance, to the power resident in the mask itself. Teri Silvio's (2019) distinction between "performance" and "animation" is useful here. Performance would be a primary descriptor for the dancing, miming, and speaking that give presence to gods/spirits in Vietnamese, Korean, and Burmese ritual settings as enabled by gods present in static images. Animation would be a primary descriptor for the activities of an empowered mask in Balinese temple festivals, with emphasis on the mobility of an otherwise immobile material subject. As Silvio notes, such distinctions are never absolute; mobile materiality in the form of bodies, costumes, props, offerings, and the like, is never absent from any ritual performance and the animated temple masks of Balinese ritual appear amid a richly constructed performative surround. Even so, and as Silvio also notes, "performance" and "animation" are good to think with, and both characterizations necessarily bring a conversation

about ensouled and empowered images down from the altar and into the domain of enlivened ritual practice.

The foregoing chapters also evidenced disagreements inside local traditions, the gist of which was legible from one place to another. Was it dangerous or inconsequential to sell a dead medium's *nat* images to an antique shop? To bring into a private collection the god pictures that had once graced a Korean *mansin*'s shrine? Were senior *mansin* giving their apprentice "spirit daughters" adequate advice on how to select god pictures for their new shrines? Were the spirit daughters installing the images too early in their practice? Was it possible that an ordinary Balinese mask, gifted to an expat and carried abroad, could become enlivened and capable of great renown in Ubud, Bali? Generalization belies the complexity of human interaction and the inconclusiveness of most human projects, particularly when they are socially present and coeval in contemporary space.

The most predictable area of disagreement within and across localized practices was the question of how the images should be produced. In each of my four cases, conversation partners could cite traditions of careful craftsmanship where workshop magic is deployed as part of the process of fabrication and where the artisan's skill and material choices are also seen as having magical consequences. These sorts of workshops cohabit with more rationalized and less expensive practices. In South Korea, traditionalist painters of god pictures have been almost completely eclipsed by production-line workshops, cheap colored prints, and itinerant painters from China. Some *mansin* still claim, as a mark of their own distinction, that only paintings made by inspired painters who put their whole heart and soul into the project are paintings that really work, or at least make the *mansin*'s task easier and more effective. But when asked, even these *mansin* would ultimately give primacy to the *mansin*'s own ability to call forth inspiration from the image. These ambiguities are consistent with broader notions of *mansin* power; when the gods favor the *mansin*, she causes the gods to be powerfully present, to inhabit the images in her shrine. In Vietnam, the debate seems to fall between younger mediums who have filled their private shrines with less expensive statues and the established keepers of old shrines who hew to a strict adherence to tradition.

I suspect that in both Vietnam and South Korea, the former a few decades behind the latter, the availability of cheaper images enabled their installation in circumstances where, in the past, the practitioner would have waited for many years to make a significant investment in

images. In Bali, where several carvers are recognized as masters who scrupulously follow strict protocols for producing temple masks and where their work is supplemented with commissions from secular art troupes, museums, and collectors, the masters seem to be in no danger of disappearing. Distinctions between a seriously sacred Balinese mask and a secular mask seem relatively clear-cut, but the same experienced craftsman will be commissioned to produce fine examples of both forms. Even so, and while carvers and others told us that a temple mask was necessarily made by special commission and according to traditional protocols, we visited a workshop where temple masks were being produced and sold off the shop floor for use in temple festivals, and heard accounts of ordinary masks that had become "sacred by accident." How commodities mean, and how such meaning reflects or elides the human labors invested in their production, is a question that has been with us in the social sciences from Marx through Benjamin to the material (re)turn of recent decades. But such questions also rise to debate in the places and among the people that I have been describing.

An ontology of ensoulment, a generalization with multiple local inflections, brings much of Asia into the animism conversation as more than a residual category. I have been describing viable, durable practices that have engaged significant populations over a huge swath of time and space. In these contexts, ontologies of ensoulment assume the skilled professional production of images and with it, a bundling of issues regarding materials, craftsmanship, magic, and ritual knowledge. Where the animism conversation offers a refined sense of the ontological practices of different Amazonian peoples and makes a talking point for other places, the ontological practices that I have been describing here resist the a-word, at least for this author. "Animism" has baggage in Asian ethnography; it has too often been sloppily applied to characterizations of Japan, Bali, Borneo, or highland Southeast Asia as places where every aspect of the landscape is said to be infused with spirit, soul, or sacredness. Such a characterization will not account for the possibility that some statue images work better than others and that even a carefully commissioned statue, mask or painting might not work at all. Nor will "animism" account for a museum curator's desire to know whether or not an object in her collection has been ritually de-souled or is socially still alive, a distinction at least as important as the identity of the wood used to carve it. These are conditions of doing, making, and using, as much or more than being and becoming. We need to know more about the processes and choices that cause images to be

commissioned, celebrated, and disposed of and the dreams and visions that might hasten their production or replacement. For this we need fieldwork. Reliving field encounters has been an unanticipated pleasure of writing this book; I hope that some of this emerges from the writing and that it will propel others down similar paths (plate 30).

. . .

In December 2005, the exhibit *Vietnam Journeys* came home to Hanoi. The three gilt Mother Goddess statues appeared in the appropriate section on an altar table that had been specially prepared for the Hanoi venue. At the opening, a crowd of journalists interviewed a beaming Bà Đồng Duyên as she stood in front of the statues. The improvisation initiated by her late husband was having its intended consequence; she was gaining a respectful audience for her religion. That same day, American and Vietnamese curators and the Vietnamese collections manager had bent the rules of acceptable museum practice, allowing a devotee to present an offering of fresh fruit and flowers to the images of the Mother Goddesses in the exhibit. We understood them better now.

# Notes

https://en.wikipedia.org/wiki/MacGuffin, accessed 9 August 2018 3:24PM.

1. See also Meyer (2014; 216); Orsi (2010); Plate (2014); and others.

2. Following van der Veer's (2014) turn of phrase and substantive discussions on this topic by Meyer (2014) and others.

3. For Hindu images see Davis (1997); Eck (1998; 51–55); and Venkatesan (2014). For Buddhist images in different traditions of practice see Swearer (2004); Bentor (1996); Brinker (2011); Groner (2001); and Horton (2007). For the commissioning of temple images and reliquaries as a meaningful religious practice see Bogel (2008); Chiu (2017); Gimello (2004); Sharf and Sharf (2001); and Ruppert (2000). The list grows and these citations are by no means comprehensive.

4. For example, the Asia Society's 2016 exhibition *Kamakura: Realism and Spirituality in the Sculpture of Japan* revealed the prayerful inscriptions on the statues' interior cavities and displayed some of the animating material that had been placed inside them (Covaci 2016). Some museums with Buddhist statues, such as New York City's Rubin Museum of Art, now sometimes include animating material beside the image from which it was removed.

5. For example, Chan (2012); Lin (2008; 2015); McDaniel (2011); Nguyễn Văn Huy and Phạm Lan Hương (2008); and Robson (2007) as well as the collaborative research cited in my acknowledgments. Again, this is by no means a comprehensive list.

6. Following John Austin, cited in Tambiah (1973, 220).

7. Freedberg provided Gell with the much-cited account of "Slasher Mary" defacing the Rokeby Venus as a protest against the incarceration of the suffragette Emmeline Pankhurst (Freedberg 1989, 409–10), an exercise of "magic" in Freedberg's terms, "volt sorcery" in Gell's (1998, 62–65).

8. A notable exception is Teri Silvio's (2019) recent study of animated puppetry, which she grounds in an ontology derived from Taiwanese popular religious practice.

### CHAPTER 2. ENSOULMENTS

1. This seems to have happened in the 1970s, after the Vietnam/American War and under high socialism, but no one with whom I spoke about this incident was very clear about the date.

2. My notes from that day say "river." In 2004 I learned that in this village, confiscated statues were cast into the village pond. If the temple-keepers managed to cast their images into the river in advance of confiscation, they would have given them a purer and consequently more respectable end, but when I heard this story, I was not in a position to appreciate these distinctions.

3. For China, see Chau (2005); Cohen (1991); Duara (1991, 1995); C.K. Yang (1961, 390–91); and others. For Korea, see Kendall (2009, 1–11); Walraven (1995, 1998). For Japan, see Grapard (1984); for Vietnam, see Malarney (2002); and for an interesting comparison of India and China see van der Veer (2014, 48, 115, 128). These sources describe iconoclastic impulses across the political spectrum and within modernizing religious reform movements as well.

4. The tablet transmits supplication across space toward a properly animated statue in the god's distant home temple, something our conversation partners recognized as analogous to a telephone connection.

5. The novel describes the fate of Hiền, a young activist, who mobilizes the village youths for a month's rampage that will obliterate most material traces of the village's six-hundred-year history. The remainder of the novel charts Hiền's subsequent miserable life as his attempts to better himself and his community repeatedly run afoul of the authorities. He becomes the object of slander, loses his ability to work, and is reduced to a state of poverty in which he sickens and dies. Too late, the villagers realize their mistakes. I have been told that Mr. Võ's childhood neighbors regard the novel as a work of local history, and that since its publication, many readers have responded with accounts of similar histories in their own villages.

6. One major Hanoi spirit medium temple remained completely intact even when everyone fled the site for several days during heavy bombing by American forces.

7. Vendors on Hàng Quạt Street also described an ongoing hide-and-seek with the authorities in more surveilled times in the recent past (Kendall 2015).

8. At the same time, much of the writing on contemporary religious life in Vietnam describes a continuing tension between popular devotion and official atheism, now sometimes reconciled under the banner of "traditional culture," as happened a few decades earlier in South Korea (DiGregorio and Salemink 2007, 433–35; Fjelstad and Nguyễn 2006, 15; Malarney 2002, 103, 106, 219; 2003; H. Nguyễn 2016; Philip Taylor 2007, 6–9; cf. Kendall 2009, 1–33 for South Korea).

9. Reflecting Clare Harris's (2013) thoughtful consideration of this and other appropriate terms for an animated image.

10. For a full discussion of the animism question and this work in particular, see Lenclud, et al. (2014). In an ambitious typology, Descola (2014) describes ancient China as characterized by "analogist worldview," for which Silvio (2019, 84) finds resonance in contemporary Taiwanese popular religious practice. I am less comfortable with typologies, particularly where they relegate much of Asia to a residual category or, in Descola's case, render a long and complicated history through a secondary understanding of ancient texts.

11. There are, of course, exceptions to this generalization. The Balinese Barong walks on four legs and has some explicit resemblance to different animals, but is a fantastic creature beyond zoology. Inari, the Japanese Shinto god of prosperity and rice cultivation, appears as a white fox. Hanuman, the fantastic white monkey of the Ramayana, is regarded as a god, and in India, emphatically not a monkey. The much-anthropomorphized Chinese Monkey God Sun Wukong appears in some Chinese temples both in statue form and as manifested by spirit mediums. These are arguably animals who have become human/godlike rather than a human appropriation of animal powers in the manner of many shamans. Caroline Humphrey and Urunge Onon (1996, 339–40) describe Chinese cults involving foxes and some other animals, including weasels and snakes, who are incarnated by mediums, but these entities seem to bear the aura of danger Chinese and other East Asians have long attributed to fox spirits. The Daur Mongols regarded these same fox spirits as were-animals, in both cases not an animistic sharing of souls but an invasive external threat.

12. See Emigh (1996) for a clear and concise discussion of these two contrasting forms of mask drama and the very different mask types used to effect them.

13. For a more detailed description of the animation ritual, see Nguyễn and Phạm (2008). Vũ Thị Thanh Tâm, Nguyễn Thị Thu Hương, and I exchanged interview information with Nguyễn Van Huy and Phạm Lan Hương in our mutual efforts to reconstruct the animation ritual as part of our collaborative project on sacred objects in the collection of the Vietnam Museum of Ethnology. We benefited from the extensive ritual knowledge of Vũ Hồng Thuất, another member of the VME staff.

14. Strictly speaking, this term is used for the ensoulment of all of the statues in a temple, as when the new statues replaced the paintings in our first example. When a single statue is added, the ritual is less elaborate. The rite has much in common with descriptions of the animation of Hindu and Buddhist statues noted in chapter 1.

15. The VME team did meet one female spirit medium who had learned to perform some of the ritual master's work, and I suspect that there are others.

16. The coins, when placed on a family altar, carry a prayer for luck and business success; the needles repel malevolent spirits; and the grain can be sown to bring a bountiful harvest or fed to livestock so that the animals will flourish.

17. At the Tiên Hương Palace, the temple-keepers have generously allowed researchers access to the temple's forbidden room, a practice consistent with the couple's welcoming attitude, which they see as ultimately benefiting their religion.

18. The systematization of *nat* worship is commonly attributed to King Anawratha, who had initially but unsuccessfully tried to suppress the cult.

Scholars dispute this eleventh-century origin story (Brac de la Perrière 1992, 204; 2002; Shorto 1967).

19. Popular religion is no less fluid in Myanmar than anywhere else; most mediums do not house the full pantheon of Thirty-Seven *nat* in their personal shrines, some popular and widely venerated *nat* are not a part of the official Thirty-Seven, and in recent times, some *nat kadaw* have incorporated other spirit entities into their rituals and shrines to address the concerns and tastes of contemporary clients (Brac de la Perrière 2011, 2016; Skidmore 2007, 182).

20. Melford Spiro (1967) characterized the *nat* as "anti-Buddhist" except insofar as their unambiguously subordinate status reinforces a Buddhist moral order, but this seems an overstatement. See Schober (2008) for a critique and an integrated discussion of Burmese religious practice, and in passing, J. Nash (2007).

21. In this sense, Manning Nash (1966, 113) characterized *nat* veneration as concerned with individualistic appeals rather than the communal aspirations of collective Buddhist celebrations. It should not, then, be surprising that *nat* veneration flourishes in urban settings among traders and businesspeople.

22. Art histories of Southeast Asia generally focus on the study of Buddhist images, lacquer, and architectural features produced for the elite prior to the twentieth century and have regarded the humble *nat* statues as having little artistic merit (McDaniel 2011, 246 for Thai vernacular practice; Isaacs and Blurton 2000, Tun 2002, Myint 1993 for Myanmar). *Nat* statues receive brief mention in Sylvia Fraser-Lu's history of Burmese art (2002 [1994]), and Fraser-Lu and Donald Stadtner (2015) made an effort to include *nat* images in their exhibition, *Buddhist Art of Myanmar* at New York's Asia Society. I am grateful for Erin Hasinoff's bibliographic knowledge of Burmese art.

23. Pinney (2017) describes an analogous irradiation when Scheduled Caste households in a central Indian village remove their domestic chromolithographs and place them in the Jhuijhar Mata *autla* (shrine): "The (usually) framed prints spend nine lunar days nestled against the red stones and paraphernalia that form the center of the shrine and accumulate additional power from the excess energy of the consecrated shrine during this period" (148).

24. The word most often used in Korean scholarly writing and by many *mansin* is "*musindo*," literally "shaman god picture." In and around Seoul, *mansin* use the term "*t'aenghwa*," the word for paintings in a Buddhist temple, and this was the term that Yongsu's Mother and her circle used.

25. Literally ten thousand gods.

26. This incident is presented in more detail in Kendall, Yang, and Yoon (2015).

27. In Korea, a shaman's gods may be present in a variety of material forms: clothing, string, brass coins, hats, dolls, knives. In central Korea, god images are made of complex paper cutouts. But painted images on paper are the form in which shamans, devotees, and scholars most frequently encounter them, originally in the traditions of northwest Korea, particularly Hwanghae Province and in and around Seoul, but more present throughout South Korea today. By one account, *mansin* have been hanging these images above their altars since at least the thirteenth century (Yoon 1994b).

28. Commemorative portraits were installed in shrines and venerated on appropriate occasions, sometimes as the focus of state-encouraged cults (Cho 2010).

29. I use the word "trance" carefully. Yongsu's Grandmother fell into a dissociative state marked by glassy eyes and frenzied behavior, as very occasionally non-shamans, overwhelmed by a god or ancestor, would do at a *kut*. This is not the affect or the behavior of a *mansin* manifesting a god, a more controlled, more orchestrated evocation of inspired presence (see Kendall 2009 for more detail, as well as chapter 4).

30. This seems to be a recent practice. Buddha statues do not appear in early twentieth century photographs of *mansin* shrines (Akamatsu and Akiba 1938; Kim Tae'gon 1989, 28; Murayama 1932, 19–20). In some local traditions, inspirational diviners (*posal*) enshrine simple buddha figures or found stones in suggestive shapes as sites of a buddha presence.

31. *Niskala* can be used to indicate "god," "demon," or "spirit," or more generally, invisible and intangible forces. While a concentration of *niskala* goes to ground in a mask, a *keris* blade, a *lontar* text, or a place in the landscape, *niskala* are also regarded as generally omnipresent (H. Geertz 2004, 36, 271).

32. *Sesuhunan* literally refers to something precious and/or powerful carried on the head as a mark of reverence, a term of respect for a traditional ruler or a tutelary god carried on the head through the medium of a divinely empowered mask. I am grateful to Ni Wayan Pasek Ariati and Thomas Hunter for unpacking this complex term for me.

33. John Emigh (1996) makes a useful contrast between the powerful full-on trancing induced when the medium's head is fully encased in a temple mask and other Balinese masked performance, most particularly the quasi-historical *topeng* plays which use a simpler face-covering mask and where trancing is not the expectation (although not impossible).

34. I share Hildred Geertz's concern that English terms like "black magic" come to us from a Christian history which relegated them to an outside and oppositional sphere, "evil" in antithesis to "good," rather than a Balinese understanding of the mutability of one into the other. I consider "magic" the best fit for what Balinese call *pangiwa* or *pengiwa* and Geertz (1994, 81) describes as "mobilizations of *sakti* (power)," including acts that might be called "sorcery" and acts that might be called "worship." When such operations occur under the ascendency of dark and demonic powers, they have been glossed in English as "knowledge of the left" (Connor 1995, 125); "magic of the left" (Wiener 1995, 109); or "black magic" (Ariati 2016, 38). See Ariati (2016, 196–97, 205); Bandem and deBoer (1995, 102–26); Dibia and Ballinger (2004, 64–75); H. Geertz (1994, 65–81); A. Hobart (2003, 178; 2005); Emigh (1984, 30–34); Stephen (2001); and others.

35. In this discussion, Balinese words are unmarked, and those from Bahasa Indonesia are marked "Ind."

36. The entire process of purification and animation is referred to as *keplaspasin*.

37. The term is Sanskrit, meaning five *(panca)* elements *(dhatu)*. These are gold, silver, bronze, iron, and diamond or ruby. As in the five-element scheme

of the Sino-sphere, the elements exist in relation to each other and as equivalents for other things such as directions and colors, but these are two distinct systems and their components are not the same.

38. These accounts are written as though the bursts of light are visible to all, and some accounts only make sense this way, but conversations with close participants suggest that enlivening can be communicated to the priest through a waking vision rather than as a display of collectively experienced fireworks.

39. Personal communication, April 4, 2012.

40. As one of our conversation partners explained, white is associated with the east and the god Iswara; red, the south and the god Brahma; yellow, the west and the god Mahadewa; black, north, and the god Wisnu; center, and mixed colors, the god Siwa.

41. When I asked a puppet carver in Taiwan who had also been trained to carve temple statues about the poisonous insects, he told me that these were for gods invoked for business success and that no sentient being would be sacrificed to ensoul a buddha image. He also described a controversy involving the entombment of a living bird inside an important statue.

## CHAPTER 3. MATERIALITY, MAKING, AND MAGIC

1. Vũ Thị Thanh Tâm did additional interviews with the Sơn Đồng carvers. The following discussion combines information from both our collective work and material gathered by Tâm for our project. She found that *ông đồng* and *bà đồng* choose statue carvers for a variety of reasons, sometimes asking senior mediums or colleagues for recommendations, sometimes seeking out carvers of beautiful images they have seen in other temples. Some new mediums entrust the ordering to the master medium who initiated them or the medium whose temple they use for *lên đồng* rituals and do not involve themselves in the process, placing their trust in a more experienced medium.

2. This is similar to the logic of the Korean *mansin*'s practice that will be described in chapter 4; the *mansin* who displeases her gods loses customers because her practice is not efficacious and she incurs other punnishment.

3. Although Mr. Hạ had few specific memories of this particular commission for the Tiên Hương Palace, he described in great detail his procedures for carving a religious statue.

4. In the past, carvers went themselves to the forested provinces of Thanh Hóa, Nghệ An, or Hòa Bình to get wood. Now, with the proliferation of carving and the increased demand for wood, the carvers order lumber from suppliers or buy it from shops in the village. When they have money, carvers usually buy a truckload of wood (five to ten cubic meters). If a family cannot afford to buy the whole shipment, two to four families will buy one together. Mass purchases eliminate the ritual of first cut in these workshops.

5. In Korean contexts, *linh*, or in Korean *yŏng*, is usually translated as "soul."

6. Klaas Ruitenbeek (1993, 8) notes the venerable almanac heading "Going to the mountains to fell trees" (Ch.: *rushan famu*, 入山 伐木). The Sino-Korean almanac I bought in Seoul for 1978 uses only the last two ideographs, "fell trees," or "cut wood" (Kr.: *pŏlmok*, 벌목, 伐木), but the intention is the same.

7. The offerings include incense, flowers, betel, water, and seasonal fruits. If the ritual takes place on the first or the fifteenth day of the lunar month, days when offerings are made to the ancestors, a chicken and a dish of sticky rice will be included. If the clients live nearby, they attend, bringing betel, wine, incense, and sometimes cash as offerings. Some clients bring packaged cookies, candy, and beer. If they live far away, clients give money to the carvers to purchase offerings. The carver himself might prepare one or two trays of food to treat the clients.

8. The idea that carpenters and carvers might inject harmful sorcery into their work seems to be both old and widespread (e.g., Ruitenbeek 1993).

9. Daoist ritual masters/shamans of the Yao and related peoples along the Vietnam/China border also transport paintings to ritual sites, rolling them up as scrolls so that the gods can be present at the ritual site. Similarities in representational styles between these and some Korean shaman paintings hint at possible Daoist roots for the Korean practice (cf. Nguyen 2015). Although "Daoism" is commonly cited as one source of some Korean shaman gods, the topic has not yet been adequately pursued with respect to Daoism as a lived religious practice with important material components.

10. One of the traditionalist painters I interviewed thought that these Korean-Chinese productions were overpainted on large, colored photocopies.

11. Now defunct, this shrine was one of a disappearing number of old shrines that were transformed in the twentieth century into commercial *kuttang* where shamans rent space to perform *kut*. Most *kuttang* lack these antecedents and many *kuttang* proprietors treat their work as pure business, as many *manmulsang* proprietors do. Some others are shamans themselves. This particular proprietress, although not a shaman herself, has a close connection to the gods who send her portentous dreams. She is empowered to drum during *kut*, having been taught the rhythm in a dream.

12. This is the identical Chinese ideograph to the Vietnamese *tăm,* although some of my interviewees also used the pure Korean expression *maŭm* (마음)to indicate a seat of moral consciousness not unlike the heart-mind.

13. *Hwan* is dialect for painting (*hwa*), *pullim* the act of summoning.

14. An Chŏng-mo holds a local level heritage-bearer designation awarded by the City of Incheon.

15. For a detailed description of equivalent Thai practices regarding the fabrication of a buddha image, see Swearer (2004, 47–48) and Chiu (2017).

16. See Chiu (2017, 149) for related practices regarding wood in northern Thailand.

17. I am most grateful to Erin Hasinoff for this observation.

18. This is, of course, a simplification. As Mark Hobart (1985, 170) notes, "the Balinese have absorbed Hindu, Buddhist, Tantric, Old Javanese and other, including apparently indigenous, religious ideas and have mixed them into a textual and practical tradition which has so far baffled description"; it has also been subject to the ebb and flow of history (Ariati 2016).

19. For example, Eiseman (1990b, 207–19); Herbst (1997, 62–63); A. Hobart (2003, 132–49; 2005, 165–68); and Slattum and Schraub (2003, 23–27), and with profound gratitude for many conversations with scholars and with the

distinguished mask-makers Ida Bagus Anom, Ida Bagus Anom Alit, Ida Bagus Anom Suryawan, I Wayan Candra, I Ketut Kodi, Wayan Lalar ("Kak Dalang"), the late I Wayan Tangguh, and Tjokorda Raka Tisnu. I take full responsibility for any misunderstanding of what they so generously tried to tell me.

20. In some accounts, the *pulé* tree grew from the seed of Siwa (Shiva), in the persona of the Barong when he reunited with his banished consort Uma, in the persona of Rangda. In his excitement, Siwa spilled his seed prematurely (Stephen 2001 and others, including some of our interviewees).

21. One mask-maker told us that in some cases the priest or the community sees a light entering the appropriate bump on the tree. Sometimes a nail is driven into the bump and if it stays in the tree for more than a day, the wood is good. Once, in this conversation partner's experience, a trancer indicated a block of sacred wood stored under a temple, which was subsequently used for a Rangda mask. According to Herbst (1997, 62–63), a tree felled by lightning just outside the Pura Dalem might be reserved for a sacred Rangda or Barong mask.

22. *Ngepel* is derived from the Balinese word *pel*, "cut" (Eiseman 1990b, 212), a parallel to the Sino-centric attention to auspiciously cutting wood.

23. The tree's spirit or soul is sometimes identified as the Banaspati Raja.

24. Many, but not all, carvers of temple masks are Brahmins. Master carvers have learned their craft either through lifelong exposure to a family tradition or through rigorous apprenticeship. I Ketut Kodi, a well-known carver and performer, has described how the seed of his knowledge of carving was planted by a touch of the hand of his father's teacher, the renowned master carver Cokorda Raka Tublen (Foley and I Nyoman Sedana 2005, 201–2).

25. Investing the mask with one's *jiwa* is called *menjiwai*.

## CHAPTER 4. AGENCY AND ASSEMBLAGE

1. See Rosalind Morris's (2000, 183, 192) seminal discussion of the popularity of photography among Northern Thai spirit mediums, which is similarly narrated locally as "evidence of the spirit's willingness to be photographed and indeed as an index of magical agency."

2. One of our conversation partners described *kadaw* as "like ceremonious bowing to the king."

3. While earlier accounts emphasized the "ecstasy" or "frenzy" of the dance and the seemingly spontaneous quality of the dancing, more recent scholarship highlights the stylized nature of different *nat* manifestations and the attention that professional mediums and transvestite dancers in their entourage give to the execution of skilled choreographic moves (Brac de la Perrière 2005, 78; Schober 2004, 805).

4. For more about mountain pilgrimage see Kendall (1985, 128–31; 1988, 18–30; 2009, 177–203; 2017).

5. Personal communication, March 24, 2012.

6. Hildred Geertz (2004, 274) glosses *sakti* as "mystical power or mastery"; "the dual competence to heal and to hurt, to fructify and also to destroy and to be able to divert the destructive efforts of other *sakti* beings" (73).

7. The reference is to a performance style developed by the Polish avant-garde director Jerzy Grotowski (1968), who trained actors to simulate transformative and expressive "masks" by using their facial muscles. Korean *mansin* also accomplish this, some more convincingly than others, when manifesting particular gods, most notably the greedy Official whose lips sometimes twist into a piglike snout.

8. Belo (1960, 98–99) describes the process of removal and restoration but does not mention the temporary shrine.

9. "Ratu" is a high-status honorific sometimes translated as "royal."

10. "Ratu Ayu" is the female status equivalent of "Ratu Anom." Both of these names are frequently encountered among Brahmin Balinese and by extension, temple masks.

11. The notion of images becoming more empowered over time is not unique to Bali, although instances of a secular thing leaping a category seem fairly unusual and worthy of comment. Lin Wei-ping (2015, 45) describes how in Taiwan, temple images are regarded as becoming more efficacious with use.

12. The old Barong would be kept in the temple in baskets or, in some places, cremated as a human corpse would be cremated, libated with holy water by a priest, and cast into the ocean.

13. Now called Institute of Art of Indonesia, or ISI.

14. Kajeng Keliwon, a conjunction of the last days of three- and five-day weeks in the Balinese calendar, occur at intervals of fifteen days and are considered a particularly appropriate time for prayers and temple festivals (Eiseman 1990a, 179).

## CHAPTER 5. THE AMBIGUITIES OF THE UNSACRED

1. Likewise, in Myanmar, Erin Hasinoff found that where several contemporary painters take inspiration from *nat* images, they produce in anticipation of a foreign clientele and assume that Burmese would not consider it auspicious to naïvely hang these images in their own homes (Hasinoff and Kendall 2018).

2. Following descriptions in Huang and Yi et al. (1988); Im (1999); Kim Tu-ha (1990); Kim Tu-ha et al. (1991); Kungnip minsok pangmulgwan (2003); Yi Chong-ch'ŏl (1992); Yi Kwan-ho (2005); Yi Pilyŏng (1997); and Yi Tu-hyŏn (1984).

3. For example, see Cavendish (1894, 176); Clark (1961 [1932], 42, 108, 198); Gale (1898, 243–44; 1911, facing 86, 86–87); Gifford (1898, facing 110); Griffis (1911, 280); Jones (1902, 42–43); Moose (1911, 194); and Poleax (1895, 143–44).

4. The earliest of these accounts might be Suzuki Kentaro's 1890 description of the functions and putative origins of the *changsŭng*. In 1902, Yagi Shozaburo published a detailed study based on his own fieldwork and illustrated it with sketches and photographs (Knez and Swanson 1968, 72 #207, 76 #220). *Changsŭng* appeared in ethnographic and folkloric accounts throughout the colonial period, including a 1933 work in Japanese by the first-generation Korean folklorist Son Ch'in-t'ae that would be much-cited, and to some degree modeled by subsequent generations of Korean folklorists (Knez and Swanson 1968, 66 #186).

5. For example, the American Museum of Natural History's AMNH 70.3/2435 and 70.3/2436.

6. This list is based on carvers' descriptions of their commissions and my own observations. The foregoing discussion of *changsŭng* revival is based on Im (1999), Kim Tu-ha (1990), and my own observations.

7. This discussion is based on Eiseman (1990b, 207–19); Slattum and Schaub (2003, 13–14, 23–26); A. Hobart (2003, 124, 132; 2005, 167); Stephen (2001, 159–60); Dibia and Balinger (2004, 67–68); Duff-Cooper (1984); and interviews with Ida Bagus Anom, Ida Bagus Anom Suryawan, Cokorda Raka Tisnu, I Wayan Tangguh, I Ketut Kodi, Pak Wayan Lalar, Pak Chandra, and Ida Bagus Alit and with souvenir vendors in the Ubud and Sukawati markets.

8. Also known as Ida Ratu Gedé Gombrang (Exalted Gentleman with Wild Hair), Sesuhunan Amerika (American Tutelary), Tapel Amerika (American Mask), and more recently by the exalted titles Ratu Gedé Manik (Gem-like Exalted Gentleman) and Ratu Gedé Sapuhjagat (Exalted Gentleman who Cleanses the Universe).

9. Personal communication, April 4, 2012.

10. Even so, the spectacularly *tenget* masks of Tegaltamu that Jane Belo (1960) described in the 1930s burned in a conflagration sometime in the mid-twentieth century.

11. Personal communications, April 4, 2012; April 23, 2018.

CHAPTER 6. AFTERLIVES

1. Personal communication, December 15, 2005. I am grateful to Nguyễn Thị Thu Hương for the translation.

2. In a similar move, although not intended for a museum, the Balinese painter Togog made a modern painting of the image he might otherwise have painted on a funeral shroud. Togog included a painted background and omitted the scriptural writing that makes the shroud a powerful and dangerous image, the words that would "bring it to life" (H. Geertz 2005, 213–14). If we look for them, such practices may in fact be quite common. Describing Franklin Hamilton Cushing's controversial and inaccurate replication of the Zuni Ahayu:da, described in a repatriation claim as a misappropriation of sacred knowledge, Gwyneira Isaac (2011, 222) speculates, "If the Ahayu:da are not 'duplicates' and do in fact diverge slightly from the standard carvings, did Cushing do this on purpose in order to present something to the Berlin museum that was not complete and would therefore not be harmful or dangerous? This practice is rumored to take place among artists in the Pueblos who leave out certain elements in pieces that are made specifically for consumption by tourists and collectors—a practice that is rumored to nullify their efficacy." She concludes that Zuni understandings of the power of Ahayu:da would argue against the appropriateness of any out-of-context use of associated ritual knowledge, but leaves the question hovering with respect to other Puebloan material and Cushing's own intentions.

3. Fred Eiseman (1990b, 213–19) has described how he commissioned a *topeng* Sida Karya mask, a mask that would not be ensouled and would not be *tenget,* although some (not all) of the dancers who use this mask in temple ritu-

als do ensoul Sida Karya. Eiseman commissioned the late renowned carver I Wayan Tangguh in Singapadu. Tangguh abstained from working on the first day of the Balinese three-day week, "which is considered a very unlucky day for almost everything and anything in Bali," and when the mask was complete, he performed a simple ritual of purification for it (melaspas/melaspasin).

4. According to the respected performer and carver I Ketut Kodi, "Whoever tries to explain *taksu* doesn't hit the mark" (quoted in Foley and Sedana 2005, 209; cf. Belo 1960, 2; S. Davies 2007, 21; Dibia 2012; Bandem and deBoer 1995, 14; Emigh 1996, 30–31, 116).

5. On the advice of Alexandra Konstantinova Chirkova, the daughter of a renowned Sakha shaman who was approaching her father's path, I smudged AMNH 70/8440 before it went on exhibit in 1997, using a bundle of sacred herbal grasses from the Yukaghir country which Alexandra located, fortuitously, in the depths of her capacious handbag and gifted to me. When the exhibit opened I tried, through an intermediary whose English was limited, to let Dr. Kurilov know what I had done.

6. See for example Davis (2015, 14) and Dalrymple (2009, 178, 198) with respect to Hindu statues; Pinney (2017, 147) with respect to printed images of Hindu deities; and Lin (2015) with respect to images in popular practice in Taiwan.

7. In one newly renovated temple, my Vietnamese colleagues and I were shown a photograph documenting the burial of several clay images, humble works that had been replaced by higher-quality and consequently more expensive wooden images.

8. From a 1980 critique of the AMNH Asia Hall by Schuyler R. Cammann, who identified the image as the Warrior God Wei-t'o and suggested that the cavity might have been used when the statue was "consecrated" (AMNH Library Archive, Cammann to Nicholson, 25 October 1980). The image entered the museum identified by an unattributed source as "probably Chinese god of fortune" with a "hole in back for deposit of money" (AMNH Catalogue Cards 70.2/5100s-6800s).

9. Although the objects of most of these thefts were gilded images, gilded wood, jewels, or coin statues, temple masks were also stolen.

10. He identified the ceremony as *mecaru,* a ritual held to neutralize demonic forces. If the thief is apprehended, he must pay for the cost of the ceremony.

11. The statues' fate is similar to the incarceration-like storage of the Indian Śiva Naṭarāja image, whose repatriation Richard Davis (1997) recounts in detail. Unlike the Śiva Naṭarāja, at least the *nat* images are accessible to devotees, albeit behind glass in their refurbished shrine and at least during the daylight hours.

12. *Kuttang* is sometimes translated as "ritual hall."

13. In the United States, the Native American Graves Protection and Repatriation Act's provision for the potential repatriation of "objects of cultural patrimony" is an opening to such dialogues with respect to Native American and Native Hawai'ian material and offers a model for other negotiations beyond these groups.

14. I am grateful to Dr. Jongsung Yang for many conversations about god pictures and other shrine paraphernalia in museums.

# Bibliography

Akamatsu Chijo and Akiba Takashi. 1938. *Chōsen fuzoku no kenkyū* [Study of Korean shamanism]. Tokyo: Osakayago Shōten.

Appadurai, Arjun, ed. 1986a. *The Social Life of Things: Commodities in Cultural Perspective*. Cambridge, UK: Cambridge University Press.

———. 1986b. "Introduction: Commodities and the Politics of Value." In *The Social Life of Things: Commodities in Cultural Perspective*, edited by Arjun Appadurai, 2–63. Cambridge, UK: Cambridge University Press.

Ariati, Ni Wayan Pasek. 2016. *The Journey of the Goddess Durga: India, Java, and Bali*. New Delhi: International Academy of Indian Culture and Aditya Prakashan.

Atkinson, Jane M. 1989. *The Art and Politics of Wana Shamanship*. Berkeley: University of California Press.

Ballinger, Rucina. 2004. "Historic Ubud." In *Ubud is a Mood*, directed and designed by Leonard Lueras, 14–32. Batuan, Sukawati, Gianyar: The Bali Purnati Center for the Arts in cooperation with the Lembaga Ketahanan Masyarakat Desa (LKMD).

Balzer, Marjorie Mandelstam. 2011. "Shamanic Objects, Repression and Resilience." In *The Siberian Collection in American Museum of Natural History: Circumpolar Civilization in the World Museums: Yesterday, Today, Tomorrow*, edited by Zinaida Ivanova-Unarova, 25–41. Yakutsk: National Committee of the Sakha Republic (Yakutia) for UNESCO.

Bandem, I Madé, and Fredrik E. deBoer. 1995. *Balinese Dance in Transition: Kaja and Kelod*. Oxford: Oxford University Press.

Bateson, Gregory, and Margaret Mead, dirs. 1952. *Trance and Dance in Bali*. Institute for Intercultural Studies. http://www.interculturalstudies.org/resources.html#films.

Bautista, Julius. 2010. *Figuring Catholicism: An Ethnohistory of the Santo Niño de Cebu.* Quezon City/Manila: Ateneo de Manila University Press.

Bekker, Sarah M. 1994. "Talent for Trance: Dancing for the Spirits in Burma." In *Tradition and Modernity in Myanmar: Proceedings of an International Conference Held in Berlin from May 7th to May 9th, 1993,* edited by Uta Gärtner and Jens Lorenz, 287–98. Münster: LIT.

Belo, Jane. 1949. *Bali: Rangda and Barong.* Locust Valley, NY: J.J. Augustin.

———. 1960. *Trance in Bali.* New York: Columbia University Press.

Belting, Hans. 1994. *Likeness and Presence: A History of the Image Before the Era of Art.* Chicago: University of Chicago Press.

Benjamin, Walter. 1969 [1935]. "The Work of Art in the Age of Mechanical Reproduction." In *Illuminations: Essays and Reflections,* edited by Hannah Arendt, 217–51. New York: Schocken.

Bennett, Jane. 2010. *Vibrant Matter: A Political Ecology of Things.* Durham, NC: Duke University Press.

Bentor, Yael. 1996. *Consecration of Images and Stūpas in Indo-Tibetan Tantric Buddhism.* Leiden: E.J. Brill.

Bogel, Cynthea J. 2008. "Situating Moving Objects: A Sino-Japanese Catalogue of Imported Items, 800 CE to the Present." In *What's the Use of Art?: Asian Visual and Material Culture in Context,* edited by Jan Mrázek and Morgan Pitelka, 142–76. Honolulu: University of Hawai'i Press.

Brac de la Perrière, Bénédicte. 1992. "La fête de Taunbyon: le grand ritual du culte des naq de Birmanie (Myanmar)." *Bulletin de l'École française d'Extrême-Orient* 79, no. 2: 201–31.

———. 2002. "'Royal Images' in Their 'Palaces': The Place of the Statues in the Cult of the 37 Nats." In *Burma: Art and Archaeology,* edited by Alexandra Green and T. Richard Blurton, 99–105. London: The Trustees of the British Museum.

———. 2005. "The Taungbyon Festival: Locality and Nation-Confronting in the Cult of the 37 Lords." In *Burma at the Turn of the 21st Century,* edited by Monique Skidmore, 65–89. Honolulu: University of Hawai'i Press.

———. 2007. "To Marry a Man or a Spirit? Women, the Spirit Possession Cult, and Domination in Burma." In *Women and the Contested State: Religion, Violence, and Agency in South and Southeast Asia,* edited by Monique Skidmore and Patricia Lawrence, 208–28. Notre Dame, IN: University of Notre Dame Press.

———. 2009. "'Nats' Wives' or 'Children of Nats': From Spirit Possession to Transmission Among the Ritual Specialists of the Cult of the Thirty-Seven Lords." *Asian Ethnology* 68, no. 2: 283–305.

———. 2011. "Being a Spirit Medium in Contemporary Burma." In *Engaging the Spirit World: Popular Beliefs and Practices in Modern Southeast Asia,* edited by Kirsten W. Endres and Andrea Lauser, 163–83. New York: Berghahn Books.

———. 2016. "Spirit Possession: An Autonomous Field of Practice in the Burmese Buddhist Culture." *Journal of Burma Studies* 20, no. 1: 1–29.

Brinker, Helmut. 2011. *Secrets of the Sacred: Empowering Buddhist Images in Clear, in Code, and in Cache.* Seattle: University of Washington Press.

Brown, R. Grant. 1915. "The Taungbyôn Festival, Burma." *The Journal of the Royal Anthropological Institute of Great Britain and Ireland* 45: 355–63.

Buyandelgeriyn, Manduhai. 2007. "Dealing with Uncertainty: Shamans, Marginal Capitalism, and the Remaking of History in Postsocialist Mongolia." *American Ethnologist* 34, no. 1: 127–47.

Bynum, Caroline Walker. 2015. *Christian Materiality: An Essay on Religion in Late Medieval Europe.* New York: Zone Books.

*Catechism of the Catholic Church.* 1997. Vatican City: Libreria Editrice Vaticana.

Causey, Andrew. 2003. *Hard Bargaining in Sumatra: Western Travelers and Toba Bataks in the Marketplace of Souvenirs.* Honolulu: University of Hawai'i Press.

Cavendish, Captain A. E. J. 1894. *Korea and the Sacred White Mountain: Being a Brief Account of a Journey in Korea in 1891.* London: George Philip and Son.

Chan, Margaret. 2012. "Bodies for the Gods: Image Worship in Chinese Popular Religion." In *The Spirit of Things: Materiality and Religious Diversity in Southeast Asia,* edited by Julius Bautista, 197–215. Ithaca, NY: Southeast Asia Program, Cornell University.

Chang Chu-gŭn. 1994. "Han'gugmusindo sogo" [A brief report on Korean shaman painting]. In *Kŭrimŭro ponŭn han'gugŭi musindo* [Korean shaman painting seen as paintings], edited by Yul Soo Yoon, A–J. Seoul: Igach'aek.

Chau, Adam Yuet. 2005. *Miraculous Response: Doing Popular Religion in Contemporary China.* Stanford, CA: Stanford University Press.

Chiu, Angela S. 2017. *The Buddha in Lanna: Art, Lineage, Power, and Place in Northern Thailand.* Honolulu: University of Hawai'i Press.

Cho, Insoo. 2010. "Materializing Ancestor Spirits: Name Tablets, Portraits, and Tombs in Korea." In *Religion and Material Culture: The Matter of Belief,* edited by David Morgan, 214–28. London: Routledge.

Christian, William A., Jr. 1989. *Person and God in a Spanish Valley.* Rev. ed. Princeton, NJ: Princeton University Press.

Clark, Charles A. 1961 [1932]. *Religions of Old Korea.* Seoul: Christian Literature Society of Korea.

Cohen, Leonard. 2011. "Be with Me." In *Stranger Music: Selected Poems and Songs,* 125. New York: Vintage.

Cohen, Myron L. 1991. "Being Chinese: The Peripheralization of Traditional Identity." *Daedalus* 120, no. 2: 113–34.

Connor, Linda H. 1995. "Acquiring Invisible Strength: A Balinese Discourse of Harm and Well-Being." *Indonesia Circle* 66: 125–53.

Costa, Luiz, and Carlos Fausto. 2010. "The Return of the Animists: Recent Studies of Amazonian Ontologies." *Religion and Society* 1, no. 1: 89–109.

Covaci, Ive, ed. 2016. *Kamakura: Realism and Spirituality in the Sculpture of Japan.* New Haven, CT: Asia Society Museum in association with Yale University Press.

Covarrubias, Miguel. 1972 [1937]. *Island of Bali.* Kuala Lumpur: Oxford University Press.

Dalrymple, William. 2009. *Nine Lives: In Search of the Sacred in Modern India.* London: Bloomsbury.

Davies, Stephen. 2007. "Balinese Aesthetics." *The Journal of Aesthetics and Art Criticism* 65, no. 1: 21–29.

Davis, Richard H. 1997. *Lives of Indian Images*. Princeton, NJ: Princeton University Press.

———. 2015. "What Do Indian Images Really Want? A Biographical Approach." In *Sacred Objects in Secular Spaces: Exhibiting Asian Religions in Museums*, edited by Bruce M. Sullivan, 9–25. London: Bloomsbury.

De La Paz, Cecilia. 2012. "The Potency of Poon: Religious Sculpture, Performativity, and the Mahal Na Senyor of Lucban." In *The Spirit of Things: Materiality and Religious Diversity in Southeast Asia*, edited by Julius Bautista, 183–96. Ithaca, NY: Southeast Asia Program, Cornell University.

Deleuze, Gilles, and Félix Guattari. 1987 [1980]. *A Thousand Plateaus: Capitalism and Schizophrenia*. Translated by Brian Massumi. Minneapolis: University of Minnesota Press.

Descola, Philippe. 2014 [2004]. *Beyond Nature and Culture*. Chicago: University of Chicago Press.

Desjarlais, Robert R. 1996. "Presence." In *The Performance of Healing*, edited by Carol Laderman and Marina Roseman, 143–64. New York and London: Routledge.

de Zoete, Beryl, and Walter Spies. 1973 [1938]. *Dance and Drama in Bali*. Kuala Lumpur: Oxford University Press.

Dibia, I Wayan. 2012. *Taksu: In and Beyond the Arts*. Denpasar: Wayan Geria Foundation.

———, and Rucina Ballinger. 2004. *Balinese Dance, Drama and Music: A Guide to the Performing Arts of Bali*. Singapore: Tuttle Publishing.

DiGregorio, Michael, and Oscar Salemink. 2007. "Living with the Dead: The Politics of Ritual and Remembrance in Contemporary Vietnam." *Journal of Southeast Asian Studies* 38, no. 3: 433–40.

Drazin, Adam, and Susanne Küchler, eds. 2015. *The Social Life of Materials: Studies in Materials and Society*. London: Bloomsbury Academic.

Drumheller, Ann, and Marian Kaminitz. 1994. "Traditional Care and Conservation: The Merging of Two Disciplines at the National Museum of the American Indian." *Studies in Conservation* (Preprints of the Contributions to the Ottawa Congress, 12–16 September 1994) 39, sup2: 58–60.

Duara, Prasenjit. 1991. "Knowledge and Power in the Discourse of Modernity: The Campaigns Against Popular Religion in Early Twentieth-Century China." *The Journal of Asian Studies* 50, no. 1: 67–83.

———. 1995. *Rescuing History from the Nation: Questioning Narratives of Modern China*. Chicago: University of Chicago Press.

Duff-Cooper, Andrew. 1984. *An Essay in Balinese Aesthetics*. Hull, UK: University of Hull Centre for South-East Asian Studies.

Eck, Diana. 1998. *Darśan: Seeing the Divine Image in India*. New York: Columbia University Press.

Edwards, Elizabeth, and Janice Hart, eds. 2004. *Photographs Objects Histories: On the Materiality of Images*. London: Routledge.

Eiseman, Fred B., Jr. 1990a. *Bali: Sekala & Niskala: Essays in Religion, Ritual, and Art*. Singapore: Tuttle Publishing.

———. 1990b. *Bali: Sekala & Niskala: Essays in Religion, Ritual, and Art*. Vol. 2, *Essays in Society, Tradition, and Craft*. Singapore: Periplus Editions.

Emigh, John. 1984. "Dealing with the Demonic: Strategies for Containment in Hindu Iconography and Performance." *Asian Theatre Journal* 1, no. 1: 21–39.

———. 1996. *Masked Performance: The Play of Self and Other in Ritual and Theatre.* Philadelphia: University of Pennsylvania Press.

Endres, Kirsten W. 2011. *Performing the Divine: Mediums, Markets and Modernity in Urban Vietnam.* Singapore: NIAS Press.

Engelke, Matthew. 2011. "Material Religion." In *The Cambridge Companion to Religious Studies,* edited by Robert A. Orsi, 209–29. Cambridge, UK: Cambridge University Press.

Fjelstad, Karen, and Nguyễn Thị Hiền. 2006. "Introduction." In *Possessed by the Spirits: Mediumship in Contemporary Vietnamese Communities,* edited by Karen Fjelstad and Nguyễn Thị Hiền, 7–18. Ithaca, NY: Southeast Asia Program, Cornell University.

Foley, Kathy, and I Nyoman Sedana. 2005. "Balinese Mask Dance from the Perspective of a Master Artist: I Ketut Kodi on 'Topeng.'" *Asian Theatre Journal* 22, no. 2: 199–213.

Fraser-Lu, Sylvia. 2002 [1994]. *Burmese Crafts: Past and Present.* New York: Oxford University Press.

———, and Donald M. Stadtner, eds. 2015. *Buddhist Art of Myanmar.* New Haven, CT: Asia Society Museum in association with Yale University Press.

Frazer, James G. 1980 [1890]. *The Golden Bough: A Study in Magic and Religion.* London: Macmillan.

Freedberg, David. 1989. *The Power of Images: Studies in the History and Theory of Response.* Chicago: University of Chicago Press.

Gale, James S. 1898. *Korean Sketches.* New York: Fleming H. Revell.

———. 1911. *Korea in Transition.* New York: Missionary Education Movement of the United States and Canada.

Geary, Patrick. 1986. "Sacred Commodities: The Circulation of Medieval Relics." In *The Social Life of Things: Commodities in Cultural Perspective,* edited by Arjun Appadurai, 169–92. Cambridge, UK: Cambridge University Press.

Geertz, Clifford. 1973. "Person, Time, and Conduct in Bali." In *The Interpretation of Cultures,* 360–411. New York: Basic Books.

Geertz, Hildred. 1975. "An Anthropology of Religion and Magic, I." *The Journal of Interdisciplinary History* 6, no. 1: 71–89.

———. 1994. *Images of Power: Balinese Paintings Made for Gregory Bateson and Margaret Mead.* Honolulu: University of Hawai'i Press.

———. 2004. *The Life of a Balinese Temple: Artistry, Imagination, and History in a Peasant Village.* Honolulu: University of Hawai'i Press.

———, and Ida Bagus Madé Togog. 2005. *Tales from a Charmed Life: A Balinese Painter Reminisces.* Honolulu: University of Hawai'i Press.

Gell, Alfred. 1998. *Art and Agency: An Anthropological Theory.* Oxford: Clarendon Press.

———. 2002 [1988]. "Technology and Magic." In *The Best of Anthropology Today,* edited by Jonathan Benthall, 280–87. New York: Routledge.

———. 2010 [1992]. "The Enchantment of Technology and the Technology of Enchantment." In *The Craft Reader,* edited by Glenn Adamson, 464–82. New York: Berg.

Gernet, Jacques. 1995 [1956]. *Buddhism in Chinese Society: An Economic History From the Fifth to the Tenth Centuries.* Translated by Franciscus Verellen. New York: Columbia University Press.

Gifford, Daniel L. 1898. *Every-day Life in Korea: A Collection of Studies and Stories.* Chicago: Fleming H. Revell.

Gimello, Robert M. 2004. "Icon and Incantation: The Goddess Zhunti and the Role of Images in the Occult Buddhism of China." In *Images in Asian Religions: Texts and Contexts,* edited by Phyllis Granoff and Koichi Shinohara, 225–56. Vancouver: UBC Press.

Goossaert, Vincent. 2006. "1898: The Beginning of the End for Chinese Religion?" *The Journal of Asian Studies* 65, no. 2: 307–35.

Graham, Elizabeth. 2018. "Do You Believe in Magic?" *Material Religion: The Journal of Objects, Art and Belief* 14, no. 2: 255–57.

Grapard, Allan G. 1984. "Japan's Ignored Cultural Revolution: The Separation of Shinto and Buddhist Divinities in Meiji (*Shimbutsu Bunri*) and a Case Study: Tōnomine." *History of Religions* 23, no. 3: 240–65.

Greenblatt, Stephen. 1991. "Resonance and Wonder." In *Exhibiting Cultures: The Poetics and Politics of Museum Display,* edited by Ivan Karp and Steven D. Lavine, 42–56. Washington, DC: Smithsonian Institution Press.

Griffis, William E. 1911. *Corea: The Hermit Nation.* New York: Charles Scribner's Sons.

Groner, Paul. 2001. "Icons and Relics in Eison's Religious Activities." In *Living Images: Japanese Buddhist Icons in Context,* edited by Robert H. and Elizabeth Horton Sharf, 114–50. Stanford, CA: Stanford University Press.

Grotowski, Jerzy. 1968. *Towards a Poor Theatre.* New York: Simon and Schuster.

Gwon Hyeok Hui (Kwŏn Hyŏk-hŭi). 2007. "Iljesigi 'chosŏn p'ungsok inyŏng'gwa Chosŏninŭi sigakchŏk chaehyŏn" [A study of 'Joseon Folk Dolls' and visual reproduction of Koreans during the period of Japanese imperialism]. *Kungnip minsok pangmulgwan* [The National Folk Museum of Korea] 12: 7–29.

Hallam, Elizabeth, and Tim Ingold. 2008. "Creativity and Cultural Improvisation: An Introduction." In *Creativity and Cultural Improvisation,* edited by Elizabeth Hallam and Tim Ingold, 1–24. Oxford: Berg.

Hanks, Michele. 2016. "Between Electricity and Spirit: Paranormal Investigation and the Creation of Doubt in England." *American Anthropologist* 118, no. 4: 811–23.

Harris, Clare. 2013 (19–21 July). "The Digitally Distributed Museum and its Discontents." Paper presented at The Future of Ethnographic Museums conference, Pitt Rivers Museum and Kebel College, University of Oxford.

Harvey, Penny, et al., eds. 2014. *Objects and Materials: A Routledge Companion.* London: Routledge.

Hasinoff, Erin, and Laurel Kendall. 2018. "Making Spirits, Making Art: Nat Carving and Contemporary Painting in Pre-Transition Myanmar." *Material Religion: The Journal of Objects, Art and Belief* 14, no. 3: 285–313.

Henare, Amiria, Martin Holbraad, and Sari Wastell. 2007. "Introduction: Thinking Through Things." In *Thinking Through Things: Theorising Artefacts Ethnographically,* edited by Amiria Henare, Martin Holbraad, and Sari Wastell, 1–31. London: Routledge.

Herbst, Ed. 1981. "Intrinsic Aesthetics in Balinese Artistic and Spiritual Practice." *Asian Music* 13, no. 1: 42–52.

———. 1997. *Voices in Bali: Energies and Perceptions in Vocal Music and Dance Theater.* Hanover, NH: University Press of New England.

Herzfeld, Michael. 2017. "Thailand in a Larger Universe: The Lingering Consequences of Crypto-Colonialism." *The Journal of Asian Studies* 76, no. 4: 887–906.

Ho, Tamara C. 2009. "Transgender, Transgression, and Translation: A Cartography of *Nat Kadaws*: Notes on Gender and Sexuality within the Spirit Cult of Burma." *Discourse* 31, no. 3: 273–317.

Hobart, Angela. 2003. *Healing Performances of Bali: Between Darkness and Light.* New York: Berghahn Books.

———. 2005. "Transformation and Aesthetics in Balinese Masked Performances—Rangda and Barong." In *Aesthetics in Performance: Formations of Symbolic Construction and Experience,* edited by Angela Hobart and Bruce Kapferer, 161–82. New York: Berghahn Books.

Hodder, Ian. 2012. *Entangled: An Archaeology of the Relationships between Humans and Things.* New York: Wiley-Blackwell.

Holbraad, Martin, and Morten Axel Pedersen. 2017. "Things as Concepts." In *The Ontological Turn: An Anthropological Exposition,* edited by Martin Holbraad and Morten Axel Pedersen, 199–241. Cambridge, UK: Cambridge University Press.

Holland, Eugene W. 2013. *Deleuze and Guattari's 'A Thousand Plateaus': A Reader's Guide.* London: Bloomsbury Academic.

Horton, Sarah J. 2007. *Living Buddhist Statues in Early Medieval and Modern Japan.* New York: Palgrave Macmillan.

Hoskins, Janet. 1998. *Biographical Objects: How Things Tell the Stories of People's Lives.* London: Routledge.

———. 2006. "Agency, Biography and Objects." In *Handbook of Material Culture,* edited by Chris Tilley, et al., 74–84. London: Sage Publications.

———. 2015. *The Divine Eye and the Diaspora: Vietnamese Syncretism Becomes Transpacific Caodaism.* Honolulu: University of Hawai'i Press.

Houtman, Dick, and Birgit Meyer. 2012. "Introduction: Material Religion—How Things Matter." In *Things: Religion and the Question of Materiality,* edited by Dick Houtman and Birgit Meyer, 1–26. New York: Fordham University Press.

Howe, Leo. 2005. *The Changing World of Bali.* London: Routledge.

Howes, Graham. 2007. *The Art of the Sacred: An Introduction to the Aesthetics of Art and Belief.* New York: I. B. Tauris.

Hu Tai-Li, dir. 2012. *Returning Souls.* Film. Taipei, Taiwan: Institute of Ethnography, Academia Sinica.

Huang Hyŏn-man, Yi Chong-ch'ŏl, et al. 1988. *Changsŭng.* Seoul: Yŏlhuadang.

Humphrey, Caroline, and Urgunge Onon. 1996. *Shamans and Elders: Experience, Knowledge, and Power Among the Daur Mongols.* Oxford: Clarendon Press.

Im Tong-gwŏn. 1999. *Taejanggun sinangŭi yŏngu* [Research on beliefs regarding the great general]. Seoul: Minsogwŏn.

Ingold, Tim. 2007a. "Materials Against Materiality." *Archaeological Dialogues* 14, no. 1: 1–16.

———. 2007b. "Writing Texts, Reading Materials: A Response to My Critics." *Archaeological Dialogues* 14, no. 1: 31–38.

———. 2010. "Bringing Things to Life: Creative Entanglements in a World of Materials." ESRC National Centre for Research Methods, NCRM Working Paper Series, Working Paper No. 15, 2–14. Manchester, UK: University of Manchester.

———. 2013. *Making: Anthropology, Archaeology, Art and Architecture.* New York: Routledge.

Isaac, Gwyneira. 2011. "Whose Idea Was This? Museums, Replicas, and the Reproduction of Knowledge." *Current Anthropology* 52, no. 2: 211–33.

Isaacs, Ralph, and T. Richard Blurton. 2000. *Visions from the Golden Land: Burma and the Art of Lacquer.* London: British Museum Press.

Jochelson, Waldemar. 1926. "Shamanism." In *The Yukaghir and the Yukaghir-ized Tungus,* 162–92. New York: G. E. Stechert and Co.

Jonaitis, Aldona. 1999. "Northwest Coast Totem Poles." In *Unpacking Culture: Art and Commodity in Colonial and Postcolonial Worlds,* edited by Ruth B. Phillips and Christopher B. Steiner, 104–21. Berkeley: University of California Press.

Jones, George Heber. 1902. "The Spirit Worship of the Koreans." *Transactions of the Royal Asiatic Society, Korea Branch* 2, no. 1: 37–58.

Kalb, Laurie Beth. 1994. *Crafting Devotions: Tradition in Contemporary New Mexico Santos.* Albuquerque: University of New Mexico Press.

Keane, Webb. 2003. "Self-Interpretation, Agency, and the Objects of Anthropology: Reflections on a Genealogy." *Comparative Studies in Society and History* 45, no. 2: 222–48.

———. 2007. *Christian Moderns: Freedom and Fetish in the Mission Encounter.* Berkeley: University of California Press.

———. 2013. "On Spirit Writing: Materialities of Language and the Religious Work of Transduction." *Journal of the Royal Anthropological Institute* 19, no. 1: 1–17.

Kendall, Laurel. 1985. *Shamans, Housewives, and Other Restless Spirits: Women in Korean Ritual Life.* Honolulu: University of Hawai'i Press.

———. 1988. *The Life and Hard Times of a Korean Shaman: Of Tales and the Telling of Tales.* Honolulu: University of Hawai'i Press.

———. 1996a. "Initiating Performance: The Story of Chini, a Korean Shaman." In *The Performance of Healing,* edited by Carol Laderman and Marina Roseman, 17–58. London: Routledge.

———. 1996b. "Korean Shamans and the Spirits of Capitalism." *American Anthropologist* 98, no. 3: 512–27.

———, 2008. "Editor's Introduction: Popular Religion and the Sacred Life of Material Goods in Contemporary Vietnam." Special issue, *Asian Ethnology* 67, no. 2: 177–200.

———. 2009. *Shamans, Nostalgias, and the IMF: South Korean Popular Religion in Motion.* Honolulu: University of Hawai'i Press.

———. 2011. "The *Changsŭng* Defanged? The Curious Recent History of a Korean Cultural Symbol." In *Consuming Korean Tradition in Early and*

*Late Modernity: Commodification, Tourism, and Performance*, edited by Laurel Kendall, 129–48. Honolulu: University of Hawai'i Press.

———. 2015. "Can Commodities Be Sacred? Material Religion in Seoul and Hanoi." In *Handbook of Religion and the Asian City*, edited by Peter van der Veer, 367–84. Oakland, CA: University of California Press.

———. 2017. "Things Fall Apart: Material Religion and the Problem of Decay." *The Journal of Asian Studies* 76, no. 4: 861–86.

———, and Ni Wayan Pasek Ariati. 2020. "Scary Mask/Balinese Local Protector: The Curious History of Jero Amerika." *Anthropology and Humanism* 45 no. 2 (Winter): 1–22.

Kendall, Laurel, Vũ Thị Thanh Tâm, and Nguyễn Thị Thu Hương. 2010. "Beautiful and Efficacious Statues: Magic, Commodities, Agency, and the Production of Sacred Objects in Popular Religion in Vietnam." *Material Religion: The Journal of Objects, Art and Belief* 6, no. 1: 60–85.

———. 2012. "Icon, Iconoclasm, Art Commodity: Are Objects Still Agents in Vietnam?" In *The Spirit of Things: Materiality and Religious Diversity in Southeast Asia*, edited by Julius Bautista, 11–26. Ithaca, NY: Southeast Asia Program, Cornell University.

Kendall, Laurel, Vũ Thị Hà, Vũ Thị Thanh Tâm, Nguyễn Văn Huy, and Nguyễn Thị Hiền. 2013. "Is it a Sin to Sell a Statue? Catholic Statues and the Traffic in Antiquities in Vietnam." *Museum Anthropology* 36, no. 1: 66–82.

Kendall, Laurel, Jongsung Yang, and Yul Soo Yoon. 2015. *God Pictures in Korean Contexts: The Ownership and Meaning of Shaman Paintings*. Honolulu: University of Hawai'i Press.

Kim T'ae-gon. 1989. *Han'gugmusindo* [Korean shaman paintings]. Seoul: Yeolhwadang.

Kim Tu-ha. 1990. *Pŏksuwa changsŭng* [Pŏksu and changsŭng]. Seoul: Chimmundang.

———, et al. 1991. *Changsŭnggwa pŏksu* [Changsŭng and pŏksu]. Seoul: Taewŏnsa.

Knez, Eugene I., and Chang-su Swanson. 1968. *A Selected and Annotated Bibliography of Korean Anthropology*. Seoul: National Assembly Library, Republic of Korea.

Kopytoff, Igor. 1986. "The Cultural Biography of Things: Commoditization as Process." In *The Social Life of Things: Commodities in Cultural Perspective*, edited by Arjun Appadurai, 64–91. Cambridge, UK: Cambridge University Press.

Kreps, Christina. 1998. "Museum-Making and Indigenous Curation in Central Kalimantan, Indonesia." *Museum Anthropology* 22, no. 1: 5–17.

Küchler, Susanne. 1997. "Sacrificial Economy and Its Objects: Rethinking Colonial Collecting in Oceania." *Journal of Material Culture* 2, no. 1: 39–60.

Kumada, Naoko. 2004 (22–23 May). "Rethinking Daná in Burma: The Art of Giving." Paper presented at "Burmese Buddhism and the Spirit Cult Revisited: An Interdisciplinary Conference on Religion in Contemporary Myanmar," Stanford University, Stanford, CA.

Kungnip minsok pangmulgwan [National Museum of Folklore]. 1988–1997. *Chibang changsung sottae sinang* [Survey of regional changsŭng and sottae belief]. Seoul: Kungnip minsok pangmulgwan.

———. 2003. *Sajinŭro ponŭn minsokŭi ojewa onŭl, 1950–2000: Nyŏndae, Chang Chu-gŭn Paksa Kijungsajin charyujip* [Folklore's yesterday and today as seen through photographs, 1950–2000: Photographic data donated by Professor Chang Chugŭn]. Seoul: Kungnip minsok pangmulgwan.

Kwon, Heonik, and Jun Hwan Park. 2018. "American Power in Korean Shamanism." *Journal of Korean Religions* 9, no. 1: 43–69.

La, Công Ý. 2008. "Đàn Tính: The Marvelous and Sacred Musical Instrument of the Tày People." *Asian Ethnology* 67, no. 2: 271–86.

Landis, E. B. 1895. "Notes on the Exorcism of Spirits in Korea." *The China Review* 21, no. 6: 399–404.

Latour, Bruno. 1993 [1991]. *We Have Never Been Modern*. Cambridge, MA: Harvard University Press.

———. 2010. *On the Modern Cult of the Factish Gods*. Durham, NC: Duke University Press.

Lederman, Rena. 2017. "Remapping 'Magic': Extending the Terrain of an Already Capacious Category." *HAU: Journal of Ethnographic Theory* 7, no. 3: 373–75.

Lee, Diana S., and Laurel Kendall, dirs. 1991. *An Initiation* Kut *for a Korean Shaman*. Film. Los Angeles and Honolulu: Center for Visual Anthropology, University of California, distributed by the University of Hawai'i Press.

Lenclud, Gérard, et al. 2014. "Book Symposium—Beyond Nature and Culture (Philippe Descola)." *HAU: Journal of Ethnographic Theory* 4, no. 3: 363–443.

Lin, Wei-Ping. 2008. "Conceptualizing Gods Through Statues: A Study of Personification and Localization in Taiwan." *Comparative Studies in Society and History* 50, no. 2: 454–77.

———. 2015. *Materializing Magic Power: Chinese Popular Religion in Villages and Cities*. Cambridge, MA: Harvard University Press.

MacRae, Graeme S. 1997. "Economy, Ritual and History in a Balinese Tourist Town." PhD dissertation, University of Auckland.

Malarney, Shaun Kingsley. 2002. *Culture, Ritual, and Revolution in Vietnam*. New York: Routledge.

———. 2003. "Return to the Past? The Dynamics of Contemporary Religious and Ritual Transformation." In *Postwar Vietnam: Dynamics of a Transforming Society*, edited by Hy V. Luong, 225–56. Singapore: Institute of Southeast Asian Studies (ISEAS).

Malinowski, Bronislaw. 1954. *Magic, Science and Religion and Other Essays*. Garden City, NY: Doubleday Anchor.

Manning, Paul, and Ilana Gershon. 2013. "Animating Interaction." *HAU: Journal of Ethnographic Theory* 3, no. 3: 107–37.

Marx, Karl. 1867. "The Fetishism of Commodities and the Secret Thereof." *Capital*, Vol 1. Accessed October 1, 2020. https://www.marxists.org/archive/marx/works/1867-c1/ch01.htm.

Masuzawa, Tomoko. 2005. *The Invention of World Religions: Or, How European Universalism Was Preserved in the Language of Pluralism*. Chicago: University of Chicago Press.

Mauss, Marcel. 1972 [1950]. *A General Theory of Magic*. New York: W. W. Norton & Co.

McDaniel, Justin Thomas. 2011. "The Agency Between Images: The Relationships Among Ghosts, Corpses, Monks, and Deities at a Buddhist Monastery in Thailand." *Material Religion: The Journal of Objects, Art and Belief* 7, no. 2: 242–67.

McGowan, Kaja M. 2008. "Raw Ingredients and Deposit Boxes in Balinese Sanctuaries: A Congruence of Obsessions." In *What's the Use of Art?: Asian Visual and Material Culture in Context*, edited by Jan Mrázek and Morgan Pitelka, 238–71. Honolulu: University of Hawai'i Press.

Meyer, Birgit. 2014. "An Author Meets Her Critics: Around Birgit Meyer's 'Mediation and the Genesis of Presence: Toward a Material Approach to Religion.'" *Religion and Society: Advances in Research* 5, no. 1: 205–54.

———. 2015a. "How Pictures Matter: Religious Objects and the Imagination in Ghana." In *Objects and Imagination: Perspectives on Materialization and Meaning*, edited by Øivind Fuglerud and Leon Wainwright, 160–83. New York: Berghahn Books.

———. 2015b. "Medium." In *Key Terms in Material Religion*, edited by S. Brent Plate, 139–44. London: Bloomsbury.

———, David Morgan, Crispin Paine, and S. Brent Plate. 2010. "The Origin and Mission of *Material Religion*." *Religion* 40, no. 3: 207–11.

Mibach, Lisa, and Sarah Wolf Green. 1989. "Sacred Objects and Museum Conservation: Kill or Cure?" In *The Concept of Sacred Materials and their Place in the World*, edited by George P. Horse Capture, 57–66. Cody, WY: The Plains Indian Museum, Buffalo Bill Historical Center.

Moilanen, Irene. 1995. "Last of the Great Masters? Woodcarving Traditions in Myanmar—Past and Present." PhD dissertation, University of Jyväskylä.

Moose, J. Robert. 1911. *Village Life in Korea*. Nashville, TN: Methodist Church South, Smith and Lamar, Agents.

Morgan, David. 1999. *Protestants and Pictures: Religion, Visual Culture, and the Age of American Mass Production*. New York: Oxford University Press.

———. 2005. *The Sacred Gaze: Religious Visual Culture in Theory and Practice*. Berkeley: University of California Press.

———. 2010. "Introduction: The Matter of Belief." In *Religion and Material Culture: The Matter of Belief*, edited by David Morgan, 1–18. London: Routledge.

Morris, Rosalind C. 2000. *In the Place of Origins: Modernity and Its Mediums in Northern Thailand*. Durham, NC: Duke University Press.

———, ed. 2009. *Photographies East: The Camera and its Histories in East and Southeast Asia*. Durham, NC: Duke University Press.

Mueggler, Erik. 2001. *The Age of Wild Ghosts: Memory, Violence, and Place in Southwest China*. Berkeley: University of California Press.

Murayama Chijun. 1932. *Chōsen no fugeki* [Korean shamans]. Keijō (Seoul): Chōsen Sōtokufu.

Myers, Fred R., ed. 2001a. *The Empire of Things: Regimes of Value and Material Culture*. Santa Fe, NM: School of American Research.

———. 2001b. "Introduction: The Empire of Things." In *The Empire of Things: Regimes of Value and Material Culture*, edited by Fred R. Myers, 3–61. Santa Fe, NM: School of American Research.

Myint, U Aye. 1993. *Burmese Design through Drawings*. Bangkok: Silpakorn University.

Napier, A. David. 1986. *Masks, Transformation, and Paradox*. Berkeley: University of California Press.

Nash, June C. 1966. "Living with Nats: An Analysis of Animism in Burman Village Social Relations." In *Anthropological Studies in Theravada Buddhism*, edited by Manning Nash, 117–36. New Haven, CT: Yale University, Southeast Asia Studies.

———. 2007. "Multiple Perspectives on Burmese Buddhism and Nat Worship." In *Practicing Ethnology in a Globalizing World: An Anthropological Odyssey*, 77–104. New York: Rowman & Littlefield.

Nash, Manning. 1966. "Ritual and Ceremonial Cycle in Upper Burma." In *Anthropological Studies in Theravada Buddhism*, edited by Manning Nash, 97–116. New Haven, CT: Yale University, Southeast Asia Studies.

Ngô Đức Thịnh. 2003. "Lên Đồng: Spirits' Journeys." In *Vietnam: Journeys of Body, Mind, and Spirit*, edited by Nguyễn Văn Huy and Laurel Kendall, 252–72. Berkeley: University of California Press.

Nguyễn, Hiền Thị. 2007. "'Seats for Spirits to Sit Upon': Becoming a Spirit Medium in Contemporary Vietnam." *Journal of Southeast Asian Studies* 38, no. 3: 541–58.

———. 2016. *The Religion of the Four Palaces: Mediumship and Therapy in Viet Culture*. Ha Noi: Thế Giới Publishing House.

Nguyen, Trian. 2015. *How to Make the Universe Right: The Art of the Shaman from Vietnam and Southern China*. Santa Barbara: Art, Design and Architecture Museum, University of California.

Nguyễn Văn Huy and Phạm Lan Hương. 2008. "The One-eyed God at the Vietnam Museum of Ethnology: The Story of a Village Conflict." *Asian Ethnology* 67, no. 2: 201–18.

Norton, Barley. 2000. "Vietnamese Mediumship Rituals: The Musical Construction of the Spirits." *The World of Music* 42, no. 2: 75–97.

———. 2002. "'The Moon Remembers Uncle Ho': The Politics of Music and Mediumship in Northern Vietnam." *British Journal of Ethnomusicology* 11, no. 1: 71–100.

O'Hanlon, Michael. 2000. "Introduction." In *Hunting the Gatherers: Ethnographic Collectors, Agents and Agency in Melanesia, 1870s-1930s*, edited by Michael O'Hanlon and Robert L. Welsch, 1–34. New York: Berghahn Books.

Orsi, Robert A. 2005. *Between Heaven and Earth: The Religious Worlds People Make and the Scholars Who Study Them*. Princeton, NJ: Princeton University Press.

———. 2010. "Introduction to the Third Edition: History, Real Presence, and the Refusal to be Purified." In *The Madonna of 115th Street: Faith and*

*Community in Italian Harlem, 1880–1950*, ix–xxvi. New Haven, CT: Yale University Press.

Owen, Alex. 1990. *The Darkened Room: Women, Power, and Spiritualism in Late Victorian England*. Philadelphia: University of Pennsylvania Press.

Paine, Crispin. 2013. *Religious Objects in Museums: Private Lives and Public Duties*. London: Bloomsbury.

Pedersen, Morten A. 2007. "Talismans of Thought: Shamanist Ontologies and Extended Cognition in Northern Mongolia." In *Thinking Through Things: Theorising Artefacts Ethnographically*, edited by Amiria Henare, Martin Holbraad, and Sari Wastell, 141–66. London: Routledge.

———. 2011. *Not Quite Shamans: Spirit Worlds and Political Lives in Northern Mongolia*. Ithaca, NY: Cornell University Press.

Pels, Peter. 1998. "The Spirit of Matter: On Fetish, Rarity, Fact, and Fancy." In *Border Fetishisms: Material Objects in Unstable Spaces*, edited by Patricia Spyer, 91–121. London: Routledge.

Petersen, Martin. 2008. "Collecting Korean Shamanism: Biographies and Collecting Devices." PhD dissertation, Copenhagen University.

Phạm Quỳnh Phương. 2007. "Empowerment and Innovation among Saint Trần's Female Mediums." In *Modernity and Re-Enchantment: Religion in Post-Revolutionary Vietnam*, edited by Philip Taylor, 221–49. Singapore: Institute for Southeast Asian Studies.

Picard, Michel. 1990. "'Cultural Tourism' in Bali: Cultural Performances as Tourist Attraction." *Indonesia* 49: 37–74.

———. 1996. *Bali: Cultural Tourism and Touristic Culture*. Singapore: Archipelago Press.

Pinney, Christopher. 2004. *Photos of the Gods, The Printed Image and Political Struggle in India*. London: Reaktion Books.

———. 2017. "Piercing the Skin of the Idol." In *Anthropology of the Arts: A Reader*, edited by Gretchen Bakke and Marina Peterson, 143–50. London: Bloomsbury Academic.

Plate, S. Brent. 2014. *A History of Religion in 5 1/2 Objects: Bringing the Spiritual to Its Senses*. Boston: Beacon.

Poleax, Alexandis. 1895. "Wayside Idols." *The Korea Repository* 2: 143–44.

Reader, Ian, and George J. Tanabe, Jr. 1998. *Practically Religious: Worldly Benefits and the Common Religion of Japan*. Honolulu: University of Hawai'i Press.

Reedy, Chandra L. 1991. "The Opening of Consecrated Tibetan Bronzes with Interior Contents: Scholarly, Conservation, and Ethical Considerations." *Journal of the American Institute for Conservation* 30, no. 1: 13–34.

———. 1992. "Religious and Ethical Issues in the Study and Conservation of Tibetan Sculpture." *Journal of the American Institute for Conservation* 31, no. 1: 41–50.

Ridgeway, William. 1964 [1915]. "Burma." In *The Dramas and Dramatic Dances of Non-European Races in Special Reference to the Origin of Greek Tragedy with an Appendix on the Origin of Greek Comedy*, 228–62, 387–94. New York: Benjamin Blom.

Robson, James. 2007. *Inside Asian Images: An Exhibition of Religious Statuary from the Art Asia Gallery Collection.* Ann Arbor: University of Michigan Institute for the Humanities.

Rodrigue, Yves. 1992. *Nat Pwe: Burma's Supernatural Sub-Culture.* Gartmore, Scotland: Kiscadale.

Ross, Laurie Margot. 2016. *The Encoded Cirebon Mask: Materiality, Flow, and Meaning along Java's Islamic Northwest Coast.* Leiden: Brill.

Ruddick, Abby Cole. 1986. "Charmed Lives: Illness, Healing, Power and Gender in a Balinese Village." PhD dissertation, Brown University.

Ruitenbeek, Klaas. 1993. *Carpentry and Building in Late Imperial China; A Study of the Fifteenth-Century Carpenter's Manual.* Lu Ban Jing. Leiden: Brill.

Ruppert, Brian D. 2000. *The Jewel in the Ashes: Buddha Relics and Power in Early Medieval Japan.* Cambridge, MA: Harvard University Asia Center.

Santikarma, Degung. 2001. "The Power of 'Balinese Culture.'" In *Bali: Living in Two Worlds: A Critical Self-Portrait,* edited by Urs Ramseyer and I Gusti Raka Panji Tisna, 27–35. Basel: Schwabe.

Santos-Granero, Fernando, ed. 2009a. *The Occult Life of Things: Native Amazonian Theories of Materiality and Personhood.* Tucson: University of Arizona Press.

———. 2009b. "Introduction: Amerindian Constructional Views of the World." In *The Occult Life of Things: Native Amazonian Theories of Materiality and Personhood,* edited by Fernando Santos-Granero, 1–29. Tucson: University of Arizona Press.

Schepers, M.B. 1967. "Sacramentals." In *The New Catholic Encyclopedia,* 790–92. Washington, DC: McGraw-Hill.

Schober, Juliane. 2004. "Burmese Spirit Lords and Their Mediums." In *Shamanism: An Encyclopedia of World Beliefs, Practices, and Culture,* edited by Mariko Namba Walter and Eva Jane Neumann Fridman, 803–6. Santa Barbara, CA: ABC CLIO.

———. 2008. "Communities of Interpretation in the Study of Religion in Burma." *Journal of Southeast Asian Studies* 39, no. 2: 255–67.

Sen, Moumita. 2019 (1–4 July). "The Demon, the King or the Rebel: Forging a New Iconography for Mahishasur." Paper Presented at AAS-in-Asia, Bangkok, Thailand.

Sharf, Robert H., and Elizabeth Horton Sharf, eds. 2001. *Living Images: Japanese Buddhist Icons in Context.* Stanford, CA: Stanford University Press.

Shorto, H.L. 1967. "The 'Dewatau Sotāpan': A Mon Prototype of the 37 'Nats.'" *Bulletin of the School of Oriental and African Studies* 30, no. 1: 127–41.

Shulman, David Dean, and Deborah Thiagarajan, eds. 2006. *Masked Ritual and Performance in South India: Dance, Healing, and Possession.* Ann Arbor: University of Michigan, Centers for South and Southeast Asian Studies.

Shway Yoe [James George Scott]. 1963 [1884]. *The Burman: His Life and Notions.* New York: W.W. Norton & Co.

Silvio, Teri. 2008. "Pop Culture Icons: Religious Inflections of the Character Toy in Taiwan." *Mechademia* 3: 200–20.

———. 2010. "Animation: The New Performance?" *Journal of Linguistic Anthropology* 20, no. 2: 422–38.

———. 2019. *Puppets, Gods, and Brands: Theorizing the Age of Animation from Taiwan*. Honolulu: University of Hawai'i Press.

Skidmore, Monique. 2007. "Buddha's Mother and the Billboard Queens: Moral Power in Contemporary Burma." In *Women and the Contested State: Religion, Violence, and Agency in South and Southeast Asia*, edited by Monique Skidmore and Patricia Lawrence, 171–87. Notre Dame, IN: University of Notre Dame Press.

Slattum, Judy, and Paul Schraub. 2003. *Balinese Masks: Spirits of an Ancient Drama*. Singapore: Periplus.

Spiro, Melford E. 1967. *Burmese Supernaturalism: A Study in the Explanation and Reduction of Suffering*. Englewood Cliffs, NJ: Prentice Hall.

Steiner, Christopher B. 1994. *African Art in Transit*. Cambridge, UK: Cambridge University Press.

Stephen, Michele. 2001. "Barong and Rangda in the Context of Balinese Religion." *RIMA: Review of Indonesian and Malaysian Affairs* 35, no. 1: 137–93.

Stewart, Susan. 1984. *On Longing: Narratives of the Miniature, the Gigantic, the Souvenir, the Collection*. Baltimore: Johns Hopkins University Press.

Swearer, Donald K. 2004. *Becoming the Buddha: The Ritual of Image Consecration in Thailand*. Princeton, NJ: Princeton University Press.

Swergold, Leopold, et al. 2008. *Treasures Rediscovered: Chinese Stone Sculpture from the Sackler Collections at Columbia University*. New York: Miriam and Ira D. Wallach Art Gallery, Columbia University.

Tambiah, Stanley J. 1973. "Form and Meaning of Magical Acts. A Point of View." In *Modes of Thought: Essays on Thinking in Western and Non-Western Societies*, edited by Robin Horton and Ruth Finnegan, 199–229. London: Faber and Faber.

———. 1990. *Magic, Science, Religion, and the Scope of Rationality*. Cambridge, UK: Cambridge University Press.

Tapsell, Paul. 2015. "*Ko Tawa*: Where Are the Glass Cabinets?" In *Museum as Process: Translating Local and Global Knowledges*, edited by Raymond Silverman, 262–78. London: Routledge.

Taussig, Michael. 1993. *Mimesis and Alterity: A Particular History of the Senses*. London: Routledge.

Taylor, Paul Michael. 1994. *Fragile Traditions: Indonesian Art in Jeopardy*. Honolulu: University of Hawai'i Press.

Taylor, Philip. 2004. *Goddess on the Rise: Pilgrimage and Popular Religion in Vietnam*. Honolulu: University of Hawai'i Press.

———. 2007. "Modernity and Re-Enchantment in Post-Revolutionary Vietnam." In *Modernity and Re-Enchantment: Religion in Post-Revolutionary Vietnam*, edited by Philip Taylor, 1–56. Singapore: Institute of Southeast Asian Studies.

Telle, Kari. 2019 (1–4 July). "New Demons, 'Deep Play': Playing with 'Demons' on Lombok." Paper Presented at AAS-in-Asia, Bangkok, Thailand.

Temple, Sir Richard Carnac. 1906. *The Thirty-Seven Nats: A Phase of Spirit Worship Prevailing in Burma*. London: W. Griggs.

Tun, Than. 2002. *Buddhist Art and Architecture with Special Reference to Myanmar*. Yangon: U Nyunt Htay (Monywe Books).

Turner, Victor, and Edith Turner. 1978. *Image and Pilgrimage in Christian Culture: Anthropological Perspectives.* New York: Columbia University Press.

Tylor, Edward B. 1958 [1871]. *Religion in Primitive Culture.* New York: Harper and Row.

Tythacott, Louise. 2011. *The Lives of Chinese Objects: Buddhism, Imperialism and Display.* New York: Berghahn Books.

van der Veer, Peter. 2014. *The Modern Spirit of Asia: The Spiritual and the Secular in China and India.* Princeton, NJ: Princeton University Press.

———. 2016. *The Value of Comparison.* Durham, NC: Duke University Press.

Venkatesan, Soumhya. 2014. "From Stone to God and Back Again: Why We Need Both Materials and Materiality." In *Objects and Materials: A Routledge Companion,* edited by Penny Harvey, et al., 72–81. London: Routledge.

Vi Văn An. 2008. "A Thái Divination Kit in the Vietnam Museum of Ethnology." *Asian Ethnology* 67, no. 2: 257–69.

Viveiros de Castro, Eduardo B. 2004. "Exchanging Perspectives: The Transformation of Objects into Subjects in Amerindian Ontologies." *Common Knowledge* 10, no. 3: 463–84.

Võ Thị Thường. 2008. "Sacred Object, Artifact, or Cultural Icon? Displaying the Xăng Bók Tree of the Thái People." *Asian Ethnology* 67, no. 2: 287–304.

Võ Văn Trực. 2007. *Cọng Rêu Dưới Đáy Ao* [Pond Scum]. Hanoi: Nhà xuất bản Hội nhà văn.

Volkman, Toby Alice. 1990. "Visions and Revisions: Toraja Culture and the Tourist Gaze." *American Ethnologist* 17, no. 1: 91–110.

Vossion, Louis. 1891. "Nat Worship Among the Burmese." *The Journal of American Folklore* 4, no. 13: 107–14.

Vũ Hồng Thuật. 2008. "Amulets and the Marketplace." *Asian Ethnology* 67, no. 2: 237–55.

Walraven, Boudewijn. 1995. "Shamans and Popular Religion around 1900." In *Religions in Traditional Korea,* edited by Henrik H. Sørensen, 107–29. Copenhagen: Seminar for Buddhist Studies.

———. 1998. "Interpretations and Reinterpretations of Popular Religion in the Last Decades of the Chosŏn Dynasty." In *Korean Shamanism: Revivals, Survivals, and Change,* edited by Keith Howard, 55–72. Seoul: Royal Asiatic Society.

———. 2009. "National Pantheon, Regional Deities, Personal Spirits? *Mushindo, Sŏngsu,* and the Nature of Korean Shamanism." *Asian Ethnology* 68, no. 1: 55–80.

Warnier, Jean-Pierre. 2006. "Inside and Outside: Surfaces and Containers." In *Handbook of Material Culture,* edited by Chris Tilley, et al., 186–95. London: Sage Publications.

———. 2009. "Technology as Efficacious Action on Objects . . . and Subjects." *Journal of Material Culture* 14, no. 4: 459–70.

Whitehead, Amy. 2013. *Religious Statues and Personhood: Testing the Role of Materiality.* London: Bloomsbury.

Wiener, Margaret J. 1995. *Visible and Invisible Realms: Power, Magic, and Colonial Conquest in Bali.* Chicago: University of Chicago Press.

Wolf, Margery. 1992. *A Thrice Told Tale: Feminism, Postmodernism, and Ethnographic Responsibility*. Stanford, CA: Stanford University Press.

Yang, C.K. 1961. *Religion in Chinese Society*. Berkeley: University of California Press.

Yang Jongsung. 2008. "Seoul Musoggwa Kŭmsŏngdangŭi silch'e" [The essential facts about Seoul shaman practices and the Kŭmsŏng shrine]. *Saenghwalmunmul yŏn'gu* [Material Culture Studies] 15: 56–82.

Yi Chong-ch'ŏl. 1992. "Changsŭng." In *Han'gugmunhwa sangjing sajin* [Dictionary of Korean myths and symbols], 518–21. Seoul: Dong-a Publishing.

Yi Kwan-ho. 2005. "Maulŭi anyŏnggwa p'ungyorŭl chik'yŏjunŭn maŭljik'imi" [The village guardian who takes care of the village's peace and prosperity]. In *Ch'ongyech'ŏn pokwŏn chungongginŏm t'uekpyŏlchŏn Han'gungmiŭi chaebalkyŏn—Yigaragŭi changsŭng sottaejŏn* [Special exhibition commemorating the opening of the Ch'ongye Stream: The rediscovery of Korean beauty—exhibition of Lee Garag's changsŭng and sottae], 4–5. Seoul: Sejong munhwa hoegwan.

Yi Pilyŏng. 1997. "Changsŭnggwa sottae" [Changsŭng and sottae]. In *Han'gungminsokŭi ihae, Kungnip minsok pangmulgwan* [Understanding Korean folklore, National Museum of Folklore], 267–77. Seoul: Kungnip minsok pangmulgwan.

Yi Tu-hyŏn (Lee, Du-hyon). 1984. "Changsŭng." In *Han'gug minsok hangnongo* [Vintage discussions of Korean folklore studies], 39–45. Seoul: Haksosa.

Yoon Yul Soo. 1994a. *Kŭrimŭro ponŭn han'gugŭi musindo* [Korean shaman Paintings seen as paintings]. Seoul: Igach'aek.

———. 1994b. "Hwehwasaro salp'yŏponŭn han'gugŭi musindo" [Looking at Korean shaman paintings through the history of visual art]. In *Kŭrimŭro ponŭn han'gugŭi musindo* [Korean shaman paintings seen as paintings], 7–23. Seoul: Igach'aek.

# Index

Founded in 1893,
UNIVERSITY OF CALIFORNIA PRESS
publishes bold, progressive books and journals
on topics in the arts, humanities, social sciences,
and natural sciences—with a focus on social
justice issues—that inspire thought and action
among readers worldwide.

The UC PRESS FOUNDATION
raises funds to uphold the press's vital role
as an independent, nonprofit publisher, and
receives philanthropic support from a wide
range of individuals and institutions—and from
committed readers like you. To learn more, visit
ucpress.edu/supportus.